for Richard
from

The Sweet Singer
of Modernism

A. K. A.
your friend Bill

Also by Bill Berkson

The Sweet Singer of Modernism

AND OTHER ART WRITINGS

1985–2003

BILL BERKSON

 QUA BOOKS

LIBRARY OF CONGRESS CONTROL NUMBER:
2003095236

ISBN:
0-9708763-4-3

Printed in the USA

COVER PAINTING:
December by Alex Katz (1979)
Hiroshima City Museum of Contemporary Art, Hiroshima, Japan
© Alex Katz, licensed by VAGA, New York, New York

BOOK DESIGN:
Deirdre Kovac

SERIES DESIGN:
Elizabeth DiPalma/DiPalma Design

Published by Qua Books
211 Conanicus Avenue
Jamestown, Rhode Island 02835

www.quabooks.com

EDITORS
Michael Gizzi
Craig Watson

Contents

The Sweet Singer
of Modernism

Critical Reflections

*Yes, when I address someone, I do not know whom I am addressing;
furthermore, I do not care to know, nor do I wish to know. . . .
Without dialogue, lyric poetry cannot exist. Yet there is only one
thing that pushes us into the addressee's embrace: the desire to be
astonished by our own words, to be captivated by their originality
and unexpectedness.*

— Osip Mandelstam, "On the Addressee," 1913

*It seems to me that it is not the critic's historic function to have the
right opinions but to have interesting ones. He talks but he has
nothing to sell. His social value is that of a man standing on a street
corner talking so intently about his subject that he doesn't realize
how peculiar he looks doing it.*

— Edwin Denby, "Dance Criticism," 1949

People who buy art magazines complain that the writing found there
is unreadable. Some sense a conspiracy at work. A specific reader is
either alienated or accedes by learning – as anyone can, in six weeks or
so – to talk the talk. "He sounds like the art magazines" is not how any
writer I know would want to be characterized. The magazines, for
their part, have style sheets and staff editors geared for the care and
feeding of manuscripts. Out of thin air they invent an image of the
general reader whose willingness to be informed about art and whose
tolerances for specialized language or high-sounding foolishness they
try to anticipate. The general reader is a unicorn to be lured so the
magazines can maintain their costly looks, which after all say some-
thing about the importance (and never mind the fashionable expense)
of the visual arts to enough people living in enough places. A mod-
icum of sales and advertising permits the editors of the two or three
serious glossies to get on with their missions of providing intelligible
facts and observations for the artistically inclined and/or otherwise
alert art audience.

Critics are neither culture heroes nor art stars. Assiduous art-world insiders know perhaps fifty full-time critics' names and can identify half of those with particular attitudes or styles. The forms of art writing – the five-hundred-word short review, for instance, in its compression and flexibility comparable to a sonnet – are dictated by the magazines. Members of the wider art public can identify different editorial forms and stances among the magazines to which they do or don't subscribe. Very few individual critics become household names. Even Clement Greenberg, I would guess, hasn't been indexed into the crossword puzzles or the cultural-literacy manuals, but then neither have most of the contemporary artists he has discussed.

It's a truism that the general reader looks to criticism as a consumer guide. The critic is an expert soothsayer whose authority is measured by the seamless suasion of his or her arguments. "The existence of an 'authoritative critic' or a 'definitive evaluation' is a fiction like that of the sea serpent" (Edwin Denby). Verdicts and explanations call for fairly transparent and flatfooted prose styles. A critic like myself, who is less interested in systematic argument than in communicating the spontaneously dense, specific and often paradoxical events of consciousness in the face of contemporary works, allows for occasional opacities of language. The critic who faces art's manifold dialectic head-on risks seeming to want to be abstruse when really he or she is only trying to stay true to a complex situation. I like to think that my opacities can be enjoyed for themselves, at face value, as well as for their relation to both the artist's work and the reader's sense of language in the world. Given a vivid sense, in words, of what one sees in the work, one goes as deep and as wide as one can. A typical response to one of my reviews has been: "That was an interesting piece of writing, but I couldn't tell whether you liked the work or not." Liking or not is often not the point, or if so, it is an ulterior point. The main point is to give people something to read, to be accurate about the work without saying the same thing over and over.

As one writes, one's conception of the audience develops as a phantasmagoria of known and unknown persons. Only by negotiating that crowd of possible listeners does the critic find a vocabulary and a com-

panionable tone by which to register what sort of information is meant to be conveyed. Criticism goes wrong when its vocabulary petrifies and its practitioners pontificate aimlessly, having forgotten to whom they're writing. Run-of-the-mill criticism is tone-deaf; it addresses an undifferentiated mass, or no one in particular. Positing a receptivity no deeper than that of the word-processor screen, it fails to conceive of a composite, real-time, colloquial reader who reacts to every word and knows where the commas go. Eventually, the copy editor alone personifies this elusive regulator of humane, if often intergalactic, discourse.

What good is criticism and why does anyone write it, not to mention whether it is read? For anyone who enjoys looking at art, writing criticism can be an opportunity to articulate in public what is ordinarily consigned to tangential mutterings: your otherwise silent, on-site responses to works of art. As Fairfield Porter put it, "Criticism should tell you what is there." The critic's job is to respond to what is visually and conceptually there, to continue the conversation that making and looking at art both propose. To the extent that art says anything, the critic devises what can be said next. "We do not respond often, really, and when we do, it is as if a flashbulb went off" (Frank O'Hara). The truest criticism, I believe, reveals that flash, or series of flashes, in a language communicative of the intensity or force experienced in looking long and hard at art. Then it can begin to tell the polymorphous story of the thing.

The words go across the topic, making discriminations. Art writing claims to know what it's discussing. It has a topic and a referent; it's grounded in signification and continuity – a prosoid buildup of what Carter Ratcliff calls "language in the vicinity of what it's talking about." In a review, the topic is whatever artistic occasion you have attended and care enough to write about. The homework is endless, and you gather any number of essential facts. But reviewing, with its contingencies of deadlines and short-term looking, involves rhetorics, not essences. Essence is distinct but inarticulate. A review, to be articulate, tends to work away from the experience of essence, and thus is rarely definitive, although it may imply the writer's prior epiphanies. It covers a host of secret, ephemeral, and often unspeakable perceptions.

Functionally, art writing serves as commercial expository prose. If one estimates that hardly anybody reads it, one is bound to view it effectively as typographic filler – or a sign of relative importance by the inch – between gallery ads and color plates, which are the magazine's main attractions. Aside from this dismal estimate, art writing should be read – and written – primarily as reportage. An article or review can aspire to the level of a philosophical essay, belles-lettres, or a kind of prose poem. It can insinuate itself with an equivalent vitality into the orbit of an artwork as a parallel text. Whether it does this or not, it is unavoidably an exercise in communication requiring first an attention to fact and then a sensitivity to vocabulary and style. An art writer's prime ambition is to discover a critical vocabulary that illumines a specific art beyond the occasion of the provisional piece.

Criticism's provisionality is intoxicating. It's the working critic's siren call, seductive and maddening. The concomitant pleasures and terrors derive from an uncertainty that overrides almost every impulse towards assertion of either sense or value. That's where the fun lies, and the angst, and an eventual stupefaction. Because, *ideally*, much of the time, I hardly know what it is I'm looking at. Or if I do, I know it in such fashion that putting it into words seems to promise only the most bald-faced fabrication: sheer rhetoric, nothing to do with having seen anything at all. How account for the dumb wonder that accrues the longer one has stood transfixed by a painting that seems to satisfy the situation by being beautiful in one unalloyed respect or many? The stunned initiate riffles the dictionary (or a few trusty critics' texts) to search out a beginning. As in ordinary conversation, the critical faculties face a chaos of impressions, blanks, needs, memories, obfuscations, and intermittent facts for which orderly language makes an absurdly insufficient account. A picture can tell of all this, and so can a sentence. The sentences in a review turn up in a kind of order. Cracks in the order may show an alertness to, and duplicitous tolerance for, the actual chaos occurring in the mental space between the reviewer and the work.

Poets bring a technical proficiency to art writing as well as an attitude that, in art's increasingly institutional settings, seems proportion-

ately ever more off the wall. Their interventions carry a fierce love of language and an abiding curiosity about the world of things. Perhaps more than the full-time critics, they simply want to say something interesting about the things they've seen in words that evoke the excitement and oddness of living in a world where these things occur, things made by contemporary people with a variety of purposes in mind. They would be the last writers to apply "poetic" as an adjective to an artwork, since "poetic," synonymous with "inscrutable" or "soft" to art critics, to them means something technically specific.

Poets see art as social behavior and less as a specialized mode. Being artists themselves, whose art brings in next to no money, they look askance at the art-world economy. A few may hang out shingles proclaiming that as critics they mean business, but even those retain a sense of criticism as a minor occupation and of their own pronouncements as groundwork rather than definitive assays. The "poet who also writes about art" (as the contributors notes so often say) is interested in observation for observation's sake. To claim exemptions for poets writing monthly reviews seems like an insult directed both ways: when Eileen Myles wails of poets forced into "flattening . . . responses into conventional prose . . . the virgins thrown into the volcano," I wince for such an etherialized conception of poets as special keepers of the unconventional; but when in the next breath she says that as a poet faced with painting "you want to be excited, ennobled, teased alive," my heart goes with her. How many workaday art writers regularly forget that such demands – on oneself as well as on works of art – go with the territory?

As a poet/critic, I often typecast myself for the purposes of argument as a more or less forlorn aesthete. More insistently, and playing down the "forlorn," I would say I'm an esthetic hedonist. I'm "in" art for the sensual and intellectual pleasures I continue to find there, and as far as the practice of criticism goes, I commit to that for the joy of giving my verbal attentions to things that answer them and usually stay put long enough to allow my views to add up. Criticism that dampens, rather than heightens, esthetic pleasure seems to me worthless. The aesthete proceeds, by stumbles and veers, along the lines of articulated sensation, cultivating a shifting horde of passions, tolerances, fascina-

tions, glees, and disgust that marks the temporary side effects of what keeps promising to be a civilized habit.

The art world, like the freeway system, runs on combustible energies. The supply is all a matter of faith. Every season has its test of faith administered by at least one artist perceived as the exception who might just be delivering the goods, or at least keeping the pumps from going altogether dry. (For "pump," read "discourse"; for what is pumped, read "meaning.") The new season gushes forth its spectacular authenticities: Anselm Kiefer and the Raiders of the Lost Ark, Jeff Koons as Luke Skywalker, and so on. Current critical surveillance stakes out art as a site of meaning production. Esthetic pleasure – suspect, illicit – rips in where too much meaning has clamped down. The "meaning-production" racket is funny. In what has come to be read as "normative" criticism generally, the purveying of meaning thrives by syllogism and other brassbound tropes of merciless logic, which are convenient ways of getting around how things work when you meet them face-to-face. Logic tries to erase the distance between correctness and in-your-face truth.

A determined meaning usually spells a short esthetic track, which is fine if the issue is an other-than-esthetic efficacy or critical practice as a power unto itself. Meaning is critical power. A critic's will to power betrays itself to the extent that the critic insists that meaning be explicit and tethered by what the critic writes. The convenience language of the magazines and art-history departments requires constant testing. Otherwise, it becomes predictable and painfully false. Predictable language suits only an art with predictable meanings. If criticism has all the words in place – a fixed vocabulary – it has stopped looking and won't listen for the words that might be there for the work.

Art criticism is a nonprofession, and yet there are professional critics – "a tidy guild on the fringe of useful human endeavor," as Peter Schjeldahl once called them. The rise of professional art critics coincided with the art-school boom of the '60s and '70s, which issued forth the middle-aged and younger artist contingents we see today. Artists are educated mostly away from where the art is; they know art – as do the art-history majors who become career critics – by theory and slides, rather than by perceptual confrontation. Slides are more verbal than

visual equivalents of works of art. Criticism based primarily on theory and slides tends toward the post-retinal, and art based on the implications of such criticism tends to give one less to look at. Art students view criticism, whether theoretical or not, as a querulous organ or protuberance of the alien art world they expect to confront. For them, as for most artists, criticism by nonartists posits a language foreign to artistic practice and the spoken criticism of studio and street. Eventually, an art student begins to read criticism seriously as a kind of boot-camp maneuver. The student mistakes criticism for either subject matter or the audience, or both.

Why does art writing continue to seem like just so much art writing? Only the layouts and typefaces change. An art writer's self-importance is nonsensical. History shelves all but the few critical pieces that give pleasure and interest as something more than topical position papers. And it recognizes the next work of art as the criticism that matters most. If as a critic I remain relatively unprincipled – an amateur at heart – it's because I've learned that my pleasures come most fully from works that outstrip everyone's principles, and most especially my own – at which point everyone, even the artist, should feel amateurish, and a bit humble. Criticism should be modest in principle and quick or excessive enough so that everyone can enjoy how hypothetical it is.

1990

Thiebaud's Vanities

> *If one takes the down-to-earth as a point of departure and neither makes nor wastes any effort in trying to rise to an exalted or splendid level, every effort, every artistic contribution goes into transfiguring the method of execution, changing the language, advancing the spirit, thus constituting a magnificent progress. . . . Treat the most common subjects in the most ordinary manner, and your true genius will appear.*
>
> – Francis Ponge, "De la nature morte et de Chardin"

Wayne Thiebaud's "true genius" is of the kind least likely to appear in these millennium-prone, disaster-happy times. He is an ironist as befits the age, but not gnarled, not disappointed, not a satirist, not an escapee either. Like the Dutch masters he resembles, and like Chardin after them, he is an "honest" painter. Like Morandi, whom he has called a "schoolteacher-painter," he is interested in mastery of the small matters of his métier, and determined to exercise it, even though his immediate audience could care less about masterful techniques.

He is a problem painter. His progress has been circuitous instead of meteoric. He is no stylist, however much he may pursue style. His pictures have a quick charm, which diminishes under scrutiny, and a ponderous staying power. Their surface aspects please a large segment of the museum-going public as well as other artists, mostly of course other realists. There must be something wrong with what he does, but I haven't yet figured out what it is, and neither have his detractors. Millenarian critics see him as complicitous with rank consumerism; they miss the dark side of his displays, and the unappetizing quality, even, of their veneers. The best review of his work is still the one by Donald Judd from 1962, which is condescending but says important things. (Judd's phrase "communicative of the object" is exactly right for Thiebaud's technique, as is "existential nausea" for what it entails, at least partially.)

Karen Tsujimoto's text for the catalogue of the present exhibition is admirable, thoroughgoing, and informative; it explicates for a gen-

eral audience the artist's own knowledge of his procedures. Neither the catalogue nor the exhibition, which focuses primarily on work of the last fifteen years, makes any claim to telling the whole of Thiebaud's story so far. The show will travel no farther east than Columbus, Ohio, which is a shame and says something about the East Coast curatorial blind spot not just for the less zappy forms of California art, but for energetic contemporary realism generally. (Alex Katz's only full-scale retrospective to date, after all, occurred exclusively in the West, and that will have antedated the upcoming Whitney show by a full decade.)

In the preamble to a slide lecture accompanying his retrospective when it opened at the San Francisco Museum of Modern Art in September, Thiebaud enumerated what he called the "characteristics" of painting as basically fivefold: "pressures" (which "make worlds, make space"), "light/value/color," "size," "time" and its register, and "sin" (e.g., "mistakes, anomalies, flaws, secrets"). He then showed slides of: Copley, Gordon Cook (who had recently died), Alice Neel, Sassetta ("who made his own rocks"), Ingres ("manipulator of the world!"), Coptic portraiture, Brueghel's *Tower of Babel* (Vienna version), a Mondrian chrysanthemum and *Red Tree*, Rembrandt, a lot of Hals ("fast brush!"), Van Gogh, de Kooning, Seurat, Cézanne, Monet, de Chirico ("a visual sinner"), Matisse, a Diebenkorn still-life drawing, two Ryders, Morris Louis, O'Keeffe, Frank Stella, Isabel Bishop, Gentile da Fabriano, Christian Bérard, Bonnard, Guy Pène du Bois, Soutine, and Balthus. He showed no examples of his own work and none of other artists whose names have been linked with it, such as Hopper, Chardin, Morandi, Kline, Degas, Eakins, or David Park. Apropos of Mondrian's flower picture, he mentioned the necessity of resonance ("to build time into our lives"), and he likened Bonnard's colors to "hot coals." The talk had been advertised as "Thiebaud on Thiebaud," but it was in fact a defense of painting, passionate and funny and instructive at every level. Thiebaud himself suggested a number of alternate titles, among them "Realism: The Flip Side of Taxidermy." At the media preview a few days before, he reminisced about his background in commercial art and referred to his present standing as "a sign painter gone uppity."

9

But most of all it's that shining glazed sweet counter – showering like heaven – an all-out promise of joy in the great city of kicks.
— Jack Kerouac, *Visions of Cody*

Alex Katz says "Wayne Thiebaud paints social symbols." The story goes that early on, Thiebaud was mistaken for a Pop artist, but that was mere coincidence. Pop was a catchy term as misnomers go; but New Realism, a name that came to New York from France and lasted about a month, was better. Had it persisted, it would have accounted more penetratingly for Jim Dine and Red Grooms as well as for Warhol, Rosenquist, Martial Raysse, Pistoletto, and Wesselmann; it could have encompassed Oldenburg and Segal (perhaps the only "realist" sculptors), and it would have let Jasper Johns ("I'm not a Pop artist!") out of the bag sooner and thrown sooner into question the relation of Roy Lichtenstein's vehemence to the cheeriness of the general scene. It would have made a more comprehensive space, too, for both Thiebaud and Katz, and possibly for Philip Pearlstein at one pole and Ed Ruscha at another. (Not that any of them suffered for lack of accounting.)

All these artists foregrounded the connection between commercial and serious art as Courbet had done in the 1840s. They dealt with culturally enforced habits of seeing and desire. An art of cultural consciousness, whether symbolic or propagandistic, necessarily does this. The culture-conscious art of the 1980s – that of Barbara Kruger, Robert Longo, Neil Jenney, David Salle, Keith Haring, Walter Robinson, and others – would be pointless without its commercial techniques, including its techniques of marketing, which are equally evolved. Thiebaud's early paintings of pie-counter displays and toys, like the pants and hamburgers from Oldenburg's *Store*, were candid, even adamant, about their cultural origins. The great thing that Thiebaud has done since is to be even more candid about *his* origins, i.e., to lead to his strengths and combine the trade secrets of commercial illustration (and their implied melodramas) with those of serious painting. It's not a smooth mix. No matter how refined the techniques of commercial illustration, their associations with schlock are bound to rankle, at least temporarily. In *Woman in Tub*, for instance, the mottled tones of late-

'40s-movie-poster "flesh" butt to self-consciously "minimalist" white. The flower paintings carry gaudy overtones of scratchily modeled motel décor. The dark still lifes are svelte as mounted Kodachromes. Two of them, *Dark Candy Apples* and *Boxed Rose*, are glazed panels. They remind you how perfectly oil paint and wood are made for each other. (You wonder why anyone ever started using canvas instead.)

When first shown in New York in the early '60s, Thiebaud's still lifes were accepted as stylish researches into the commonality of signs. Little attention was paid to their traditional genre aspect, and none at all to their symbolic necromancies. (Both Judd and Hess caught their tinge of disgust, but Hess mistook it for social criticism.) Looking at the early still lifes in the retrospective – at *Confections*, for instance, or *Five Hot Dogs* – you see how unanonymous, how un-sign-like and nuanced each object in them can be. You also see how Thiebaud had to manage their settings with bands or bars of color so the whole field would appear together rather than come forward in sections, and also how the bands "rope off" the view. The bands had to go – in *Candy Counter* they are fully obtrusive and overbright. They are replaced by a simpler, tighter framing that coordinates the field and amplifies the scale to permit intensified drama and a more uncertain feeling of space.

Cast off into decontextualized space, the imagery can move virtually anywhere, even into contexts other than those of still life. *Black & White Cakes* is a still life but it is also a portrait of two related beings. *Heart Cakes (Valentine Cakes, Four Valentine Cakes)* is a family portrait. Implied human presences among Thiebaud's objects are often like those in the situation dramas of Douglas Sirk and Yasujiro Ozu. All three artists are fascinated by the question of whether we possess objects or they possess us. *California Cakes* suggests that the latter is true. It also shows Thiebaud's tenacity to his original motif, and how he can turn it to an unsuspected use. It's a complicated idea: five cakes of equal size jostling each other vertically in a nearly straight row, embedded in a sort of cement-mortar gray. The icings read like doggerel (and like a lexicon of Thiebaudisms), front to back: "birthday," with a rose; then a lemon-ellipse sun, a slightly squashed squiggle of a Valentine heart, a flattened California poppy, and a round of berries like a distant grove. (Something else about heart sym-

bols in Thiebaud: many of the pictures are signed in the lower right with the artist's surname preceded by a tiny outline of a heart, which seems arbitrary until you realize that the symbol is actually an inverted "W.")

These paintings represent the sort of thing that for an Easterner is wrong with California. The streamlined improbable trees, like eucalyptus trees, have no character. The colors are bright and without savor. The weather is dramatic, but no one has to cope with it. Each painting is like a stage setting ready for actors who have confidence and health but no feeling.

— Fairfield Porter

"These paintings" were not Thiebaud's. (Porter, alas, never wrote on Thiebaud's work, which he might have liked better than that of the other California painters he did write about – Diebenkorn, Bischoff, and Wonner, in the early '60s.) "California," along with the niceties of its climate and light, tends to be overgeneralized by non-Californians, and especially by East Coast art writers. The *two* Californias (of the coastal edge, anyway), north and south, have very different weathers and terrains. Thiebaud grew up in the south and lives and paints in the north. (He has two homes, one in Sacramento and the other on San Francisco's Potrero Hill.) The northern light is nice but difficult and not always clear. It is anything but "relentless." It lopes, jounces, jags, spreads (at its brightest like aluminum foil), and is often befogged when not rained out. It isn't "knife-like" and definitive like the New York light that Porter loved, and in it the landscape is overwhelming and not commodious.

For California realists, those few who persist, the local scale must be held in check, or else allowed to swallow every detail. Diebenkorn's solution to this has been a flattening of detail into wedge-and-patch designs resembling intaglios in wood, which accounts for the patchiness of his light. (Influenced by Diebenkorn's layouts, Thiebaud has modulated the harshness of wedges, often by using "rainbow" outlines.) Then there's the problem of acidulous local color – greens, blues, yellows, and combinations thereof – struck in the reflective glare. One

Eastern painter, after driving from Santa Barbara to the Bay Area, remarked upon what she called "that awful palette," explicitly sympathizing with those fated to struggle with the indigenous tones. Another complained of tired eyes after a day of trying to see contours. Thiebaud himself speaks of "managing the landscape"; in fact, he keeps its details and basic look, and reinvents it in terms of continuous structure.

Whitney Balliett called Fairfield Porter "the kind of realist who uses a lot of abstraction." The same could be said of Thiebaud. The same in fact could be said of most American commercial artists. Thiebaud uses a lot of commercial-type fantasy, along with the fine-art type once known as "magic realism." Porter's painting bears next to no relation to commercial art in its style and only a tangential one in its subject matter, in its genres. Resemblances between Porter's work and Thiebaud's are general: both artists reflect great care about things as they can be seen, including painting as painting (and about being "good" painters); neither takes much stock in Cubism or in any other ideology of modernism per se; the works of both have exactitude and stillness, a broad light (though Thiebaud's panoramic light is slower and more artificially conceived) and dark underpinnings; both are easily taken as dulcet and dreamy and aren't; and both are the results of highly professional, if noncommercial, stances.

Something more positive should be said for the relation of commercial art to the tradition of serious American painting. Ask any painter about his/her initial experience of color and figuration, and eventually you'll be treated to an analysis of some particular excellence in commercial art – be it Disney animation, Foster & Kleiser (billboards), the Wheaties carton, or Ernie Bushmiller. One could cite an impressive list of important American artists between 1850 and the 1960s art-school glut who received their primary schooling, or who were apprenticed significantly, in the context of commercial art. Included would be Winslow Homer, Maurice Prendergast, Sloan, Luks, Hopper, Stuart Davis, and more recently Warhol, Rosenquist, and Alex Katz. De Kooning's training in applied art at the Rotterdam Academy is well documented, but Guston's and David Smith's early sources in cartooning are usually taken as ancillary biographical oddments.

"Self-taught" is a specious category. I'd hazard a guess that most artists born between 1900 and 1945 began their art educations with correspondence courses in caricature or basic figure drawing, which at that level are pretty much the same thing ("Can You Draw This Dog?"). The fabled toughmindedness of much mid-century art was due as much to the demystifying of technique (you *can* draw this dog) engendered by commercial practices as to Outsider skepticism about both academic and modernist esthetics. Alex Katz says that, while he was learning to draw from plaster casts in high school, he had no aspirations to fine art: "The only art form I knew at that time was dancing." A side issue is how many commercially trained and/or apprenticed draftsmen hit their strides as painters relatively late. The "self-taught" Winslow Homer started painting at twenty-seven, using schemes he had developed over the previous six years as an illustrator and journalist. Hopper clarified his motifs in commercial etchings and returned to painting full-time in his early forties.

Thiebaud started painting at thirty and had his first one-man show at forty-three. He's now sixty-five. As a teenager, he had worked at Disney as an "in-betweener" on animated films. (He wowed his schoolmates with ambidextrous renderings of Mickey Mouse, Goofy, Jiminy Cricket.) During his twenties, he did freelance cartooning, movie posters (*The Killers* and *Dead of Night* for Universal), Air Force reconnaissance maps, fashion illustration, and stage sets, and worked as an art director and cartoonist for Rexall Drug. As a painter, much of his finesse comes from illustration, and much else from a fondness for the wilder shores of traditional painting as well as from a tense and oddly balanced view of material essence.

To thee were solemn toys or empty shew,
The robes of pleasure and the veils of woe;
All aid the farce, and all thy mirth maintain,
Whose joys are causeless, or whose griefs are vain.
— Samuel Johnson, "The Vanity of Human Wishes"

The men and women in Thiebaud's figure paintings have the air of being looked at, almost as if they were under glass. They can barely look back. Uncertain of their situations, they deliver their frames, the *sine qua non* of public selves. Reduced to the neutrality of scrutinized beings, their characters insist. *Standing Man* has a faintly nasty curl of upper lip; he is posed like Watteau's clownish *Gilles* and recalls those eminent, plainclothed loners of '50s movies, Glenn Ford and Gregory Peck. In *Toweling Off* the towel is a dramatic occlusion, becoming in fact the central character, with a countenance of its own.

Thiebaud paints the vanity of material essences. His antecedents in this respect are Brueghel, Vermeer, Chardin, Cézanne, and Hopper, and maybe closer to the bone, Morandi, de Chirico, and Ryder. He has none of Morandi's quietude, some of his fixity, and all of his tension. His humor aligns with Brueghel's on one side and de Chirico's on the other. It is vernacular and Platonic, sly and a little bumptious. The connection with Chardin is interesting. Like Chardin, Thiebaud interrupted his concentration on still life with a series of figure paintings and then resumed painting still lifes with a more delicate technique and a closer focus. Like Chardin, he participates in the tradition of *la vie silencieuse*, the original French term for *nature morte*.

As citizens of the world of things, the cakes and other foodstuffs in the still-life pictures are dislocated, virtually unwanted. They are the products of appetite but they don't whet it. Their appeal is to sight and touch only, and not to taste. Dressed-up, as it were, for their own special occasions, they are as dysfunctional as Miss Haversham's wedding cake, that vestigial lump of woebegone desire. Similarly, the cityscapes and images of household tools appeal to an appetite for control. The cultural visibility of Thiebaud's objects is hypnogogic; they are unbelievable dreams. However, their visibility in the actual arrangements of paint is of the daytime world, maximal but with barred access. A handgun is a toy. A real cigar smokes spontaneously. Artificial flowers face away and show us their stems. (They recall Ted Berrigan's remark that all flowers are narcissistic.) To the extent that these objects are encased in pictorial structure, they are not so much forbidden as virtually undesirable. They look familiar, but their col-

ors, the bright hues of enticement, are ironic. The colors fix the images perceptually but let them slip from familiarity, from use, from any sense of possession. The colors are both nice and deadly. The images, too, carry a double sense: to use Meyer Schapiro's distinctions between kinds of objects in still life, they are "decorative and sumptuous" *and* "symbols of vanity, mementos of the ephemeral and death." Like the double image (half portrait, half skeleton) in an eighteenth-century *vanitas*, they are caricatures of deliquescence, ceremonious freeze-frames of what the poet Anne Waldman calls "makeup on empty space."

"The flowers have fallen, the fruits have all been torn down." In the world of things, isn't scatter synonymous with structure? If things do possess us, what do they require? Just breathing space, perhaps, or as Thiebaud has suggested, "an independent repose." The head of *Woman in Tub*, staring into space, is repainted in miniature twenty years later as a pink rosebud sticking up out of a dark blue florist's box. The world indeed is fully prepared, laid out in state.

Slipperiness of made-up space, both physical and psychological, comes with the territory in Thiebaud's still lifes and figures as much as in his recent vertiginous landscapes. Things and people seem to hug the surface. Things, as in *Various Cakes*, sometimes huddle together and make a brave show of marching forward off the plane as if testing its traction, or, as in *Untitled*, take to the edges like novice swimmers in a pool. Sharp value contrasts and brushings-up of voids dramatize the peculiar "hung" nature of painting. The horizontal strokes isolating a cake or pair of shoes make absence functional like a place to sit. They form what Wolfgang Kemp has called "constitutive blanks." Every painter knows the horror of waking up to find that the imaginative stuff his pictures are made of has fallen off or collapsed. Thiebaud takes this potential entropy to imply an extreme vulnerability at every point in the picture space and for any image put there.

Although not in the show, *Girl with Ice Cream Cone* is perhaps Thiebaud's best-known image. The painting's dynamic glissade is at odds with its ostensible subject. The girl is just sitting there (in a pose albeit well-nigh impossible to hold). The girl's backward hand clings

for support to nothing so much as its own shadow. Her heels dig into shadowy pools. Some of Thiebaud's shadows are shaped like keyholes, others like tongue depressors, farm plots, buttresses. A tree growing on an urban incline is rescued from the abyss only by its cobalt flourish of shade, which snaps taut like a rock-climber's line. Thiebaud's principle is not that all shadows are one but that each is various and a specific adjunct of character – an accoutrement that rates special tending because in moments of spatial duress it may prove to be literally a saving grace.

Shadows are the "fall guys" in Thiebaud's spectacle of gravity stunts. Even the ones cast by human figures don't quite match their antecedents; they are accompanying subtexts. In *Man Reading*, the gray glyph produced by a hunched figure and a three-legged stool stretches out on a parallel plane like a woolly, attendant dog. The "sunhat" shadow in *Girl with Pink Hat (Nude in Pink Hat)* bolsters identity like a thought balloon. In *Street and Shadow*, the russet silhouette projecting across a median line suggests the features (nose, chin, overbite, hayseed's forelock) of some benign, slightly oafish giant.

In the urban and rural landscapes, the scramble for toeholds gets uniformly hectic. The giddiness induced by such pictures as *Clouds and Ridge (Ridge and Clouds)* and *Apartment Hill* makes the outrageous proportions of Bierstadt and of Church look picayune by comparison. Thiebaud's landscapes are arguments about space. The foreground of *Clouds and Ridge* is a fantastic, frontal slab of sheer erosion, with clots of dark brown paint protruding. The view is mid-air, as if from a hang glider, and backlit. The lower atmosphere is aflutter with clouds, one very big and others rhyming punctiliously with trees that are rooted to the ridge top like toothpicks with "cello-frills." Three footpaths lead nowhere in one direction and straight to perdition in the other. The sky is a standardized, utter cerulean. The whole image is a mite silly, and also awful, but it compels. It is the unpicturesque face of geologic dailiness confronted practically nose-to-nose – recognizable, incredible, of small comfort, endless thrall.

Thus is time recorded by space: an augmentation upon the surface.
The visual world is an accumulation of time apprehended instanta-
neously.

— Adrian Stokes, *Colour and Form*

Thiebaud began painting cityscapes in San Francisco in the mid '70s —
at first outdoors, then at home from outdoor sketches, and eventually
from sketches combined of many different views. Ambiguous about
being the "real" San Francisco, his cityscape recalls the composite one
(shot partly in San Francisco, partly in Los Angeles) of Hitchcock's
Family Plot. Nevertheless, the look of that somewhat toy city is there,
with its swirls, lumps, sudden flats and tilts, its block-long assemblages
of stucco/wood/brick, its multiplicity compounded by later sprouts of
concrete, glass, and steel. Sense of place (as Jack Kerouac said, "the clar-
ity of Cal — to break your heart") contends with fear of slippage on
glossed-over sandstone hills. In *Day City (Bright City)*, the milk-white
side of a twelve-story building presents simultaneously a barrier and a
blank. Thiebaud's "pressures" have their work cut out for them. They
manage. *Hill Street (Day City)* shuttles up, down, across; red helps
bring it all together — the red of stoplights, of brake and directional sig-
nals, of a bus and two cars (the same red, in fact, of *Dark Candy Apples,
Cherries, Dark Lipstick*). There are modulated brushings of streak,
wedge, dot, squiggle, etc., that stack upward to crossbars of sky. In
Sunset Streets there's a muted homage to late Mondrian in the shady
side of a blacktop thoroughfare that zooms up and, at a bump, yields to
a creamy suburban freeway under a flesh-colored sky. In an aerial view,
tall buildings have little depth and no monumentality. There are gin-
gerbread houses and pudding-colored highrises. Some areas look
entirely edible: a line of Queen Anne cottages, each a different pastel
tone like those of Necco wafers.

The freeway paintings are monumental. The landscapes and street
views, with their unsociable steepnesses, risk overcomplication. But the
freeway pictures break clear. In *San Francisco Freeway*, a row of houses
perches above two parallel whiplashes of fast road with some tall build-
ings like sentinels (or cenotaphs?) at either side. The picture is built of

about nine different shades of blue. Blue is the enemy of Bay Area painting. Thiebaud fixes it by taking it in hand, giving it air and continuity. In *Freeways*, there's the shock of air appearing for the first time in a Thiebaud setting, and it is the crinkly, sooty air of a warehouse district replete with truck traffic and smokestacks and the distinct pleasure of a pink warehouse roof, and again of a stand of wishful palms around a paved lot, overlaid by arabesques.

The installation of this show at the San Francisco Museum of Modern Art was magnificent. It seemed to resolve itself happily into "movements" like those of a big piece of music: *allegretto* for the still lifes; *adagio* for figures and flowers; *largo* for landscapes and *andante* for streets; a *finale presto* for the freeways; and a hushed coda for the new, mysterious pastels. The selection shows Thiebaud at his most versatile – although it leaves out his printmaking achievements – and nowhere more than in his most recent work, which shows him capable now of just about any scale and mood. What a solid love of painting it manifests. Thiebaud is going full tilt.

1985

Kline's True Colors

All the complications besetting the recent Franz Kline retrospective couldn't stop one from feeling ultimately grateful that the show happened, that there was, at any rate, the chance to see gathered a bright sampling of the facts of Kline's greatness, if not his true range or magnitude. Short of some miracle, such an opportunity is not likely to come again, and if it does, the likelihood of its being improved upon by a fuller and keener choice seems practically nil. A dismal prospect, surely, because we need Kline's example in toto, his forthright manner and breadth and dogged invention, his largeness of spirit, his seriousness – his melancholy, even. We have always needed it but never so much, the portents say, as from here on out.

The show's complications had to do mostly with the fragility, increasing with age, of the material surfaces and underpinnings of Kline's works: the nondurable house paints he favored (well into the late '50s) for many large, important paintings; the impermanent telephone-book and newsprint pages and fugitive inks and oils of countless drawings and collages; the hard-to-transport homesote and Masonite panels of the later "walls." Fragility and insurance worries led to major absences, and to difficulties (such as very low light) in viewing the eighty or so works that finally did circulate. In his monograph accompanying the show, curator Harry F. Gaugh says: "Advanced thinking among conservators today tends to be conservative, namely the less done to a Kline painting the better. That includes moving an unstable painting, for Klines have been known to shed bits of paint in shipment." Further: "The inevitable aging process interacting with Kline's combination of black and white pigments is softening the effect of his work. Not only have surfaces cracked, whites yellowed, and bonded layers pulled apart, paintings once intensely black have taken on a flat, hazy appearance . . ."

It must have been difficult to conceive of mounting a definitive Kline exhibition without the likes of *Nijinsky*, *Thorpe*, *Wanamaker Block*, *The Bridge*, and *Shenandoah Wall* – to name but five of a plausi-

ble dozen essential pictures that did not make it into the show. But there's no gainsaying either the reluctance of collectors, curators, and insurers to allow such pictures to travel, or their need to keep close tabs on the handling of the ones that were lent. As it was, the checklists for the show's three museum versions differed, as did the methodologies of display. Cincinnati saw a rather willful grouping by theme and structural types; San Francisco and Philadelphia, a rough chronology.

In all three museums, the contracted-for lighting followed the latest strictures for dimness in deference to conservation – i.e., five-footcandle intensity for works on paper and fifteen for canvas and boards. Thirty to fifty footcandles is typical for most contemporary art galleries. Working nights under strong ceiling lights, Kline himself probably used five-hundred-plus intensities in making his better-known works. (The Cincinnati and San Francisco installations used progressive darkening of gallery walls – in Cincinnati, for instance, from sandy gray to midnight blue – to reduce losses of ambient contrast.)

All this foregrounds what might be called the "mutability factor" between the Klines we think we know and those same works as we now see them. (As one expert put it, "The race is on between '40s–'50s painting and '60s–'70s process art as to which disintegrates first.") Mutability – whether the result of partial or complete physical change or ruination, or simply different readings of the same, unaltered presence – is a factor in the perception of any work of art. We don't know the original colors of Piero's walls, but we know that the colors that remain are amazing – that they are "right" for us. Part of the present glory of Kline's *Painting Number 11*, which probably comes from shifts in the saturation of back and white pigments, is its resemblance to a well-aged limestone megalograph. There are no templates for Klines any more than for antique ruins – and given the inherent qualities of light and touch in Kline's case, there are really less than none. Neither can reproductions cut the impasse. As James Schuyler commented, "The difference between the painting and its diminishment is that between a face and a snapshot of it. The paintings are that full of life and that close up." Kline's pictures are leading material lives that outstrip our certainties of them. The importance that accumulates about

these works may be extending apace with the life cycle of their physical surface – strange to say, because there are few surfaces so factual, so literally "all there" as the ones Kline made.

Near the beginning of Frank O'Hara's dramatic monologue "Franz Kline Talking," Kline says: "In Braque and Gris, they seemed to have an idea of the organization beforehand in their mind. With Bonnard, he is organizing in front of you. You can tell in Léger just when he discovered how to make it like an engine, as John Kane said, being a carpenter, a joiner. What's wrong with that? You see it in Barney Newman too, that he knows what a painting should be. He paints as he thinks *painting* should be, which is pretty heroic." Kline continues his discourse on organization and process, having surveyed the upper reaches of Velasquez and Cézanne: "They painted the object they looked *at*. They didn't fit out a studio and start painting without a subject. I find that I do both. Hokusai painted Fuji because it was there . . ." And the talk dovetails with a clincher: "To be right is the most terrific personal state that nobody is interested in."

"Franz Kline Talking" is an extraordinary document, an arrangement of probes and piths that incorporates, and forever after transmits, both the painter's knowledge of his procedures and the general ethos of the New York School (a feat that only Edwin Denby's essay on de Kooning, "The Thirties," had managed previously). It is a mistake to say, as Gaugh does in the catalogue, that "the 1958 interview was actually a fabrication by O'Hara, which Kline went along with." An interview it was, with Kline's words recollected from one sitting, and, as O'Hara noted later, "Since the painter felt that set questions were too stilted for him, the agreement was that he 'would just start talking.'"

Kline came to his conception of what painting should be, what it *would* be for him, by an open, piecemeal logic that fits together now, as we look, under the heading of "character" or "fate." The steps of his early development are clear, decisive, but there's no urgency in any one of them that directs towards the next. Outwardly, his progress – from cartoonist/illustrator to Greenwich Village sketch artist and genre painter to "Action Painter par excellence" – seems a manifest bumbling, his real genius filling whatever form came to hand. "Eclecticism"

barely suggests that goofy mix in his earliest work of old-masterishness and ragtag modern – something Rembrandt, something Gauguin, something Armory Show, something stiff-necked American Cubist – all heated and stirred in the nightbird crucible of Sheridan Square. The assortment was catalyzed with memories of a Carbon County, Pa., youth – trains, coal, homelessness, a "zero panorama" like that of Robert Smithson's forlorn Passaic.

Kline was distinguished from his New York School peers by two negatives in the stylistic mélange they otherwise shared: he did no fantasy (surrealist or other) and no social commentary either. Not a symbolist, he was interested in a thing's being itself – simply so, and at its full extent. His barroom murals are caprices, and his city scenes and landscapes either straight reportage or lyricism. The 1940 Bleecker Street tavern commission *Hot Jazz* zooms in and out of scale, steadied by the quick frontal poise of the singer's outstretched hand. The memoryscape *Palmerton, Pa.*, a National Academy prizewinner in its day, is exact in scale and cropping and takes a sudden dare in its embedded red caboose. Both paintings are good at their required levels – and then some.

The '40s portraits and landscapes show Kline's instinct for cartooning along the lines of stress as well as his tonal panache. In *Portrait of David Orr*, the cheekbone contour seems ready to pop free of the face, straining against a too-fixed design. A later extravagance, *Pennsylvania Landscape*, translates a commanding desolation as acid green, and fortitude as orange and black. If, as Schuyler says, Kline eventually "forced drawing to the point where it vanished, but not by abandoning it," he could have done so only by seeing color everywhere, inside drawing and out. He made the separation vanish, not the materiality on either side.

Whatever blew the lid off – and it was probably a timely combustion of many things, including an off-contour quickening of line in the ink drawings, the fabled session of Bell-Opticon enlargements cast upon de Kooning's wall, the zeroing-in on the value range of blacks and whites – Kline's mature efflorescence, circa 1949, marks a giant shift from incidental perception to a wide-open world view. The scaled-up focus on masses and speeds (or what Alex Katz calls "colors

as weights and surfaces") gave Kline his world, an entirely possible place, to the surface of which he fitted space and light, power and impeccable dignity. He didn't withdraw into that world, but brought it forward into the observable life around him, to let it be, as he put it, "part of the noise." It's as if once he got hold of his simplified gestalt, he could move everywhere the view took him. And it was almost too much: his versatility of statement has about it a terrific, and almost maddening, restlessness. Although sets of drawings make exhaustive study of the intricacies of certain forms, the final paintings sweep past them. Kline's definitiveness tended to jump around. He never painted in series, or rather a series to him would be a set of two, neither of them typical. One such pair from 1958, *Requiem* and *Siegfried*, makes a near mirror-reversal, though in impact one is a squall and the other a deluge.

Kline simplified but allowed plenty of noise. His hard finishes show a permeability to vision like the night air. His directional lines make for dual sensations of passage and grip. (Some mid-'50s pictures show similarities in scale between impasto textures and the coarse grain of heavy linen fabric, which account for the palpable tractions.) A black-and-white surface gathers sharply and wells towards the observer; moored to the edges it nudges them to expand. The blacks connect to edges or to other blacks, while the whites divide and scintillate. Black and white together or separately careen edge to edge as prodigiously stretched lines. There are things white does that black will never do, and the other way around, like consonants and vowels. Two blacks in the same stretch are distinct and make a difference – not a third color but a shade. In *Lehigh V Span*, a long, tapering black plows through a traffic of tones (including shimmers of green, pink, blue), as different whites press forward, projecting more and less solidly than a wall. Given the scale, it's peculiar how close you can look and still see a unified image. The light, as Adrian Stokes said of Turner's light, "takes actuality to itself." Among the sheared contours, there's a quasi-mathematics – lateral divisions into threes and fives – as in the parts of a sonnet. (There are rhymes as well, like blank/yank/flank/plank.) The light spreads the same way the paint is smeared, though with an extra elasticity. Motion is concretized, a characterization, not an issue of per-

formance, not the painter's gesture as such. It's the picture, not the man who made it, that seems to say with Godard, "I want to do things, not just name them."

Kline's line: there's nothing quite like it, which is why his commentators see all things in it. The dark strokes, one-shot or repeated, scuff, tower, bevel, loop, and dart; but mostly they just span, hence Kline's and others' perception of them as bridges, roads. Both darks and lights look considered, not impulsive (there's less "action" in the way of spills and spatters). The lines corroborate the surface tautness, much as their angles reconfirm the angles of the perimeter. Figures stand or impend, don't sit or float. As likenesses, allusions to specific things or people, they never add up. As architecture, for instance, they're too dysfunctional, too wayward and frayed (try geophysics, e.g., plate tectonics, instead). As characters – or, in de Kooning's apt word, "countenances" – they click. Kline himself spoke of "associative" forms and explained, "What I try to do is create the painting so that the overall thing has that particular emotion, not particularly just the forms in it." Thus, *Figure Eight* is not a numeral but a dissociated vulnerability strung and dipped in fractured space. It has the feeling, and some of the inclination, of the earlier "Nijinsky" images. The comical *Le Gros* snaps together like an epigram. *Palladio*'s vertical buildup is a scouring of crosswise trumpet blasts with a sung note, an open square, upheld at the middle. In *Andrus*, the tonal drift rhapsodizes, its orchestral densities riding no point of rest in a headlong, lateral swell.

Kline died in his prime, at age fifty-one, on the edge of a resolution. Years before, he had complained that colors, when he tried using more of them, "kept slipping away." They didn't have the snap of black-and-white arrangements, but there was no reason why they should. One obvious solution, that of *Andrus* anyway, was to let them slip. Kline had already moved from neatness to mess, out of kilter and into kinetic rapture, consolidating some forms but letting style generally go by the boards. The struggle over color in big formats hinged on maintaining frontality and extension. In smaller oils there was no such problem. The larger color pictures seem to know less what to do, if anything, with white. But in *Zinc Door* white assumes a new form of command,

as the softened blacks comply with a tenderness made firm by repeated application. There is still that "smooth feeling about the black areas," noted early on by Robert Goodnough, "that tempts one to caress the surface." The staying powers of these late works should silence any qualms about Kline's alacrity at the end. They recall Pound's dictum that "it's the quality of the emotion that endures." Exact emotions are in the paintings, intimate with the poise and push and splendor of physical stuff. What Pound said was right, and to that extent, we have Kline's works, in their live intimations, virtually intact.

1986

First Painter of Character

An eye is wide and open as a day.
— Edwin Denby

Alex Katz has worked at deciding for himself what is most admirable and ripe in traditionally balanced oil painting – a tradition he confronts quite sharply and has gone some lengths to enlarge. Through some of the thornier questions of contemporary style and content, as well as through the curatorial bans on energetic realism, he has managed to cut his own wide, steady swath. His big, clear, largely declarative pictures take their basis in peculiar facts of seeing and how seeing and knowing match up. Their luxury is a wealth of style. Their realism extends from how the world looks to Katz's eye and incidentally from how his models present themselves.

Katz's subjects are from life: New Yorkers mostly, friends and family, observed singly or as groups in ordinary social space – a city loft or vacation house or field in Maine where Katz spends summers. As in conventional portraiture, a sitter's personal expression will be seen to hold sway over the final image. The sitters' poses are natural but the naturalness of their settings is simulated (that is, the situations themselves are posed), and the colors, light and space usually have an extra measure of formality or idealization or both. There are rooms and landscapes with and without people, and window views and animals. There are few objects aside from clothing and other appurtenances: a glass, a cup, cigarettes, a radio, a free-floating canoe. In *Night*, a houseplant tilts in front of a painting, and opposite, there's an empty chair beneath a lamp, rare items that click to the mood.

Asked a few years ago about the gracefulness of his figures in contradistinction to their realism, Katz replied, "I might be showing things at their best moments – under the best conditions – but that's as real as anything else." Katz paints character in the light of the moment. If the moment is casual or bland, he doesn't press it with an anterior sense of importance. His profounder images, which can be

counted on the average of about one a year, posit the difference between intending a pathos and observing if it happens – the former being a privation of the moment's integrity while the latter is an extrusion in the present tense. The human meaning is proffered at face value, self-evident.

Critics stymied by the seeming offhandedness of Katz's noneditorializing approach have no use for the actual surface look of his paintings. Others, those who object to the class appearance of his figures – stylish clothes, civilized miens, and other ambient pleasures of the urban art milieu, whether bohemian or straight – show a strange irritability where their own social markings are concerned. The culturally touchy among iconographers resent finding themselves or their next-door neighbors represented at the level at which they actually live. (As one poet/critic who should know once countered, "If we're not middle-class, what the hell are we?") Katz, for his part, delights in recognizable neighborhood plumage as physical fact. About the declassified cultural openness of Rudy Burckhardt's street documentaries he once wrote: "It's great to have someone show you a thing you have passed thousands of times as something you never saw, and after seeing it you continue to pass it again and again and not see it."

A typical Katz will have an unfussed look as if done on the spot, *alla prima*, even though the most recent ones are more methodically designed. Since the mid '60s generally, he has gone more for power than charm, and the wit that used to be part of his subject matter now serves formally – to get a composition out of a tight corner, to turn an unwieldy tableau into a ruckus of deflection, no less beguiling for the outsized oddities gathered edge to edge. Instead of romanticizing the blockbuster format, he takes it as a public conveyance for information just wide of the general scope. His extravagances have pleasurable sweeps and disconcerting elements. Where an awkward passage in a four-foot portrait can be charming, at twice that size it is grotesque. Many of Katz's bigger pictures are grotesque. Like Guston, to whom he is otherwise antithetical, Katz came to grand-scale painting by discrete stages from an essentially lyric impulse, consolidating and then retrenching for definition and release. In the '50s, Katz showed the influence of

Guston's shimmering touch and softly spreading tonal light. Of course, Guston's imagery was the more subjective. Katz is an objectivist.

If scale is the live aspect of size, character is that quality of energy discriminated as vivid fact. Painting's imaginary light modulates character and scale and introduces a time element. In a broadly conceived tradition of imagemaking intent on maximum visibility (viz., Egyptian murals, Edo prints, quattrocento frescoes and bas-reliefs, Mondrian, Léger), one general approach involves integrating stylized character, light, and scale so that the whole of an image can be seen in the instant before the mind entangles itself in lesser details. The outright appearance forestalls bafflement about what's visibly real and hypothetically improbable. A remark on this score made by Edwin Denby in 1965 has become so identified with the light-and-energy quotient of Katz's work as a whole that its original application to the tiny collages of the '50s is largely forgotten. What Denby said was in the form of a question: "How can everything in a picture appear faster than thought, and disappear slower than thought?"

At the Whitney, the immense space of the central gallery designed for the present show put the public on notice as to the maximizing tenor of Katz's work, as well as its distancings. This "great hall" effect took some getting used to, although right off you could see the benefits of the airy, long-range focus conferred on a thirty-foot painting at the far end. Close to the elevators, facing them and away into the room, the freestanding group portrait (some forty front-and-back, head-and-shoulders cutouts) *One Flight Up* (1968) provided the show's overture. The eye, thus oriented, cast clockwise to five big paintings.

Here are three of them:

In *December* (1979) we see the head and shoulders of a woman (a rather Japanese-looking Ada, the artist's wife) in soft brown hat, coat, and muffler, wrapped against the elements, while the snow splotches about her. The look is slightly askance – she's just flashed an attitude – but utterly intense and furled. The entire space is pivotal, on the brink. The weather intensifies the sharpness of feeling, but the character, being projective (she is herself, the month, the climate, a sudden city sight), appears impervious to the weather. She's absorbed in something

else, serious and determined. She addresses herself to a second presence, which may well be the viewer, or light. But, on the other hand, the character and its light are one.

The weather in *Swamp Maple, 4:30* (1968) is no less intense. The slender titular tree bisects an overcast Maine landscape view. The painting doesn't flatter nature but steps right up, augmenting its sudden composure. The sky's dun chrome descends like a dusty window shade and presses forward, riding a blue ridge. A lake or cove is rimmed by three shores. The dark middle shore, jutting, discloses the source of light as do the tree's darker higher leaves, which, in the late-afternoon peace, make a sparrowlike flutter. The real cracking on the maple bark wasn't planned but happened as the paint aged in the artist's New York loft, a neat accident (also unusual: Katz's oil colors otherwise tend to retain their fresh-squeezed look).

Unlike the two other pictures, *Pas de Deux* (1983) does without nature and hinges on a kind of hieratic nonchalance. Five empanelled couples read right to left like instantaneous, progressively explosive shifts in a dance line. The performers are just schematized models wearing street clothes. The picture takes off on fashion styling and partnering conventions in classical dance. The men in the lineup recede as if in deference to the up-front women, but instead of lifting or supporting, they weigh them down – hands on shoulders, arms around waists. The women look cheerful, the men a little stupefied. Katz has the men gravitate downwards by the device of lowered eyelids. The multiple hand gestures stop short of intimacy; palms in or out, fingers pointing or spread, they jab and flicker laterally across the frieze. The figures are cropped at the thighs, the stage lighting steady and unstopped by the perimeter cuts.

For years, Katz has been attempting large formal dance pictures, always with mixed results, silly and/or mechanical. *Pas de Deux* succeeds like a machine painting in the good sense, a showpiece that works. It has a strange abstract zing. The figures are real people acting out an artifice, which is the surface show. Staging such a production number out front let the museum audience in on a secret: that Katz's paintings of people catch perceptible dancelike postures in everyday

life, postures that are part of the theatrical forward thrust of character associated with contemporary New York.

If New York is the court of modern high visibility, Katz stands as First Painter to its acculturated peers. His figures are focal points in the neatly partitioned syntax of urban flux, New York's nonpareil spillway of grandeur and duress. Bravely undisheveled and refusing simply to meld, their mutabilities chronicle the floating world of the downtown art scene from its blooms in the '50s and early '60s to its presently still-bright but fungoid state. You can follow the dress codes as indexes of period styles: from, say, Rauschenberg in suntans, open collar, and rolled-up sleeves to David Salle in a shiny black sharkskin suit. The art-world look, as Katz finds it, is oft times modestly dumpy, or conversely too much of the moment; more likely, though, styled for speed and comfort, with snazzy colors and touches of Olympian self-amusement – the allover pattern of little stars on a pleated skirt; a single earring, big and round like a stateroom porthole, an aqua dish.

In New York's sociable purgatory (with heaven always in mind, or at least the Empyrean of Style), the range of human types seems boundless. People, as they are set forth, suggest a native tact about distance: eyes in groups meet or stare away or come straight for you; at close quarters, elbows have a personal edge. (But what's with all these toothpaste grins – signs of a baffled complicity, or a friendly monster showing its teeth?) Portentously swaddled, a planetary character will reveal concentration at the neck, or a beautiful absence will simper, or a loft-dweller's basic tenderness be etched in features grayed-out under fluorescent glare. Surface is the great revealer. As Katz has said, "Vitality being what emanates from the surface, manners and intent have no meaning." Pungently, a single sitter's gaze flattens wide, beyond any set contingency. A technical mystery twist: the wider the gaze of the figure, the bigger the image's scale – in the realm of appearances, we are truly rounded.

Delivering a slide talk to art students in San Francisco a couple of years ago, Katz began by anticipating their difficulties. "With slides," he said, "you don't know the size, the touch, or how they're painted, and the color's wrong – so you don't really have much." That settled,

he proceeded to make a number of clear-cut distinctions, some of them professional pointers tuned to the occasion and others specific to his own painting or to painting generally. With each slide, he emphasized the "optic element" and actual dimensions. About dynamic versus implied motion, he remarked, "The more dynamic the action in a painting, the less you're able to take it seriously as painting." He outlined his art-school beginnings: "painting outdoors was where everything clicked. The paintings didn't look good but the process was dynamite – and I said, 'I'm going to be a painter.'"

He then leveled on basics, a five-point program: (1) "In painting, you have your personality and you have painting, and you have to reconcile the two. Every time period represents a different cultural attitude. My attitude was formed by the war years when people just really wanted to have a good time. I was interested in dancing and playing basketball . . ." (2) "Everyone has a three-year period when they connect, when they're hip, and that's your period." (3) "A painter has a shorter time than a fashion designer to be on top of styling. After that three-year period, good painters go out and spend the rest of their lives painting masterpieces. Painting seems to me to be an older man's business. You know you're out of it and you just paint masterpieces, and you get better." (4) "In art school, if you don't have developed cultural attitudes, your painting is limited, no matter how good you are technically. You can be hip, but your time period should be three years from now, not now." (5) "To learn good habits, paint six hours a day at least six days a week for at least six years – and then you'll see if you like it." (Q: "Could you explain 'cultural attitude'?" A: "Well, Jung was hip in the '30s and Pollock picked up on Jung.")

Elsewhere, in Rudy Burckhardt's film on his work, Katz says: "I would like to make a painting that's so proficient technically that if you're going to say it's no good it's got to be because the man's character is bad."

Katz's progress reflects his culture as a native New Yorker, his inborn sense of theater, his early training in commercial art, his interests in literature and dance, and his fascination with the relation of style to expression and of both to social manners. The earliest paintings in

the show – *Winter Scene* and *Four Children* (both from 1951–52) – have all of his elements and no particular style. You see his enjoyment of the profuse material life a painting can have – a profusion that, handled delicately later in terms of color, widened the prospects of the work. His maturity began in 1956 when he made friendships that stimulated him toward a heightening of style and richer conception of surface. Edwin Denby, Rudy Burckhardt, and Frank O'Hara all came into his life at that time; and a year later, so did Ada Del Moro, whom he married. His painter friends in the '50s included Jane Freilicher, Al Held, Philip Pearlstein, Lois Dodd and other members of the Tanager Gallery group, and Fairfield Porter.

The half-length portraits of this period and the full-length ones of a few years later charm as much by their tentative placements as by the lushness of their veneers. (The earliest are oil-on-board; with the change to canvas around 1958 the pictures begin a yearly progression of enlarging by halves, with bigger jumps in 1963 and 1969 when Katz moved to successively roomier lofts.) Where the earliest figures stop shy of the plane, the one in *Track Jacket* advances stealthily but tucks inward at the sleeve and neck. Trouble in undefined space shows up mostly at the tops and bottoms. The problem of getting a head to sit straight on the shoulders is dealt with by leaving it off-kilter and wobbling, an awkward/lively skew. As Katz remarked, "A lot of these paintings don't have any floor" – so footholds had to be established mostly within the gestures of the figures themselves. *Paul Taylor* has duck feet. In *Irving and Lucy*, Irving Sandler's brogues flatten and smudge. *Ada in White Dress* resolves the no-floor enigma by sinking up to the ankles in a green setting that spreads to the top without receding or localizing as a grassy field.

Both the collages begun in 1955 and the cutouts invented four years later figured first as ancillary problem-solving devices for painting. The cutouts have continued as both a form in themselves and adjuncts to the making of big pictures. The collages, intermittent after 1957 (the last is dated 1960), were superseded in function by prints. (The retrospective includes neither drawings nor prints.) In the collages, Katz applied his wit to the incalculability of actual size. Miniscule arrangements of near

and far tones fasten on the idea of life size and undermine it, throw it back on itself like a well-staged pun. The tiniest details agglomerate in the middles and cue the images' central weights. The basic four-tone merger of *Dog at the End of Pier* – two grays, jet black, and a buff wash – is the "Whistler's Mother" of the set. The angular profile dog sits center sheet, lifted there by oblique patchwork as if on a pedestal, a truncated pearl. A similar joke of balance and tones lifts the cutout *Rudy and Edwin* into an adjacent world. Like real New Yorkers, the two old friends are a tad off the planet, mutually amused in their folding chairs as on a parade float.

After years of watching the early portraits expand in afterthought, one is struck by what trim sizes they really are. One is reminded, too, of how such pictures led the sensibility attack of Gestural Realism out of the downtown parlors into a more public, grittier citywide scale. In *Red Smile* and *Upside Down Ada* you see how the developing tonal range takes up the graphic statement, so that colors press at the contours and color and character become coextensive. The 1965 *Ada in Bathing Cap* is the first to add a recognizable counterweight of thought (it's a green thought). In *Vincent and Tony* both thought and size are doubled. Two boys, white and brown, sit shoulder to shoulder at the edge of a lake. A mopey-looking Vincent (the artist's son) looks off, but his more inquisitive friend rivets on the viewer. Their halftone shadings jog the stillness, while the sky behind them stretches a long, thin vanilla skein.

Character, says Katz, "can get to you from a bend in the back." Two of his self-portraits are actually three-quarter back views done partly with mirrors and partly made up. He speaks of "casting" himself in self-portraiture objectively so that, in the hail-fellow-well-met of *Alex* or the hard-nosed vacationist of *Self-Portrait with Sunglasses*, you get both Katz the actor and Katz the deliberate physiognomist. (Even more typically, as in *Passing*, he'll treat you to an unalloyed Katz scowl.)

There's a sensible distinction between images of lived-with selves (the self-portraits, the Adas, Vincents, or longtime friends) and those of a less intimate cast. The Vincent pictures now represent the span of a coming-of-age. In *His Behind the Back Pass* the deep shades of lawn

between father and son as they "Frisbee" seem to be marking a major turn. The portraits of Ada and their extra-autobiographical grandeurs are better known and have been remarked upon commensurately; as Lawrence Alloway says, "Ada's phases are an index of the active life as an ongoing process." But Ada reduplicated is also basically Ada in company with her constant self, as well as seen by someone who sees her shift, limitless of aspect, in the varietal spectrum of marriage. The exact hiatus of personal/impersonal in those pictures is complicated even when most clear.

Less intimately seen models lead to the logic of blander, plainer forms. In *Eleuthera*, the huge finale picture of the show, with its rather balloon-headed swimsuit pleasures, the eight female figures exude a generic glossiness solidified only in their shady parts. Even more low-definition images can dissolve into something genuinely evanescent. Of one portrait (a rare commission of the '60s), Katz recalled at the time, "I couldn't see the face so I painted the makeup." What all this argues, I think, is that Katz's cool, his supposedly smooth detachment, has been too conveniently overrated. His passion for exact appearance (if not always for likeness as such) is aligned with a truthfulness about how people appear to one another, how they register in the world. This truth, like that of character, is a social thing. For better or worse (empty or not), an evanescent sleekness is one fact of the way we manage our communal lives.

Katz's pictures of the last ten years or so stand or fall literally according to their lights, which extend to the nature of social events. When the pictures lapse, it is into a clatter of partial caricature – that is, they fall back on a lesser wit, with seams and blanks showing between bravura details. At their best – as in *Round Hill* – distinct shapes meet the rush of light as if cued by a beat. The confident light drives across the likenesses, probing, adjusting, zooming on. Looking at *Round Hill* in the last gallery of the Whitney show, one observer noted the way the local scale "implicates the viewer and throws the light back on him." Of such powers – and of Katz's attitude generally – the mountainous moose of *Moose Horn State Park* seems particularly emblematic. A juggernaut of heaving lights and darks, with his rear slammed up against

the picture plane, he is guardian, from his marsh end, of one of Katz's most munificent lake views – a soft-focus, silvery stretch with bright stabs of birches along the far shore.

The installation at the Whitney had a pedagogical bearing, a cumulative air of proof that seemed unnecessary (and unwise), like a case of last-minute jitters. What could be proven at this point? That Katz's development, unique and challenging, must be reckoned with in the dilapidated modernist canon? That his virtuosity should somehow be more astonishing than it is? On the whole, I thought, a show calculated to impress rather than please, although, as it turned out, it accomplished both. In the five days I was in town last spring, the exhibition drew crowds pleased to linger over the formal and fanciful imagery and the paintings' puzzles of scale and relations. The audience went for Katz's finesse, and most of the local reviewers did too.

The constellar timing at the Whitney was just right. On the floor below the Katz show, a partial guide to Katz's sources in the New York School was readily available in the permanent collection's corner placement of de Kooning's *Door to the River*, Guston's *Dial*, and Pollock's *Number 27, 1950*. (Interestingly, it is Katz's elongated and severely cropped recent cutouts, rather than his wall-size pictures, that seem to have Pollock most in mind.) The Eric Fischl show on the second floor made a telling counterpoint. As a younger follower of Katz's handling and surface clarity, Fischl is taking a logical next step – going at private symbolic gut dramas with no less sophistication and style. Fischl is interested in a persistent American awkwardness of figuration that Katz himself disdains. Katz, who has rarely even attempted the nude, has never painted a bedroom scene; Fischl, until very recently, was practically confined there.

Further downtown, at the Whitney's Philip Morris annex, another show had the theme of "urban pleasures that continue . . . to defy the notorious, nerve-wracking stresses of New York City and that serve as our reward for successfully surviving here" (catalogue note by Brendan Gill). In the way of reward, Katz's commonsense visual philosophy seems capable of allowing something for everyone. Standing in the "sun and shade" room, between the heated-up orange and green of *Ada*

with Superb Lily and the wonderfully backlit dog picture *Sunny*, a woman blurted to her friend, "See! He cares about people!" The rude assumption carried its glimmer of truth. Later, the painter Yvonne Jacquette put matters differently. In a letter she wrote: "Alex seems to have re-created himself. His early gentleness is now altered into a driving force to show the world as he would like it to be. The latest stage I only glimpsed this summer – which is to allow some lack of control in hope of a grander even more wildly brushed unlinear blaze."

Katz's new popularity – his elevation from specialty act to fast classic, however woozily perceived – provides a kind of taste test for the wider audience. Will it value his real strengths or dispose of them? His combination of lucid contemporary spectacle with a durable scale, among them, is foremost and unbeatable. Katz is a witness, transforming his views of how we do or might appear into telling, luminous, renewable states. His watchword style turns the key to resonance.

1986

Sweet Logos

The word "logos" of my title caroms off at least three senses, each one of them lighting up in its turn, abuzz in the vicinity of Ed Ruscha's work. The first, the elemental sense – old Greek for "word," "thought," "proportion," and "ratio" – is quite a bundle in itself. Ruscha, it might be said, immerses words in graphic thought zones, the better to "read" the words' true proportions. The mental size of a color plus the treatment of words as figures makes for an openness of logic. Ruscha is a field semiotician whose insistent method is "Try this."

The second, biblical sense of "logos," or "Logos" writ large, is, as Webster's has it, "divine wisdom manifest," alias "the Word made flesh." This sense requires careful handling, but it's definitely implicit in Ruscha's scheme of words as appearances plumbing indefinite space. Enough writing lately has fed off the fact of Ruscha's ex-Catholicism to provide indecorous heavy underscoring for this vector. But leave it that (to expand upon a line of Frank O'Hara's) once a Jesuit has stared you down not only do you "clink for ever after," but you are prepared inexorably for the numinous at every turn. If the Logos weren't an inexhaustible blank very like the sweet nothings wafting across the page of an Ed Ruscha sunset, we wouldn't revere it so. (It's the confiding-whisper tones of those nothings, however, that seem so lapsarian.)

"Logos" in the third sense reads as more mundane and functional, even though it subsumes the other two: it's the modest plural of "logo," meaning identifying symbol or statement, a motto or device salient in a field. In practice, it's usually words or letters set to an image. In F. Scott Fitzgerald's *The Great Gatsby*, the painted oculist's name ("Doctor T. J. Eckleburg") together with huge eyes in yellow spectacles perceived through the "powdery air" is one such device. So are most Ruschas, including even the new ones, conspicuously void as they appear to be in the words department.

Set a word plainly to any image and the eye will head straight for it. In most of his pictures so far, Ruscha has used words plainly as they exist, as physical facts, without leaning on their conceptual equivalents.

One enjoys the pointless, exquisite fact that *Satin*, is rose petals rubbed on paper, the willful-child fact of the little space-out in *Do ing*, the romantic (illusory) fact of various words (*Lisp*, for instance) written in water. What Ruscha does is the obverse of writing. As a language painter, he conveys tones but neither voice nor tense, just minimal syntax and a flatness of epithet that defeats any rhythmic expectations. Also, unlike most West Coast art involving language, his rigorously avoids puns. (It accepts rhyme convulsively, however.) Removed from gesture and absolutely commonplace as criticism, it could never get mistaken for picture-poetry or an art/language exercise. Maybe all this is why Ruscha draws literary associations like so many flies – looking at his new paintings, I kept "hearing" poetry in the room, for example John Ashbery's stellar title "Into the Dusk-Charged Air."

Ruscha gives language a specifically optical gloss. Each word or phrase blithely takes up its exact legible space on the picture surface, which tends to be otherwise abstract in design, rarely a composition but a literal fabric (moiré, taffeta, etc.) or an atmosphere painted as if out of nowhere. The letters have appropriate size and an ambient, contingent light. The whole is kept lucid, clean, and neat; otherwise, the humor wouldn't work so well. (The new spray paintings have messy splotches and are somewhat less humorous.) Part of Ruscha's humor comes from brief delays in recalling the meanings of ordinary words, delays due to the way he sets them. The referents are around somewhere, or they'll be right back. His broadside effects chortle like the barely tolerable joke you were told once, and resisted wholeheartedly, but it comes to be the only joke you know.

Ruscha maintains a more continuous, less deflatable surface light than that of any other Los Angeles artist. His pictures come into focus all at once and at just about any distance in a room. Close up, you can see that they're not so assured technically, but the graphic conceptions and lettering are adroit. They feel like utterances as much as like pictures. They present themselves as if entranced, and you get the impression of them as oracles the artist might consult as avidly as any viewer. What at first look like public commentaries double back quickly to a private resonance. Some recall mirrors beautifully fogged with breath

and marked with an impulsive notation on the spot. ("A notation of loving something," as Ruscha himself once remarked.) The occasion for utterance being absent or unspoken, the source of language as expression is up for grabs; it could be language speaking itself in fragments, laconic yet complete, nudging our feelings for speech into areas parallel to common parlance. The accompanying spatial strains – like Jack Kerouac's "long, long skies" – orchestrate the sense of an afterimage drift not quite of this world, though it is actual as anything. (It's not just the air above L.A. but the whole enchilada of flat-out vision west of the Divide, where distances cancel out each other and relations are less accountable to the eye, can't be parsed.)

Ruscha is our preeminent nostalgia artist, and a rapturous, epic one at that. The distances of even his dimmest works hum or blister regularly with declarations of yearning for some disjunct point. His latest pictures, with a new, darker poignancy, suggest nostalgia for both words and things as physically present. Words, where they figure at all, extrude in absentia, as cancellations, and things are shadows, pulverized versions of their former selves. Ruscha now proceeds at ground level, measuring forms of life on earth (what one 1983 drawing – the only recent work with actual words in it – intimates to be "right here"). But this isn't realism, and the forms he's painted are logotypes – flattened, dusky hulks air-gunned within paler tinges that flare as dramatic backlighting. The views – of animals, houses, people, a car, a sailing ship at sea – are taken in a slightly up-from-under perspective that codifies "heroic" storybook scale. (In San Francisco, what with the fuzzed blacks of the figures and the silver-screen auras about them, the Fuller-Goldeen gallery space fairly dimmed and flickered as you looked; where natural light intruded, it bleached the contours and made the images hard to see.)

Ruscha's black paintings broadcast an overriding just-so travail. They tell variously of struggle, of aspiration, of what looks to be someone else's (impossible-for-this-dude) idea of home. That just-so quality is funny: it takes a nimble sense of the commonplace to gauge the deep irony in so bluntly grandiose an image as the silhouette of an elephant (*Jumbo*) trudging up a grade, or a ghostly windjammer (*Homeward*

Bound) heeling out of some oceanic adolescent dream. Each absurdity is true, but Ruscha's not kidding about exertions. The theme is gravity and has vista – and so the slopes, the crevices and bumps, the earthy rims these characters strive or perch upon. Each figural essence appears in its merest guise. In *Uphill Driver*, the person at the wheel of a Ranchero is suggested by the merest gray blur. (That low-slung heap will never make it to the top, you think.) There's a Lilliputian grandeur to the wagon train pulling away in *A Certain Trail*: the image, an enlargement upon an ad, takes on the hokey immensity of a bank mural, a managerial anthem to upward-and-onward glory. Such images, like a lot of earlier Pop imagery, are blown up from no particular size, but they're the first Ruschas in a long time (since the early "Hollywood" images, beginning in 1969) to have anything like real scale. Their grainy sheens are a little deafening, abrasive as wind on an open mike. Forgoing realism, the paintings approach sublimity from the far side (from a kind of forgetfulness), and illustrate points along its rim. With impeccable gratuitous logic, the plump little chick in *Chick Unit* occupies its auspiciously level piece of ground while, high above, a white marker proclaims "chick." Except there's no word in the plain white space – only the size (in the digital pallor of a voice print) of the thought that word would fill, a thought, as Ruscha says, "blanked over," suppressed. Nobody's home in the boxy houses of *Name, Address, Phone*, but the white tags fasten on them anyway, blips of a certified, embodying vacancy.

The edges of that vacancy are delineated by an outland knowledge of signs that won't light up. Ruscha implies that language bodies forth and shines only as an agency of the human spirit. His pictures sweeten the melancholy ethos that spirit has learned to inhabit. He is an angelol-ogist of white language.

1987

The Sweet Singer of Modernism

Hans Hofmann found an active happiness in the material life of painting. He spoke appreciatively of "swimming in paint." His glee about the numerous ways of wringing vitality from every smear and squiggle is never less than forthright. More often than not, his titles (*Exuberance*, *Effervescence*, *Ecstasy*, *Summer Bliss*, *Gloriamundi*, and so on) set a tone for the viewer, even as they trigger associations beyond the paint. What Hofmann made under such rubrics can look funny or exotic. His *Ecstasy* is neither erotic nor profound in any religious sense, but kicks wildly like a knee-jerk reflex rendered in a *Tom & Jerry* cartoon. *Effervescence*, on the other hand, spills forth hieratically like a Tibetan thanka, all arms and legs.

"Happiness" as such (along with such close relatives as "elation," "joyous," "sunny") crops up regularly, however sheepishly, in the Hofmann literature. It is cited regarding specific works – viz., "There is a *happiness* (it is the only word) to . . . *Scintillating Space*" (Parker Tyler, 1953) – and again regarding the mien of their creator. On the latter score, there was Thomas Hess's surmise, in 1965, that Hofmann's influence "has not been stylistic, but a radiation of his sunny personality." None of this is nonsense. If delight in surface was the original message of the New York School, Hofmann became its most ardent messenger. He was the Sweet Singer of Modernism.

Then there is the happy story explicit in Hofmann's long progress as an artist. His timely move, in the early '30s, to the United States when he was already in his fifties, and his late blooming thereafter, form the barest of outlines of the tale. Hofmann had to wait for ripeness to allow his powers to disentangle themselves, and he had to relocate away from his initial sources – and his social roots in Europe altogether – so as to proceed with his singular creation. These necessary negatives of delay and removal led him to his "positive mood" – a state both of confidence and of footlooseness in which he could confer "fullness" upon the matter at hand. America (specifically Berkeley, and then New York and Provincetown) was like Oz for him; once oriented, he

let fly with a wizardry that was to the point in terms of his vocation and in many other respects, stunningly not of this world. We have the image of Hofmann as a man who transmuted his surroundings into the schemes of his art. In her monograph that accompanied the recent Hofmann show at Berkeley's University Art Museum, Cynthia Goodman tells how Maria (Miz) Hofmann, the artist's wife, "painted not only the furniture but also the floors and walls [of their New York and Provincetown homes] with the same Rembrandt green, cobalt blues, and cadmium reds and oranges that her husband used in his paintings." Hofmann's "favorite painting outfit," Goodman says, "(when he wasn't painting in the nude) consisted of an open-necked short-sleeved shirt and baggy pants of cobalt blue."

There don't seem to be any traces of Hofmann as a raw beginner. His earliest known works seem perfectly accomplished. And he never actually gave anything up. (The only aspect of his art that he suppressed when he hit his stride in the '50s was his talent for caricature, which had been given free rein in the set of *lichtdrucke* prints in the Berkeley collection, from about 1928–31. This cartoonist's talent persisted later in his habit of picking out figures, such as his many kinds of "bird," from configurations of flung or spilled paint.) Looking at Hofmann's later pictures, you feel that here was an artist who eventually got everything he wanted in his art: Cézanne's wished-for "logical vision devoid of absurdity" appears at Hofmann's fingertips in his final works. His abundant "failures" seem hardly to count as such; you gawk at those only momentarily and, as he himself must have done, pass to the next thing. Yet from another angle, "failure" in the Hofmann canon does not compute. *Badness*, perhaps, but, in the continuous magisterial *étude* that was his special strength, failure is disallowed. Hofmann's pictures, his writings, and the accounts of his students all substantiate Harold Rosenberg's view of him as one "to whom art was never in question." Hofmann's belief and peculiar wild delight in painting according to principles he devised (which became precisely "second nature" to him) shine utterly. He had arrived at his own mark: he was gloriously out of it, an anomaly.

Middle-aged, at an impasse with his painting and confronting increasingly tough times in his native Bavaria, Hofmann came to

America, much as young American artists once went to Paris or Rome, to get lost in an uninterrupted dream of art. For him the change of venue had a greater urgency. He said: "If I had not been rescued by America, I would have lost my chance as a painter." Many of the pictures in the Berkeley show commemorate that "rescue," while others stand as residual proof of its efficacy. Of the forty-nine paintings in the University Art Museum collection, forty-six were given by Hofmann in gratitude for having been asked to teach during Berkeley's summer sessions in 1930 and 1931; one other was a gift in memory of his former student Worth Ryder, who had suggested that Hofmann be invited. The museum's holdings – including the paintings, which date from 1935 to 1965, and the figure and landscape prints, some of which were made before, some just after, Hofmann arrived in Berkeley – pretty well show the progress and range of his work in this country. (All the paintings in the exhibition were from the museum's own collection, which has never before been displayed in its entirety.) The thirty-three works on paper lent by the Hofmann estate complemented them nicely. The offhandedness of the better watercolors and gouaches, especially, provided relief from the relentless enunciation of the paintings.

Any roomful of Hofmanns – not to mention three galleries full, as in this show – is likely to be too much. The paintings tend to clobber the viewing space, as well as each other. Banging his pictorial thesis onto boards or canvas, Hofmann so often states the case in such loud and even accents that you want to demand that he shut up or modulate. It's a testament to the staying power of the pictures, to their firmness and the variety from one to the next, that they don't cancel out. They are rocklike in their achievements, and, even when they aren't achieved, they hold their ground, immutable as rocks.

The paintings can feel paradoxical, both right and insignificant: you admire their buildup of synthetic truth but can bring nothing to them beyond a blank regard. They can look bereft of importance. The watercolors and gouaches, at their most casual-seeming, are exquisite and limber in ways the paintings never admit. Like the works on paper, many of the paintings are presented as caprices, but their principles

show through, and the effort involved in covering up those principles obtrudes. Hofmann was no stylist. He bulldozed style and crudely raked it over, separating elements to be enlarged upon. The elements all fit. You can see where they come from – that litany of modern masters Hofmann translated into his singular idiom – and they never for a moment seem about to dissolve or fade. (You can sometimes watch Hofmann conducting all the sections of a painting together, at some remove, like a bandleader.)

Hofmann took every risk in the book, and, even though the risks came well indexed in the annals of latter-day modernism, he got close to showing what paint can do when left practically to its own devices. The salient aspect of his pictures is the positive factuality of paint and canvas. The material qualities of paint rebound, flickering from the cloth, but the cloth is palpable too, so that a feeling of tapestry persists. Besides this factuality, everything else seems an aftereffect. Hofmann built a mesh to catch nature as he understood it, at its most oblique and slippery. But only the mesh is recognizable. Searching among its dimensions, you find Hofmann's otherworldliness.

From the mid '50s on, Hofmann's paintings are a kind of dreaming in color over (and under) otherworldly space. "Nature" and "expression" are names he gave to the impulses that kept returning him to his dream. The colors of the pictures provoke sensations but never fasten on any in particular. They make what Whitehead called (speaking, as Hofmann would, of the "laws" of nature) "large, average effects." A quantity of yellow or blue has the properties of the gummy stuff containing it, without any other vividness. The light is sticky; it nudges forward slightly, or floats, but doesn't expand. There's a radical innocence of color and light delivered, almost as prototypes of themselves, in a nascent state, and always clear.

Hofmann's clarity works against all manner of graphic blur. Critics have seen him as a master at interlocking random styles within individual pictures or from picture to picture (the kind of view that made Hofmann himself frequently exclaim in mock despair that he had "too many styles!"). It's true that, as Goodman says, Hofmann had "no uniformly recognizable style," just as it's true that Hofmann was the first

to combine vestiges of multiple styles in a single picture. But the paintings Hofmann made in the mid '50s and into the '60s are more consistent than that. There are paintings and paintings – and then there is the *one* painting – or the basic premise for it, anyway – which Hofmann seems to have discovered and elaborated on during his later years. It's a composition rigged on a central axis, just as the canvas is rigged on its stretcher bars, and every bit of surface activity is measurable against that axis. The bits play the corners, as it were, tic-tac-toe fashion. Hess may have had this consistency in mind when he referred to Hofmann's "comfortable structures," a sort of cantus firmus beside the support edge that all other moves (including Hofmann's late governing symbols, the brightly colored, hard-edged rectangles) could align themselves with and augment. The basic composition is never so visible as when the pictures empty out – in *Maiden Dance*, for instance – and the cruciform rigging itself cuts loose. Hofmann was wont to use up beautiful effects in his welter of covering all the bases. But these open paintings (*Nocturnal Splendor* and *Struwel Peter* are among them) have a practical candor that makes their other felicities look incidental.

Last October, a few weeks after the exhibition opened, Clement Greenberg came to the Berkeley campus to give a talk on Hofmann. His lecture was warm and clear and leaned toward the anecdotal. (His feistiness flared only during the question period, when in a couple of instances he misheard the drift of remarks from the floor.) Greenberg began by checking off "the bill of particulars against Hofmann . . . how he made it hard for the viewer, and for himself." He told of Hofmann's "problematic reputation"; of Pollock complaining in the 1940s "that Hofmann's line slashed too much"; of Hofmann's "jangling color juxtapositions – *notionally* jangling"; of his "too-deliberate spontaneity" and his obverse "belief in the finished picture"; of his "stoicism" where official recognition was concerned; and of his "largeness of soul." (In passing, Greenberg also characterized Hofmann as "a careful small-town German . . . afraid of the world.") Toward the close, after telling how, in the mid '50s, he himself had become "a wholehearted admirer of Hofmann's work," Greenberg said: "Hofmann's paintings . . . had the habit of faring better with time. His works never looked as bad, if

they did look bad, as they did the first time you saw them. Ever after they got better. That had something to do with character, I think."

This last remark, a variety of dialectical upside-down cake, is in fact an accurate account of a typical viewer's experience with Hofmann's work. At the very least, you *do* have to wait a Hofmann out before you can see what it has besides its obvious authority, and even so, what you don't particularly like (heavy gesticular surface, inimical or too-bright color, or contrariwise, a dimness of common sense in it all, an exoticism of "rare states") is not apt to go away. What you may gain is a further feeling for the solidity of the thing and for the odd, hedged-round conviction that such a thing could exist powerfully in just that way. Greenberg's remark parallels something said by Juan Gris (who, of the Cubists Hofmann admired, is the one nearest him in spirit). Gris said, "My work may be 'bad' great painting, but at any rate it *is* 'great painting.'" That seems close to what Hofmann was up to all along. He was a serious professional artist, but his belief in art has something too imaginative about it. Such belief, if it exists today, exists only in tatters. Hofmann fulfilled – and incidentally rang down the curtain on – one aspect of the modernist prophesy: he objectified himself as a vehicle for art, and for self-consciously modern art in particular. The "fullness" he spoke of was as much that of the promise of modernism as of anything in himself. The pictures conform to that promise. In our frayed, ironic climate, they prove nothing short of an embarrassment, a scandalous surfeit of answered prayers.

1987

Facing Eden

In his slow, determined rise to his gifts as a painter, David Park (1911–1960) was exemplary of a type of primitive American sophisticate who, starting out with an abundance of talent and taste, cultivates his primitive side as his best shot at realizing himself. He was a born mandarin, instinctively at odds with excess fancy (which he identified with posturings after artistic self-importance and superficial style), who early on recognized an essential node of meaning and then took a roundabout route toward effectively dealing with it. All of Park's energies appear keyed to such a primary recognition, which must have hit him like a rock.

One is tempted to think of Park as younger than he was because his best pictures align so neatly with those of the next generation of American painters. In fact, he was a year younger than Franz Kline and a year older than Jackson Pollock; among his San Francisco Bay Area peers, Elmer Bischoff and Richard Diebenkorn were five and eleven years his junior, respectively. Park made his first distinctively original pictures in 1950, at the age of thirty-nine. Over the past four years, Salander-O'Reilly Galleries in New York has shown him at his prime, meaning the work of the final decade of his life. The thread of consistency running through that series of exhibitions – and through the most recent full-scale Park retrospective, which occurred on the West Coast in 1977–78 – is less a measure of any imposed system or master plan than of an ardor scrupulously maintained.

Observing even Park's earliest shifts of manner, by turns ingenuous and headstrong, you sense how unfailingly spellbound he was by the world view given him to declare. No one approach seems to have held his interest for more than four years at a time. He didn't develop from period to period so much as concatenate phases. Each phase takes off as a willful departure, except that the essentials he was stuck on are carried over. By the time Park was twelve, he was painting serious landscapes and portraits. The adaptations he made in his twenties and thirties – first of the American Scene muralists, and then of Picasso and

Matisse – seem almost abjectly provisional; impinged on all sides by hankerings after an obligatory modernistic style, they lack the punch of (even) his romantic juvenile images. (The exceptions are the charming hand-colored stencil prints he did about 1934, illustrating themes from *Genesis*.) It's hard to tell what he was doing between 1947 and 1949, during his abstract-expressionist phase: the majority of his pictures from those years exist only in reproductions, which are mostly indecipherable, and, despite some coruscating passages, the three examples that escaped trashing, when he soured on his efforts in the style, look glowering and pinched. One clue to what might have distinguished the best of them is Fred Martin's recollection of "a vast horizontal in deep green with scattered, runny wide strokes of muddy red, and in an upper corner, turning, a fragment of black, like the arms and structure of a crane with the yellow of an afternoon sky behind it."

Because Park's stylistic ambitions had trouble keeping step with his idealism, his technical standards in those early years were apt to be fuzzy. The fabled turnabout of his career – when, in 1949, he gathered up all but one of the abstract paintings in his studio, made a bonfire of them at the Berkeley city dump, and within a year proceeded to the poignant naturalism for which he's known – may have issued from a spectacular personal revelation. But for his painting and *its* long-standing emergencies, clearing the decks meant only that the moment for coalescence had come. Having helped himself, as he said, by being "extravagant with paint," he returned to his original recognition and put it together with other elements and impulses that had been pacing nervously back and forth behind the scrim of modernist conceits.

In 1952, Park wrote: "I like to paint subjects that I know and care about . . . in commonly seen attitudes. It is exciting to me to try to get some of the subject's qualities, whether warmth, vitality, harshness, tenderness, solemnness, or gaiety into a picture." In the loose federation of Bay Area Figuratives, he found the first and most direct way of suiting a human figure and its associations to the abstract surface requirements of image making. The fact that he painted most of his subjects from memory may have been the key to that directness. Park's naturalism in some respects resembles Edvard Munch's. Like Munch, he painted

what he saw after he had seen it, conjoining private (and prodigious) memory and a keen eye for the solidity and random shapeliness of the external world. Park had none of Munch's mysticism or erotic torment and rarely any of his tremulous power. More literal and pragmatic than Munch, Park built his form of transcendence from his grasp of the significance of ordinary moments.

Paul Mills says that Park "could digest the forms of a face, a chair, a car without so much as disturbing the flow of conversation and use them in a painting a week or so later." He would regularly do a painting in less than an hour, and then do it over several times at the same speed. The transcendence in his work happens indirectly, as a by-product of his having kept his mind wholly occupied with the image at hand – one or more figures in a scene, lathered this way and that with generous heaps of oil paint. In his most powerful painting, *Standing Male Nude in the Shower* (1955), the heaps aren't so impressively dense as elsewhere, but the image is at once as immediate and unnerving as, say, Munch's *Self-Portrait Between the Clock and the Bed*. Park's picture is also a portrait of himself, though from what vantage point of self-awareness who can tell? In catalogues from the '60s and '70s, the work has been identified variously as *Nude Boy in Shower Bath* and *Boy in the Shower*. In any event, the boyishness would seem to hinge on the figure's stature – slightly under life-size for a grown man. But the lanky frame and deeply etched facial features are identifiably those of the adult painter in Imogen Cunningham's photographs of Park. Also, the likeness was close enough so that the artist's wife, Lydia Newell Park, remarked one night, when coming upon the painting for the first time in the hallway of their home, "What's the matter, David, can't you sleep?"

Standing Male Nude in the Shower is an image of unconditional nudity. The high-waisted figure is planted squarely, knees bent, standing in a tub; his center of gravity is assured, but the three-quarter view has him on edge, literally and otherwise. The setting is purposeful, but the figure has no purpose other than to be looked at. There's no intimacy, no erotic palpitation, only the rudiments of an anecdote, amounting to a kind of rude joke, a slightly "off" coloration on domestic space.

Park was once quoted as saying that he liked to paint "people who could do anything but don't – people of potential." The person here has the potentiality of an otherness that's been beamed in, so to speak, from some primal reserve. His stance and pendulous, rootlike hands recall the vegetal hunk portrayed by James Arness in the Howard Hawks movie *The Thing*. His skin is alive – an aching vermilionish tone, raw as raw tuna – and it's presented as otherworldly against the cool blues of porcelain and shower curtain, and against the light, which breaks in glutinous white chunks from the window ledge behind. A few years later, Park became a virtuoso at this kind of paradox between a naked figure and its everyday setting. But in 1955, while beginning to work from studio models in a figure-drawing group that included Bischoff and Diebenkorn, he was still doing tightly knit street scenes, interiors, and close-up portraits of friends. *Standing Male Nude* is pivotal in more ways than one. In the progress of Park's work, it's an agitation – both rhetorical (you never for an instant lose sight of the picture's inventiveness) and natural. It has the quandariness of light trapped and jogged, altered by something fundamental: a body occupying a temporal niche in space. It's a passing moment that feels like human history.

Park was born to a genteel Boston family with scholastic and literary leanings. His aunt Edith Truesdell was an artist. His father – to whom he used to refer as "our Father who art in Boston" – was a Unitarian minister. The family was comfortably at the center of official local culture, and young Park was expected to follow suit. Instead, he dreamed his way through the advantages of a private-school education, applied himself at drawing and painting, playing the piano and, as he told it, wandered in "secret places." He cut short his prep-school career at seventeen and lit out for the West, eventually spending six months at the Otis Art Institute in Los Angeles under Vitlacil, who within weeks promoted him to the advanced class.

A piece of juvenilia – the image of a girl beside a woodland stream – has many of Park's main thematic elements in place. His later, mature pictures show enlarged and simplified parts of similar scenes, intensified in color, with added spatial tugs between reciprocating shapes. The somewhat unstable ground; the surface opacity of water;

the juts and nets of tree branches; the figures (one or two, or at most four) just standing there, or else seated in domestic huddles; the strong feeling for tangencies of people and places (what Diebenkorn has called Park's "fabric of persons") – these were the givens of Park's view. One can only guess where he developed his taste for certain devices, especially of the idealizing kind: the long, taut necks; the anvil-like feet; the amount of energy in an uplifted forearm or the swerve from shoulder to neck; the heavily occluded light that seems to venture forth from several directions at once.

Park belonged to that first generation of provincial artists who gleaned their notions of big, harmonious forms from magazines and books. In one of the catalogue notes for the 1987 Salander-O'Reilly show, Diebenkorn suggests that "the influence of paintings on David Park had occurred before he came to the West Coast." Once settled in the Bay Area – where he lived from 1929 on, except for a teaching stint from 1936 to 1941 at a progressive girls' school back in Boston – Park found a milieu as civilized, but not so set in its ways, as New England's. In Boston, he would have been exposed to any number of Beaux-Arts mannerisms: to Puvis de Chavannes's murals in the public library, to Piero della Francesca in the Isabella Stewart Gardner Museum, to Maxfield Parrish and possibly Eilshemius or Arthur B. Davies. In San Francisco and Berkeley, however, there would be the early exhibitions of Pollock, Gorky, Rothko, and Still, the advent of diverse modernist strains via Hans Hofmann, Diego Rivera, and the WPA, and traveling shows of Marsden Hartley, Vuillard, Bonnard, and Munch.

The images of interlocking profiles Park made in the mid '40s established his scale and its edgewise pressures. Pancake shapes and arabesques taken from Picasso freed up his genius for flat, bright color. When, in 1946, Park was joined by Clyfford Still on the faculty of the California School of Fine Arts, his side of the relationship was like a belated version (though both more distant and more brotherly) of Pollock's with Thomas Hart Benton: "something to push against." Still, who was seven years Park's senior, had had his first one-man show in San Francisco in 1943, which conceivably could have influenced Park then and there. His second, larger show, at the California Palace of the

Legion of Honor in 1947, had a more general impact among the emerging generation of Bay Area artists. In the close quarters of the School, Still's dominant curriculum (in Fred Martin's phrase) "of apocalypse and posture" probably struck Park as a high-plains reprise, in a different key, of high-button Boston ethics. It probably fascinated and scared him in equal measure, and it certainly sent him home to his own strengths. Refusing the legend of a cosmo-artistic overlife argued at a too-constant fever pitch in paint, Park instead accepted from Still a heightened sense of open design plus (initially, at least) an across-the-board saturation of weirdly weathered-looking colors fastening on radically cropped silhouettes. It was in fact to the Nabi in Still that Park looked, and that, as much as any of the above, led him tumbling into his peculiar uniqueness.

Park's relatively small genre scenes and portraits of the early '50s use a kind of elastic modeling outward from the silhouette. The colors – mustards and burgundies, brittle stucco whites and sudden, flaring oranges – augment the attentiveness of the imagery and its unresolved, unsettling qualities. *Kids on Bikes*, fond and quirky, and *Rehearsal*, its swift composure sliding exaggeratedly "ear-to-ear" across the vertical, were the watchword paintings of this phase. If they look methodical to us now – even a mite too jaggedly edited – it could be because Park himself felt how shaky the ground was for his new figuration. Such paintings express the khaki of their times – the '50s look of shook-up innocence and sullen self-regard. Just as these period characters seem ill at ease with their bodies, the pictures make trouble for themselves about fitting their dimensions. Thus, bent heads regularly bang against the upper edges of canvas, or a set of dancing couples, as in *Sophomore Society*, elbow the middle distance, uniformly scrunched.

By 1953, Park settled into his groove of the domestic and personal, and over the next three years he made his most generally likable pictures. He was, as he said, "painting each day for the present day's painting," and the warmth and economy of his conviction show through. His people exhibit what Whitehead called "a clear enjoyment of space." They thrive on it, define it, and displace it, brace themselves against it with airs of dusky concentration, and, by implication (in a straightened

neck, a lowered chin), of will. Park was interested in how people look when they're seen unawares, contemplative, absorbed in something. In unposed glimpses, he caught the formal gestures that link ordinary activity – staring away, reading, writing, sewing, rowing, playing ball at the beach – with the inadvertently profound. His view of the human condition was primarily that figures sit or stand consciously, exerting individual pressures on the earth's surface. As animate subjects, they communicate a fructifying sturdiness, at work in all their parts, which pulls each of them together into a cohesive, private silence, leaving them engaged in their settings, a little stupefied perhaps, or head down, pondering an inner tautness. The fact that Park didn't polish off these images – they're like quick studies in the flux of identity – adds to their dramatic weight.

The figures in *Boy and Car* and *Boy in Berkeley* cast wide, curious glances at the ambient space as if measuring what's out there against their inward prospects. They differ physically from each other, but they maintain the same point of view, or attitude, about appearances. Their detachment is part of their consciousness, a way of being integral with the scene. Similarly, the couple in *Natalie and Fred* stands shoulder-to-shoulder before a mahogany background (her coat and his sweatshirt making a close match in tones of gray), but their stares crisscross past one another, and the viewer, to express an ulterior fixity. Park's crowd scenes express fixity by dividing groups according to their separate directional drifts. The near-, middle- and background human clusters, reading from top to bottom, in *Campus Scene* show how civilized and firm Park's touch could be. A tricky subject – in other hands (and with another title, such as, say, *Wage Slaves* or *The Daily Grind*), it would fall instantly into a state of esthetic/philosophical disrepair – but Park edges past its sentimental pitfalls. Reminiscent of Harry Callahan's contemporaneous photographs of people in the streets, Park's picture is in no way diminished by its inhabitants being lost in thought. Thought is the pressure that keeps them upright, anchored in their shoes.

Like *Standing Male Nude in the Shower*, all Park's figures show us the undraped, fleshly parts of themselves as modified by shadows and reflections unaccounted for by the quasi realism of their surroundings.

Even his commonplace interiors and occasional still lifes have this phantom cast. Outright flesh tones – those pinks, pale peach lusters, creams, pearly or limestone whites – appear only in rare flashes, and then usually as highlights, in the midst of Park's canonical "skin" palette of ochers, duns, oranges, yellows, and brownish reds. (The devilish red of *Standing Male Nude* is as odd in the Park spectrum as the "straight" creamy light tan of *Bathers on the Beach*, opalescent like the foam-flecked shore.) The male and female bathers and other nude or scantily clad figures Park turned to painting in the last third of the '50s project the appearance of aimless new arrivals. You feel they're strangers to the scenery, and to us, and they will remain so. Their preoccupied looks, signaling an innate seriousness, feel tentative, as if they've been caught in a dispute between deliquescence and solidity, between encroaching nature and their own haplessly guarded forms. Deprived of comfort, beyond control, their parts keep slipping into desperate, comical coherence. Park made his beach people singly or in groups: men and men, women and women, unmixed. Their degree of self-importance is their relation to nature and themselves. Nature is their envelope; they are cloaked with light. As Meyer Schapiro said about Giorgione's *Concert*: "The duality is social and esthetic and cuts across the sexes." Sometimes, like the two women in *Bathers*, Park's figures take up towels as props and strike classical attitudes with them, like wind nymphs. Modern folk drawn to land's end by reminders of their natural, godlike savagery – of their residual breeding out of primordial clay – they're latter-day "first people," returnees to a paradise misplaced (because the beach will never be a garden). Their nudity isn't topical or sybaritic. They don't actually bathe, but hesitate, backlit, away from the water's edge, bearing their earth shades, looking and loitering. They appear ageless. Their stances don't intend anything; like trees, they just grew that way, concomitant with the surges of paint and the strange daylight objectivity overtaking their questions of moment: unfoldings, sudden and sempiternal, of the ground – stark and telling as a dune.

Park's late pictures belong to the peculiar American tradition of awkwardly depicting (or, more commonly, avoiding depicting) the unclothed human body, a tradition – if that's what our native sequence

of habitual responses adds up to – of American-type body painting that could bear serious study beyond run-of-the-mill indictments on counts of puritanism and other forms of post-pagan perceptual angst. When Fairfield Porter wrote that "American painting contains no praise of the human figure," he had in mind those uneasy aspects of Thomas Eakins's figures neutralized by Eakins's scientism. But he might just as well have been considering the run of their descendants, from Davies's gracile sprites and Hopper's patches of flesh (seemingly flaking off in broad daylight), to Pearlstein's optically denatured studio models (who actually look *less* denatured as time goes by), and on to Eric Fischl's conscious recapitulation of the endemic question of how we see ourselves in the mirror of our own, or, more pointedly, somebody else's nakedness. Paul Rosenfeld once remarked on how there was "no woman in [Davies's] paint." The woman in de Kooning's paint is real, but she's also a figment of the paint and therefore limited in her behavioral options. Hopper's perceptual field was irreparably broken into what for him could and could not be painted: he could paint light on inanimate surfaces like no one else of his time, but he couldn't paint the sea or grass and his naked women seem to have perpetual skin rashes. In the wake of the Armory Show, the American painters' street-smart solution to the enigma of the human body was to leave it altogether and concentrate on significant form. It didn't matter that the stars of the show were Matisse's *Blue Nude* and Duchamp's *Nude Descending a Staircase*; or if it did, the impulse was to contradict Matisse with prettification or theory and to one-up Duchamp in terms of satire. (Alex Katz has spoken recently of wanting to "do a nude that would be just another person in the room, not like a peach.")

Park's nudes are peculiar within this tradition. A young New York painter, Tom Burckhardt, noticed "something European" about their blend of naturalism with subjectivity. The nudes aren't all that awkward, but they still refuse "the frank acceptance of the flesh" as the plausible skin of real people in real places. They go past that, it's true, into being the real skin of paintings that tell us something substantial about human life. Park took contemporary people and cast them in the glow of the immanent, ideal climate, a contemporary Eden generated

by art and memory. For that purpose, the nudes presented themselves as simply more physical. Park wasn't serving a style. His beaches and estuaries are not lit by any local sun. (Although they couldn't have been painted anywhere else, they don't speak for "California" the way Nathan Oliveira's, for example, do.) In the actiony layers of his pictures, you sense his impatience to get at the heart of his subjects, as if, carried by color, their surfaces could show us the spiritual activity behind the skin. Park developed a speedy, improvisatory sign language, building his figures from the inside out and grossly characterizing them with scored slabs and ingots and thick, blunt fillips of red and blue strokes that register body parts – a nose, a chin, a breastbone, a patch of pubic hair – like biological chat. The arms and knees and set of the head in *Green Canoe* speak volumes. Made of myriad sputtering vertical strokes and scuffs (there are perhaps seven horizontal marks besides), *Two Women in a Landscape* has a phantasmagoric element together with a physiological element that's as characteristic as a pulse. The bodies absorb light and throw it back as distinct colors, each with precise anatomical heat. At the same time, they have the slightly blurred contours seen by eyes reduced to squinting against a glare. One of Cunningham's portraits, in fact, shows Park with his face screwed up, squinting like so at his easel.

When the cancer diagnosed in 1959, a year before Park's death, intruded on his work habits, he reverted to making smaller paintings. He also took up gouache and pen-and-ink drawing and, at one point, felt-tip pens on a thirty-foot roll of shelf paper. His late works stand for ebullience and courage, like the last flower paintings of Manet. The final large paintings Park did of musicians – *The Flutist* and *The Cellist*, both from 1959 – are among his most emphatic. Their loosened contours, fleshing out space toward the edges, are paradoxical because instead of a mess, they make a Roman-like stability. Park's problem with the fit of his images got aggravated in large scale, and most of his big pictures tend to fade, muttering ambivalently, toward the sides, or else in the salvaging process he would punish the paint. In the final works on paper, broadly traced nudes emerge in more definite surroundings – the blank of a plain, off-white sheet or the identifiable locales of the compendious

1960 Berkeley *Scroll*. Brightening, the nudes still maintain their ad hoc, prelapsarian innocence, though not so convulsively as before. In *Nude with Tree*, Park came nearest to painting a plausible Eve, with one great paw gripping an inchoate, shoulder-high bough.

Did Park get it all in? Did he suit his vision seamlessly to the facts of his art? I don't think so. Close as he got to revealing the full scope of his consciousness, as probing as the works of his last years are, there's a residual feeling of things left out, of a wholeness suggested but never fully laid on the line. His people lurch toward completion, but since the contingent space doesn't assert itself, the landscape, the "where" of his pictures (and hence, of the figures in them), isn't ambiguous so much as obfuscated. Park displayed his conscious feeling for the ever-fresh appearance, sans trappings or credentials, of the human figure in plain view. The gentle, Prendergast-like conviviality and procession of incident in *Scroll* – scenes from Park's life in Boston and Berkeley – illuminate with a kind of pride his major theme: the indefatigable coherence of the self.

1987

Ethiopia

The great archetypal oils on canvas that David Park made during the last two or three years of his life show mostly nude male or female figures set singly or in groups amid uncertain environs. Here a landscape or interior harboring a friezelike arrangement of roughly depicted human forms seems more a raw extension of the figures' flesh than any actual place, though the reverse might be just as true and the figures have unfolded from the muddiness around them, of which both they and the sudden brushloads of scenery around them are part. The figures themselves have been transposed loosely – probably by memory, as was Park's habit – from drawings of studio models. The overall motifs recapitulate the sort of idealized conception Park took off from in his early, somewhat starchy, neoclassicist phase of the 1930s – a foregone ceremonial vision he could invigorate only after having helped himself, as he said, by being "extravagant with paint."

The people in Park's late pictures tend to be just standing there, enchanted by their own discrepancies. They're swept up in a time warp similar to the one Van Gogh observed among the bucolic sublimations of Puvis de Chavannes: "a strange and happy encounter of remote antiquity with naked modernity." Paradoxically, Park managed to locate his contemporary Golden Age, in all its prerequisite afterglows, by converting that previous, symbolic, beaux-arts "elsewhere" into a present tense of meatily applied colors.

A Bostonian who migrated to the San Francisco Bay Area in his late teens, Park used memories of his New England childhood and projections of observable California bonhomie and health to get at something more substantial, an intrinsic human radiance and weight. In 1952, three years after he had quit his nominal involvement with abstract expressionism and begun doing the genre scenes through which he realized his unique approach, he wrote: "I like to paint subjects that I know and care about . . . in commonly seen attitudes. It is exciting to me to try to get some of the subject's qualities, whether warmth, vitality, harshness, tenderness, solemnness, or gaiety, into the picture." By 1957, when

Park loosened the terms of his figuration, he let fly with an exhilarating sympathy. Building his subjects from the inside out, he fixed their transience at the interchange of light falling across contours and anatomical tones registering feelings from behind the skin. From then on, the nudes and other figures of his scenes embody earthly existence like nothing else in the pictures; as characters with the particular qualities Park sought, they emerge materially forward because everything else depends on them: chunks of earth, tumbling foliage, a water's edge – all extrude as traceries resonant of human gestures in space.

Ethiopia, done in 1959, belongs to this company of Park's late pictures, yet even in that context the painting remains a surprise. The suggestion of incident, amounting to a double drama among the participants, is unusually specific, as is the title, which alongside Park's other titles of the time (*Four Men*, *Four Women*, and so on) seems especially pointed. Does the title point to the mauvish girl who seems the agent of whatever urgency is being advanced?

And is "Ethiopia" her name as "Sheba" was the name by which the biblical queen of that place came to be known? Unusual, too, is the mixing of sexes: a boy and a girl in the foreground and another male and female couple in the middle distance between them. From painting to painting during the last third of the '50s, Park normally kept the gender groupings of his figures separate, as if to check any explicit sense of incident among them. He likewise avoided having figures within a painting confront each other and instead would direct them to turn away or else stare outward, toward the viewer. If *Ethiopia* violates the provisional ground rules of Park's art, it can only be because the occasion at hand insisted.

In *Ethiopia*, we see four standing nude figures, the two mixed pairs, gathered in a clearing. The gazes of three figures in the painting focus on the fourth, the dark girl at the right. Between and around the figures are broad hints of landscape: bushes, perhaps, and some blocked-in passages indicating ground, and, with tonal shifts, unspecified matter breaking upward from the ground – including the strange, central orange tract, like a torso stump, across which an elbow and profile breast impinge, initiating an arcane conversation. Like most of Park's pictures

of the time, this one is built primarily by shafts of vertical brushwork, with no declared border where the ground leaves off or any horizon line or "give" into the distance. A bright green and its complementary orange in the opposite corner lock the picture's frontal drama in place.

What can be said of that drama? The dark girl, pressed into the picture at one edge, appears poised to speak. She stands slightly forward on the surface plane and shorter than the rest. Three small, light blue dots drop from beneath her chin. Her forthright look is answered by the gawking boy whose head inclines toward her in an image of almost absurdly ample astonishment. By contrast, the other two assume rigid postures expressive of reserve if not downright consternation. If the girl is an "emissary," as the art historian Caroline A. Jones has suggested, then this older couple acts as overseers of what she's come to bring about. They are the presiding mediators of a close encounter that is beyond them, even though they literally stand in its way.

All four nudes comport themselves according to a skittering white sunlight that fractures, stabs, and plummets from the left. The processional light is as contiguous with the agitated, Arcadian pageantry as the human images it ramifies. It's an impaction, like those images, of the moment.

Everyone but "Ethiopia," it seems, is lost in the moment, dumbstruck by the message she imparts. And, in terms of the picture's lucidity, that message is herself, her arrival as an emblem in the canny hither-thither of paint. Unlike Park's other characters, who have a sense, as Michael Brenson observed, "both of being in the world and not knowing what to make of it," she brings the world with her, in a nexus of youthful assurance and candor. That, rather than her frankly stated skin color, is the difference that sends the rest of the picture rocking as we look.

The soul, Nietzsche said, is something in the body. Park had a way of revealing his subjects' souls as emanations of their physical selves. His imaginative naturalism – based on color decisions tied to palpable emotional temperatures – reflects a sensible view of vitality, and this made him the necessary painter we increasingly take him to be.

1989

The Idylls of Albert York

Until recently, Albert York has been a painters' secret, written and talked about by painters and a choice band of avid connoisseurs. He began showing in the early '60s. The importance of his work and a critical vocabulary for it were established promptly in brief essays by two painter-critics, first Lawrence Campbell and then Fairfield Porter. Porter, who befriended York in the mid '70s, wrote: "Albert York's paintings are popular partly because, as Gertrude Stein said of herself, he has a small audience." That situation hasn't changed much, and there's no real reason why it should. York's audience has increased apace with his output – which is to say, slowly and at irregular intervals. He has earned the sort of notoriety that seems destined to make no waves; like the succinct, unforced grandeur of his paintings, it thrives on an air of privacy, forthright but silent as to its origins.

York was born in Detroit in 1928. In 1952, having completed formal art studies in Detroit and Ontario (and after two years of active duty in the army during the Korean War), he appeared in New York. He studied briefly with Raphael Soyer, spent a few years shuttling between the city and eastern Long Island, and eventually settled in East Hampton around 1963, the year of his first show. He now lives in nearby Water Mill. He trained and worked for a time in Manhattan as a gilder with the framer and painter Robert Kulicke in the latter's frame shop, and it was Kulicke who brought York's paintings to the attention of Leroy Davis, at whose uptown gallery he has shown ever since.

By now York is famous for not appearing – a recluse by art-world standards, meticulously apart from the scene, who for the last six years has mailed paintings to Davis and his partner Cecily Langdale one at a time (at last count, eleven in the past three years) in plain brown wrappers. Before, he used to deliver them by hand, in grocery bags. Among some 325 works documented in the gallery file, there are panel paintings mounted or done directly on wood or Masonite, watercolors, woodcuts, and Conté-crayon, pencil, and charcoal drawings. They arrive unsigned, untitled, without dates or frames. A recent crayon self-portrait head

shows the kind of sturdy, concentrated mien the pictures would lead one to expect: the high, smooth brow sloping to gently angular features around a wide, fixed stare, and the mouth shut firmly above a strong chin.

York's last three shows at Davis & Langdale, including the one this past March, were mostly loan exhibitions mixing recent and earlier work. Lately, the gallery has taken to clamping the newer paintings in wide, black-painted wood frames, which accentuate their staginess – their luminosity and puppet-theater scale – but at the same time surround them with a heavy, funeral aura. The pictures since around 1980 are distinguished by a generally brighter palette blended with aerating whites. Although such variants occur, York's themes and ways of handling them are otherwise pretty well set; he seems to have been clear from the start about the kinds of things he wanted to paint. Reviewing his first show, Lawrence Campbell identified a basic range of subject matter – "fields, trees, ponds, a bird, a bull, a face or two, a figure in front of a wood" – and at least a partial artistic lineage: "the poetry of a Ryder, and without looking much like Ryder, either."

York paints small, perfect, eminently grounded pictures. The first thing you notice about them is their uniformly modest size, ordinarily about a foot in one dimension and a couple of inches shorter in the other. Next, you see their intensity, which partly depends on the particular size of the work and the just-so measure of imagery it contains. The paintings don't read as delicate miniatures; the compressed energy they embody holds up, clear and vibrant, across a room. Inspected up close, each little panel is tight as a drum. The intensity is baffling, as if unintended, out of hand; you feel that the painter would soften its impact if only he could, and let a gracile anonymity suffice. Or, on the contrary, that his obvious love of painting might spill over, become excessive, even expressionistically gross. That doesn't happen either. Instead, the epigrammatic statement of a typical motif – a broadly lit, open clearing or meadow with some trees and an occasional figure or two – registers a charge of finely adjusted, murmuring acuities. The view touches off an alarm: the world is shown exquisitely at rest; everything fits neatly (if a bit illogically) with everything else, yet bristling disturbance seems imminent at every carefully tended edge.

There's something inclement beneath all that idyllic sunlight, a bruxism out of key with the blithely tumbled midday glow, and an elegiac mood that turns the convex pressure of accumulated dabs and dry swishes of paint teetering reflectively back on itself. The light could falter, the whole scene evanesce or fall apart as you look on. A quietly refined oil sketch has an urgent, ex-voto intimacy. The postponement of collapse, like a hypnagogic pause over the void, is mesmerizing.

York's prime subject is a possible landscape grasped within an imaginary suspended moment. In duration and breadth, the moment has a compact classicism. The brushed-up solid surface gives each ceremonial visionary fact a flinty, prosaic look. The uncertainty of moment crackles with the sureness of fate. The landscape views are both real and invented and both ways scrupulously observed. Provisionally, their vistas are that Holy Land of American painting, the South Fork of eastern Long Island, its low-lying residual stretch of glacial moraine swathed with light that flares and gleams through thin, high Atlantic summer mists. York doesn't play out the celebrated panoramic horizontality of the locale but truncates it or else lets the image trail off in frayed ridges of paint that stop just short of the panel edge. In his hands, this landscape-cum-realist's-oyster doubles as a mutable stage set. It's as if a scrim of shallow-rooted trees and broad sky had sprouted forward, issuing over the proscenium floor a carpet of ripe verdure.

The place of these exterior views is properly a meadow like "the enameled green" of Dante's Limbo on the outskirts of Hell, where shades of classic philosophers gather to converse. The still expanse always looks entered upon as if for the first time. York keeps it open to a cast of intermittent and seemingly interchangeable stock characters – nudes and other figures clothed or half-clothed in some sort of generic dress. There are dairy cows whose lineaments reframe the landscape, cut flowers put into pots or tins, a hound, a beetle, a meandering, bloated snake. The mostly upright human figures arrive in flurries of brush marks like prismatic wood chips. Their flesh and earth tones are keyed to the landscape as parcels of the life that is there, inherent as the grass and its gray granite underpinnings.

Pasternak said, "Poetry is in the grass." Who paints grass? Edward Hopper fanned it out in receding waves to draw down peripheries of veering light. Alex Katz sweeps it frontally, to make a spatial eyeful coextensive with a split second's blink. York interprets the full, less brilliant fact of grass underfoot – a tough, moist, or crisp chlorophyll clump, its light and bulk gotten in the same slow breeding of greens and gray. (York works mainly in a range of closely matched halftones; all his greens are dense and calculated, and some are chilling.)

Across this live turf, panel by panel, you follow the sauntering, metamorphosed lives of the characters, each episode occurring along a strip of middle distance: a barrel-chested, mustachioed gent, like a carnival strongman, grapples with a snake; back on the ground, the snake makes a rivulet heading for a pair of trees; a lone Indian sits before the trees, puffing on a pipe; two faceless women in sunbonnets stand looking at a cow (the cow glowers – you catch the look of the women by the slightly oblique set of facial shadings and contours against the shoulders); then more trees enter, three or four of them calling to one another across a shallow pond; a recumbent dog displaces the pond, to be pounced on by three others of the same breed – the same shorthaired mongrel depicted indoors as *The Gray Dog* and *Seated Dog*, both from circa 1967. (York, it should be noted, is one of the foremost dog portraitists after Bonnard.) Next, the trees close ranks to form a bush before which sit a greenish-white skeleton and a woman, naked but for a black band at her neck, who eyes her reflection (the slightest fleck of pink) in a hand mirror. The skeleton grins sociably, balancing a scythe on one shoulder like a parasol.

Two more paintings show flowers outdoors in a close-up chin-to-ground perspective. In one, a beetle built of nine cobbled strokes approaches a monstrous blue tomato can stuffed with carnations. In the other, three towering red tulips (with a supernumerary fourth stem) have broken through the foreground loam to dwarf a distant horse and rider cantering just below the horizon from the right-hand edge. If the off-center emphasis on shadowy relations between the insect and flowers feels strange, the lack of any emphasis at all makes the tulips picture even stranger.

The plants in York's pictures often resist classification. His trees say "tree" but are otherwise botanically moot. With their broad leaves and spindly perpendicular trunks, are they young maples? sycamores? or a composite? Are tulip leaves that bushy? Why do the carnations look eked out of clay? On the other hand, the recent still-life interiors have the unassuming arrangements (including obligatory forward tilts) of high-fidelity, generic flower pieces. They are as generic as their colors are economical and fraught. According to Leroy Davis, "Right now York's fixation is with Manet" (presumably meaning not just the latter's late flower paintings but also *Olympia*, of which York has done an odd-ball, floppy reprise). The succulence of *Plant with Purple Flowers in a Terra Cotta Pot* stays put while the table and wall drink in the light off the leaves. The strength of each flower is defined in its ability to hold a specific light not more brilliant than the summary light of the painting.

Fairfield Porter wrote that the reciprocally inclined *Twin Trees* "could be Baucis and Philomen after Zeus, at their death, changed them." York's trees are in fact his most overtly realized characters. They're more philosophically disposed than his people, who, although allegorical in their own right, tend to appear introspective or stunned, caught up in consequences left undeclared. Where the people fade in and out even as they show themselves, the trees, advancing always in full leaf, project a quasi permanence as custodians – floating modifiers of the presiding topography of earth and sky. Like the people, they coexist but never touch. The skies beat laterally against them, enlarging upon stacked tiers of horizon. The side-to-side motion of the atmosphere reinforces the feeling of solid ground as well as the play of substance against mirage. Even York's recurring ponds seem like mirages. The merest streaks and smudges in his repertoire of forms, they're like premature aerial distances; they don't hold water so much as return the sky's look sullenly, with a shallow, glazed, no-comment tone.

The paintings show a tender regard for the paradoxes of figural space. The sturdiness of York's figures is circumstantial, part of the compactness of his paint. Except for a few direct portraits, the figures materialize as ghosts out of thin air. (The thin air is often traces of Masonite showing through the paint.) Transfixed from head to toe in

chunky bodily frames – the chunkiest figures since Cézanne – they appear to have just discovered gravity. They take appearance seriously, as allegories must. The cruel joke of course is in putting the indefinite, enigmatic appearance out in the open, in a natural light. The light consigns the displaced actors to cardboard cameo roles. Their big scenes happen – or might have happened – elsewhere, off the set. They share with the trees a haunted, mythological aspect, but the trees have more immediate business.

York conflates Old World Classical presence with a bedrock feeling for the American neo-antique – in other words, history with genre. An image may derive from nineteenth-century nautical carvings or turn-of-the-century poster prints, as well as from a fascination with the French outdoor and still-life traditions from Corot and the Barbizon landscapists to Manet and Cézanne. Many of York's indigenous figures assume the classiest of Classical gestures: just standing still and alone, holding something. How "realist" are they? To Baudelaire, George Catlin's American Indian portraits made antique sculpture real, or at any rate "comprehensible." In the same vein, York's *Indian Brave and Indian Chief*, which is not a portrait but a double apparition, has a blunt, believable grace. The two figures settle with an unponderous gravity squarely on the spot; they're stocky but of a buoyancy that, lifted against the bleary sky, feels both humorous and heroic. Their presence goes with the ground beneath their feet and comments on its mutability.

It's not as if York expresses any yearning for exotic bygone modes, or for history as such. Rather, you see that he has thoughtfully absorbed the meanings of anomalous things, their peculiar, visible truths. To him they're as contemporary and familiar as his backyard – he only has to look a little harder to recognize their contours. His paintings express the impartial wonder that things begin and end just where they are. The paintings may err toward the simplistically decorative at times, but there are no false notes. For example, in *Flying Figure in Landscape*, the luminous votive figure looks to have bounded full-blown from behind a row of bushes, her hair and drapery a slightly drier version of the scummy blackish greens of the field. She hovers and twists and extends herself as integrally as the weather, which hangs on the view a massive,

blotted, dull-porcelain white. A gallery note describes the painting's genesis thus: "According to the artist, the flying figure with goat legs is a Hindu goddess of peace who doesn't appear in Indian art but presumably in literature. The painting was originally taller, and there was a group of three figures over whom this goddess was showering blessings. However, this group was cut off and painted out."

1988/2003

In Living Chaos

Joan Mitchell told the interviewer Yves Michaud in 1986: "I imagine a sort of scaffolding made of painting stretchers around a lot of colored chaos as an identity." The terms of Mitchell's self-image are characteristic in that they point through the self to the work. Instead of a throwaway professional despair (or cosmic acedia at mid career), her "scaffolding" reflects the weathered pragmatism of an improviser who has seen into the heart of her method.

At sixty-two, Mitchell continues to advance a naturalistic mode of improvisational abstract painting in its most limber extensions. She synthesizes effects of landscape and other recollected sensations and expands upon them in flashes and tangles of paint. One of her paintings may dawn on the viewer as the subtlest or most vehement of sense memories spontaneously reified. But she doesn't notate or reminisce from the details of a specific view – she uses her sensibility to fasten an analogous fact. A real landscape with clamberings of foliage and sun is more likely to resemble one's memories of a Mitchell than the other way around. Her pictures are mostly big – some are polyptychs of immense proportions – and they aim for the big statement with a measured pulse. For all their immediate surface profusion, they come across as intense and willed. Even when, as in the last decade or so, Mitchell lets fly with color, you can watch her arranging, supervising, making the strokes and drips go securely where she wants. Will is intrinsic to the awareness she brings to abstract nature painting. Her project is to take clues from moments of random contact with the world as the means of entering it with the intentionality of art.

In the few early pictures gathered for the current retrospective exhibition of her work, you see how, as a young painter starting out in the '50s, Mitchell went straight to the mark. She very quickly became the expressive artist she clearly meant to be. Adapting surface excitations typical of the New York School to a bare-bones approach toward landscape imagery, her mid-'50s output has the identifiable flair of an intelligence immediately at home with its forms. *Hemlock* (1956) gath-

ers a variety of kneaded, billowing whites that double as air and muscle around skeletal blue and green dashes. The inflected space pivots on a broad, double-edged axis, from which prominent horizontal offshoots appear to be shoving toward the edge at either side. In *Metro*, you see how Mitchell, like Franz Kline, can let texture and speed go independent of each other, so that the thickness of a mark digs in and draws the eye up short while the color makes a glancing passage. The lateral crush of *Couscous* is ignited from above by glints of washed-out color. The more catastrophic moments in Mitchell's art tend to be marked by pale rather than loaded areas. She reverses the familiar conceptions of where major intensity sits among hues and textures.

Mitchell's declarations of surface thrive and teeter on a partial reserve, a reluctance that fixates upon uncertain, and sometimes feverish, middle distances. This hairbreadth remove allows the paradoxes of figure and ground to shake loose pluralities in the literal "where" of an image. Mitchell uses the semblances of motion throughout a painting to fix the appearance of the complete movement which becomes the image in focus. It's what she calls "motion made still." The early pictures register the slipperiness of vision's hold on sensational space by indicating an entrance or jumping-off place for the eye, usually in the lower middle of the canvas. Thus, above a darkly scumbled threshold or ledge – sometimes in the barest guise of a skewed X – the rest of the image skitters in a crosswise rush. In *George Went Swimming at Barnes Hole But It Got Too Cold*, the view is channeled upwards and out from a set of elliptical corkscrew whorls. Mitchell holds off the action, as it were, so one's gaze reaches into that focus where the abrupt crosscurrents can be perceived at equal force. The directional sinews don't stretch so much as vibrate in place. The succinct imaginary space communicates an astringent, tamped-down emotional position towards the agitated image. It returns to the surface a concentration like breath meted out under mental duress.

Mitchell has said that a painting is "just a surface to be covered." The primary motion, then, is a fractional shuttling towards and away from the ground plane where put-on oil paint meets the backboard of canvas. Shapes and nonshapes float or stick in a reprise of the inner

physics that make affixing pigment to a flat, upright surface possible. The gravity continuum that holds the image mix together parallels the sheer hoisted interval where contact is made. Part of the fascination of Mitchell's new work derives from how that space squeezed between paint and canvas can still be perceived among headlong, intricate swipes of color, some of them spanning, some tugging at the face of the canvas. An outright, looming, piled-up frontality of the kind you see in *Then, Last Time IV* is rare. Usually, the image is resolved as a ventilated expanse with every part set in suspension or flux. The lines of stress (those darting strokes and gathered masses sprung from Mitchell's early absorptions of de Kooning, Kline, and Guston) have cast off as ever more slippery lines of flow.

The sharpness and snap of Mitchell's colors steady the overall effusion – the sense, even, in some, that the painting might be leaping out of its skin. She adds colors together like a writer arranging by the phrase. One color seeks out another, and in the interchange, light happens. The panel-to-panel reversal of complementary color layers in the diptych *Two Sunflowers* makes a complex identity, like a personal, binocular view of time; it's both the same image focused two different ways and a composite. The new paintings are full of ripe colors applied airily or in filmy laminations that sit firm and opaque as printers' inks. They show the amount or size a color is as it exists in the space it makes rather than how much of it has been used up to occupy space.

Mitchell's intensity is specific to its occasions. Her style never seems safeguarded by insignias. There's nothing paradisiacal or even enchanted about her view. You don't confront in it anything like the "rare states" that Hofmann so assiduously went for; when Mitchell paints what could be taken for a garden, it's both more down-to-earth and more vulnerable. The syntactical air of her pictures is thick with strong feeling, aspects of a temperament so conscious and choreographed that its expressive pulsion can be clear in many places together.

By bringing out the ephemeral in crude matter – by lodging the terms of visibility at just that juncture of tension and release – the paintings defy emptiness by defining its inner limits. A void will occur at or near the frame edge, striking the image from without as an impinge-

ment. Instead of entertaining the conception of a void so as to assert mastery over it like a symbolist, Mitchell works her way in from its coordinates, relegating it to a fringe pressure. Her horizons come in tiers, curving and unstabilized. Some motions slip fitfully behind the weave, some glide or push outward. There are bravura embellishments, loose accumulations of loops and exasperated knots, and strange brackets and fencepost-like markings along the edges. Occasional voids may pop out of the mesh; corners of canvas, especially the upper ones, are left bare or grazed by wisps. But there is the deeper sense of a void framing individual works: you feel their energies, their galvanized splays of cleanly distributed color, cry out from an isolation bounded by inimical blanks.

There are no objects in any of Mitchell's paintings but plentiful suggestions of the worldly conditions in which objects exist and affect us by simply, and as if by necessity, being seen. As paintings of experience, Mitchell's state as much as they suggest. They announce exploded nodes of seeing and sensation that drag entire thing-related etymologies across the surface: a constant, further "something" at the root makes the surface feel dense and fraught even when, as in many of the mid-'70s works, it is only thinly covered. That density is reciprocal, partly a function of the viewer's imprinted sensory apparatus with its ideogramic associational track that will read in a trellised layer of dark cobalt green the concomitant likelihood of its spelling "bush." In fact, no bits of external nature serve to verify the figurative properties of Mitchell's paint, which are nature, as Thomas Hess remarked, "from a mind's eye view." The titles Mitchell herself assigns her paintings – titles such as *Maple Leave Forever*, *Salut Tom*, and *Ready For the River* that refer to objects, people, or more recently, passages of time – are verbal subtexts. They stand for partial resonance along the route of seeing and feeling, making, and making sense. In naming her paintings, Mitchell lets you know how she sees them, how they make sense to her, how they might therefore have infiltrated the world.

Without ever depicting the human body, Mitchell's paintings remind us of how the body orients itself in a matrix of sensations, how consciousness favors and transforms its immediate world view.

Sensation supposes a physiology capable of reflecting experience. The world may be recognizable but confronting it directly with one's senses is a scramble of approximations, of "more or less" from here and there. The most perfect attention can't define, and won't rehearse or memorialize, so can only add. The sensational world is a mess of additional layers. The task of an artist, Samuel Beckett said, is "to find a form that accommodates the mess." For the viewer caught up in improvisatory shifts of focus and jolts between color planes, moments of definitive visibility get tossed in a surge of intermittence, perceptible as chaos. The chaos that Mitchell depicts – and nowhere so regularly as in her latest paintings – relates to the familiar scatter at instants within one's field of sensation. It's a substantial, unmurky aggrandizing, partly from memory, of that disorderly point where integral experience in all its lumped-together fullness presents itself as both desirable and plainly too much. This upscale artistic version transfers power, arguing its way into the present tense as a kind of inverse sublime. As Fairfield Porter said, Mitchell's form is "the positive of Turner's vortex." Turner directed the eye to a confusion about how deeply it might plunge into unlivable infinite regress. Mitchell confronts the eye with an infinity corresponding to the complexities given in any act of looking. It's the elementary, lived-in quality of real-time chaos she's after – an uncalled-for, luxuriant emergency. Details within a field, she seems to say, are easy to get, but the macroscopic sprawl eludes our sight, even though it is that larger presence with which we are most intimate.

According to Judith Bernstock in her catalogue essay, Mitchell does most of her painting at night; she checks the colors' resonance in daylight. Although some patches in her '70s pictures have a contemplative, partially submerged, crepuscular glow of a sort associated with late-'40s Rothkos, there are no nocturnes in her inventory. Generally, her light arrives with a sunny, mid-morning, picture-window vibrancy, not quite outdoors but almost. It can smack the viewer head-on – rebounding as if from a fogbank in *Pour Ses Malinois* – or else, as in *Salut Tom*, it gathers pensively. The shadowless, acrobatic light that tumbles across a series of "chord" paintings of 1986–87 equilibrates among churning spatial dissolves. A muted version of this same light flickers down

through the terraced hues of *La Grande Vallée, No. 0*, landing a yellow splash like a single sunbeam finalized in the shape of a fallen leaf.

Mitchell's pictures don't contemplate; they stir, rounding out visible instants in a range of disorder hooked to intermediate orders. Their unison colors tie the double fact of sensation and visibility in terms that realistically can't be sorted out. They make refractive sensation explicit, a matter of feelings delineated by duration and amplitude. Sensation implies the momentous inkling of a possible existence. Its basis is wonder. Mitchell treats that inkling as an inspired event coordinated by the nerve-end fabric of painting, its active thread. Criticism's part in this is peculiar and limited, because criticism can't, as art so often does, tell everything at once.

1988

David Ireland's Accommodations

The cover photograph on the catalogue accompanying David Ireland's retrospective installation at the University Art Museum in Berkeley last autumn shows a glaringly backlit, blurred silhouette of the artist coming through the doorway of the basement studio beneath his home-cum-environmental-sculpture-in-progress at 500 Capp Street in San Francisco. The towering figure in shin-boots steps into an enclosure that might be taken for a mine shaft (a further alcove, in fact, serves as a wine cellar). On the dirt floor, what appear to be mineral deposits are really leftover mounds of concrete, a favored material for Ireland's recent sculptures, including a series of "Dumb Balls" made by tossing gobs of wet aggregate back and forth from hand to hand for fifteen to twenty hours and then setting the resultant "de-intellectualized" spheres down to cure. Other detectable shapes in the photograph read as rumpled paper sacks, broom handles, industrial light fixtures, and a table covered with some unspecified woolen fabric upon which rests, palm up, a single rubber work glove.

If, as Samuel Beckett once remarked, "to restore silence is the role of objects," Ireland's objects seem to store up silence. He posits an art of residue, loaded with silence and paradigmatic inertia. Without playing the holy fool or invoking exotic powers, he promotes in his work an atmosphere of unpretentious ceremony, a rudimentary alchemy that incorporates healthy doses of nonsense. His larger-scale, site-responsive works extol the complex interweavings of human history amid the traceries of fracture and decay. His household curio cabinets feature rows of seemingly uneventful objects whose textures epitomize the lags of actuality as time turns back upon itself.

Besides representing the ultimate in prolonged fits of ambidexterity, the Dumb Balls exemplify Ireland's method of converting sullen matter into images of lived time. Their rough surfaces tell of impacts and erosions, miniature correlatives of similar incidents on planetary bodies over cosmological eons. Like most of Ireland's works, they figure in the world as relics coalesced from an ambient sensitivity to

detail – all kinds of detail, most of which could take or leave the pseudonym "art." Their isolated charge of compressed formal presence is deflected towards slower, striated intimations of place, self and materials bound up in flux. The objects are so keyed to literal processes, to the encyclopedic contingencies of art and life, that one can forget that, in appearance, most of them are blatantly abstract.

When not fully elaborated as architectural environments, Ireland's works connect to whatever architecture may be available. His portable pieces rest on floors, walls, tables, shelves, stairs – sometimes covering or blocking them. The autonomous freestanding, walk-around sculpture is rare. Like the larger site pieces, the objects tend to be immersed in circumstance. Ireland's iconography ranges within an ever-expanding constellation of situational motifs and those inherent in the commonplace construction materials he prefers. The materials – concrete, cement, dirt, paper, tar, sawdust, sheetrock, and so on – are so ubiquitous as to deny confinement within any cultural bracket. Ireland shapes each one to show off its physical propensities. His references to industry are both primary and oblique. A catalogue of his basic elements would include scraps, cracks, lumps, and heaps commingled with straightedged architectural details and the less predictable components of light and climate. Rectilinear deposits of light across a wall suggest increments of time, as do, in another tempo, quasi-archeological layers of paint and plaster. Elephant ears, which actually *are* elephant ears (though Ireland has also made smaller versions of this shape in copper and wire), morphologize as the map of Africa, the artist's profile, or the severed ear of Vincent van Gogh. But a lump of tar or concrete is firstly a lump; if it also suggests a celestial sphere or a human foot or a bread roll, the resemblance is extra. Dirt is dirt. Inflected within Ireland's elective medium of time, his things interrupt the viewer's sense of smooth continuity: they literally give one pause. A four-inch Dumb Ball is "proof" of so many hours application; a sitting room in a 103-year-old Victorian house, the previous owner of which was an accordion maker, achieves mummified temporal polyphony.

Out of this multiplicity of simple impulses, materials, and techniques, Ireland has cultivated what John Ashbery calls his "home-

grown *arte povera*." Drawing upon a verbal memory as acute as his visual one, he grafts onto his anomalous procedures rationales gleaned from recent additions to the art lexicon, taking other artists' terminologies at face value, or blithely reducing them to suit his fancy. He refers to his restoration of the back wall at Tom Marioni's Museum of Conceptual Art in 1976 as a piece of "photorealism" because the hard-edge paint job was done from a photograph of the site in its original state. Likewise, he will apply such terms as "Social System" (from Hans Haacke) and "Social Sculpture" (from Joseph Beuys) to the ways ordinary objects (brooms, rubber bands, desiccated foodstuffs) accumulate in domestic space. *Broom Collection with Boom* (1978–88), with its dial-like semicircle of eighteen brooms in various stages of depilation, tied together by wire and bolstered upright by a lump of concrete at the end of a copper tube, is, as Ireland told me, "a social sculpture because you wear one out and buy another, so you end up having a series, which is a system."

In conversation, Ireland metes out a mandarin phraseology mixed with art-world slang to avoid presumption, holding to an open-ended view of what his art entails. If you point up the lumpen physicality in one of his pieces, he will counter by fleshing out its metaphoric potential, usually by way of a blunt pun; if, on the other hand, a conceptual drift threatens to become too ethereal, he steers the discussion back to materials and process. "I began as a printmaker, and printmaking *is* process. I don't even like to be called a sculptor because I came to sculpture by the back door, by default. I wasn't painting or doing performance as such. Having an idea continues to be important to me – that there's something in mind beforehand rather than having an object happen out of handling materials. The object is the evidence of the idea, the pylon. With Dumb Balls, for instance, you can't cheat the process. I call 'Smart Balls' the ones that failed – the ones where I interfered with my mind in the process by some degree of inattention. I see myself as stripping away intelligence from things so they're not overpowered."

One of the few objects that appeared in the Berkeley installation was a metal file cabinet with its single drawer pulled out to reveal a stack of manila folders screened off like a seedbed at the top with

chicken wire. Tabs on the individual folders indicated a dozen or so categories of Ireland's activities since the early 1970s when, already well into his forties, he committed to being an artist. Among the tabs were those labeled "Articles," "Services," "Teaching Jobs," and "Tony Labat," i.e., the fellow San Francisco–based video and installation artist who recorded a couple of Ireland's late-'70s "actions" at 500 Capp.

An especially large file was labeled "Trash." Another, "Hunter Africa – Accounts Receivable," held papers relating to the import business Ireland operated from the late '50s until 1974, during which time he visited Kenya and Tanzania for prolonged periods. Yet another, "Adaline Kent," referred to the annual award exhibition endowed by the sculptor of that name at the San Francisco Art Institute, for which Ireland, as the 1987 awardee, made his "Gallery as Place" installation – a two-level *omnium-gatherum* as detailed and sensually forthcoming as the UAM show was conceptually exacting and physically sparse.

Born in Bellingham, Washington, in 1930, Ireland brings to his present-day artistic persona a background as various as what he calls his "tamperings" along the margins of the esthetic map. Already drawn to art in his late teens, he studied painting and printmaking, theatrical set design, and then industrial design. His return to printmaking as a graduate student in 1972 coincided with the flowering of the Bay Area's patently limber version of post-minimalism and its emphasis on everyday behavioral processes. During the twenty-year hiatus – and before setting into any kind of regular artistic practice – he supported himself by brief stints in the insurance business and as an architectural draftsman and carpenter. In East Africa, while keeping his San Francisco outlet stocked with tribal artifacts and animal horns (ibex, oryx, and greater kudu, snapped up by the local restaurant trade), he found a temporary calling as a guide on photographic safaris.

Ireland speaks of having "always been fascinated by commerce and how it's manipulated by media," and then again, of recognizing early on in himself "a hopeless romantic" whom a childhood love of Rudyard Kipling's poems and novels had imbued with a taste for exotic climes. During the '70s, besides Africa, he visited the South Pacific, India, Afghanistan, Southeast Asia, Hong Kong, and Japan, and, more

recently, nearer faraway points in Europe and Mexico. At first, this global wanderlust might seem out of keeping with the distinctly homely (or even housebound) aspects of much of Ireland's art. But his Africa years in particular could be construed as a sort of Rimbaud-in-reverse preparation for his life as an esthetic visionary. His conceptualist's field guide includes such double-whammy axioms as "You can't make art by making art." In 1974, he made a significant move beyond the borders of conventional art making when he devised a one-time stratagem by which to rid himself of "object seriousness." This was the "94-Pound Series" of drawings made by spreading the contents of a sack of dry cement across his studio floor and then, by handling and slicing moistened segments, fashioning a drawing a day from the material until it was all used up. Each drawing was called *Repeating the Same Work Each Day*. The series was completed by discarding a drawing a day until, at the end, the artist had divested both his studio and himself of almost all tangible proof that the objects had been made.

Part of the strength of Ireland's work lies in its combination of regional flavoring and cosmopolitan adaptability. Traditional Pacific Northwest "shades of gray" are perceptible in his cement and concrete pieces, just as the fluctuations of California sunlight find their shapely foils in his wall glosses and window placements. Then there is the admixture of civilized reticence and raw whimsy that makes him a quintessential Bay Area artist of the period when that region's art has become identified primarily with displays of hybrid and otherwise gleefully uncategorizable genres. Bay Area art for the most part bypassed minimalism and went directly to the post-minimal in some of its most ephemeral, idiosyncratic manifestations. As Ireland puts it, "Minimal art was just too spare and intellectual for most people here. It belonged to East Coast people. The geometry was born out of New York, big-building grid life. The sidewalks were their model. Our grids are sloppier than theirs. The West Coast version was shaggier, more rustic."

"Rustic" is a favorite Irelandism, indicating a quality more aligned with a sense of the plain and sturdy – or, as in furniture, "made of the rough limbs of trees" – than with the rural as such. Ireland is a city

artist, and he specializes in a conceptual mode of urban pastorale. Attempts to define him as an "urban archeologist" are not far off the mark, though perhaps "urban naturalist" would be truer. What is unnerving in his work when measured against other big-city art is its very lack of urgency. Without being anti-art, he takes up a position that allows art to come to him. "So much of what I do is living my life," he wrote in 1984, "and art simply occurs in the process." This accommodating stance finds its natural basis in the climate of Ireland's home city, San Francisco. Advancing the antithesis of what they perceive as New York "systemics" (the push-comes-to-shove agons of style in that unfair city), artists along the Pacific Rim often mimic atmospheric cycles that produce soft convergences, barely perceptible groundswells or ripples – a thing a day, an idea a month.

Titled *Repository*, Ireland's nicely proportioned file cabinet lay lengthwise atop a sandblasted steel table, its succinct wire barrier at once tempting and forbidding inspection. Beyond it, set at wide intervals across the inner two-thirds of the UAM's Matrix Gallery floor, were three other equally laconic, ostensibly functional arrangements: *Table of Periods*, a card table supporting a glass-topped display case with a jumble of black-framed photographs and other mementos of the artist's life and works; *Pan of Pamphlets*, a knee-high stool crowned by a stainless-steel mixing pan from which museumgoers could take copies of the official brochure accompanying the show; and, huddled in a far corner of the room, *School of Chairs*, fourteen gray, straight-backed office chairs, some of their plastic cushions ripped and repaired with duct tape. Like remnants at the close of a walk-in warehouse sale, the institutional-type furnishings insinuated themselves as duly belonging in museological space – just another managerial storage bin, after all.

It is the way of Ireland's work to revel in anticlimax. Thus, the chairs in Berkeley provided the perfect cul-de-sac finale to an exhibition that, from the start, resisted getting off the ground and leading anywhere. The exhibition shrewdly kept its contents close to the vest, the better to divulge its idea, which was provided by the proposal of the exhibition itself. Called "A Decade Documented: 1978–1988," the show in effect comprised a mock retrospective. Taking the assigned title lit-

erally, Ireland decided to focus on the documentation of his work, rather than to consign the usual, obligatory array of milestone items. While avoiding the signature display, he managed to include, via photographs and files, "some evidence of everything I've done in the past ten years." The point was, he said, "to satisfy the title."

Sprinkling references to facets of his career as a refurbisher of architectural settings and a maker of portable objects – as the workaday sculptor he both is and isn't – Ireland succeeded in shifting attention from "object seriousness" to the institutional circumstances. The idea was to keep any obvious presence of art as such (or, as Ireland put it, "art that you think should be art") securely under wraps. During the preparations for the show, Ireland told Lawrence Rinder, the curator of the Matrix Program: "If you want to be an artist and to function in the art culture, the challenge is to see how closely you can stay to real time/space without becoming invisible. I would love the notion that whatever I do would become virtually invisible as an artwork. But you can make yourself so obscure that you don't exist."

Just as all of Ireland's work demystifies artistic labor – by displaying its products in a perceptual limbo akin to that of the parlor game "Things Hidden in Obvious Places" – his anthology installations like "Gallery as Place" tend to short-circuit the canonizing process of arts institutions by making the exhibition machinery itself an object of contemplation. Like many of his other site-responsive projects, the UAM version of "A Decade Documented" threatened to disappear into the woodwork. In this respect, the show approached the proto-conceptualist pallor of Yves Klein's 1958 empty-gallery manifestation, *La Vide*; in fact, Ireland may have achieved a more perverse degree of blankness by dint of the overall gray and cursory look of his furnishings. Playing the margins of presence and absence, enigma and unadorned fact, what was most palpable in the partitioned space was a kind of reverie upon – and an implicit refusal of – the museum mode of summing up an artist's progress to date. The objects that were there announced themselves as adjunct to the main structural component of the show, which Ireland, through a masterstroke of traffic control, centered on documentation in the catalogue.

Entering the show, viewers were invited to linger in *Reading Station*, a roomy sheetrock enclosure placed within the near end of the Matrix space, where they could sit on bentwood chairs and peruse copies of the exhibition catalogue affixed at four symmetrical points along the counters jutting from two long walls. Facing each of the readers' carrels, a low, narrow window gave onto a view of either the museum lobby or the inner gallery. Likewise, reflexively, visitors approaching the installation, as well as those who had progressed inwards, could see, framed by the window slots, torso views of those still in the *Reading Station*.

The catalogue, designed in part by Ireland himself, is a compact affair that performs its task of preempting a trotting out of past accomplishments in the flesh. Flipping through its seventy pages, replete with serviceable curatorial texts and many full-page illustrations, one could catch at least an inkling of most of Ireland's major projects over the decade in question, and then some – given that his best-known (though least-seen, except in photographs) work, the 500 Capp Street house, came under his scrutiny and renovative handiwork slightly earlier, in 1975. Besides 500 Capp, the catalogue featured views of three other large-scale architectural undertakings: the remodeled cracker-box unit at 65 Capp Street (1981; since 1984, the primary site for the Capp Street Project's adventurous artists-in-residence program); the reclaimed (or "excavated") meeting-room interiors at the Headlands Center for the Arts in the eighty-year-old former barracks at Fort Barry, just north of the Golden Gate; and the megalithic outdoor sculpture *Newgate*, a reassembling of inner-city building rubble at the Candlestick Point State Recreation Area in South San Francisco.

"A Decade Documented" managed to communicate both Ireland's conceptual austerity and his more generally sociable wit. Ireland's didacticism is less inclined toward lessons in the epistemology of art than in the perception of art as a sign of life. That his ideas don't lend themselves to diagrams or grids is due partly to the distinction he draws between East and West Coast modes of thought and practice and otherwise to the intimate contact he maintains with physical materials. "I am a builder and I deal with surfaces," he says. "Process and material

go hand in hand with one another, sometimes light being the ingredient, or else some more dense materials. But in process I'm really a hands-on person." Talking about the UAM show in retrospect, he told me: "When you work in bare, spare terms everything needs to be looked at. I saw people come into the *Reading Station* and read a portion of the catalogue and then walk away, walk through the rest of the museum, and then come back – maybe a half hour later – and sit down and read some more. Others would come and take one quick glance through the portal into the bare, bony space and turn around immediately and walk back out – all of which says something about one's expectations in a place where one thinks art should be. The show was about what you want your art world to be."

Ireland's art develops by progressive recapitulation. Like Jannis Kounellis, whom he admires, he habitually relocates separate works, elements and entire methodologies within new contexts. In terms of the artist's procedures, one chronological phase may have ended with a flip of the calendar, but many of the works produced therein still refuse closure: some keep popping back into works in progress, or process; others are more or less regularly altered just by being introduced into new situations. At UAM, for those familiar with Ireland's work over the years, some recyclings were plainly visible. *Reading Station*'s window slits, fluorescent lighting, and other architectural elements – pristine, white-painted sheetrock conjoining the angles of the museum's permanent poured-concrete side ramp and ceiling – recalled the cool, graceful lines and diurnal penetrations of natural light in Ireland's singularly thorough renovation at 65 Capp. Chairs, those arch-surrogates for authoritative human presence, have loomed large throughout Ireland's career. The "South China Paintings" of 1978–79, for instance, are actually hulking, outsized wicker armchairs, fabricated according to Ireland's specifications in Hong Kong. The same conception that produced the UAM setup *School of Chairs* was reinforced in Ireland's installation at the Museum of Modern Art's "Projects" gallery last winter as *Secondary School of Chairs*; but there the anticlimax worked differently because the rest of the gallery was so refulgent with odd-looking things.

Where the UAM's *Reading Station* had vignettes of people framed by architecture, at MoMA Ireland used architecture to frame and adjust our perception of things. If the Berkeley show took cues from the site's academic underpinnings, the MoMA installation reflected that institution's setting in the midst of New York's midtown commercial district. Passing through a plain white archway into the Projects Gallery from the broadly daylit museum lobby was like taking a turn into an elegant yet modestly sequestered shopping arcade. Just inside, one was confronted by a big plywood crate (*Space Box*) with aluminum-sash and glass windows through which could be seen ten of the artist's reliquary sculptures, most of them recent concrete ejecta augmented by wire or other industrial items such as an electric blower fan. The "space" factor of the construction was, as Ireland explained, the extended metaphor of "a cultural missile containing things from Earth sent into outer space, or a sarcophagus signaling the burial of all this stuff – an honorable funeral." It was also an anonymous little house recalling the larger plywood structure built into the 1987 "Gallery as Place," which was in turn a scaled-down version of the frame of the 65 Capp Street residence.

Facing the crate and bisecting most of the gallery space lengthwise was the most compact demonstration to date of Ireland's working principle of esthetic contingency. The show's centerpiece, *Counterpoint*, afforded, from the shaded near side of a widely angled partition, three window views of arcane-looking decorative objects, in discrete sets of four or five. The pieces gleamed like household ornaments cast in precious metals. "I was playing with the notion of commodities," Ireland told me. "Here are objects you're seeing as though through a store window. The whole collection became one work. You could treat it like walking down Madison Avenue and seeing something in a window; you could see it from outside and pass it or ignore it, or you could go inside the store for a closer look."

To go "inside" *Counterpoint*, you had only to turn a corner of the partition to find, clustered on a metal counter, the same items – only different. Having lost their initial sheen under the broader cast of track lighting, they appeared suddenly contradicted – mute, ordinary, lumpy

masses of concrete and dirt with assorted this-and-thats appended. The "window-shopping" conceit gave way to that of an earth-science lab with specimens set out along an aluminum counter. In appearance, these seventeen display items ranged from the most innocuous-seeming scrap to the blithest icon. Among them, *Six of Dirts* consisted of wads of dirt mixed with Rhoplex binder, three in and three out of an aluminum pan. Further along, a hammer and a hatchet embedded upright in a froth of concrete earned the title *Spout-o-Tools*. The most elaborate contraption, *Irish Headache*, comprised two withered oranges skewered by a couple of tent stakes that in turn were bound by twists of wire loop. The loop was buttressed by a large spring clamp sticking up from behind the flat-bottomed concrete base. Alongside the base, another clamp held a piece of rough, green cloth like fallen drapery. A species of history sculpture, *Irish Headache*, as Ireland sees it, connotes "William of Orange leaving the Netherlands to implement Protestantism into Ireland." (David Ireland's forebears, by the way, were not Irish but Scots.)

The architectural assemblage in the Projects space accomplished an a priori transformation of the premises into a place where Ireland's recurrent motifs might feel at home. Disguising both the sheets of tinted glass along the Garden Hall and the innermost wall of the gallery proper, Ireland took charge of the entire space, toning down its official-showcase look and converting it to a multifaceted tableau. Withal, one sensed a need to insulate the room layer by layer against the prepossessing MoMA givens. The picture windows were covered with gray sheetrock punctuated by more sash-and-glass inserts of varying sizes, thereby severely abridging the usual views of the sculpture garden. Looking back from outdoors, one saw a typically "rustic" touch: the bare two-by-four wood studs onto which the sheetrock had been tacked faced the garden through a neutral-toned gauze scrim lining the glass – all in a configuration that Ireland referred to as "a big Mondrian." Another stretch of sheetrock, this time bathed in a variation on Ireland's trademark glossy amber hue, lined the innermost wall; along it were sizable rectangles masked out and coated a deeper umber shade. These "prints" represented the fall of northerly light from the

sculpture garden through Ireland's inset windows at a certain time of day. For all its largesse, the MoMA installation, like the Berkeley show, was geared for what Richard Tuttle calls "second glancers." As Ireland said at the time, "I appropriated the café users who have to walk through the gallery to get to the restaurant. They don't have to like what I put here. If they go through without response, that appeals to me, too; it supports the invisible nature of the work. I like the piece not to have a flag on it that says it's a work of art."

Both Ireland's architectural constructions and his portable sculptures play havoc with the art public's sense of what's meant to be noticed, where art begins and non-art leaves off. Addressing already existing architectural sites – rooms like those at the Headlands, or entire buildings – as objects, he picks at the textures of transience. Applying wax or urethane across the venerable fissures in wall plaster to bring out a granular palimpsest amounts to a form of commemorative mural painting that enshrines the accumulated character of a place, its nature, beyond culture's bulwarks. The two rooms at the Headlands speak gently of both human and geologic strata. Their walls have legible ghosts. Their fissures and corrosions – resonant of sea air, sunlight, earth tremors, and the reports of big guns – read variously like rural road maps and reticular leaf veins. The Headlands, the Capp Street houses, the various museums and galleries – all are real-time spaces to be, as Ireland would say, "activated." Going from one to the next, Ireland casts himself as a reader of the world as a sequence of surfaces textured over time, each of which is liable to appear at once empty and full.

Robert Smithson once wrote, "Everyone wonders what art is, because there never seems to be any around." With Ireland, the puzzle shifts to the site of artistic identity. Where, after all, do we look for Ireland himself in these works? One answer would be simply that every one of his pieces bears his mark, modest as that may be. Another is that, in collecting these materialized moments in space, Ireland the artificer has disappeared both into and out of the work. With a slow but determined esthetic pulse, his ritual objects celebrate the convivial rite that is dailiness itself. Getting an idea, casting a glance – either usually leads to handling something. Mostly, though, Ireland imposes little

more than his time and attention on the materials, lending them a hand with the general shape and letting it go at that. "The smaller objects," he says, "are like words, or substitutes for words, and the larger situations become paragraphs or chapters in a novel. I think of the objects as being evidence of time passing, but you can imagine the small object elevated so that it would be a full-size thing or room-size installation. The objects are often combinations of materials and process held in reserve for the opportunity to build on an architectural scale. But also, in the absence of a larger space to work out the idea, the object allows me to document a thought. Otherwise, there would be a void between opportunities to do things."

1989

Ambassador of Light

John Button was a Californian who made New York his home and the main subject of his paintings. The New York of his most radiant pictures is a kind of sacred grove where cornices and water towers sprout up into grimeless and cloud-pullulating blues. Sharp New York was his cultural element – he disdained what he called the West Coast's "melancholy of hedonism," its parochial smallness – but in a sense, he never entirely left his native climate: born in San Francisco in 1929, he carried with him the bright sweeps of Northern California light and placed the integuments of his adopted city under their swayful limpidities. This temperate interloper's light makes of the high New York sky an occasion of tangible intimacy. Fittingly, Button's last show comprised views of California fields and mountains together with urban structures seen in ever-steeper perspectives from below; mounted at the Fischbach Gallery in 1980, two years before he died of a heart attack at fifty-three, it was titled "Coast to Coast."

The bicoastal synthesis Button managed for himself, both in and out of his art, is telling: an accomplished urban gardener (and in later life an ardent conservationist), he tended aspidistras ("they suit my period – 1910") alongside burls of redwoods (*Sequoia sempervirens*) and tomatoes in planter boxes; on his walls hung Maxfield Parrish prints and some of Rudy Burckhardt's Manhattan photographs, as well as an early-'50s nonobjective drawing by Richard Diebenkorn acquired before leaving the West. Elsewhere in his home one could also find portfolios of antique architectural prints, picture books on California landmarks, histories of ancient Greece, stacks of postcards, and snapshots taken of Busby Berkeley movies on late-night TV. Of his own paintings in this small collection, *Three Serious Ladies* (1955), which he considered his first artistic success, always held a place of honor. Bequeathed to the Oakland Museum, it shows a figure group in neo-Arcadian postures before a classic, stripped-down Mission bungalow with trellis and a flower border at the base of the porch. (About this simple stucco gem Button later commented: "It is the

house where I was partially reared, and where I spent a year in bed with TB when I was four.")

In 1959, Button wrote to a friend, Gerald Fabian, about a painting by Bonnard that he had just seen at a collector's house in New York: "Everything about the painting was wonderful. What makes it good? Who knows, the incredible surface, the astonishing color, the light that pours out of it, or the feeling in it. Bonnard seems to have looked at the little breakfast table and its window, fixed his heart on all of life, and painted." A similar merger of attentiveness, technical resolve, and sentiment at once calibrated and far-reaching is palpable in the landscapes and street scenes Button himself painted from the mid '50s on. And that same contiguous "all-of-life" apprehension on his part shows up in another letter to Fabian, detailing the events of a midwinter day near the tip of Long Island in the late '70s: "When we had left after lunch, I noticed that the fields of winter rye were a deep moss color set against a powder gray-blue of the rolling prairie. The light had been extraordinary. Everything had been extremely crisp and discrete in the clear air. The sap (or moss) green with flecks of yellow and orange, and the pale blue-gray and the azure sky . . . all completely separate as if in 'no' atmosphere at all. But now, returning at around 4:00, as the sun was going down, everything was in heavy atmosphere as the hazes arose from vast potato fields and the hollows in the woods. Deep, vivid oranges and unimaginably deep reds were set against their analogies of magenta and violet. The whole landscape was transformed again into a Romantic dream of eternity and dying." A few years earlier, he had already translated such piquant observations into paint, with a series of large, vertical sunset images panning, from his Prince Street loft, the Soho skyline – and at one point breaking clear to a postcard-that-never-was harbor vista of the Statue of Liberty backlit against a cherry horizon.

Button was an esthete in the strict sense of one who maintains a moral – or even religious – preference for the beautiful. His allegiance to New York was modified by an inherent civility that brought all things under a harmonizing touch. His pictures are full of smooth, if occasionally wistful, equations between natural and man-made beauty – the ultimate equalizer being light delivered through closely ordered

tones. There is nothing supernatural or exaggerated in his skies, which may account for what his pianist friend Alvin Novak calls their "bright clear sadness." Bonnard, Matisse, and de Kooning were "certainly [his] ideals," while further influences – the short list would include Hopper, Fairfield Porter, Caspar David Friedrich, Balthus, Rothko, and (for clouds and other castles-in-air propensities) Maxfield Parrish – provoked intricate blends of subject and technique. The scaled-up perceptual intimacy his best paintings assert is part of what the realist wing of the New York School developed, beginning in the '50s, as a counterthrust to – as well as an absorption of – abstraction's headlong specifyings of applied paint. Beauty strikes the eye and is seized by design on the picture surface.

As much as any other contemporary realist, Button sometimes fretted lest his art "descend into genre." In fact, of all his pictures, the outright genre scenes – the Balthus-like *Fire Escape* of 1960, for instance – have the most abstract compression. Partly because Button minimizes the amount of incident, in his hands the condensed specifications of a pedestrian view are more likely to lean toward the emblematic. Transposed to the unruly landscape, this compositional firmness could be prodigious. Two stands of immense trees against a densely wooded hillside in *The Final Redwoods* have the Golden Section proportions of a room by Vermeer.

Button's painting is without stunts. The clouds that bulge and quiver across his snapshot spaces achieve presence in the material world before they are recognized as effects. The clouds mass as the buildings face, in sturdy unison across the surface plane. (The frontal, shaded face of a brownstone sculpture enclosing a clock in *Grand Central* assumes the general look of cumulus transferred to the dark zone.) The clouds are never mistaken for objects or sentimental decor; rather, they occupy the roles that figures otherwise might, with the implied motions of surrogate voluptuaries, militants, loungers. We experience them sensuously through their specific, momentary structures and their optical tangencies to the shapes of buildings, trees, hills, and other relatively stable markers along the horizons, even though the angle of appearance may leave the literal horizon below the image edge, felt but unseen.

As far as his skies go, the light in them – Scott Burton once called it their "adagio light" – both suggests and veils visual infinity, and, naturalistically, you see the spread of light before you can trace its source. Like Friedrich with his encompassing cruciform designs, Button fixed the transitory flashes of air and light with architectural solidities, as well as with the breezy candor of his brushstrokes. Sunlight and geometry cut into one another, so that the light, much as any solid factor, creates form, and with it, a complex sense of time.

With so much geometry to spare, Button often tucked images of buildings at the edges of his canvases, where they function like numerals at the rim of a clock. His cityscapes break the habit of feeling one way about nature in the city and another way where nature is expected to perform as only itself: the "second nature" of the city out-of-doors is seen as equivalent because it absorbs, even as it derives from and frames, the primeval kind. The big difference may be in the degree of solace required when one's eyes cast about in the city's confusion and its contradictory synthetic orderliness.

Button's ennobling architectural vision subsumes the disorderly and factitious without hiding their indignities. Responding to an appreciation of the glow in one of his more gorgeous skyward prospects, he said, "I think that particular light is *smog*." Nevertheless, the result of his respect for appearance was a kind of mathematically oriented splendor. For the viewer, the projected, aimless, browsing glance upward becomes a form of adoration, the exact, scintillating whites and blues pressed against bare ledges a sudden, clear-eyed hymn.

1989

Sensation Rising

The large oil paintings that Martha Diamond showed in New York two seasons ago took some extra scrutinizing before their visibility, and even their sensational impacts, could register. Disoriented viewers tended to shrug them off precipitously. Taken as exercises in a post-reductive, painterly abstract style, Diamond's blithely charged surfaces seemed too glib, too erratic, diverse, or, worse, hastily slapped down; as emotive imagist glyphs, too nonchalant, rarefied, and obscure. "Nothing much at first," "not much going on," went the adumbrations in two local critics' lead sentences before those writers settled into telling what, after staying with the work for a time, they had seen and appreciated.

The nonplussed first impressions of Diamond's show suggest a cautionary tale about the checkout quotient from works that require more than a passing glance in the stressed-out sensorium of the art public. A highly sensual, nuanced art, it seems, won't cause much disturbance in the millennial spillway of theoretical quick reads. A few months before Diamond's show, the experience of watching people enter and leave a small installation of Robert Ryman's paintings in San Francisco had resulted in my estimating a thirty-second requirement for the viewer willing to see either that there was anything there but bare walls, or that the Rymans, once their recognizably literalist formats were brought into focus (they were in fact white and aluminum-gray constructions bolted to the walls), had much to offer by being inspected further. Most of those who gave the installation a half minute's close study were hooked, and likely to remain for anywhere from twenty minutes to an hour or more while each of Ryman's nominally perfect blanks intimated light and sense.

By comparison, Diamond's pictures are far from blank, though some of them deal, much like any Ryman, with great gobs of evanescence. Rather, each is painted fully, near to impaction, which is where some of the work's difficulties lie. At a glance, you can't see the painting for the paint; and the massive image the paint amounts to spreads nonsensically, as if some essential, mediating focal point were missing.

Only over time do you see that the strangely resolved, surface-wide image is the point, and that its time of arrival is double: fast for color and light, slow for graphic statement. The paradox is that these slow-to-be-perceived surfaces evoke the kind of unscheduled rushes of perception that most keenly fall to sight in ordinary experience.

For most of the past ten years, Diamond has painted cityscape abstractions based on the canted New York vistas one's eyes meet inadvertently out the window several stories up, or in passing from the street. Such discrete actualities tend to impinge on one's consciousness as sensations only tenuously connected to the solidity of things. All of a sudden, one is struck by a ratcheting amalgam of stone-and-glass gridwork with the reflection or shadow of a second architectural bit, plus perhaps the cropped profile of an incongruous third across a chemically coated slip of tumbled island sky – and all of this bunching upward from no foothold in a spatial continuum that flattens out much as the distances across the Grand Canyon when observed from the rim. Animated by weaves, darts, and scrubbings, alternately glistening and dry, of Diamond's pigment, such mirages claim the giddiness and pathos of the aimlessly grandiose.

Diamond's New York views developed out of a number of generic city images the artist made after switching from acrylic to oil paints in the latter half of the '70s. Her earlier acrylic paintings were, she says, "about brushstrokes," with some landscape references. Her first oils were a variety of what Rene Ricard then called "single-image painting" – one rudimentary form per painting, floated in the center of the pictorial field – a mode to which she occasionally reverts, though with a broader attack (especially in a series of enigmatic, thorny abstract still lifes begun in 1986 called "Sets"). By 1980, when she zeroed in from memory on specific Manhattan subjects, her pictures began to project a footloose elegance commensurate with a sensibility at home with its motifs.

Diamond is a New York visionary. Her pictorial embodiments of the stuns and implosions of urbanity are best understood in the company of those painters of Manhattan across whose surfaces the arguments between representation and abstract form are deflected by the urge to nail down the forces that contend at just about any intersection.

One thinks of the vector-ridden outcroppings of John Marin's "down-town" pictures, Georgia O'Keeffe's night-blooming monoliths, and the hectic avenues looming up in pictures by Franz Kline and Willem de Kooning. The energetic realist wing of the New York School belongs here, too: Jane Freilicher's ever-deepening skylines, John Button's reveries upon cornices and clouds, Yvonne Jacquette's contemplative particularist overviews, and the recent "black" paintings of Lower Manhattan at night by Alex Katz.

A Manhattan native, Diamond returned in 1965, after graduating from Carleton College in Minnesota and a year in Paris, to discover New York School painting: "I felt sympathetic to Kline, de Kooning, and Rothko," she has said, "but I was most influenced and fascinated by Pollock and Warhol." For the young painter starting out in the mid '60s, the "persistence" of Andy Warhol's images and Jackson Pollock's "graceful, complex space," as she saw them, presented the necessary challenges. De Kooning at the time seemed "more graphic." Nevertheless, it was to de Kooning's highway abstractions of 1957–63 that the physicality of Diamond's recent pictures most relates. In the highway pictures, de Kooning brought forward an image of the sweep at the peripheries of vision – literally, the landscape rushing away at the side of the road as seen from the passenger seat of a car. Frontality – the paint in front of the picture – put the viewer on intimate terms with the accelerated image as it spread out in scale and light.

More accurately, it could be said that Diamond has retrieved the blunt physicality of de Kooning's and Kline's paint at one remove – by seeing it through the use Alex Katz made of it during his own phase of directly handling imagery that included, besides landscapes and por-traiture, a series of head-on window-frame views done circa 1959–62 in his West Side loft. (Somewhat earlier, Katz had announced his sense of the procedural issues involved by the remark "The paint goes across the canvas making discriminations.") Apprehending the agitated marks of Action Painting through Katz's nimble, more circumspect realism means removal for the painter in another sense: the image agglomer-ated of a dual attentiveness to the external world and to the contiguous behavior of paint is objectified and transposable. Hence Katz's progress

away from direct painting and into his current "artificial" phase of working from drawings, through oil sketches, to the transpositions of images (via drawing and pouncing) onto huge canvases where, as he has said, "you see the image first and not the paint, but if you want to look closely you can see how it's painted." Hence, too, Diamond's way of similarly transposing images worked out on small Masonite panels to big, mostly vertical paintings in which the basic scheme is altered only by more refined touches and a greater care as to scale.

It's as if Diamond has put the paint back in front of the picture where de Kooning had it, and from where Katz eventually (and other '60s reductivists, generally) smoothed it away. But, like Katz's, Diamond's art is distinguished from that of the exemplars of Action Painting by a heightened intentionality apropos image and appearance, including a pragmatic approach to the mediating messages of style. "On the surface," she told me,

> my work resembles expressionist paintings, but I'm more concerned with a vision than expressionism and I try to paint that vision realistically – I try to paint my perceptions rather than paint through emotion. A familiar subject in a radically generalized or edited treatment is a formalist device I use, so that recognizability or familiarity leads the viewer to look for expected detail. For the most part the details are not there so you look harder at the paint and the painting. You begin to distinguish between paint, performance, image, idea, expectation, and you.

The normally rigid components of the urban grid – of what James Schuyler calls "the continuous right-angled skin of the city" – yield to the eliding fluency of Diamond's brushstrokes. Contrariwise, for oil paint to look so fresh and articulated – for it to articulate solids and gases as seamlessly as they appear in the bat of an eye – it must be handled dryly: thus unblended white and blue streaks, through which poke the extremities of tall buildings in *Tips*, make, Diamond says, "a sign for sky, mist, and water on a gray day." The atmosphere left by the brush doesn't undulate but zips laterally or hunkers down. Atmosphere and light cushioned by mass and tone are a view's most

salient traits. Tingles of offshore light and weather modify the diaphanous facades in *World Trade* and *Winds*. But the particulars of those skeletal prospects are left for memory (including memory's illogical color statements) to extrapolate. What appear most nonsensical – the gummy penumbras and moonstruck calcium rows of girders, or a sunny apartment tower's feathered-off, dithering incline – ring most true. In the overall image a precise look of combined architecture, light, and air may be reflected, but the reflection is without objects; it veers instead to fasten on sensations analogous to those high-pitched, random instants of vision when our associations of contour and particular objects merely percolate in the effect.

Diamond extends the optical life of her sensations with bold integuments that verge on cartooning. Like a comic-strip artist, she has come up with a repertory of marks with interchangeable connotations: a reduplicated single stroke hooked into an open *V* can stand for a rooftop ledge in one painting and a stack of balconies in another. This as much as anything – as much as her taste for jarring (or, as she says, "conspicuous") colors – has led some critics to mistake her as a latecomer to the ranks of neo-expressionism. Diamond's vision may be subjective – sensation, finally, can be nothing else – but her painting's expressivity derives from a feeling for live fact. Joan Mitchell has spoken of "a feeling that comes . . . from the outside, from landscape." And it may be that Diamond is doing for the cityscape what Mitchell does for the great(er) outdoors. Where Mitchell layers her canvases with the irregular swatches of nature perceived as chaotic sense impressions, Diamond builds edifices that bring citified chaos into focus as character, condensing the rush and stabilizing it as an emblem.

Diamond's brand of real-life abstraction reminds us that, conversely, the most piquant New York realism has always made the object of its contemplations the city dweller's quick response to the immediate environs. What becomes visible with a cursory turn or lift of the head is what makes the city click into place, revealing its larger nature and dynamism. One gives oneself up to such excess with a plausibility that briefly overrides the baseline bludgeonings by which whole zones of sense are quashed. The city seen with a naturalist's bent tran-

scends its witless negotiations. Light on buildings against the high Atlantic sky makes New York life tenable.

Diamond's pictures make a close analogy of brushed-on oil paint to immanent light. Indeed, some of her latest paintings take light alone for their subject matter. A spree of closely adjusted color values, *Red Light* is four red tones folded against each other to envelop a blushing white wedge. "*Red Light* is light that's white in red," Diamond says. "Light and rhythm are such basic parts of order. Almost everything can be defined by them – joy as well as monumentality. They can be thrilling even before they become attributes. That's where my spirituality lies."

1990

Invocations of the Surge Protector

Midway in *A Philosophical Enquiry into the Origins of Our Ideas of the Sublime and Beautiful*, Edmund Burke identifies power as an essential component of sublimity by a rhetorical double negative: "I know of nothing sublime which is not some modification of power." Sublimity's sensory or ideational lift is characterized by a murky flow of negatives. Besides his "nothing . . . which is not," Burke lists such "general privations" as vacuity, darkness, solitude, silence. Negativity is as convenient a source of astonishment and awe as any display of positive excess.

Nowadays, to assert the sublime, with its associations of epiphenomenal grandeur compelling an abject piety, might appear unlikely and, more to the point, insufferable. Residual notions of transcendence have been tailored to the present's loose fit of skepticism and chastened nostalgia. When high-minded artists like Philip Taaffe and Ross Bleckner speak respectively of a "mock" or "degraded" sublime, we hear them to mean a constricted, upended loftiness – a grossly self-conscious art trespassing upon the Empyrean as if by the back door. As a term of Romantic moral philosophy and esthetics centering on the correlations of irresistible external forces and fitfully soaring inner states, the sublime has assumed a vaguely sociopathic tinge. Surely Immanuel Kant's idea of it as "an attempt to feel fear by aid of the imagination" proposes a heedless, possibly lethal pleonasm: the imagination has already made us fearful enough. In an age of image terrorism spawning reams of iconophobic critique, artists whose images bear the stamp of sublimity necessarily present their dressed-down surfaces as cautionary. The power struggle between intensified feeling and conscious reflection implicit in any traditional version of the sublime may now be analogous to the contradictory surges of dysfunctional meanings that build within a circuitry tuned by unseen, nameless cultural forces. The upshot is irradiated stasis – a standoff, in fact, where images and viewers alike hang fixated, rapt in the recognition of their mutual displacement.

Doug Hall is an image-maker whose images carry the threat of such a stasis by regularly exposing the contrivance by which ineluctable

powers are brought to visibility at a pitch where only fictions can exist. That contrivance is reciprocal, as much the viewer's business as the art's. In most of the videotapes, installations, paintings, sculptures, and other mixed-media pieces he has made during the past decade, Hall invokes the sublime both to participate in its intensities and to isolate its ways of claiming mastery over mental space. Finally, the sublime becomes in Hall's work an issue of spatial orientation: to find a legible footing amid his images, one is thrown back to knowing how one sees them.

Beginning in 1985 with *Prelude to the Tempest*, the videotaped views of landscape under heavy weather that Hall, together with his principal cameraman Jules Backus, have recorded and edited, ravish the eye. But each of those views contains a formal reminder that our sensations are being prompted by careful formatting. As Hall writes:

> The language in place in Romanticism to describe the epiphanous landscape, for instance, allows the viewer to achieve a sublime response – to nature, to machines, to the Nuremberg rallies, to architecture. It encourages an extreme subjectivity, which I think is a very dangerous state because it dispels that sort of cerebral mediation that should take place in experiencing the world.

> Spectacle fulfills the functions of reinforcing aspects of power. The fallacy is that these displays are consumed passively. But events occur that manifest power, and we participate in them. Power is enforced from beneath. We're all complicit in it. I include agitation and intensity in my work to see how these mechanisms work, and the levels they play on. Art examines the mechanism.

At once disembodied and boxed in, the video image of a tornado plowing up the near horizon (actually the lower rim of the matrix screen itself) stands revealed as just the whiff of an ur-text within a fastidiously mediated sign system. Within the limits of the make-believe image-field, Hall's self-proclaimed "insidious triumph of form over content" lets us envision the coordinates – mental, emotional, public, and private – by which images negotiate their meanings.

Meaning is power. A meaning may be too deep or too convoluted to matter. Awaiting conversion into relevance, meaning spins in place,

a pantomime of intent. The overdetermined symbol as a trap for meaning cuts off particularity and leaves a tag of dangling nonsense instead. An overload of groundless meaning can wipe out the field in which it appears, leaving images and our responses to them suddenly, stunningly, stranded. Given the pressure of some images to mean more than any field can withstand, an artist may function to protect his field (and his audience, as well) against the excess surge. When meaning rises above a certain threshold, he detects it and shunts it aside, dissipating the surge.

Hall's work plies, as it supervises, the precipices of meaning and its lack. Or, more darkly, his spectacular displays entice us into the penetralium of image-and-meaning management, where power plays are effected with recognizably hyperbolic devices and defeat is necessary if we are to see what is actually before our eyes. By constantly pointing up his images' modes of presentation, Hall deflects belief in the very rhetoric he appears to celebrate. Perverse hyperbole meets conscientious deflation at the corners of his art's overt frames.

In both his early video and performance pieces (where the artist himself was visible) and his recent work (where he is not, having been replaced mostly by landscape), Hall has adopted the wittily austere persona of the executive artist – a kind of hypnogogic wizard who cranks up furious, high-visibility displays while ensconced at the controls. "There's a level of perversity in my work," he says, "a mad flirtation with the thing that is being deconstructed." Obsessive in his conceptions but detached in his procedures, he invokes executive privilege over matters that are arguably beyond control.

The Terrible Uncertainty of the Thing Described is a large-scale installation aligning three-channel video imagery and voluminous recorded sound with architectural devices and a live Tesla coil. Originally commissioned to form a part of Hall's 1987 multimedia retrospective at Boston's Institute of Contemporary Art, the piece appeared in a slightly different form at the San Francisco Museum of Modern Art two winters ago as his contribution to the touring "American Landscape Video" exhibition. (The work will reappear there this May as part of the museum's permanent collection.) In a

panel discussion linked to the opening of that show, Hall characteristically identified his entry's major themes as "signs of power" and "the terror of mediation" and his particular interest as being "less . . . in landscape than in images of landscape" communicated via the "flatness" of video.

Like the previous single-channel videotape *Storm and Stress*, which uses some of the same footage, *The Terrible Uncertainty of the Thing Described* establishes much of its scale acoustically: the soundtrack's roar and hiss, abrupt silences, and bird twitters, all keyed to images of natural or fabricated turbulence, command more space more continuously than their visual counterparts. Hall has forced the flow of these audio portions so that they sweep through and galvanize abstract video's typically horrific real-time tempos. Altogether, the installation presents the spectator with a diversified – and ultimately collapsible – esthetic machine. In the immaculate thrusts of its individual parts, it recalls constructivist engineering esthetics enlarged upon by late minimalism's charge that inert materials speak in their given languages. *The Terrible Uncertainty of the Thing Described* forms an emblematic locale – an impersonal, speculative test site for our persistent notions of how external phenomena condition or confirm strong emotion. The title, suggestive of Romantic sensationalism, comes directly from Burke's *Enquiry*. As an example of the obscurity required to transfix the mind in its amazement, Burke singles out an account of disembodied vision from the Book of Job ("Then a spirit passed before my eyes. The hair of my flesh stood up."); this passage Burke credits with "a sublimity . . . principally due to the terrible uncertainty of the thing described."

Inside the dark gallery at SFMOMA, you meet with a thirty-foot-long, ten-foot-high, black-steel-mesh fence that looms outward at a ten-degree tilt. As the prime structural element, the fence shears the room in half diagonally, forming, at the far end, the see-through front of a trapezoidal cage. Against the near wall behind the fence perch six video monitors hoisted on steel tubes. The videotape, projected onto the far wall where the fence stops as well as on the monitors, intercuts between tidal rushes of assorted cataclysmic scenery – a flood, a blast furnace, a forest fire, the prow of a Coast Guard vessel plunging into

massive swells on the Bering Sea, thunder and lightning, a clash of energy in a utility company's test facility, storm plains matted onto video "snow." Near the wall projection, in the enclosure fronted by the fence, are two spotlit, grotesquely outsized metal chairs, and behind them, the work's featured eminence, the Tesla coil.

The coil is alarming. Hall refers to it as "an information-encoding and transmitting device in a very crude form." (Its visionary, Serbo-American inventor, Nikola Tesla, thought of the high-frequency current transformer as capable of resonating "if nothing else, intelligence" throughout the earth's atmosphere, and farther, to other planets; as it is, his tunings of such apparatuses form the basis of present-day electronic-media circuitry.) While the videotape continuously reshuffles its exquisitely edited turmoil views, the Tesla coil has been timed to discharge its million-volt-plus plasmic load in lengthy, chaotic streamers of branch lightning at half-hour intervals. The enclosure made by the porous fence and the attached metal sheeting lining the ceiling, floor, and connecting walls is necessary to ground the violent discharge and filter out the attendant radio waves (as the blueprint says, "to minimize RF interference").

Set in the penumbral recess of this housing device, the coil's squat, ithyphallic presence viscerally overprepares us for the audiovisual shock of its eventual "information" dispersal, which, when it happens, is instantly distinguishable from the remote depictions piped in on the monitors. Upstaged by the immediate fireworks as if by some monster from the id, the video imagery gains another sort of credence as the sublimated representation of powers analogous to those of the coil. Awaiting the coil's eruption while watching Hall's capsule vignettes of technology and weather, the museumgoer submits to half an hour's worth of drawn-out conceptual panic. In a sense, the coil is the work's surrogate performance artist, leaving room to spare for the viewer as the ultimate subject. Then the explosive moment passes, and we are back with the sensory baffle of video's imagistic elsewheres and the coil's tacit threat.

Obviously, part of the thrill lies in the viewer's submitting to the event on the premise that the artist knows what he's doing – that Hall

has supervised the work so as to keep the audience safe from the coil's potentially destructive powers, as safe as they are from the tornadoes ripping apart fields and city blocks on the video screens. The viewer's sublimity is measured by the capacity to epiphanize his or her position in the room, as well as to form any number of mental models for what is happening in it. Hence Hall's motto for the total experience: "The storm is in the mind; the lightning is in the room." But the mind knows that it, too, is in the room and the storm is a conventional narrative it tells itself by rote. Acknowledging the dream state induced by the luminous views flickering in the dark space, Hall indicates that the Tesla coil's actual discharge "wakes you from your reverie."

Hall makes esthetic distance literal. It's his way of protecting his art from the upheavals and outages that are its norm. Churning and wagging across the monitor screens, the tornadoes have a forlorn, self-importantly stupefied charm like the heroines of Romantic decadence. In *Storm and Stress*, the soundtrack of the "Lux Aeterna" passage from Guiseppe Verdi's *Requiem* is as perfect an accompaniment to the video images' distanced power as to their almost quaint, dreamy imagistic languor. The tornadoes are, in a sense, funerary icons, dead dreams; and the intimate, beaming video box is their crypt. We may imagine ourselves tossed about by these sights, but the game of haunting appearances is up when one member of the tornado-intercept team in *Storm and Stress* exclaims, as a funnel cloud exits screen right of the image, "I got it, I got it on video!" and another calls out, "That's close enough – let's go!"

We know that real power is invisible; it can only be indexed by paltry sign systems, or else talked up in the manner of the solitary tyrant bombinating on the chill, empty set of *These Are the Rules* from *Songs of the '80s*. The social equivalent to nature's moods, whether primal or artificially engineered, is demagogic pageantry. From his early days as a member of the conceptualist group T. R. Uthco (1970–78), through to his current set of wall pieces, "Winners and Losers," Hall has plumbed the visual and verbal mannerisms of political power foisted through the news media. In T. R. Uthco and Ant Farm's 1975 performance/video collaboration *The Eternal Frame*, he portrays a "celebrity heaven"

mock-up of John F. Kennedy reduplicatedly assassinated on the streets of Dallas. Near the beginning of the videotape, he faces the camera to intone a monologue from behind an appropriately laminated desk: "As your image president . . . I suffered my image death . . . August 10, 1975." The heroic climate has been designed to fit the format and not the other way around.

The main body of "Winners and Losers" is a stop-and-go sequence of thirty-one steel-framed panels. Hung as the centerpiece of Hall's show this past March at the Fuller-Gross Gallery in San Francisco, the panels were, as he says, "laid out like a page" across a wall. Proceeding by syntactic subsets – groupings of from two to five and an occasional single piece, with blank spaces in between – the sequence amounts to a rebus of uncertain closure. The panels themselves are standard art-supply canvases snugly overlaid with either rag paper or double-weight photographic stock; with their obdurate-looking frames they have roughly the same proportions as a television screen. Hall has built up the surfaces by applying dense layers from his customary palette of dry, blended pigments bonded with shellac; there are masked-out areas where key images break clear of the murk. Six of the panels have central elements resembling reductivist abstractions. Four of these contain a color disk spray-coated on a nebulous field of scumbled browns and yellows; the other two repeat the same four colors, once as the quadrants of a color wheel and again as squares abutted like the color bars in a video test pattern. Emblematic, nominally abstract images, punctuating a sequence whose terms of legibility are otherwise keyed to the human figure in its most public phases, the disks and their grounds readily suggest close-up images of pupils and irises, an association that Hall himself accepts without having planned it: after all, he says, the red, blue, green, and yellow shapes, which refer to the printing industry's four-color separation process, are "about seeing."

The remaining twenty-five panels show fragmentary halftone images of twentieth-century male political figures, severely cropped into simple geometric shapes and set in mostly blackened, matte fields. Judiciously defined by the sharp peephole edges of a triangle, circle, or rectangle, the stark, close detail – sometimes just a pair of eyes, or, more

radically, the fingers of one hand – teases our appetite to complete what we see. Commandeering a globular node very like the man in the moon, a glaring pate, squinty eyes, and a stub of nostrils come to evoke the countenance of Nikita Khrushchev. A scalene triangle and an off-center circle in separate panels hold two different slices from the by now iconic media image of Jack Ruby killing Lee Harvey Oswald while Oswald's jailers look on (we need only see the slant of a Dallas deputy's tie and shirtfront to recall his fall-away grimace at the shot).

Hall's synecdochical details slip into the nonfigurative as readily as their hyperbolically localized features demand acknowledgment of the physical characteristics we have memorized without half trying. If the colored disks refer to the mechanics of information-processing, these studiously isolate archival hieroglyphs spark our feeling for lost essences in the ranks of the already processed: the token immanence of a face, revealed by the weak signals of its most intimate aspects, leaves us in a blanket state of incomprehension. In the game of naming, we don't know what we see, although we know how to recognize almost anything and to assign it a name.

The steel frames possess their own peculiar resonance: they have the burnished, authoritarian look of gun barrels. If we have been targeted to receive the mnemonic blips and figments they contain, some response must be in order. But what does the attenuated image show us besides the fact that it has been edited to a state of informational thinness almost literally beyond recognition and that, despite this – and despite the bleak, wraithlike appearance that such shards from vintage photographs often possess – recognition persists? Such recognition pinpoints the random allusiveness of memory's debris.

Some of the other multipanel pieces in the Fuller-Gross show contain mug shots of mass murderers blocked out with slots that emphasize the eyes. These polyptych portraits put a fresh spin on the adage "If looks could kill." Interspersed among them are panels that partake of Hall's color-coded brand of abstraction – low-resolution streaks of blue, red, and yellow appear once some of the surface layers have been rubbed away. The killers' grim stares are answered by a prickliness like broadcast static in the excoriated paint. Since murderers and political

figures appear in similar formats, there's the implication that dema-
goguery and criminality are aligned. But then positing a complete iden-
tity as either a murderer or a tyrant is a kind of abstraction, too. As Hall
says, "Abstraction is that point on either side of coherence. The look of
the murderer's eyes is significantly different from the eyes of politicians.
The eyes of those murderers are pretty unsettling."

In yet another new group of paintings, Hall has let enamel paint
run down the faces of inset squares and then lined up the same colors
"rationally" in horizontal rows of smaller monochrome blocks below.
Like the opaque layouts of "Winners and Losers," these composite sur-
faces leak nostalgia for psychospiritual depth perception. Possible
meanings accumulate in entropic spills while all the signifiers flatten. In
place of content there is surface drain. Hall guides us to the point at
which cultural modalities sink back into nature. "Nature" can be any
artist's materials – pigments to be smeared (or dripped) or subject mat-
ter or memory, the more compelling the better. Hall keeps his nature
on a short leash. Playing it out, he lures us to both grant nature's pow-
ers and test them, without ever actually allowing the tension into which
envisioned power throws our faculties to collapse.

Erecting and then peeling away layers of surface – can the truth be
gauged on either side? Mostly, art tells us that its messages, mixed and
unmixed, can be received only at face value. But Hall says, "I want
more than that. The poignancy in my work comes from the need to get
beyond the surface, to another level of meaning. You want to peel
underneath the image and find out what's there and of course you can't.
Into this quest is built a horrible futility, but just because I can't find it
doesn't mean that level doesn't exist."

1990

The Dark Pictures

For two decades now, the dramatic paintings that Philip Guston made during the early and mid 1960s have been in danger of getting lost in the shuffle – or scuffle – of attention paid to his late work and then, circuitously, to his earliest abstractions. Thus, a crucial, archetypal phase has been comfortably marginalized, marked "transitional"; in even the more perspicacious texts, it is passed upon with respectful brevity, and rarely sighted among accompanying colorplates. Color may have been irrelevant as a working principle of these predominantly gray and black paintings, but light, nuance, and a quarried density are their staples, impossible to bring across in halftone prints. The range of Guston's work is known and its overall, expressive coherence fairly well understood, so the critical imbalance regarding these paintings is odd. Meanwhile, the pictures themselves have kept on looming.

Of course, they are among Guston's most difficult and complex. Think how oppressive, how literally dreadful, they must have seemed at the time: dark and heavy with care, they represented everything the '60s ostensibly weren't. Duress is their theme. Exasperation being a subtext, degrees of harshness (theretofore uncharacteristic – Guston was notorious in the '50s for his refined touch), transgressive impaction (like what it might be to watch the intake of forlorn matter from within a black hole), and nebulous passages (where pressure trails off to grace-note washes of rose and hopeful blues) follow. The problem was of a typical, age-old pictorial kind and then some: how to stand for more of life and at the same time confront every moot angle to the question of whether painting as such holds any value in life's scheme. There is the fact that the artist's remarks most favored by exegetes to illumine his eventual overt imagemaking – "Doubt itself becomes a form," "the 'pull' of the known image for its own 'light,' its own sense of place," and so on – come mainly from interviews and statements related to these earlier pictures. Contrariwise, considering the work of his final years, Guston wrote, "The images that appear somehow reveal more in terms of forces than what the images represent." This is as true of the

paintings you see here. Shape spells force, and each force enunciates a vernacular history intact.

Between tentative abstract removal and explicit figuration there was neither break nor denial, and certainly no sacrifice involved. Of necessity, the late work carries with it an abstract past, just as the abstractions outline the basic traits that similar forms are later brought to bear upon. As a summa of previous modes, showing all the parts (palette, touch, space, and subject matter) in place, the late work doesn't diminish what preceded it. Close inspection reveals a late form to be a look-alike of an earlier one, with lineaments brought further towards completion. "Late" informs "early," lets us see in retrospect with new eyes. The late paintings have things their way: theirs is multiplicity declaimed across horizons littered, or flooded, with honest, pained recognition. The '60s paintings focus hard, and with a different honesty, on doubleness. They have things two ways: abstraction as an emblematic condition of the real, abstraction applied to intimate physical fact.

Guston himself called them his "dark pictures." Apt enough for the strong darkness – that splendidly visible, variable penumbra in which subject and mood extend from one another – so declared. They are also known as the "Jewish Museum" paintings, for the occasion (a selection in 1966 of then-recent works) in which many of them were first shown – or else "the erasures," for the probing method employed. As Guston described it: "I use white pigment and black pigment. The white pigment is used to erase the black I don't want and so becomes gray . . . Sometimes the erasure gets more real to me than the image."

The painter's process crystallizes as surface. There is the sensation of slowly struck form – of compound liminal matters in a scoured basketry mesh. There is structure but no center, or rather the center is the frayed fabric of interspersion itself, those somewhat stretched relations spread out friezelike in edgeward space. Composition need not apply; tangency and metaphoric seizure are all. The usual terms of arriving at contour are reversed: reflexively, solid bodies "stir" into view. In the intricate cross weave of wet-on-wet strokes, black shapes – stasis riding on flux, flecks of near-graspable stuff – extrude, dawning in their pockets of space. Under such duress, a nexus of black marks can suggest a

hulk or an ingot or the lash ends of a paintbrush. Some of the blacks look hot to the touch, soldered to the environment as if the brush had become a torch. One feels that spatial position has been inflicted as much as won. What Guston called "the weight of the familiar," seen but not touched, is perilous to expectation. There is no floor, barely any distinguishing forward plane, yet often enough the axiom of ledge or sill. As ever, in Guston's syntax, it's clear where the bottom is.

Also clear is the loaded semblance of specific gesture – how in *Looking*, for example, the palisaded portrait bust twists one way definitively, to the viewer's right. The least acknowledged strengths of Guston's pictures from the mid '60s on are their perceptual qualities. The warmth with which Guston once recalled observing the sagging pants on a New York intellectual – while the man had argued on about Sartre – was at the heart of his professional respect for the way he saw perceptual character expressed in Sung painting ("my ideal," he once said) or in American cartoons ("Cliff Sterrett did the best furniture") of the '30s. The luminous grays make a ground-rolling fog, or else sinews, striations. Their pressures coalesce to position a rock, a battered cup, the painter's blunt, tufted dome of a head. One squarish, lumpish noodle totters on its base; another, more tensed, seen from the rear in *Painter IV*, ogles a distant rectangle; yet another in *Portrait II* looks confident, breaking into song. Elsewhere, in caches of circumstance, studio implements sit tight and puff. A seasonal figure – *Winter* in its muff wrapper – skids to a stop. Axial triads in *The Three* and *The Light* are identifiable family groups. (Candidly, the former shows the lingering juncture of a kiss.) Scale is multiple – the domestic aligned and magnified in celestial compartments. Spread from the meatiness of put-on oil paint or thickest gouache, light in these paintings often seems coaxed as much by fine-ridged bristle marks as by closely adjusted tones.

The paradox is how permanent the imaginatively volatile, dilated shapes appear. Strange to the surface, they might easily shift or fade. (In recollection, as one thinks back on the pictures, they do just that.) Yet in the next bat of an eye, they manage further assertions. Guston's shapes are denatured in this way: that they show "nature" to be a weak intuition in the face of the physical world. The dark pictures represent

the extreme case of Guston's operative schema of doubt, his entrance into what would come to be told of, in the late work, as the Evil Empire of Painting. Here, reluctance breeds a febrile iconography. Guston's ceremonial placement turns on the painter's constant question of moment: a provisionality that lasts.

1990

Bladen's Mounds

"It's a million miles from this mark to that." This comment by the painter Guy Goodwin about the isolate mounds of white pigment contrasting with an otherwise all-black firmament in one of Ronald Bladen's early-'60s pictures so delighted Bladen that he pronounced it the best ever about his work – even though the painting in question had been done some twenty-five years before. In the meantime, Bladen himself had made the considerable trek from making paintings that fairly sang of their spectacular tonnage and raw physicality to the geometric sculptures sheathed in a gravity-resistant, technological look for which he continued to be best known until his death in 1988.

Bladen came to art as a painter and, even in his most simplified freestanding constructions, never relinquished his painter's eye for imagistic nuance and the ins and outs of fictive space, much less for color and light, which were always strong factors in his work. Although never so iconically surefooted as his sculptures, his best paintings are saturated with the same sense that what is there is what Bladen most wanted to see. He once told his longtime companion Connie Reyes of standing high on Partington Ridge at Big Sur sometime in the 1940s, stretching out his arms and seeing his shadow spread on the clouds below. Later he would speak of wanting to place a sculpture on a mountaintop so that its shadow could be similarly cast. In 1968, by which time his reputation as a sculptor had begun to figure largely in the environs of minimal art, he identified his ambition with "that area of excitement belonging to natural phenomena such as a gigantic wave poised before it makes its fall, or man-made phenomena such as the high bridge spanning two distant points."

"A million miles" might serve to define not just the scale inherent in much of Bladen's art, but also its imaginative scope, which in turn is only partly indicated by the range of forms he employed. The whole trajectory of his career is fraught with deep grooves of mnemonic retention and synthesis. Indeed, one is struck by how patiently and distinctly Bladen articulated each of his successive ways of working. His

progress from provincial boy wonder to late-blooming avant-gardist seems to have been deliberately tortoise-paced. There were switchbacks and retrenchings but no detours. Fused together along the way were the familiar high-pitched spatial sensations of his youth in the Pacific Northwest, and of California where he lived as a young man, as well as the complementary dynamism he later discovered for himself in New York. In his twenties, while living and painting in San Francisco, he developed a unique latter-day symbolist vision inspired by Blake, Redon, and, especially for shocks of amber luminosity, Ryder. Using a palette knife to layer his colors and occasionally raking them back with a comb or stick, he was then depicting pale angelic figures set flatly on dark patches and played about by flares of light – images that, with their trailing twists of astral matter, would return to haunt the later work. By the time he turned thirty, he had pretty much subsumed such traces of figuration (though not of organic life) in the incantatory climate of his paint and was geared for a succession of increasingly radical abstract phases, which culminated – after he moved to New York nearly a decade later, in the mid 1950s – in the uncommonly dense surfaces of pictures like the one Goodwin admired.

In the past few years, since a cache of thirty-five canvases and panels was discovered in his studio behind a particleboard wall that Bladen built to conceal them from sight, a legend has grown about his New York pictures. It is probably true that he wanted to forget them, the better to concentrate on his identity as a sculptor. But some, at least, were regularly visible on the walls of his Twenty-first Street loft, while others surfaced sporadically in group shows. It is also true that, until their posthumous retrieval in 1988, the paintings received only cursory mention in the critical writing about Bladen's art.

During his life as a painter, Bladen rarely titled or signed his works and almost never dated them. Because of this – and because details of his early exhibition history are spotty at best – it is difficult to assign exact dates to most of the paintings. Reviews of the ten or so Bladen exhibitions held between 1946 and 1961 indicate the general look of his pictures from phase to phase, and a few contain telling descriptions of individual paintings that make those works recognizable today.

Happily, when it came to the impromptu descriptive styles of reviewers, Bladen had consistent luck of the draw. In the nature abstractions that made up his second (1951) San Francisco show, Lawrence Ferlinghetti found "a personalized beauty" and "a kind of reality glimpsed and just vanished over a horizon which itself no longer exists." Two other poet-critics, John Ashbery and James Schuyler, wrote brief but to-the-point notices of his first two New York shows, at the Brata Gallery in 1958 and 1960. Where Ashbery seemed edgily nonplussed by "swirling raked impasto masses whose interlocking speed is slowed by mounds of pigment placed on each form as a kind of highlight," Schuyler, in his turn, sighted "an original temperament and an emerging style." "They are Tenth Street maps of no place . . . On an earthy ground, spatula loads of yellow, black, blue, dark red, wander up the canvas, then turn, describing an inverted, weak-jointed 'L': a purposeful trail: here is the mail box, this way leads to the store . . ." What Schuyler provides here is an accurate portrayal of *Untitled No. 11*, later acquired by the Met.

Bladen was born in Vancouver, B.C., in 1918. Together with his sister and their British émigré parents, he spent his childhood in towns on either side of the U.S.–Canadian border. In a 1969 interview he told Corinne Robins, "Art for me started when I was ten years old [in Aberdeen, Washington] and made copies of Botticellis, Titians, Matisses, and Picassos. I did drawings of eyes, noses, and feet, and made many watercolors of personal fantasies and myths. I did my first social propaganda painting in 1929, entitled *The Strike*." By the time he reached high school, he was being hailed by the local art community as something of a prodigy. In 1931, before his thirteenth birthday, a show of his paintings and watercolors at the University of Oregon was arranged by an art teacher; the next year, having moved back to Victoria, B.C., he was included in the Modern Room of the Island Arts & Crafts Society annual, along with such senior Northwest Coast luminaries as Emily Carr, Max Maynard (with whom Bladen studied through most of his teens), and Jack Shadbolt.

In San Francisco during the early '40s, while working in shipyards and studying off and on at the California School of Fine Arts, he deep-

ened his interests in myth, symbolist poetry, and occult metaphysics. He read Baudelaire, admired Morris Graves and D. H. Lawrence, visited Henry Miller at Big Sur, listened hard to the new bebop music, and, through his poet friends, became familiar with Gnostic and theosophical texts. By 1946 he could say that his painting had "returned to the spirituality and mysticism of its beginnings." Throughout the '40s and '50s he was a "painter among poets," maintaining friendships with Kenneth Rexroth, Robert Duncan, Philip Lamantia, and, later, Michael McClure and Jack Kerouac. Another set of close friends included the philosophical-anarchist "foot soldiers" of the Libertarian Circle for which Rexroth acted as the catalyst.

Painting out of his soul required cultivating both artistic solitude and a few carefully chosen sources of inspiration that would confirm but not intrude upon his original search. While keeping his distance from the Bay Area painting scene in general, Bladen caught glimpses through Edward Corbett and others of the kind of abstraction then being advanced by Clyfford Still and Mark Rothko. Although he met neither Still nor Rothko (both of whom arrived at CSFA more than a year after Bladen stopped attending night classes) until much later in New York, Bladen credited their presence in San Francisco with influencing his eventual change to abstract painting. Even so, when his abstract pictures do resemble Still's, they seem to look back to the latter's convoluted, less-stringent images of the mid '40s, which Bladen saw at the time, rather than the "blistered slab" style that was the rage in San Francisco through the '50s when Bladen made his move.

The painter and critic Knute Stiles recalls that Bladen's improvisatory palette circa 1950 "ran to the earth tones: ochre, sienna, umber, sometimes Naples yellow . . . and white." Closely packed swirls and dabs of such colors suggested to Ferlinghetti "a texture world of arrested sunlight, caught and spread with a palette knife." There followed a number of evanescent paintings with sprawled, subtly smoothed-on forms in sheets of keyed-up (or, variously, dusky) hues. These spectral canvases, some done on flimsy muslin, represent perhaps Bladen's closest encounters with that ultimate site of symbolist improvisation, the Void; their forlorn fog-bank glows partake of the shadings

of unfocused, introspective feeling common to the "open form" mode in the years after Still and Rothko had left their marks on the local scene. In an unpublished memoir, Michael McClure tells of Bladen's proceeding in his mid-'50s oils (many of which have since disappeared) from "palpable, slim silhouettes in the air" to "biomorphic shapes on single background colors." He also recalls a trip to Slater Hot Springs (now Esalen) at Big Sur and seeing "Ronnie, bright-eyed and tousled in the very early morning out in a field, drawing with earth and water and leaves on large sheets of paper." Two of the resultant "earth drawings" were reproduced in the little magazine McClure and James Harmon edited in 1956, *Ark II/Moby I*.

In 1955, while sharing a communal house with a group of artists and poets that included the McClures, Bladen met Al Held, who had arrived from New York after having spent the first few years of the '50s in Paris. Impressed by the younger artist's "pigment paintings" – for which Held knifed bricklike patties of mostly dark, hand-mixed paints across the support – Bladen began upgrading the size and heft of his own pictures. The next year, when Held returned to New York, Bladen followed and soon lent his quiet, firm, though always somewhat anomalous voice to the "depersonalized esthetic" of presence and specific geometry he and Held, along with George Sugarman, came to share. What sparked him in such company, he said, was "commitment" of an order he had known before only among the San Francisco poets. Doubtless the more variegated and competitive Tenth Street ethos, which, as Held says, was "bubbling" at the time, gave his energies the necessary push to fructify themselves and find release in larger formats and bolder forms.

Bladen's first New York pictures contain broad, buttery hints of landscape: some suggest peninsular outcroppings seen from above, others plunge the eye into the midst of frontally bunched arabesques like undersea growths. A ruined canvas from around 1957 has gobs of paint so heavy that they caused the fabric to rip from the stretcher bar at the top; from then on, Bladen used only Masonite or plywood panels. His paint, too, increased in density. There was, he said, "less nature imagery, more realism in the paint itself . . . like fields of electricity."

In a windfall moment, he and Held acquired large sacks of powdered pigments discarded from the preparator's storage at the Museum of Modern Art. Over the next few years, they experimented with different ways of mixing and applying these and similar paints. At first, both had serious technical problems with flakings of brittle colors unfused with those below and, conversely, with bulbous masses still fluid behind the skin. Bladen eventually devised a way of blending the powders with small portions of stand oil; after letting the gritty mixture set overnight on a worktable, he would haul it with masonry trowels or lengths of two-by-fours and then knead or pound the colors to make them adhere to the panel. He told Irving Sandler: "I liked the strength that was in it . . . the heaviness. I also liked the blocky feeling you could get by just throwing it up there. I even hammered some of it on – it was so hard." So that the piled colors would bind together well, he took care to work them wet-on-wet in single sessions. Thus the final, lucent "mound" paintings, reductive in both color and shape, were painted very fast, starting at the top and finishing at the bottom, as he said, "like pulling down a window shade."

Perhaps because omitting landscape references didn't mean Bladen was giving up his feelings for the vitality of nature as such, the change freed him to make his most forceful paintings. Like many artists who arrived at grandly simplified imagery around the same time, Bladen reduced his forms to see what would insist. Pushing abstraction with fewer and more compressed elements, finally, was a way to make the revelatory glimmers he had been carrying around inside him appear commonsensical rather than fantastic. Goodwin speaks of Bladen's "uncanny ability to visualize in the most basic terms." It's as if his later paintings threw off the trimmings of cloud and leaf to get at a root language for the energies that went into forming such things. Oriented by gravity, shapes and distances turn at once blatantly tangible and galactically awesome, so that the scale of a single picture never settles in the mind as measurable in just one way: a black lump projecting from near the center of a brine-gray field might be somebody's big toe as much as the lunge of some primordial berm. No one before or since has made paintings quite like these. In some, one

could speak of a "patina": some blacks look charred and crumbly, others have an obsidian majesty.

Knotty as runes, Bladen's wildly canted mounds and the rough pavings that enclose them precipitate associations with any number of titanic forces. They plot the shifts in a geometry that has less to do with right angles than with the tangents, slumps and interstices of phenomenal physics. Their ostensibly simple schemes confront the viewer with figure-ground reversals and implausible asymmetries that make any perspective seem speculative. You can see readily where the paint has come to rest, but the perceptual properties of the image insist on multivalence. Snagged in the anaxial interchanges of field and object, forms get flipped.

The hybrid forms of Bladen's panels from 1958 to 1961 (right after which he produced further hybrids by way of painted wood relief constructions) strain at the boundaries of painting's traditional precincts. They are, in Thomas B. Hess's phrase about Bladen's sculptures, "famously overconstructed." Just as the sculptures' sleek façades hide inner thickets of trusses, struts, and weights that literally allow the outward icons to stand, the outermost colors of the paintings rest upon piles of other colors barely detectable but felt as pressures heaving the images into view. Instead of dickering with the rectangular layout of the support, Bladen let nodes and crests of pigment dip into the space beyond the panels' edges. The mounds themselves sometimes protrude as much as four inches amid stucco or frothlike surrounds. Thus, instead of constituting a plane, the clean edge support is just that – a convenient surface on which to hang masses of paint.

Building with color was the means Bladen shared with Held to move the picture forward into the viewer's space (though by the time Bladen was erecting his mounds, Held had switched to a different kind of frontality based on the inverse illusionism of overlapping geometric shapes). Loading chunk by slab and urging his color-and-texture balances every which way outward, Bladen tightened the bond of the image with its constituent muddy matter. Oddly, because you can see every layer and shove of paint, the handicraft of these paintings remains one of their deepest mysteries. Not that any of it looks acci-

dental, but the image of the paint's having come together by some ineluctable process – without touch or gesture – is dominant.

Sometime around 1960, discussing the extent to which his colors were advancing into the room, Bladen confided to George Sugarman, "I'm going to be a sculptor." Within three years, logic and a leaning toward greater objectivity dictated that his pieces fully enter actual space by detaching themselves from the wall, though, as he also said good-humoredly, "I fought all the way to stay on." The last paintings – especially those few that extend to mural-size dimensions – take whatever wall space they're given and keep calling for more. In them, spatial breadth becomes a kind of activity, an event rather than an effect. Such scale is combustive and leads to wonder – which may be the ultimate message of Bladen's work, a wonder analogous to the artist's foregone epiphanies in the world.

1991/1992

A Moment of the Psyche

According to the numerals the artist wrote in deep brown diagonally across the lower right of his picture, Jackson Pollock completed *Guardians of the Secret* in August 1943 during the surge of studio activity leading up to his first one-person show at Peggy Guggenheim's Art of This Century that fall. (Two years later, Grace Morley acquired the painting for the permanent collection of the San Francisco Museum of Modern Art, where it has since held pride of place.) At least two other pictures included in the Guggenheim show, *The She Wolf* and *Search for a Symbol*, are dated from the same month. Taken together, such paintings index a furor of headlong consolidation and brilliant flailing – at times so breathlessly aligned as to erase any distinction between the two – that constitutes the prime emergency in Pollock's first mature style.

Just past thirty, Pollock was then well into his phase of coordinating devices taken from the modern painters he admired (preeminently Picasso – whose bullish raids on pictorial convention Pollock was disposed to match – but also Miró, Klee, Matta, Siqueiros, Beckmann, and Matisse) with an instinct for recombinant mythic imagery, of which *Guardians of the Secret* can be read as both a concordance and an emptying out. *Guardians* was Pollock's largest painting to date. In retrospect, Pollock scholars tend to see in it a prediction of the allover abstract manner for which he's best known, and towards which the paintings of the next couple of years certainly would supply plentiful hints. But *Guardians* itself feels packed with several possible liberating futures, precious few of which hold promise for abstraction as a guiding principle.

When the painting appeared at Guggenheim's gallery that November, Clement Greenberg pointed up its uniqueness among Pollock's other "not so abstract abstractions": "The mud abounds in Pollock's larger works, and these, though the least consummated, are his most original and ambitious. Being young and full of energy, he takes orders he can't fill. In the large, audacious *Guardians of the Secret* he struggles between two slabs of inscribed mud (Pollock almost always

inscribes his purer colors); and space tautens but does not burst into a picture; nor is the mud quite transmuted. Both this painting and *Male and Female* (Pollock's titles are pretentious) zigzag between the intensity of the easel picture and the blandness of the mural."

Greenberg's citing of an untransmuted "mud" indicates the similar quality of dense, flat-out paint (though purged of muddy tendencies, it's true) that so defies a viewer's attempts to squint past the surfaces of Pollock's full-fledged abstractions, the drip paintings of 1947–50. *Guardians of the Secret* comprises a smorgasbordlike outlay of images created insistently spurt-by-spurt – oils smeared and squiggled, lathered and flicked in Pollock's then-customary method, a reliance on clot-stiffened brushes, brush handles, palette knives, and streamers of unmixed colors squeezed straight from the tube. Partly due to the conversely viselike grip of regulating symmetry (an atypical late-Gothic trap Pollock exploited only this once), most every element presses up on the surface. (There are close recesses in the grid work at the picture's sides where Pollock had a field day with obbligato passages of pure color.) Pollock advanced his airtight scheme as an imponderable among imagemaking genres: he was after, and nearly got, an icon of the unconscious as Freud described it, "another showplace."

Guardians of the Secret shows a moment of the psyche whose details kick into space as if at the stroke of some synaptic gong. Together with the title, the sheer prominence of the central panel would tell us the impetus comes from that interior spread where a few fish contend with other, weedy glyphs in an irradiated scrim reminiscent less of the sea than of an aquarium tank. Is it the unconscious portrayed as an inset sink? Or dream work on a platter? Although the skin of any painting can be adduced as a model of liminal event, the unconscious as chartable terrain would seem unavailable for depiction: the ostensible contents of inner flux – bits and pieces rather than the whole soup – are what art normally claims, by way of images, to divulge.

Distress, psychological and aesthetic, is at the center of Pollock's canvas – right where it should be. If the "secret" is, as Pollock's friend and biographer B. H. Friedman has suggested, Pollock himself, that secret is no secret. It could only be a velleity of psychic self-portrayal, a

purposely vague mock-up of how the self's inner flow chart might look if there were any pictorial access to it. Pollock's iconic spillway, rather than pulsing with inner vitality, in fact shrinks from life. This diminution may be what Greenberg had in mind when he said of the space in *Guardians* that it "does not burst into a picture." What this particular subdivision *does* do is effect a mediating space, a place of relative let-up for the real intensities clustered around it.

In the fitful tableau, two schematic figures stand or sit at either end of a pale rectangle scored in tube-drawn black with yellow and orange highlights. As the figures command the far sides of the canvas, so a large dog hunches prone, with ears perked, nearly filling the space along the bottom edge between them. This bulkily modeled profile hound makes for the most clearly focused detail of the painting, the main, squarish area of which builds upward in a sequence of neatly measured tiers. The dog's heavily outlined sidelong stare and specific implications of alarm set the mood. The spectator is designated as a possible intruder, unwelcome witness to nocturnal frenzy. The darkly mantled right-hand "guardian" seconds the mangy canine's look, emphatically frontal and wall-eyed in his blocky visor, while the one on the left, a female skeleton, shimmies, pitched legs-akimbo in dismay. A red dash connects her to the only legible utterance among Pollock's wayward handwritings, an enigmatic "of," tantalizingly articulated in white, letter-perfect Palmer-method script. Across the top, a set of hectic variations on totemic themes parades in a sort of galvanized barnyard register, each figure sprung in its slot and slapping at the upper perimeter of the frame.

What gives? The sensational rigmarole is impenetrable and compelling. Naturalistic human flesh is notably nowhere present. Instead, we get accoutrements: a mask, a flaccid skull, a ribcage, a brooch (but only orange and blue capillaries seem to hang there), bare outlines that say "breast" or "arm." Pollock's guardian figures appear as imposing, outsized puppets, shamanic vacancies draped over separately stabilizing grid-work rungs. Then, there are the eyes: the image greets the spectator with many eyes (or, here and there, empty elliptical sockets) – in all, nearly two dozen of them. This was, by the early 1940s, an

identifiably corny fantasist's trick for triggering self-reflectiveness at either end of the pictorial psychodrome.

A degree of corniness is something we have learned to assume about Pollock's art, as well as about the sadly "mythic" persona he came to inhabit. (In this excruciatingly unhip but fanatically resourceful artist, recourse to cliché may be seen as grabbing for a lifeline in an all-too-subjective morass.) Commentators have remarked on how Pollock took – and wasn't wholly taken in by – the loads of symbolical clichés made accessible to him through Jungian analysis and the researches of automatism, along with his own sincere ethnographical fascination with the imagery of Southwest and Northcoast American tribes. As Peter Schjeldahl says, such "fashionable commonplaces of the time's surrealist and psychoanalytic iconography . . . may have been exciting and liberating for Pollock, but that's neither here nor there in the paintings, where they function instrumentally and neutrally." Well, maybe not so neutrally. The symbols in *Guardians of the Secret* are neither standard textbook issue nor window dressing: they sustain properties too edgy to be bound by the iconology of any single cultural argument. Lawrence Alloway saw them as keeping to "that enigmatic center which it is the function of myth to preserve."

Actual vision would come from amidst the convulsive workings of Pollock's paint or not at all. What Elizabeth Frank calls "the interconversion of form" and Rosalind Krauss "an imagery which is conceived of as fundamentally unstable" amount to the same thing: a way of rendering the different aspects of symbolical figures as visible all at once. *Guardians* projects a hotbed of simultaneity, with the elements launched in its crucible on the edges of their isolate transformings. Hence, the seemingly "extra" touches lavished throughout (a dainty Haida lunar deity coils into a black embryonic beetle to which two swift strokes append a white beak); and hence, too, the look of demolition and hiding exemplified by the gray wash that has submerged however many parts of the painting's history.

"I choose to veil the image," Pollock said when Lee Krasner asked him why he didn't let his personages stay plainly identifiable. Pollock's romance of veiling conforms to a general rule: the more he blots – the

more tightly he bolts and shims his picture to the surface – the more revealing the surface becomes. The gist of *Guardians of the Secret*, as of much of Pollock's work from then on, is to put forth, instead of an iconography to be unraveled and defined, a charged surface whose circularity – from paint to visionary import, and back again to paint – defines its own nexus and our raveling, or ravishment, in the face of it. Pollock's question of choice, "Is this a painting?," was linked in his sensibility with the mind's embarrassed strainings after substance – material and fabulous, alike.

1992

What Piero Knew

"Nowadays the most popular fifteenth-century Italian artist is that enigmatic figure Piero della Francesca. There is something called the Piero della Francesca trail, and tens of thousands of people pursue it every summer, driving rapidly from place to place." So says John Pope-Hennessy in his memoir, *Learning to Look*, published in 1991. More than forty years earlier, Bernard Berenson wrote of "the mass admiration," dating back to the 1920s, for the better-known markers along the trail, Piero's fresco cycle on *The Legend of the True Cross* in Arezzo and the *Resurrection* in Sansepolcro. These were modernist discoveries. A century after his death, and until another 250 years had gone by, Piero was scarcely looked at. His historical rehabilitation began slowly, in the late 1840s, soon after that of Vermeer. By the first third of this century, he had emerged from being appreciated as a curiously affecting primitive to the ultimate in mandarin cool and stability, the perfect ghost of formalism-past.

As with Vermeer, the attraction to Piero as a cult figure – "enigmatic" is the operative word in that regard – continues. It's thought that Seurat and Cézanne were both impressed by copies of his works installed in the Paris Ecole des Beaux-Arts during the 1870s. Matisse pondered him; he was hailed more than once as "the first cubist"; for Philip Guston he was "like a visitor to the earth" whose pictures indicated no less than "the presence of a necessary and generous law." Yet he is everybody's secret: an artist with one niche in the canonical histories and quite another in the consciousness of those who, with or without scholarly or artistic credentials, confront him firsthand. The public appeal of his most telling pictures is paradoxically one-to-one – that's how he designed them to work and how the carefully staged flash of momentary life we see in them lingers. Though the scale of his art is Olympian, you don't think of him as sitting imposingly in the towering-genius mode, an honorific status that would never have occurred to him. (Granted that once, in passing, he wrote of a desire for perpetual fame.) The mildness Piero normally projects can be disquieting; the

world of his pictures is taut and never completely calm. His grand manner is of the contemplative, insinuating kind, and moves into your being by spells that read at length just so, as plainest fact.

There are more books in English on Piero than on any other artist between Giotto and Leonardo. The last two years alone marked the appearance of an armful of five – including a lecture by Pope-Hennessy himself, other original texts by Marilyn Aronberg Lavin, Ronald Lightbown, Albert Cook and Bruce Cole, and a seemingly rushed translation from the Italian of Carlo Bertelli's 1991 monograph – all timed to coincide with the quincentenary, in 1992, of the artist's death. (Beside these, there appeared also in 1991 a telling chapter on the history of Piero criticism in David Carrier's *Principles of Art History Writing*.) Italian contributions to the literature are of course no less voluminous; nor has any single study unseated Roberto Longhi's inaugural one, which in its first (1927) version lifted Piero's reputation out of the vagaries to which all but a very few historians had consigned it. For those fluent enough to follow the intricacies of that great scholar's peculiar idiom, Longhi's book in its final (1963) revision and Eugenio Battisti's catalogue raisonné, enlarged posthumously in 1992, are the basic literary sources.

None of Piero's images have the type of big-time demotic clout that generates T-shirt editions or parodies in the realm of kitsch. How many really are known and loved by a wide audience? Of the works that still exist – there are twenty-two reasonably attributed to the artist's hand, counting individual panel paintings and frescoes, polyptychs (more or less entire, or else cut into parts now scattered), and the majority of the Arezzo cycle – relatively few reside outside of Italy. Among those expatriated during the last 150 years, the *Baptism of Christ* and the *Nativity* in the National Gallery, London, Lisbon's *St. Augustine*, and the large *Hercules* fragment in Boston's Isabella Gardner Museum are major works. Toward one end of the Sala delle Udienze in the Ducal Palace at Urbino, the thick poplar panel of the *Flagellation* – frameless and bigger than you'd think from the color plates – sits cordoned off on a velvet-covered easel, properly below eye-level; hung on a near wall to the right, the scintillating *Sinigallia Madonna*, comparable to Vermeer's *Milkmaid*, like a tank. The *Resurrection* holds pride of place (intrinsi-

cally, because it was made there) in the former council hall, now part of the Museo Civico, of Sansepolcro. Inside the Uffizi, crowds vying for a good perspective on Uccello's battle painting back up against the free-standing vitrine encasing the Montefeltro diptych, then pass to the next gallery where the Botticellis prettify behind greenish bullet-proof glass. The phenomenon Pope-Hennessy has observed, of scads of "tourists in their rented Fiats" following the Piero trail, surely happens, but it is no breeze to complete the course in a single day. Having arrived from wherever, the typical sightseer spends half the morning in Arezzo, proceeds to Sansepolcro with a slight jog for Monterchi, breaks for lunch, and, reeling but still eager, zips along the Apennine switchbacks to Urbino. The truly serious will then plunge farther eastward for the Tempio Malatestiano, and the solitary fresco there, in dreary Rimini. You can do it all, as I did with a group from the American Academy in Rome, in three days, and feel you have merely blinked at the paintings, even if you concentrated on only those by Piero and leave the rest (Rosso Fiorentino, Signorelli, Cimabue, Pietro Lorenzetti, Uccello, Raphael, et alia), not to mention their surroundings, for another time.

An Umbrian friend of mine tells me that in Italy "Pieromania" is taken generally for a strange delirium to which English and Americans (and a few French poets, filmmakers, and theorists) are especially prone. Ambivalence notwithstanding, Italy does its part to cultivate and promote the strain, and not just for specialists or the foreign-tourist trade. A sample case was the "Piero 500" sequence of twelve exhibitions and three symposia held during 1991–93 in all the right places, those towns and cities of Tuscany, Umbria, and the Marches most closely associated with Piero and his work. Cumulatively, the shows, and the hefty set of catalogues accompanying them, went some lengths toward documenting the full range of Piero's culture, artistic and otherwise; his development and influence; his iconography; and the progress of conservators in analyzing and restoring the ever-compromised *True Cross* murals, the much-disturbed San Antonio altarpiece in Perugia, and the *Madonna del Parto* in Monterchi.

One such celebration, "Con Gli Occhi di Piero" (Through Piero's Eyes), in the lower church of San Francesco, Arezzo, offered tangible

present-day reconstructions of the sometimes unusual garments and jewelry with which Piero dressed his figures – "highly original concepts," claims the brochure, "that bring him very close to being a great designer of clothing and accessories." More to the point, because it involved looking hard at the paintings with (literally) fresh eyes, was the project engineered through the public-school district of Piero's hometown, Sansepolcro, for which schoolchildren of every grade made paintings, collages, tableaux vivants, poems, maps, formal analyses, and study charts based on their new-found familiarity with this local legend. A selection of these bright, and often awesomely witty, juvenilia was mounted in the backroom of the schoolhouse in Monterchi to which the *Madonna del Parto* had been removed for restoration. (By way of a nice touch, the process there of securing and cleaning the fresco – like Rembrandt's *Polish Rider*, a great and popular image of uncertain attribution – was open to public view.)

All in all, 1992 was a banner year for commemorations: the Shelley and Rossini bicentennials (both born in 1792); the two thousandth, five hundredth, and hundredth anniversaries, respectively, of the deaths of Horace, Lorenzo de Medici, and Walt Whitman; and the hundredth, too, of the Russian poet Marina Tsvetaeva's birth. October 12, 1492, may stick (both fair and foul) in the collective memory as the date of Columbus's fateful Bahamian landfall, but it is also by no small coincidence the one on which, as entered in a Sansepolcro necrology at the time, "M[aestro]. Pier dei Franceschi famoso pictore" was buried, in accordance with the will he had made five years earlier, in his family tomb within the church tower of the Camaldolite abbey.

As it happens, the day of Piero's death stands as the only intimate fact we know about him. Any record of his birth seems to have been lost; he never married, and there is no mention of his having fathered any children. As Marilyn Lavin says, "In the hundreds of pages of his own writings there is not one remark of a personal nature." Archival evidence of his professional and public life – new documents all the time, since scholars have become more assiduous in searching out such things – helps to pinpoint his whereabouts at particular times and some of his activities, including commissions for which documentation exists

although the actual works have disappeared. Only one of his surviving paintings, the 1451 fresco at Rimini of Sigismondo Malatesta with St. Sigismund, carries an undisputed date, so the chronology of his work is largely up for grabs. Every monograph differs on the order of his development, probable dates and attributions, and the relative importance of individual pictures. Then there is the constant fuss over iconographic sources and intentions, much of which must strike the average reader as farcical. (Highest ratings for a long-running series go to the hotly contested theorizings over the *Flagellation*, its subject matter and the identities of the mysterious threesome sprung to the fore of its kaleidoscopic spatial compound.)

But just when the iconology wars seem to succeed only in muddying the flow of discourse with heaps of recondite slag, one keeps catching sight of the healthy impulse behind them: Piero's is an art of complex meanings put forth with astonishing resolve, and the masses of footnotes that accrue do so incrementally with the need to articulate the amplitude sensed in the face of the pictures themselves, to ferret out every term by which they have been made, and to forestall complacency about ever fully comprehending them. The more unequivocally grand, the more clear of circumstance any one of them appears to be, the more we want to know about it, its circumstances and the purposes and circumstances of the person who made it – the better to be returned thereby to the work.

Piero was born sometime between 1413 and 1420 in Borgo San Sepolcro, an agricultural commune (pop. 4,397 by mid-century) in the northeasternmost pocket of central Tuscany. His mother, Romana di Perino, came from a merchant family in nearby Monterchi. His father, Benedetto dei Franceschi, was a storekeeper, listed successively in the town records as a tanner and a dealer in textiles and wool clothing. Benedetto was at least occasionally involved, as were Piero and his brothers, Marco and Antonio, in one of Borgo's major export trades, the production and marketing of *guado*, or woad, a cabbage that, when processed into cakes or powder, yielded an inexpensive blue dye comparable to indigo. The picture we get from the documents of Piero in his maturity is that of an astute, independent-minded, successful outland

painter – a "genius in the provinces," in Creighton Gilbert's phrase – engaged in further boosting the newly elevated intellectual prestige of his craft (including its claims to scientific probity, for which two of his theoretical books were prime assertions) while at the same time helping to consolidate his family's holdings and social position in the town. Whatever else may have gone on with him, he was an upstanding citizen who preferred, after the itinerant years of his twenties and thirties, to stay pretty much close to home. Aside from executing, in his distinctly slow and careful way, a steady run of commissions for paintings in and out of Sansepolcro proper, he served three terms as an elected member of the People's Council and, in later life, headed the Confraternity of San Bartolomeo, locally the most powerful laymen's religious organization. There, too, he proved himself at least once a competent architect: with touches that draw on his experiences at the court of Urbino, the house he redesigned in middle age for his brothers' families and himself stands as perhaps the first in Borgo of Renaissance-style detailing and construction. (Restored as the "Casa di Piero," it is now a study center devoted to his memory.) About the time he moved into his new quarters there, in his early sixties, he was put in charge of rebuilding the town's fortifications.

The goiter at the throat of one figure traditionally held to be a self-portrait – the soldier facing us, asleep, with his head thrown back, in the *Resurrection* – indicates a hypothyroid condition (with resultant slow metabolism) due to the iodine deficiency in Borgo's water supply. Vasari claims that Piero lived well into his eighties. He reputedly died rich. It also may be that in the last years of his life he went blind – Lightbown suggests that this happened suddenly, from glaucoma. Nearly sixty years after Piero died, a street-lantern maker named Marco di Longaro recorded that as a small child he used to lead the old, blind painter around town by the hand.

Such bare facts and/or surmises throw no light on what personal elements could possibly have fueled the lucent truth and turned-out vision of the pictures. Vasari's account of Piero as a mathematical prodigy who switched at age fifteen to follow a painting career seems little help either, or at best a half-truth. It's just as likely that these complementary aptitudes developed apace of each other, at least after a certain point –

that, having been given the thorough grounding in mercantile arithmetic, geometry, and accounting (along with vernacular literature and Latin) appropriate to a boy of his social background, he found his computational skills increasingly applicable as the arrangements of his painting became more regularly identified with schemes that were abstractly derived. As it turned out, his contributions to mathematics and to painting were just about equal; the inscription on his commemorative portrait names him as the great "amplificatory" of both, though for the dark years when his paintings went unnoticed his fame rested mainly on the former.

In terms of the progress of Renaissance styles, Piero can be seen as coming "almost out of the blue," as Berenson said, and disappearing right back into it. He was a border artist in more senses than one. Just how and when he began as a painter is unclear, but he appears to have trained in his teens under Antonio d'Anghiari, a regional journeyman who specialized in heraldic banner painting. Piero's earliest known works, those panels of the Misericordia altarpiece completed by the end of the 1440s, show a familiarity with the latest Florentine-driven inventions – particularly the light-and-space concretions of the slightly older Domenico Veneziano, with whom he had worked at least by 1439 in Florence, and, perhaps through him, Masaccio and Fra Angelico – as well as with Sassetta and others of the antithetical Sienese "resistance" who provided much of Sansepolcro's painting culture until Piero himself came along. It's intriguing to suppose that Piero accompanied Domenico in Perugia in 1437–8 while Fra Angelico was at work on an altarpiece for that town and while, in Siena, Sassetta had begun his double-sided polyptych for the Franciscans of Sansepolcro. A feeling for such simultaneous artistic cross vectors – most of them outside Florence – is necessary for an understanding of how Piero figured within the context of heady quattrocento individualism, but it won't explain his hold.

It's right that Piero should be understood as somewhat anomalous, outside the march of events – neither a beginning like Giotto nor a culmination like Michelangelo, and not a transitional innovator either, like Masaccio. Instead of a revolutionary surge, you feel in him a successive accumulation of faculties that, at every juncture, pause to consider among themselves with speculative amazement how perfectly they

were meant for each other. On his rounds he picked up assorted bits of contemporary art without pledging himself to any single competitive urban style. His copybook, assuming he kept one, would be compendious, a marvel to inspect: if one is to believe his commentators, it would contain sketches and recollections of Giotto, Cavallini, Ravenna mosaics, Rogier Van der Weyden, Jan Van Eyck, Donatello, Agostino di Duccio, Alberti, Jacopo Bellini, Pisanello, Etruscan and/or Roman murals and statuary, and more. Longhi, who enjoyed pointing to Piero's "archaic" or "Egyptian" traits, once speculated that he might even have seen Chinese scroll paintings in the Vatican. He also served just about every kind of client there was: princes (the enlightened samurai despot Federico da Montefeltro and his rival, Sigismondo Malatesta), bourgeois councils and confraternities, individual private patrons, Pope Pius II, and diverse religious orders. (The Gardner *Hercules* he made for himself, and the late *Nativity* for a relative's family altar.) Like his figures with their characteristic rural chunkiness and tooth, his sensibility feels permanently pitched on some vibrant edge, a threshold where the necessary elements have been prepared to be seized and combined for a more philosophically enriched type of substance. He carried with him a wholeness and humanist ground residual from the early trecento into the amplified spatial aspirations and questionings of the 1400s. Fused eventually with these would be aspects of Flemish realism, an innovative tonal harmony, and an original bent for stunning sweeps of light. He absorbed and tempered the novel Northern rage for verisimilitude (in landscape, especially) along with his Tuscan predecessors' bedazzlement over linear perspective. For the latter he showed a conceptual brilliance matched by a commitment amounting to a profession of faith and produced the first treatise on the subject by a painter as such. He arrived at color as light, and light as binder similar to the integrating gold-leaf grounds in medieval painting. Space, on the other hand, he contrived as a massive diffusion of surface. Fixity and fluid, spanning light are his specialties, with all the incidentals spread to view in kinds of freeze-frame. In the archetypal images of his middle and later years, these make for a wide intensification, a rightness, with feelings of containment and grandeur elicited as phases of the same focal charge.

What Piero created was not a style, though, typically, his assistants and few imitators tried to reduce it to one. Some of them came close to his "look" but nowhere near his peculiar, thoroughgoing exaltation. When his contemporaries were tending toward fripperies of excess description or radically convulsive dramatic effects, Piero steered firmly away, aloof from both. (He developed along with one demon dramatizer, Andrea del Castagno, whom he would have known, and preceded another, Luca Signorelli, who was his prize pupil.) His holding back from too-overt characterization (even in straight portraiture, where the likenesses are often erected flatly in profile) resulted obversely in a gain of overall specificity for the pictorial moment, which included its none-too-strict but, as Vasari would say, "divinely measured" gridlike underpinnings.

His images were intended mostly for people who knew their culture from the ground up. He had only to set the characters in their places – and in full view – for the communal mind to ante up its knowledge of the roles depicted. The pictures adequately expressed their conventional meanings but augmented or subtracted from convention in ways that may have puzzled some of the contemporary audience. Piero was given to painting rare subjects, and even for those his iconography is oddly encrypted or else makes unexpected leaps. Beside supplying an image of godly suffering as somehow analogous to current events, the *Flagellation* is an emblem, possibly a critique, of administrative ethics: from the conferees in the piazza to Pilate's stupor and Christ's commiserating glance, policymaking is the theme, if not what the whole thing is about.

A professor of theology once described to me how, as a seminarian, he was taught to meditate: by imagining Piero della Francesca's "resurrection" one detail at a time, beginning with the foot of the sleeping centurion and working his way up to Christ's face, in intervals of time marked off by the ringing of a bell.
— Judith Thurman, "Sad but True"

With whatever combination of reasons, devotional, esthetic, or, optimally, both, Piero's admirers hold his works to be sacred objects. People savor them as flawless in their way, especially in reproduction, often without considering the objects themselves in their physical conditions. "Mere wrecks" is how James Dennistoun, the chronicler of dynastic Urbino court life, described the *True Cross* frescoes covering the choir walls at San Francesco, Arezzo, in 1851. Today they appear in better shape than Dennistoun's sorrowful verdict suggests, but that's not to say their physiques have improved with age or the various pamperings, some helpful and none apparently disastrous, at the hands of successive restorers' teams. Begun in 1985, and with no end yet in sight, the recent effort at analyzing and determining how best to conserve the Arezzo murals has turned up, beside the most thorough, technologically enhanced accounting so far of their actual states, evidence of Piero's work habits and resourcefulness. "Much experimentation," comments one conservator, standing on a narrow platform of the scaffolding that now takes up the whole left half of the choir. He points by turns to the several kinds of binding agents for pigments applied to the plaster both damp and dry, then to spots from the wet rags the artist laid on an area of one register at the end of a *giornata* to keep it workable for the next day. Hearing of the long sequence of indignities, natural and otherwise, to which the frescoes have been exposed, you are apt to feel grateful that anything of them remains at all. Typically heavy damage from earthquakes and fluvial slippage – the spread of salt solutions from water leaks slowly eroding the surface layers, and their colors with them, from behind – is evident at almost every level on all sides. Discolorations have been produced at different times by dust (risen off the old brick floor of the barnlike, aisleless preaching church) and, from the not-so-distant coal-burning days, soot. Large sections of the right-hand wall fell away due to the weight of an erstwhile sixteenth-century clock tower addition, as well as from a 1785 thunderclap. Low on the left, the combatants' faces in *The Defeat of Chosroes* show the marks from bayonets and musket balls inflicted by idle troopers of the Napoleonic occupation force bivouacked in the church in 1799–1800. There are also occasional graffiti (a horse in the *Chosroes* scene bears the

tag of "Giuseppe Saachi 1761"), oxidation, and much flaking of the artist's favored blues.

Postcards and antiquarian researches aside, the present physical states of art objects are palpably what those works have come to be: we can see them only as they are and so our appreciation of them is contingent. The abiding physicality of Piero's surfaces makes this caveat in his case all the more poignant. He was the fresco painter par excellence – no other artist in that medium has his crispness. The sparkling, powdery, wall-emitted colors at Arezzo are nearly impossible to photograph. (The best postcards are the old ones, still sold in the sacristy, in black and white.) There's always the chance that, as with a lot of antique art, wreckage has added to the pictures' mystique. Have Piero's colors become even more beautiful with age? Probably not, judging from some of the trial cleanings at San Francesco, by which a dull red is disclosed as piercing violet or radiant orange and the many whites (among them, areas, such as that of the annunciate angel's wing, of almost untouched plaster) have been returned refreshed to brilliance.

As it is, whole works – other frescoes done in Sansepolcro, Ferrara, Florence, and the Vatican – have been destroyed, and significant parts of remaining panel paintings hacked away. There's a huge Pieran inventory of cracklings and abrasions; cracked boards and wormhole hollowings; scalings off, oxidizings (greens gone to brown or black), and other chemical shifts; in- and overpainting and structural interpolations and deletions by restorers and less scrupulous antiquaries. It's a rare item that has escaped some kind of abuse, even just the inevitable disruption caused by ecclesiastical placement and function. In the Duomo at Arezzo, the *Magdalene* fresco appears superbly intact but for a large splotch disfiguring the porch beneath her, thanks to repeated splashing from a holy water font. Despite losses in the landscape, the tones of the *Resurrection*, altered under whitewash sometime before 1700, retain their fabled, softly trumpeting, aerated glow.

Fresco was Piero's ideal medium. He was a practiced master in the plain, professional sense. His perspective theory is expounded in the most outright practical prose. He fortified an already well-refined tempera-on-wood tradition and was one of the first Italians to work dis-

tinctively with oils, but it's on his gift for transfiguring a porous face of
tinted plaster (with pigments locked upon drying in a layer of recrystal-
lized lime) that the inner life of many of his best paintings depends. It's
in fresco that objects best appear, as Adrian Stokes says they can, as "self-
lit in virtue of their color, as if breathing." The nutty mirage of a blunt,
implacable, front-and-center Christ hoisted lithely free of death could
happen only in that medium so communicative at once of breathy forms
and supravisible powers. True (or *buon*) fresco is, or should be, in the-
ory, as durable as the wall it's part of, and yet its colors are truly only skin
deep, a gauzelike veil. (It can in fact be peeled away, as the *Sigismondo*
fresco has been, and transferred to canvas.) The notion of evanescence
implied has been beautifully rendered in the time-lapse sequence in
Federico Fellini's *Roma* where modern urban blight, whooshing
through the drill hole in an ancient subterranean wall, causes the murals
of a Roman domus to evaporate in a matter of seconds.

*Classicism: a brief, perfectly balanced instant of complete possession
of forms; not a slow and monotonous application of "rules," but a
pure, quick delight, like the acme of the Greeks, so delicate that the
pointer of the scale scarcely trembles.*
> – Henri Focillon, *The Life of Forms*

That classiest of classical poses – just standing there, in a confident
enough manner, which is what most of Piero's people do – sends a clear
signal that something "pure, quick," and purposely beyond individua-
tion is at hand. It's not for lack of emotion that the figures hold their
breath and refuse to kick over into dynamic postures: a torque of upper
lip (as if speech were suddenly halted or about to begin) or fingers artic-
ulated as a tension where an attendant folds his arms across his chest is
enough to animate a scene; and there's the standard semaphore of arms
thrown wide, showing amazement or grief.

Succinctness, a delicacy sustained in large scale, is part of what
makes Piero so compelling. It likewise makes the hyperboles by which
his critics seek, as they must, to explain their fascination with him seem

ever intrusive and wrong. Piero is a classic artist – but *classicism*, or any clear advancing of that term without rank self-consciousness or nostalgia, is painfully beyond the reach of this epoch's critical vocabulary. Any artist nowadays who invokes it – from time to time, David Salle has been a case in point – risks being shunned as "merely" arrogant. As it happens, for its direct association with other words like "noble" and "selfless," and even more directly with its etymological parent, "class," the word is politically nervous-making; as a byword for artistic excellence, it can be an overbearing nag. Only a simpleton would proclaim an investment in its values without first making sure of the required rhetorical armor. By dint of generational crusts and cave-ins affecting every basis of faith, we have come far from the root language in which something akin to "classicism" as Focillon envisions it forms part of the agenda for any culture that regards the world's intelligibility as valuable in itself. Crowe and Cavacaselle's "elaborate certainty," applied in the 1860s to Piero's pictures, and Guston's argument, no less true, that "a certain anxiety persists" in them are separated by an abyss.

Among scholars writing currently on Piero's work, Marilyn Lavin stands out as clearest about his efficacy: the paintings, she writes, "are like acts of charity, and more: they contribute to the general good . . ." Align that "good" with the "generous law" Guston detected in the *Flagellation* and you get a fair estimate of what Piero's vision entails: a conception of – if not exactly a better, more beautiful life – a better, more comprehensive view of the terms by which life on earth can be contemplated. This providential attitude is pervasive. Longhi compares the propitiating air in which Piero casts his saints and dignitaries with the "grim, blind space trodden . . . by Masaccio's men." In the processional scenes at Arezzo, where contemporary types assuming storybook roles beckon with their rangy scale, beatitude and secular good manners become look-alikes. A spiritual glamour extends from the features of people and architecture to gather up assorted details and offer a closer sense of them.

The balance of matter is a continual demarcation. Instead of looming oppressively, the above-life-size personages of Christian myth are geared to draw us to their level without ever really making contact.

(Note how the strangely accurate, walnut-contoured eyes are usually directed at something off-center and away, some distance past our heads, or else lowered askance, closed off as pictures of thought; scanning the facial expressions, you can feel parallel consciousness moving with the flick of an eyelid.) These columnar presences – watching, listening, awake to the gravitational verities at their feet – exhibit above all a deep receptivity. It's within Piero's power to project this receptivity onto his ideal viewer, who indeed "gazes," not rapt, but emphatically alert to the viewing distance. One way to participate in the measures of Piero's world is to imagine a place for yourself against the milky azurites of its skies and, within the absolute revelation of its light, to select your fate. An alternative would be to simply attend to the image and its textures – both the *Resurrection* and the *Baptism* appear plotted for such an approach – to see them plain, with the extra hope of rising to the occasion, getting to heaven in kind.

Piero had virtually no immediate followers. In the Uffizi and elsewhere you can watch the wholesome sensation made explicit in the forty-odd years of his imagemaking career devolving piecemeal in the entertainments and imperious dynamisms of most sixteenth-century Italian art. Its legacy persisted in and out of Italy as an ideal to be grasped (in Giorgione and Brueghel, for instance) spottily, at rare intervals. Stokes gives the clue to an almost surreptitious continuity by locating Piero at the head of a line that, within the confines of European painting, leads next to Vermeer and, after refurbishings by Chardin, takes a sharp hook with Cézanne. This core faculty makes a lineage of orientation to the phenomenal world as visibly positive – the fleeting glimpse nailed down in ineluctable dabs of paint.

The plot thickens when you realize that only Cézanne, of the later painters, could have known even facsimiles of Piero's work. Vermeer's passion for optics matches Piero's for mathematical relations and perspective. Like Piero, he made a business as a painter of meticulously conceived and executed pictures. Chardin, ambitious for glory on a par with the history painters, monumentalized genre painting and deepened its tones to a sometimes unearthly, warm glow; he invented the good taste of French color in ways similar to Piero's chromatic inven-

tions. Posthumously, in the nineteenth century, he was liberally compared to Vermeer, whose work he never saw. Cézanne admired his precision and feeling. De Kooning describes Cézanne's worldview as "trembling, but very precisely." Ordinarily, the shaky Cézanne's induction into the intensified Empyrean of Piero and Vermeer would seem something less than a sure bet. But the very word "sensation" in this context comes straight from Cézanne. His "little sensation" was realized, he said, in the presence of his motif and with a conscious preference for the solid, enduring art of the museums, of which, at the time, Piero's had become exemplary. Cézanne, as it were, grasped the slippage of that solidity in the face of another, close-to-the-bone perceptual truth. He searched out the contours of intermittence and made them stick. He let the noise of phenomenology into still life.

The basis of still-life painting – it's often noted that even Piero's battle scenes smack of things scrutinized in repose – is silence. *La vie silencieuse* was the indigenous French term in Chardin's time. "How do we know," de Kooning once asked, "that everything is really not still, and only starts moving when we begin to look at it?" In Piero, the world laid out as abruptly fixed in light and air appears so imaginatively stabilized that you can't help feeling it might explode in an instant. This stillness is provisional, like the conception of a sentence as a complete thought; it recalls Samuel Beckett's idea of "the interior of a stone one thousandth of a second before it disintegrates."

It isn't "Cubism" that makes Cézanne and Piero members of the same sodality – but the recognition that painting, whatever else it does among its plausible fictions, is committed to revealing terms and degrees of visibility. Stokes called this "the compulsion to make manifest"; we have from Piero, he said, "a fullness without boast" in consequence of "the separateness of ordered, outer things." With those terms in mind, it's easy to see how certain of Piero's pictures have come to stand, for Stokes and others since, as suitable approximations of the pictorially ideal. After Cézanne, as Piero's fame accumulated, the offshoots were mostly "little masters" like Morandi and bizarre interlopers like Balthus. The legacy also suited the counter-modernist taste of sundry neo-classicisms. (In America, starting from the 1890s, it

became central to the Beaux-Arts mural manner disseminated from Puvis de Chavannes; later, in France and Italy during the '20s and '30s, Piero was revered by the *rappel-a-l'ordre* set.) Thereafter, one reaches, like Longhi, for parallels and adjuncts in archaic art as well as in modern abstraction, and in those few contemporaries – as diverse as, say, Alex Katz and Sol LeWitt – who participate in the question of continuance. The pertinence of Piero right now might be calculated alongside the types of modestly proportioned, blithely unhedged abstract painting that have gotten more notice in the past few years, even though some of the practitioners broke in by the '70s. (I mean such artists as Ron Gorchov, Mary Heilmann, and Thomas Nozkowski in New York, and Dan Connally in Santa Barbara.)

But there is another connection. Matisse's break into the dimensions of mural painting with large, flatly declared colors followed upon his and his wife's first trip, accompanied by Gertrude and Leo Stein, to Italy, in 1907. Although the drawing in those pictures – especially *Bathers with a Turtle* (1908) and the two versions of *Le Luxe* (1907, 1907–8) – relates to Giotto, the scale and tonalities fructify, bearing Piero's stamp. (Matisse made regular outings in a chauffeured car from Fiesole to see the Giottos in Padua; but the one day he spent in Arezzo was, according to Walter Pach, "enough . . . to last a lifetime.") Pierre Schneider writes of Matisse's mythological phase as a signal effort to retrieve likenesses of primordial splendor, albeit under heavy erotic stress. Figured around the Mediterranean as Arcadia or the Golden Age, the old myth of origins is founded on the conception of earliest humanity thriving, so the story goes, on elemental nature: the byproducts of sunlight, gravity, and air. The autochthonous, probably matriarchal First People exist pleasantly attuned, untroubled by labor or strife, before terror and darkness set in. (Most modern versions of the type stand around or lounge naked on a riverbank or beach.) If for the recent past this notion gained the currency of, as Schneider says, "the only viable myth," it managed by being absolutely futuristic and without plot, a static afterimage of a future ultimately more desirable than any recorded past. "Ancient" happiness is happiness deferred. This is conceivably an ingrained, muted, or unspoken theme of most painting.

But it has a special application in Piero, in Cézanne and Matisse, and in even the last-ditch optimisms of abstract art. (It is Mondrian's "utopia" and the likely impetus behind Guston's "law" – but then, as one painter confided lately, out-and-out abstraction runs on optimism.) The later Matisse, after the dance pictures of 1909–10, could be said to have "lapsed" into depicting modern armchair comforts (voyages to exotic climes not excepted) as compensatory from the moment his fix on that undomesticated primal vision ran out.

The variety of existence Piero shows us in Arezzo is essentially ceremonial; the intimation there is that divine knowledge exists at every point nearly within reach. The scenography of the *True Cross* tracks a progress from loss (in the *Adamites*, the first natural death) to retrieval through grace – the grace of the Holy Wood, identified with perspective and proportion throughout. Structurally, such a redemptive projection has to remain strictly imaginative; it's on the horizon of remote possibility, not to be crossed over by any spectator. We only contemplate the view. Alberti's prescription for perspectival construction, "a distinct distance," might be the wall text for any number of Pieros. It's the crux of how his people keep their balance staunchly in the world we know, the world of contingencies, while retaining something recognizably from elsewhere.

Piero both was and wasn't an abstract artist; or, the process of abstraction was reversed in his method: his lifelike images arrive fledged from abstract figures – dodecahedra and the like – instead of reducing down to them. He himself wrote abstractly of painting as "a demonstration of surfaces and bodies." If Piero was born when we now think he was, he would have been about ten when Brunelleschi produced his famous vanishing-point image of the Baptistry in Florence. Brunelleschi discussed with his friend Paolo Toscanelli the relations of things in space, including what he called "sites and measurements" from Dante's *Commedia*. (As early as 1260, Roger Bacon had recommended that painters learn geometry so as "to make legible the spiritual sense.") Like mathematics as a whole to the Renaissance sensibility, perspective remained, as Jonathan Goldberg puts it, "an analogy – the best the mind can make – for the mystery of the relationship between

appearance and spiritual reality . . . between sight and vision." The painters of Piero's generation took to it as eminently speculative: nobody obeyed the rules; the sweet science was generative and unpredictable, both a quasi-new way to make believable images and a refitting of the world in the cosmological abstract, a device for showing how being has been organized by an artful god.

Last year I returned by myself to the choir of San Francesco to look at the frescoes not hidden by the conservators' scaffolding. One other person was in the choir, a man seated on the floor, his back against the scaffolding, muttering to himself. One hand bobbed in the air as if conducting a small orchestra. What was he up to? I followed his movements directed toward the painting on the lowest tier. He was counting, pointing one by one at the traffic of horses' hooves beneath the bright figures of Constantine and his cavalry. In this most-ruined of all the frescoes (about a quarter of the scene has fallen away with large bits of plaster) the tiny reedlike cross marks the center of what for the victorious soldiers must seem like a nonevent. (It's not Piero at his best – the foreground groups are unusually pinched – but pivotal within the overall scheme.) Except for the excitable type spurring his mount into action near the left edge, the lucky winners trot along dazedly in profile, watching the opposing pagan remnant scramble up the far shore. Painted in oil with azurite and white lead, under a sky spotted by layerings of saucer-perfect clouds, the luminous Tiber tells its insouciant tale: a mother swan and two cygnets (all white, in front of a possible third, diving) command the stream as three stucco houses and two tall trees line up, each distinguished by just a shade from its reflection.

It's as if Piero's conceptual rigor freed up the "mind" of his art, allowing an extraordinary amplitude to occur. Here, even in the simplest arithmetic, the thought of Piero as a mathematician of genius comes clear as integral to his poetry – to the everywhere vibrant stasis from which his pictures sing out.

1993

As Ever, de Kooning

By the time "Willem de Kooning: the Late Paintings, the '80s" began its inaugural run at the San Francisco Museum of Modern Art last October, rumors of the circumstances besetting de Kooning himself, as well as, by implication, anything he produced since 1980, were swarming preemptively between the public and the works on the walls. Nothing, it seemed, could dispel them totally: not optimal viewing conditions, which at SFMOMA included opening the skylights of the fourth-floor galleries for the first time so as to greet the paintings, done by daylight in the artist's East Hampton studio, with great washes of California sunshine; not the pictures themselves, many of them glowing with the same urgent, sometimes involuted, often maddening pictorial fullness that has long been basic to our sense of de Kooning's art; not even the carefully orchestrated catalogue essays by Gary Garrels and Robert Storr, both of whom give eminently lucid accounts of those pictures and the conditions under which de Kooning made them. (Garrels curated the show, and Storr joined in researching it.) True, de Kooning's circumstances formed, as ever during his career, part of his art, and vice versa. But, as the exhibition makes its rounds (to Minneapolis, Bonn, and Rotterdam, and finally to New York, where it opens this month at the Museum of Modern Art), seeing the paintings as things this endlessly particularizing artist made out of his own intentions continues to be compromised by the urge, fueled by piles of misinformation, to take them as autographic specimens of a pathology. Despite Garrels's caution that the "aim of this exhibition is not to attempt a diagnosis of de Kooning's illness by using the paintings as a chronological index of its development," that is just how many people have approached it.

Tragicomic implications – mixed extremes of the calamitous, the jubilant and the nearly (yet never merely) silly – are rife in the fact of this show. De Kooning is ill – no one knows exactly of what his illness consists (although the symptoms of some type of senile dementia are said to be plain). He turned ninety-two this past April. He stopped

painting early in 1990, one year after he was diagnosed as having Alzheimer's disease. (Technically, the enzyme deficiency known as "Alzheimer's" can be diagnosed with certainty only by a post-mortem microscopic study of brain matter; cognitive failure of the kind de Kooning has suffered can be ascribed to other kinds of neurological impairment.) The cut-off date for Garrels's selection is 1987, which forces a distinction between "late" paintings and "final" ones, the latter being roughly anything done after the show's 1987 terminus. During 1987, Garrels says, "it seems certain that de Kooning's health took a downturn, that he could sustain the energy to paint for shorter periods of time, and that his ability to concentrate was weakening," with the result that, in his pictures from the time, "formal tautness and overall composition begin to disappear."

Given that the man himself is still alive, the obligation to write of de Kooning the painter in the past tense takes some getting used to. Try picturing, without slipping all over the absurdity involved, the scene in which de Kooning, as they say, "laid down his brushes for good," or, as Storr more plausibly has it, "drifted away" from them. One of Storr's paragraphs begins, "De Kooning was a classical painter in an anti-classical age," and with that "was" both de Kooning and the classicism he carried with him ride off to an antiquity more ancestrally pristine and remote for being little more than a half a decade gone by. This is the same de Kooning who only instants ago stood as the last artist of consequence in the history of Western art to matter solely as a painter, and who (given also his isolation and the legendary decrepitude of his metier) therefore had positioned himself so perfectly out of it that the greatest living painter was *all* he was. The '80s paintings either create their own historical moment or are negligible. Museologically, those are the stakes. De Kooning and his paintings – alongside anyone engaged with them as ample visual artifacts in a fabulously sustained perceptual present – could care less.

The tragicomedy of de Kooning's late years plays best if we grant its central character to bear the aspect of an elder artist from whose creative life every hindrance, save the indignities of aging itself, had been, however briefly, removed. By 1980, with the demon alcohol out of the

picture and the common distractions of daily life reduced to a minimum (thanks mainly to regimens imposed by Elaine de Kooning from 1978 until her death in 1989), the then seventy-six-year-old de Kooning found himself, his remaining energies and brilliance, at his own, or more pointedly, his art's, disposal. This scenario, the happy one of a man in old age having come through to enjoy for himself the mastery he had struggled after, and then with, and finally to revel in it with combined singsong bemusement and intrepid joy, needs only minor qualifying to ring true. A man of roving cultural curiosity, de Kooning had been a great reader whose deft critical remarks were the stuff of anecdote. But in 1980, when asked if he had been reading much lately, de Kooning told me, as if surprised at the path down which his resolve had taken him, "No, I get up and paint all day, and when I get tired I take a drawing pad and watch television while I draw." To such Parnassian confinement are owed both the impression of aimless if dapper tinkering that is the low end of the late work and the flashes of uncorked grandeur that obtain when the tinkerings transmute, as they so often do, cumulatively.

The layout at SFMOMA was superb: eight galleries – enough running feet for any significant artist's mid-career retrospective – with thirty-five sizeable paintings representing seven years' work. Of those thirty-five I counted twenty that add to this world some aspect or edge – awesome, ennobling, hilarious, or just plain beautiful – that would be otherwise distinctly missed now that it has been experienced. And these occur in a selection proposed as not at all definitive. Apparently, de Kooning did some 340 paintings in the 1980s, well over three-quarters of them during the show's time frame. Garrels tended his selection so as to clarify the work in groupings, both by years and by types of imagery. His choices are explorative, "selected both for their individual character and as they begin to suggest comparisons and contrasts when seen together."

The pictures are elementary. None of them look mechanical, or even just routinely interesting. Some of the best are the funniest, with a playfulness at once affectionate and sharp. (For perfection in this category, seek out *Untitled III*, 1982, a succulent, foursquare fable, in one

quadrant of which preens, half-formed and evil of regard, a bruised-citron duck.) The lesser, unappealing works, bizarre as they mostly are, won't be dismissed routinely, either; at the very least, they show what happens to fragile equipoise when the master's hand bears down a tad too hard (in *Untitled XV*, 1982, greasily contoured monotonies and a sluggishness where they join) or not hard enough (nonplussing Aeolian wisps in *Untitled XV*, 1983).

Painting of the type that de Kooning professed and carried forward implies a fictive body spread out parallel to one's own, a body that, for de Kooning, appears ever, inextricably between formal existences, caught up with what he called "the metamorphosis of passing things." "The surface of it is a metaphor," he once said. In their rudimentary fashion, the 1980s paintings are surfaces with images in them, and, in ways that de Kooning made typical, the images, partly by being wildly unresolvable according to the discriminating logic of their contours, bring you back to the paint. This circularity holds even when, as in the majority of works from 1982 on, there's less paint left to come back to. By 1982, paint and image are more bound up with each other than they were in the blearier stretches of de Kooning's 1970s works, where they were somewhat pried apart. Writing in *Art in America* about paintings done mostly a year earlier, in 1981, Lawrence Campbell caught the advent of "something new" as it was developing: de Kooning, he wrote, "has brought back some of the gentleness which he banished more than forty years ago. There is a new feeling of breath and decision. The colors are lyrical."

In general, these ingeniously ventilated, mass-declaring '80s pictures ride on nuance as never before. Nuance forms part of their decisiveness. Allowing for a small number of one-shot items that evade even the simplest developmental scheme, some of Garrels's gallery groupings suggest sequences from an illuminated medieval calendar or book of hours. You turn from a tall canvas ripe with shocks of summer yellow to an array of blue skaters' marks slung across shadowy January ice, and to either side, autumnal dawns and otherworldly sunsets, their blush-effects of red and/or yellow tints suffusing omnifarious white. Parts defined by scraping with a spackling knife sit in an abraded

splendor similar to the "jewel-like haze" Edwin Denby remarked in de Koonings of the early '40s. Then there are places where an especially solid, shapely paint mass (a deep red, ordinarily) looks to have landed and smoothed itself out without any intervening handiwork.

Whether soft- or hard-focus, regardless of how gestureless some of the passages appear, there's the fairly constant sense that the paintings were, as one enthusiast said, "made by arms." Thus, people when they talk in front of one of them tend knowingly to mime at arm's length, with a swash from the shoulder or a lilt of the hand, not just the directional orders or the corkscrew structure of the whole but the way the paint feels or tells about itself in application. The sometimes riotous liberality of pictorial invention that prompts viewers to such charades can range from what properly might be called "show painting" (de Kooning in his bravura Houdini mode, playing out intimate interstices, combinations of lariat loops, labyrinthine entanglements, and flatly stated arabesques) to a lavish perspicuity communicable of a state of bliss. In *Untitled III*, 1983, the coalescence of feathery, suspended stuff is both slow and sly. Tab A (a white lobe) does not slip readily into Slot A (a gully of greenish blur) but meets resistance, a requisite friction fundamental to even the most relaxed-looking of the late works. Resistance is what builds the charge of a de Kooning. As the artist says on the soundtrack of one of the films of him at work in the early '80s, "It's a necessary evil to get into the work, and pretty marvelous to be able to get out of it." The physical comedy involved suggests the sort of pragmatic ravelings under sublime duress practiced by Buster Keaton, de Kooning's peer in the sight-gag department. (Then again, even as you watch the painter disporting himself, flipping through his repertoire of gists and embellishments, there's a melancholy strain, like Emmett Kelly sweeping the moon across sawdust.)

Not until the early 1980s does anything like the full range of imagery unleashed over the previous twenty years in de Kooning's drawings enter the world of his paintings. In the '60s de Kooning recharged his art by drawing with his eyes closed or else using his other, left, hand to undercut his facility. The drawings, he said, began "often . . . by the feet but more often by the center of the body in the middle

of the page" – that is, with a feeling for the bottom, the base, or for the solar plexus. The explicit figures in the '60s drawings include sinister little men with hats, frenzied divas, and even a few ripple-edged, witty, but nonetheless wrenching, crucifixions. The '80s figurations, many of them extrapolated from those and other drawings both early and late, present themselves almost entirely by innuendo. The familiar body parts extrude in odd unisons, congeries of synergistic matter close-up in scale (like of nuzzled joints) or so abstracted as to appear cartographic (whole continents kicked adrift in *Untitled XIII*, 1985). It's here that de Kooning's love of the bold, jazzy, rounded forms, abbreviations, and generally wacky assuredness of the American cartoonists comes clear: George Herriman, the Disney and Warners animators, Billy ("Barney Google") DeBeck, all are there, but so are Tom and Jerry, Tweety and Sylvester, and the Flintstones. Further, in place of finalizing signatures, notably absent from all but two of the paintings in the show, de Kooning seems to have signed off on some canvases at the top with skittering, tube-drawn glyphs – a curliqued airplane snout in one, an upside-down word balloon in another.

Drawing in the late paintings (de Kooning did no more drawings on paper after 1983) includes the compensatory stratagem of rendering graphically, almost as an object, the look of de Kooning's fabled slapped-on brushstrokes, as if his style had finally become a matter of interest to him as something "out there," in the world. If de Kooning succeeded in making his touch transparent by smoothing it away, at the same time, and by way of a reversal, his scraper tracks and brushed-in "ribbons" of bright color reproduce uncannily, in enlargement, the long, thick charcoal traceries of the drawings.

But what is most insistently present is white, the ultimate locus of de Kooning's renegade sensuality. White, when posited as a color rather than as a colorless ground, is always forward. Among the whites here are deep mists and dry glares, finely shaded alabaster membranes and swansdown plumage, brimming creams, spumes, and the taffylike laminates and florid glosses that result from loading tube colors with excess varnish. There are areas as literal as bone or plain white enamel on the side of a clapboard house. White works editorially – obliterat-

ing, by 1984 and '85, as Storr says, "all but the skeleton of de Kooning's original compositions" – or elsewhere as a solvent or tissue within which other, lumped-together devices are held. *Untitled III*, 1983, has five or six whites in it, all of which function and weigh in differently. On the whole, where white occurs unmodified it is sheer, taut surface, not atmosphere. In a "white" de Kooning, as in Mondrian, the point is to bring every other color up to white's pitch of visibility. Thus exposed, the simple rule of painting's surface reads like so: if you can't see it, either it isn't, or you aren't, there. Rather than the pallid oblivion some have found in de Kooning's whitenesses, what flows in them, as I see it, is ceaseless, effulgent memory, or a flickering coefficient thereof.

Old men sum up, or so the story goes, and the impulse toward summation in itself urges fresh invention. De Kooning's late paintings take their peculiar baseline culture – Ultramodern, call it, for pressing lissomely beyond the categorical stylistic straits of modernism proper – to new limits as well as recapitulations. As artists, Ultramoderns like de Kooning came of age during the high-modernist phase of the 1930s, bearing with them vestiges of earlier, even nineteenth-century, fervor. (The '30s, as Denby recalled them, "had not only a kind of Biedermeier parochialism, they had also insight in the eternity of a moment of grace.") With its love of refraction and its profoundly ironic mindfulness, the Ultramodern turned multivalence loose among all available artistic options. "The art of the '30s," Robert Smithson wrote (having in mind not the dull umbers of Social Realism but the sparkling ziggurat walls of Radio City and Central Park West), "seemed to refer to everything." De Kooning and George Balanchine, both born in 1904, carried the Ultramodern, including the Depression years' sometimes desperate sunniness, into later amplifications. (Count Basie, also born in 1904, was a third who built a transcendent style on making more insinuating and more supple the vocabularies of his immediate predecessors.) It makes sense that Balanchine would share not just de Kooning's tastes in music and movies and a fascination with Ultramodern large-scale streamlining and the postures of longlegged American women but what Denby identified as "a love of style" and "force of expression" that would not be divided and got only more limber with age. Like second-generation

Renaissance artists born in the early 1400s, they refined and broadened while at the same time reaching backwards for lost essentials – for instance, de Kooning's grasp of the grand, elastic perspectival scale of a Cézanne brushstroke before it was snagged in the cubist shallows.

Mondrian and Léger were older artists who developed from the mid 1920s into prototypical Ultramoderns. Léger had the thirty-five-year-old but still burgeoning de Kooning on his team for the never-completed mural at Manhattan's French Line pier in 1939. From Léger (as well as from Stuart Davis) de Kooning learned the manners of the democratizing, professional worker-in-art. Recalling Léger, de Kooning told Irving Sandler: "His collar was frayed but clean. He didn't look like a great artist; there was nothing artistic about him . . . You got the feeling from Léger that to be an artist was as good as anything else." Together with Mondrian, Léger is poignantly visible in the bright primary bands and akimbo arrangements of certain late de Koonings. One, an untitled picture of 1987 hung in the last gallery at SFMOMA, brings the gaiety of vintage Ultramodern styling to a feverish edge. Nicknamed (or so I was told) "Easter Parade" by the SFMOMA staff, its fibrillating, start-stop movements indeed recall a tap-dancing Ann Miller in the MGM musical of that name. It's a wonderful, silly image that at first feints melodramatic befuddlement and then, having shot the viewer a sidelong wink, uncoils a slinky kind of grace.

Such pictures might say anything. The robust elusiveness of their terms may be their author's final trick on our critical faculties. De Kooning's summation, if that's what it is, for all its jokes and stunts, its lustrous pageantries, proclaims glee and admonition in equal measures. It intimates that painting, as a solitary venture, can sustain classical coherence only by (occasionally, at least) leering ironically back at itself and confessing the goofy, untoward rudiments of its esoteric patter. Having seen through his own methods by externalizing them, de Kooning fulfilled his art's ambition to be larger than any style. His late pictures play painting for everything it's got. "Here is the song," they tell us. "It goes like this."

1997

De Kooning, with Attitude

Looking at an early de Kooning called *Summer Couch* in the early '60s, Edwin Denby told how, in the '40s when the painting was done, de Kooning had intended "a wind blowing across the surface" to keep the parts of his pictures off kilter while their overall compositions settled in. The painting's furniture scheme admitted an undertow – there were sharks in that wind! – and a finely tethered, wobbly balloon. Similarly, in the teeming *Woman I*, an eventful composure seems the whole point of the image's arrival; Rudy Burckhardt's documentary photographs of the painting at different stages show that the objective was to get the elusive figure to declare herself, to sit still in an otherwise uncertain space. (Not to be tiresomely iconological, but if you know your chair-bound madonnas by Duccio, Cimabue, Giotto *et alia*, you know what de Kooning was wrestling with.) Once she had plunked herself down, the woman's eyes and smile flared accordingly. *Woman I* got down without style. The goddesses we know from Western culture don't, as de Kooning said he wouldn't want to, "sit in style." Instead, they take up attitudes. De Kooning said of himself: "I have to have an attitude."

Throughout his career, in writing and talking, de Kooning can be spotted using this word, one of his multi-purpose words (others are "marvelous," "space," "light," "ordinary," "absurd"), and this word "attitude" changes in his usage in much the same way certain shapes change according to how he tilts them or the colors they wear. In 1949, in a talk about movements in modern art as distinct from his own feelings for tradition and the professional life of painting, de Kooning said: "An artist is someone who makes art too. He didn't invent it. How it started – 'the hell with it.' It is obvious that has no progress. The idea of space is given to him to change if he can. The subject matter in the abstract is *space*. He fills it with an attitude. The attitude never comes from himself alone."

Here it should be obvious that de Kooning didn't intend "attitude" in the more recent, negative sense of affecting a nastily argumentative stance. De Kooning's sense, I believe, is closer to the one in classical dance vocabulary having to do with how parts of the body are

arranged: for example, lifting the body from the toes of one foot, up and outward, with one leg out behind and bent – a balancing act, like Mercury's classic one, that lasts only a couple of seconds or it has to be regained. Or else, and more to the point (from *Webster's Tenth*): "a . . . state of readiness to respond in a characteristic way to a stimulus (an object, concept or situation)." Here is de Kooning on how he works, mercurially, from scratch: "I see the canvas and I begin." And for the affective part, as he told a TV interviewer: "It's a necessary evil to get into the work, and it's pretty marvelous to be able to get out of it."

De Kooning's great old friend was Edwin Denby, the poet and dance critic who met de Kooning in the '30s when de Kooning's kitten wandered off the fire escape into Edwin's loft on West 21st Street and Edwin then found out who had been playing Louis Armstrong, flamenco, and Stravinsky's *Symphony of Psalms* on a phonograph with the volume turned way up in the next-door building. Nowadays, the idea of art as a form of social behavior seems lost in the mists of time. Denby's memoir of de Kooning in the '30s, written in 1957, conveys the feeling of simultaneously making and inhabiting a hometown New York culture during the Depression years; it conveys the understanding that attitude matters, not as the stuff of manifestos but as something extending from what Baudelaire called "temperament" – an everyday sensibility manifest in the work.

It's my impression that Denby's writings on de Kooning are too little known, or else too little observed, although for many writers of my generation they long ago settled into the category of basic texts. A couple of excerpts should give you the flavor of them:

> In the presence of New York at the end of the '30s, the paranoia of surrealism looked parlor-sized or arch. But during the war Bill told me he had been walking uptown one afternoon and at the corner of 53rd and 7th he had noticed a man who was making peculiar gestures in front of his face. It was Breton and he was fighting off a butterfly. A butterfly had attacked the Parisian poet in the middle of New York. So hospitable nature is to a man of genius.

•

Talking to Bill and to Rudy for many years, I found I did not see with a painter's eye. For me the after-image (as Elaine de Kooning has called it) became one of the ways people behave together, that is, a moral image. The beauty Bill's depression pictures have kept reminds me of the beauty that instinctive behavior in a complex situation can have – mutual actions one has noticed that do not make one ashamed of oneself, or others, or of one's surroundings either. I am assuming that one knows what it is to be ashamed. The joke of art in this sense is a magnanimity more steady than one notices in everyday life, and no better justified. Bill's early pictures resemble the later ones in that the expression of character the picture has seems to me of the same kind in early and later ones, though the scope of it and the performance in later ones becomes prodigious.

In 1951, de Kooning gave his talk at the Museum of Modern Art in New York on "What Abstract Art Means to Me," in the course of which he famously said: "Spiritually I am wherever my spirit allows me to be, and that is not necessarily in the future . . . Art never seems to make me peaceful or pure. I always seem to be wrapped in the melodrama of vulgarity." The force of those sentences came home to me afresh thanks to a talk given a few years ago by T. J. Clark in Berkeley on Hans Hofmann and abstract expressionism. Clark shrewdly pinpointed vulgarity as a positive factor in Hofmann's art. He had a lot of fun with it, and he didn't mention de Kooning's "melodrama." It struck me how correct he was about some degree of vulgarity being crucial to the abstract expressionism – especially to de Kooning and Hofmann as ex-Europeans, and in another way to Clyfford Still and maybe to early Rothko as well. In fact, the intrusion of vulgarity divided the New York School down the middle, or more literally at the midtown mark: "uptown" artists like Newman (whose trouble, Clark says, was that he was "never vulgar enough") or Rothko, and most especially Motherwell, were never in the same league vulgarity-wise with "downtown" (or "Tenth Street") artists like de Kooning, Krasner, Kline, or even Pollock (although Pollock was supposed be aligned with the former "uptown" group).

Be all that as it may, the word "vulgar" means one thing to the keen little Dutchman aswim in American slang and something else to an

astute English art historian who quotes liberally on the topic not from de Kooning but from Jane Austen, John Ruskin, Matthew Arnold, and George Eliot. Strictly speaking, "vulgarity" – or call it simply any rude sampling of vernacular energy wafting in from street level – has been a constant sign in Western art of where the action is. It is what everybody knows, as against the cloistered, protectionist assumptions of official taste. Oil paint, behaving as it does, is, or can be, "vulgar enough." As de Kooning sensibly recalled, "Flesh was the reason oil paint was invented." Frank O'Hara's poems speak of "love's life-giving vulgarity" and argue for a poetry "at least as alive as the vulgar." O'Hara once met de Kooning hurrying back to his studio on Tenth Street with a blue box of Kleenex under his arm: "I've been out buying some environment," de Kooning said.

It was part of de Kooning's genius to invent a kind of English as well as a vocal pitch perfectly suited to communicate the attitude he had at any particular moment. This "beautiful lingo" (as Robert Rauschenberg calls it), a kind of urban American Mandarin emitted in stubby staccato bursts, allowed for gorgeous malapropisms like "I'm no country dumpling" – for "country bumpkin," I guess, but conflating "Humpty Dumpty" and "ugly duckling" – and some wonderfully accurate redoubling. He once told Rudy Burckhardt: "What you do when you paint, you take a brush full of paint, get paint on the picture, and you have fate" (that is, "faith" with a Dutch accent).

It makes sense that George Balanchine, the other artist closest to Denby's heart, would share not just de Kooning's tastes in music and long-legged American women but what Denby called "a love of style" and "force of expression" that could not be divided and that just got more limber with age. Balanchine's neoclassical court dance in *Agon*, set to Stravinsky's score, premiered in 1957, the same year as de Kooning's "highway" pictures. As Denby described it, "*Agon* shifts traditional actions to an off-balance balance on which they swiftly veer. But each move large or small, is extended at top pitch. Nothing is retracted. The ardent exposure is that of grace way out on a limb."

"The subject of *Agon*, as . . . O'Hara remarked, is pride" – a character trait noted early on in the de Kooning literature. In 1955, Clement

Greenberg identified de Kooning's "Luciferian pride" with an ambition that "were he to realize it all other ambitious painting would have to stop for a while because he would have set its forward as well as its backward limits for a generation to come." Were he to realize it, de Kooning/Lucifer, the fallen rebel archangel – and let's not forget that the name Lucifer means "bearer of light" – would upset the tidy cosmic order of Greenberg's dialectical "modernism," which is pretty much what happened in the ultramodernity of de Kooning's wayward art.

As the years went by, Greenberg was more and more at pains to qualify and corner de Kooning's achievement. This titanic struggle (for such it was) is paralleled by anyone's attempt to nail down the ultimate quality, yes or no, of de Kooning's individual phases or works. Without abjuring for an instant whatever critical powers I might possess, I would argue that de Kooning's paintings both oddly and regularly work to defer or render achingly provisional any such judgment. The paintings just won't sit still for it. When the tallies were in on the retrospective exhibition shown a few years ago, in 1994–95, no two critics agreed on which were de Kooning's best years, best paintings, or where his level had, if ever, fallen off. There was much less agreement, in fact a kind of across-the-board stalemate, in discussion of the late pictures shown a year later. A de Kooning can be just as vulnerable as any other painting to context and disposition. It's as if the "slipping glimpse" of his process transfers to the viewer. Your principles just hit the skids.

Susan Rothenberg recently told of having similar troubles with Matisse: "The problem with Matisse is that I can't ever figure out when he's done a good painting or a bad painting because I don't know how to analyze him. I just know that I like the way he put it on and I like his airs and forms." Analyzing a de Kooning puts you up against a certain tenuousness – not of critical standards exactly (he doesn't trouble my standards the way Hofmann, for instance, does) – but of critical timing, or even necessity, and certainly, consistency. Just as de Kooning's pictures contradict themselves internally, favoring the opening out rather closing down of what they might show or become, one is exposed to the contrary tugs of one's own sensational logic.

Some artists fill the airs of their eras so utterly that you feel lucky to be contemporary with them. When Balanchine died in 1983, one admirer took the news as proof positive of "the end of civilization"; certainly some phase had come and gone, the remnants of which would never be that full anymore. With the end of de Kooning's able-minded life as a painter, one painting culture, perhaps Western-style painting itself as accumulated and sustained in de Kooning's hands, runs out. Unless, of course, you take the attitude that it doesn't. At the San Francisco Art Institute, a few years back, Alex Katz told a group of students: "Painting seems an old man's business. After a certain time you're out of it, and you just paint masterpieces." The sense of "masterpiece" here is professional and precise; it focuses on artistic activity in a condition of impersonal mastery, not on the object as having any value other than as evidence of that condition. De Kooning showed what easel painting has been, can be, and simply is: "Here is the song, it goes like this." Or like one of Denby's sonnets:

Alex Katz paints his north window
A bed and across the street, glare
City day that I within know
Like wide as high and near as far
New York School friends, you paint glory
Itself crowding closer further
Lose your marbles making it
What's in a name – it regathers
From within, a painting's silence
Resplendent, the silent roommate
Watch him, not a pet, long listen
Before glory, the stone heartbeat
When he's painted himself out of it
De Kooning says his picture's finished.

1999/2000

Herriman and Friends

Born in New Orleans in 1880, George Herriman arrived right on time to be the first-generation modernist he became. He was a year older than Picasso and a close contemporary of Wallace Stevens, James Joyce, and Damon Runyon, all of whom built poetic vernaculars in verse and/or prose comparable to the one Herriman made in pictures with a few odd words peppered across them. (Of the lot, Runyon is the only one with whose work Herriman would certainly have been familiar.) The unsolved riddles of Herriman's general culture aside – did he in fact visit the Armory Show, which opened in New York in 1913 six months before the first episode of *Krazy Kat* as independent strip? – his immediate peers were his friends among the cartoonists of his day: Bud Fisher who did *Mutt and Jeff*, Cliff (*Polly and Her Pals*) Sterrett, George (*Bringing Up Father*) McManus, Fred (*Happy Hooligan*) Opper, James Swinnerton, Rube Goldberg, and the sports cartoonist "Tad" Dorgan. Likewise, his early artistic models seem to have been exclusively older draftsmen like R. F. Outcault and Rudolf Dirks, who, at about the same time Herriman entered their company in the late 1890s, were advancing popular graphics in the direction of the modern multiframe strip. By the time he was seventeen, Herriman was getting steady work as a newspaper cartoonist; by the time he put his earliest cat-and-mouse impersonations on the boards in 1911, he already had a good seven years of inventive cartooning behind him.

It's intriguing to think of Herriman growing up, however briefly (since the family seems to have left for Los Angeles by the time he was in his mid-teens), in more or less the same milieu as Jelly Roll Morton. Like Herriman, Morton, born Ferdinand Lamothe in New Orleans in 1890, was a Creole. Apropos what seems to have been for Herriman an unmentionable aspect of his existence – albeit one that puts a sharp twist on the interspecies relations of characters in his art – his birth certificate designates him as "colored." Appropriately, the choreographer Brenda Way used tapes of Morton's music for her *Krazy Kat* ballet, which premiered in San Francisco in 1990. Morton claimed to have

invented jazz in 1902, and, as early as 1917, Herriman has a force line say "Jazz" as it trails behind Ignatz's "Willing Tool," the airborne brick. Strips – especially the very brief daily ones – are comparable to the three-minute form of ten-inch 78 r.p.m. records, which Morton uniquely mastered in the mid 1920s. Bob Callahan places Morton in residence at Jazz City during his first visit to California in 1906 while Herriman was working at the L.A. *Times*. Morton died in a Los Angeles hospital in 1941, Herriman in his Hollywood home in 1944.

Although he often accompanied Swinnerton and Dirks on plein-air painting jaunts around his favorite home-away-from-home, Monument Valley, Herriman seems to have made only two oil paintings as such; he was a great draftsman first and, once he accepted the inlays of color to his Sunday strips in 1935, a delicate, fanciful tonalist. "We deal in gentle humor," he once said. A sort of committed gentleness, together with the intensity and spring of a smooth-running combustion engine with no devious intent, characterizes his mythopoeic imagery. Exacting a just-so scale from his figures and settings within the confines of the tightly ruled comics frame, he hit upon a classic emphasis akin to Léger's or the early de Chirico. "The continuous and obstinate series," as Umberto Eco calls Herriman's strip-by-strip sequencing, nurtured his peculiar virtuosity. Robert M. Quinn has said: "His drawing is energetic and accurate. While most artwork done for commercial use is a mess, loaded with white-outs, scratch-outs, paste-overs and other corrigenda that are invisible to the camera, in the *Krazy Kat* originals such corrections are as rare as to be virtually nonexistent." Such adroitness fueled the infernal/Arcadian machine that the strip's basic scenario came to be – one in which, as David Carrier points out, "no character learns from experience" because no change can occur without absolute transformation.

As Jess says, "It's all in the light and dark." The syzygy of mouse, cat, brick, and sprung heart that Adam Gopnik sees as possessing "the eloquent symmetry of a photograph of a subatomic collision" is the same profound mystery (as Robert Duncan had it) "of the original state, the mysterious beginning of everything we translate out from our imagination of what was the beginning." Indeed, Jess's perception of

familial link between Krazy and the figures on an Egyptian papyrus was anticipated by Herriman himself, who once clued us to the roots of ricochet/brick love in Kleopatra Kat's affair with the Roman Marcantonni Maus. Similarly, with Herriman's African American identikit out of the bag, Sherrie Levine holds up the last frame of a 1915 daily strip for closer inspection. Originally, the inked-over silhouette – "splattered," and thus minus the hatching strokes that make the kat the elusive hybrid we know – was the end result of Herriman's having insinuated his then-infant daughters into the strip; it's Bobbie and Toots who've spilled the ink bottle and made Krazy "so med."

Lines radiating between Herriman and artists putatively unimaginable by him dazzle and tantalize by turns. One nexus would be that of the Navajo patterning that Herriman loved and put into both his art and household décor, the post-Kandinsky "nonobjective" paintings in New York in the late '40s (some of which participated in the so-called "Indian blanket" manner), Frank Lobdell's incorporation of both Herriman and archetypal symbols in his pictures, and on to the variously Woolworth-Building and adobe stylings of Ron Nagle's and Ken Price's ceramic sculptures. Another set would spiral out from the blockiness of Herriman's homemade weathervane toward the pancake figuration in Joan Brown's '70s images and Elmer Bischoff's abstractings, in his late paintings, of Herriman's signs for body parts in motion to matters of sheer directionality and light. Bischoff and Gordon Cook debated the typology of light in Herriman's vistas; as Cook told it: "Elmer makes people very worried when he talks about George Herriman and his Rembrandt light. I don't see it as Rembrandt light. I see it more as a kind of Spanish still-life light – Zurburan light is what I'd call it."

Ruminating upon Herriman's compendiousness, Wayne Thiebaud (whose childhood memories of southern Utah have prompted afterimages similar to those of Herriman's own Arizona days) told me: "I see Herriman as a primitive in the best sense – in the absence of academic ideals, in a kind of free-fall visual enterprise. He's comparable to Van Gogh in that he's come up with a totally different visual species. As in most primitive painting, you never know where you are in time. With

all the vaudevillian repertoire, the cascading gestures, slapstick and pratfalls, the storms and catastrophes, the child's play and philosophic meanders and ritual moon gazing, his is a universe of frauds, love, fatalism . . . but nothing about death."

1997

Shaw Business

The exhibition of the California ceramicist Richard Shaw's new poly-chrome sculptures at San Francisco's Braunstein/Quay Gallery this spring consisted of one of the artist's typical arrays of a few large and many small images. There, in high-fired porcelain with decal overglazes, were mostly common objects (a stack of books, a miniature house made out of domi-noes) and some wittily conceived, uncommon ones (a toy sailboat of Camel packages and dollar bills folded origami-fashion) that appear, as Shaw says, "obsessive, made of the wrong things." To announce the show, Shaw designed a poster juxtaposing a pair of black-and-white photo-graphs, each a closeup view of a middle-aged man with a bushy mustache wearing black-rimmed eyeglasses, a striped, short-sleeved shirt, and solid-color necktie. Both men sit with their arms on the back of a desk chair; each holds a lit cigarette pointed downward from between the index and middle fingers of his right hand. The man on the left, in a likeness arranged and taken last year, is Richard Shaw himself at age fifty-four, his salt-and-pepper hair tumbling to shoulder length, his expression unchar-acteristically clenched. On the right, with dark, closely cropped hair and somewhat heavier of frame, is Dick Shaw Sr., Richard's father, as he looked in 1964. As with the sculptures at Braunstein/Quay, the general resemblance is close enough to make you notice the slightest incongruity.

Dick Shaw, who died in 1976 at the age of sixty, was a writer and cartoonist; in the 1940s and '50s, during the glory days of animated films, he worked in the story department at Walt Disney Studios and later developed the *Mr. Magoo* series for UPA. A series of "envelope" pieces the younger Shaw included in the Braunstein/Quay show — white bond and manila replicas, with pencil and ink doodles fired on — commemorates the world Dick Sr. gathered about him in and around Hollywood, a world made up of such family friends as the Disney ani-mators Ward Kimball and Virgil Partch and Jerry Payne, who wrote the TV show *Truth or Consequences*. "The envelopes are centered on all those guys," Shaw says, "people who have passed on, as if each is the last letter I wish I'd sent them before they died."

For Shaw, his latest gallery announcement is partly a way to keep a weather eye on artistic leanings that seem to run with wildfire rampancy in the family. Above each photograph floats a roughly inked word balloon. Dick Sr.'s cautions "Richard . . . Get out of this lousey [sic] art racket before it's too late," while Richard at his end repeats the plea to the two oldest of his five children – thirty-year-old Alice Shaw the photographer and Virgil the twenty-seven-year-old musician and painter – both of whom have succumbed.

Compared to other layouts for posters Shaw has come up with since he began showing in early '70s, the present one is surprisingly plain. Previous schemes – for tableaux vivant photographed in color – have involved more elaborate costuming and props and sometimes extensive crowd control. To advertise his 1986 show at Braunstein, Shaw had himself photographed in a meadow wearing a buckskin jacket and cavalry cap and plunked down at a portable easel amid some eighty friends performing an all-smiles version of Custer's Last Stand. For another show two years later, he collaborated with his wife Martha on staging a variation on a self-portrait by Giorgio Morandi he had seen and admired while in residence at the Sèvres museum-and-workshop complex in Paris: the result, in a color photograph by Alice Shaw, is a tantalizing seamless fit of Richard Shaw's actual face and hands – albeit carefully daubed-up for appearances – poking through Martha's loose, tonalist overpainting of his open-neck shirt and vest, which had been draped onto a plaster armature built out from a big canvas with a lot of creamy "atmosphere" lathered onto it. Appropriately, the show, entitled "Still Lifes & Palettes," featured works that Shaw completed during his Sèvres residency – wall-mounted palettes and light-raked tabletop images of paint tubes, brushes, crumpled rags, turpentine cans, and mayonnaise jars, complete with pigment smearings, pencil streaks, and snippets from *Le Monde* and French-English phrase books.

"The show announcements are nice to do because they're like big gifts," Shaw told me recently. "It's not mass media exactly, but getting to a lot of people with a keen gag. When I was a kid everyone in the family did elaborate Christmas cards because they were all artists. My father was at Disney. He had met my mother, Katherine Dexter Shaw,

when they were both students at the Art Institute of Chicago. We would sit around the table in Van Nuys or wherever and Pop would do a drawing of something and we would watercolor it in. Then we would send them out. I guess I started doing show announcements like that to sort of lighten things up, and then it got into being almost as big a production as the show. The one of Custer's Last Stand related back to the movies I made when I was in high school where we literally made all the uniforms and guns. We made a whole film about the Second World War with a 16-millimeter Bolex camera. If you took little pieces of it and didn't realize that everybody in it was sixteen years old it would look like real wartime footage. The rest of it looks like a bathroom pageant, but we tried real hard. 'Cecil B. Shaw,' they were calling me then."

Shaw was born in Hollywood in 1941. While still in grade school, he became adept at drawing battleships, P38 fighter planes, and the like. Although he planned to become a painter, he first became attracted to ceramics in 1961 while matriculating at Orange Coast College in Costa Mesa, California. When he entered the San Francisco Art Institute a couple of years later, his ambition was still to continue the tradition of Bay Area figurative painting. He likes to say that he switched to working in clay partly because he couldn't find anything to paint that hadn't been covered already by his San Francisco predecessors. As it happened, Shaw's timing was perfect. His teachers at SFAI included Robert Hudson, Manuel Neri, Jim Melchert, and Ron Nagle, all of them slightly older artists who were just then starting to make works indicative of the preeminence that assemblage and sculpture of one kind or another – in clay, wood, metal, and other, often mixed, media – would have on the Bay Area art scene for the rest of the decade. (Shaw recalls the close distinctions made then among sculptors in different materials with glee: "We were the ashtray makers, and they were the hairy chest beaters.") By 1966, while getting a master's degree at the University of California, Davis – that other, percolating site of esthetic hybridism, where he connected with, among others, William T. Wiley, Robert Arneson, and Roy de Forest – he had begun superimposing pictorial imagery onto a series of earthenware "couch" sculptures in which the eponymous home furnishing, rendered in the round

and exuding textures like that of worn leather, served as a support for depictions in acrylic paints of, variously, a bucolic hillside, a battle scene from the Civil War, and (in what would eventually become one of Shaw's talismanic images) a view of the Titanic going down.

Fool-the-eye stunts are standard issue in the Shaw repertory. In 1971, he began working in porcelain – "because it looked translucent and easy to work with, which of course it wasn't" – and for the next year and half he and Robert Hudson collaborated on a series of intricate constructions of slipcast porcelain parts, using molds of found objects. As Shaw remembers, they cast "everything imaginable," airbrushed, china-painted, and underglazed the surfaces, and incorporated functionality (some were teapots, others were jars, mostly lids). Soon thereafter, the ceramic-decal invention Shaw refined in 1974 with the silkscreen artist Wilson Burrows provided another, more reliable way to re-create the surface look, photographically precise colors and all, of just about anything so that (allowing for some shrinkage during firing) the actual-size, characteristically hued object seems nakedly visible, sitting tight in nothing but its shiny, three-dimensional skin.

Shaw's professed contest with himself toward remaking the entire world – or a fair compendium thereof – in clay has something stronger than whimsy about it: a fiendish delight in things being exactly what they appear to be, and then again, an itch to have them be, or mean, something more. Beside items already mentioned above, he has cast and combined such things as tree branches, cups and saucers, playing cards, pencils, cigarettes, fish, rope, cardboard, oatmeal, nuts, beans, beer bottles, a frisbee, skulls, tools, various types of cans, jars, hoses, and rocks. On top of these and more, he has sometimes depicted with his paints and glazes what he calls the "bare-lightbulb effect," which evokes just as readily the sweeps of changeable sunlight around Fairfax in Marin County, where he has lived and worked since 1976. Confronted by one of his sculptures, the incredulous viewer is likely to mutter something like "It's all clay, right?" (you always have to ask) and then perform a number of up-close squintings to verify same (only Shaw, one suspects, knows for sure, and there's no proof, even, about that). The eye is disturbed and tricked into a state of hyperalertness so

that you look harder to perceive what's actually there, all the while flailing about mentally for an exact memory of the familiar thing or set of things it's meant to represent. The mild, deadpan deception, unsettling at first, then hilarious, produces an esthetic-cum-philosophical buzz, which lingers.

"Another question," Shaw says, "is what those things add up to be – plus the uselessness of it all." For all its superfluity, fool-the-eye satisfies its own requirements with the unfathomable, no-context efficacy of a nursery rhyme. Both play on memory's functional expectations, embarrassing the mind in its rote habits of belief, its connective gullibility. Things add up in our regard for them, and in their sometimes spooky hold over our sense of ourselves. Such speculative matters, like the brittle stuff that Shaw uses to embody them, foreground the fragile nature of consciousness as much as of physical existence itself. The beauty of a still life may reside in the feeling that, as Shaw says, "someone has just put something and walked away from it." Then there are the instances in which his serendipitous household accumulations rise on two makeshift legs from their tabletop reclinings and strut. It makes sense that the natural-born caricaturist in Shaw would find release in making stick figures; "taking the still lifes and bringing them up on these people," as he puts it, he will fashion a thorax from reduplicated hamburger buns, a pumpkin head with a sheet-music face, a bowl for one foot and a block of cheese for another. (Fired separately, the parts are joined by unseen metal rods.) Lately, he has returned to drawing to supplement what he calls his "library of images," the dusty shelves of molds that line his basement studio. Casting a quick glance about the place, he says: "This stuff comes from looking in sketchbooks and combining. You build the nomenclature for your act and then you start eating off your own things, combining the things you love."

1996

Nagle Wares

In a slide lecture sponsored by Friends of Contemporary Ceramics at the annual S.O.F.A. (Sculpture, Objects, and Functional Art) exposition in Miami, Florida, last March, Ron Nagle traced his progress from his beginnings in the late 1950s as the youngest of the San Francisco abstract-expressionist ceramics makers to his present stature in a realm of his own devising – the palm-size, polychrome, anomalous earthenware vessel that recalls parlor serviceability the way cartoon characters recall flesh and blood. At the outset of his talk, Nagle projected slides of two "childhood icons": first, a row of squat, pastel-toned, Ultramodern, stucco houses in San Francisco's outer Mission district, where he grew up; second, a three-quarter showroom view of a 1932 Ford Roadster ("the definitive hotrod"), its glossy red veneer preening over thirty-odd coats of sprayed lacquer beneath. (A Nagle sculpture, rarely larger than six inches in any dimension and more often than not a lot smaller than that, has been known to sport a comparable number of overglazes and firings.)

Nagle proceeded with his story, lacing it with the sort of ceramics in-jokes his work is wont to include ("If you don't know what to call something, call it an incense burner"). He told how in 1961, three years after he converted from jewelry making to ceramics while still an undergraduate at San Francisco State College, he became Peter Voulkos's unofficial assistant at University of California, Berkeley, "as part of the so-called Auditors Program." He recalled how, beside setting a early example of "stylistic authority," Voulkos helped to educate his taste, showing him catalogues of seventeenth-century Japanese Momoyama pottery, the idiom of which ("the drip, the exposure of the foot, the looser feel") he favors to this day. He acknowledged that seeing the "exploded cup forms" Ken Price had been creating since the late 1950s eventually turned him irrevocably toward his own possibilities in hand-scale sculpture. Near the end of the talk, he showed slides of a couple of "dripping nose cups," collaborations done with Price at the Anderson Ranch Arts Center in Colorado in the early 1990s. "Emotion

in cup forms" was one phrase Nagle slid past the enthusiasts in Miami by way of declaring his esthetic intentions. "Totally transcendent," he said flatly of works of artists he admires – most tellingly among them, painters known for working in exceedingly compact formats such as Giorgio Morandi, Albert Pinkham Ryder, Josef Albers, and Vermeer – and he added: "I want my pieces to have the kind of profile a Morandi object would have."

Nagle's initial technical contribution to high-style ceramics circa 1961 was introducing slipcast, china paints, luster glazes, decals, and other detailing peculiar to the worlds of commercial gift-shop items or hobby crafts, techniques to which he had ready access thanks to the ceramics club his mother used to convene in the family basement. The ultimate invention with which he's credited is his melding of hobbyist-type china painting – "the closest and most predictable material in ceramics in terms of what-you-see-is-what-you-get" – with the multi-layerings of color peculiar to car culture.

But the concomitant rage, apparent also early on, for defining preferred graphic profiles of things that obviously might be viewed from many different angles gave his pieces a distinct, pictorial edge. The diminutive objects have an elusiveness more related to the surface dynamics of painting than to anything that stakes its existence in real space. Partly, this quality followed from the "tough and tender" improvisatory look Nagle appreciated in Momoyama, which he experienced at first only in reproductions. "Like paintings, they were printed flat," he told me recently. "There was a fixed orientation, and what you saw was the 'A' side, the beauty side. So profile, or the best angle, became a big issue for me."

By the end of the '60s, in order to direct the viewer's gaze to this optimal aspect of certain works, Nagle adapted another stratagem of tea-ceremony culture, the carefully worked presentation box. In the Japanese version, the box's importance is emphasized partly in its being the site for the master potter's signature; Nagle's boxes, however, are unsigned – he doesn't believe in signing his work at all – except insofar as they bear the same, unmistakable type of strangely diffused color as the cups nestled in their central niches.

Nagle was born in 1939 and views himself determinately as "a child of the '50s." Bernal Heights, where he lives now, is not far in actual distance or in character from the outer Mission of his childhood. Both were, and still are, predominantly Latino communities; in his teens, Nagle headed straight for local high-fashion statements like "peggers" (the tapered slacks component of the zoot suit) and powder blue, mocha, or pink-and-charcoal-gray combinations, color schemes that regularly appear in the glazes in which his forms are drenched. He also went for the diversity of musical raptures – via jazz, rhythm and blues, and lounge music – that the street, youth-oriented radio stations, and quasi-occult record stores of the time made accessible. (Nagle himself has since cut a considerable swathe as a keyboardist and songwriter; his recordings include the 1970 Warner Brothers album *Bad Rice* and sound design for some of the more fiendish cinematic moments of *The Exorcist*.)

As the critic Charlotte Moser points out, "All of Nagle's works function as metaphors for social history," meaning that every choice in them will contain some trace of the various strains of material life that Nagle over the years has collated personally into what amounts to a wildly composite, general culture. For instance, the phantasmagoric knotty pine in the top half of *Tahoe Cup* stands for "what I wanted, but we couldn't afford, in my room as a kid, and my father chose gas-chamber green instead, because he'd heard it was soothing to mental patients." In 1978, on the occasion of an award exhibition at the San Francisco Art Institute, Sylvia Brown enumerated the strictly-California aspects Nagle's surfaces continue to commemorate: "The turquoise of swimming pools, the salmon glow of sunsets, waxed enamel surfboards, candy-apple custom cars, stucco walls and sun-ripened oranges are all reflected in . . . these small sculptures." So, one might add, are pachuco secret signs; but from there Nagle's cultural affinities extend beyond state lines to the music of the Kinks, Duane Eddy, Big Maybelle, and Henry Mancini and artists as various as Antoni Tàpies, Lucio Fontana (whose spazialismo ceramic interventions deserve to be better known), Philip Guston, and H. C. Westermann.

The language spoken by Nagle's "wares" – a designation both he and Price prefer for what has become known in academic circles as "the

sculpturally oriented vessel" – is authentic twentieth-century American ceremonial. The sculptures' metaphorical appeal as ritual objects carries, beside their hyper-precise regional inflections, a screwball tinge no celebrant can ignore. Unlike ordinarily space-hungry modern sculpture, they don't command the visual field so much as beckon the viewer to what Nagle calls "a secret world, a looking-into-the-Easter-egg mentality." Within this chosen "parlor scale" occur the chromatic glows, collisions, and packed-in nuances for which Nagle is perhaps best known, and which serve to blow wide open one's spatial sense of the object at hand. Thus, a field of black or purple, flecked like the night sky with ornamental comet trails (actually spit-on slip from a spray gun) and edged with a thin line of iridescence, is set squarely on another field of markedly different hue. The abrupt contrast and mediating "sunset" edges suggest that, in passing from one color to the next, the eye has crossed some interstellar timeline. Pragmatically, such stylings are just part of Nagle's program to integrate surface and glaze, or, as he told the artist and writer Susan Wechsler, "to make the surface conditional to the piece, and not just a paint job."

Both the outer and inner limits of Nagle's not-so-blanket cultural acceptance show in the way he works with the givens of traditional ceramic forms. "The vessel is a very limited format," he says. "If you are going to say these are cups, there will be a hole in the top. Some people say, if you had just closed that hole, then it would be legitimate sculpture. But I refused to do that. Same with songwriting: there's a chorus, a bridge, maybe another verse – it's a very prescribed format, and it works. It worked for Cole Porter and for Chuck Berry. The truth of the matter is, I'm extremely rooted in the utilitarian tradition. The so-called 'vestigial handle' is where the handle might be. It's as if I'm using the cup as a kind of road map."

Nagle may be "doing cups," as the saying used to go – or more accurately, portraits of cups – but his vessels often bear signs of challenged functionality such as reduced apertures and shapes that, if taken as handles, would give the wary beholder pause. In the exquisite porcelain pieces Nagle began making in 1992, the vestigial member can resemble either an inchworm or a cartoon body-part blob or squiggle

found in Marjorie Henderson's *Little Lulu* or Ernie Bushmiller's *Nancy*. These hot spots, so to speak, simultaneously invite and forbid touch (even if only imagined) in equal measure. Some are plainly phallic, others vaginal ("A lot of them look as if they're giving birth," says Nagle), and still others resemble long, furry rodents' tails. One recent piece, in both its title and mock-elephantine appearance, constitutes a shameless pun: *Peanut Envy*. Even in the absence of protruding parts – as with the mid-'80s set of nonvessel, split-image sculptures Nagle calls "knob jobs" (they've been followed lately by a group of "neo knobs") – the obscene allusion never is far beyond reach. All this Nagle concedes jubilantly: "I happen to be right-handed. The pieces have to be shown, they have to be reproduced, with that thing on the right side." Into the pitted blue rectangle set on the appropriate side of a "hair ware" – one of a new series inspired by the "dippety-doo" stylings of the 1960s ("but this one's bald, it's a *ne'er-do*!") – Nagle has attached a separately cast, achingly smooth, bright red "thumbnail" that also suggests a warning light on some preternaturally engorged erogenous zone. (It's the perfect visual counterpart to a song he wrote with Scott Mathews, "Don't Touch Me There," recorded in the mid '70s by the Tubes.)

The quiet consistency with which Nagle keeps recapitulating his solitary forms, while continually expanding in surprising ways their color range, bespeaks a succinct idealism. He watches his own production – about twenty pieces a year – with a stern curatorial eye ("That's the good one and the rest go out"). Pouring coffee in the kitchen while standing beside his twelve-year-old daughter Lucy's tablelength Elvis shrine, he remarked: "I hate bananahanded art, and I hate useless virtuosity. But I like a certain panache. In the '60s I realized there was more humanity in a Morandi bottle than there was in any figurative art I was seeing. In Japanese ceramics you see that the bowl is the highest art form in the culture. I work to alter my consciousness. If somebody's work – Morandi's, for example – moves me, I am transported to another place by somebody else's efforts. That's what good art's done."

1997

In the Heat of the Rose

Some time in 1958, Jay DeFeo propped against the sliding double door
of her back-room studio on San Francisco's Fillmore Street a roughly
seven-by-nine-foot canvas that bore the scraped-down green, pink, and
orange marks of one of her discarded "Mountain" series paintings and,
under those, faint traces of another, still earlier picture on the theme,
prophetically enough, of Jacob wrestling with the angel. Onto this sur-
face she began loading piles of mostly white and dark gray oil paint in
sharply divided, deeply grooved segments radiating from a recessed
point slightly more than four inches to the right of, and slightly less
than four above, the canvas's center. (People who saw the work as it
progressed have reported the presence of other colors – reds, ocher, and
blue; of these, only a few flecks of very pale ocher remain visible on the
face of the picture today.) DeFeo later told the archivist Paul Karlstrom
that initially her only guideline for the painting was "an idea that had
a center to it." There was, she said, "no notion of 'the rose' about it."
Months would go by before DeFeo assigned even a working title to her
picture; finally, after eight years – and an eternity's worth of bedrag-
gling vicissitude – she called it *The Rose*.

For a while, starting from about the time she committed to her
seemingly harmless idea, DeFeo attracted a considerable following as
the painter to watch in a group of young West Coast artists that
included Bruce Conner, Wallace Berman, and DeFeo's husband at the
time, Wally Hedrick. The three-story building at 2322–24 Fillmore,
where DeFeo and Hedrick lived and worked, was the unofficial epi-
center of the small San Francisco art world; in the years 1955–65, other
occupants of the four shotgun flats into which the building's upper two
floors had been divided were Michael and Joanna McClure, Craig
Kaufmann, Ed Moses, James Kelly and Sonia Gechtoff, Joan and
William Brown, and Jim Newman, the founder of the Dilexi Gallery.
In late summer of 1959, going on six months after her thirtieth birth-
day, DeFeo had her first major solo show at the Dilexi's upscale new
space on Union Street, and on the strength of works seen both there

and in the studio, Dorothy Miller chose five pieces by her for the "Sixteen Americans" exhibition at the Museum of Modern Art – a country-wide (albeit mostly New York–parochial) gathering that, during its midwinter run at MoMA, also introduced to the museum-going public the likes of Jasper Johns, Ellsworth Kelly, Robert Rauschenberg, Louise Nevelson, and Frank Stella. In January 1961, Miller featured DeFeo again in a "New Talent, U.S.A." survey article for *Art in America*. The next year, a color photograph of DeFeo crouching on a ladder as she worked on a painting easily twice her height (it was *The Rose* in one of its intermediary phases) appeared in a *Look* magazine spread on "Creative America" with a text signed by then-president John F. Kennedy. Overtures from collectors and New York's prominent Stable Gallery ensued. J. Patrick Lannan, the Chicago banker turned philanthropist and grand acquisitor, who visited DeFeo's studio in 1959, just before Miller arrived on her scouting mission, bought a total of six works from the Dilexi and MoMA shows.

What followed amounted to both everything and nothing. From the mid '60s on, DeFeo continued as a legendary figure in local art circles – indeed she epitomized the unbuttoned approach, at once achingly earnest and appositely reckless, that was Northern California's big contribution to mid-century art making – but eventually her larger reputation faded. Although she had visited New York both before and after a fellowship trip to Europe in the early '50s, the importance of being on hand for the "Sixteen Americans" opening eluded her: she and Hedrick, who was also in the show, took the pair of airplane tickets MoMA had sent and gave them away to friends. DeFeo had another one-person show, of abstract pictures from her European sojourn, at the Ferus Gallery in Los Angeles in 1960; after 1963, she withdrew from exhibiting and didn't resume until 1971. With opportunity knocking, she had something else in mind. The "big gray painting," as she referred to the work-in-progress she had shown Lannan and Miller in her studio, was getting bigger in both conception and literal size, and a pattern of refusal was beginning to emerge: Lannan offered at first sight to buy the picture (to DeFeo's delight, he nicknamed it "The Endless Road"); Miller wanted it for her show;

DeFeo demurred, declaring the work, by then titled "Deathrose," to be unfinished. Miller eventually settled for a reproduction of the first phase of the painting in the "Sixteen Americans" catalogue, where its eruptive, quasi-symmetrical image still strikes up an engaging, if fundamentally uneasy and inconclusive, structural chat with such coeval emblematic works as Frank Stella's *Die Fahne hoch!* and three of Jasper Johns's target pictures. (In hindsight, DeFeo's work at the time, although she herself couldn't have been aware of the extent of its connections, ranks more pointedly with the types of metapainting – in high or low relief or with otherwise challenged pictorial surfaces – then practiced by, say, Jean Dubuffet, Antoni Tàpies, Alberto Burri, Lucio Fontana, and Yves Klein in Europe, by Kazuo Shiraga and others of the Gutai group in Japan, and, in America, by Rauschenberg, Ronald Bladen, Lee Bontecou, and, among DeFeo's own San Francisco friends, Joan Brown and Jess.)

As it happened, the momentum of DeFeo's career stalled around the demands of a single picture that held the promise of telling all and that finally swamped all else, to the point that, for people not privy to the range of her art, she would register as a one-work artist. Throughout the first half of the 1960s, once DeFeo had embarked fully on *The Rose*, she produced only one other picture, the stunning, and even thicker, narrow escarpment called *Incision*, 1958–61, now in the San Francisco Museum of Modern Art. For four years – between 1966, when she let the painting go, and 1970 – she stopped working altogether. At the end of the '60s, when *The Rose* emerged briefly in public from what had come to seem a process of its own devising – beyond the artist's power to sustain, its accumulated mythology had already become something of an albatross – it measured over a foot larger in its height and width than the original canvas and, alarmingly, bellied out eight inches at the highest relief of the strange cementlike mix of pigments and other substances that made up its surface. When tested for probable impact on a trucking company's forklift, it was estimated to weigh a menacing 2,300 pounds. (A more accurate recent estimate puts it at closer to one ton.) Its dense yet fragile crust also had begun to break apart. During the two months it was on view at the San Francisco

Museum of Art in 1969, it was observed to be shedding debris daily, and a chunk had already disappeared from the lower right corner. Clearly the question in 1969, and for twenty-five years after, was where to put it. Among the various museums and private collectors approached, there were no takers. Out in the world, visibly glorious yet homeless and in bad physical shape, *The Rose* was inappropriate.

Fittingly, the lead sentence of DeFeo's statement for the "Sixteen Americans" catalogue read: "Only by chancing the ridiculous can I hope for the sublime." Sublimity was built into the tremulous body language – "organic" and full of "growth forms" in the parlance of the time but with supra-organic, and dashingly clear, cosmological overtones – that characterizes the paintings, outsized drawings, collages, and other mixed-media constructions DeFeo made from about 1954 on. The ridiculous, too, was ever at hand. At even her most obsessive, DeFeo was gifted with a sprightly sense of play that allowed her to follow her intuitions and yearnings without hammering them into theses. As early as her student years, she later told Karlstrom, she had conceived of making an image "about being on an edge . . . I wanted to create a work that was just so precariously balanced between going this way or that way that it maintained itself."

Why DeFeo began *The Rose* illogically off-center in the first place has never been addressed. It may have had something to do with the strange, razor-sharp, focus-shunting markers that vertically divide *The Eyes*, the large 1958 graphite drawing that DeFeo always said pointed her directly to *The Rose*'s more compendious, abstract image. Neither is there any clear evidence as to exactly when she revised the "Deathrose" format, but after putting it aside for a while to focus on its convex companion picture, *The Jewel* (1959), she decided "that the canvas should be symmetrical and it wasn't really the right proportions." Balancing the painting on a couple of paint cans and two plywood shims set atop a footstool, she placed it above and to the left of its customary position and drew elaborate extension lines on the door and wall moldings around the support; a photograph of this arrangement served as the prototype for a new version of the work that wouldn't sacrifice the image that was already there. Assisted by Hedrick, McClure, Kaufmann, and Bruce

and Jean Conner, DeFeo then cut away the initial canvas, lifted it into the squared-off window bay of the front room, and there glued it onto a larger, nearly eight-by-eleven-foot, unprimed canvas stretched to just fit the dimensions of the two middle windows and wall. The point was, as Hedrick puts it, "to center the center" while expanding the parameters of the whole design.

Over the next six years or so, the painting heaved its way through a whorl of transformations. DeFeo later told Rebecca Solnit: "It went through a whole cycle of art history: the primitive, the archaic, the classic, and then on to the baroque . . . All those stages were interesting and complete in themselves, but just not what the final version was or what I intended." Photographs taken in DeFeo's studio between 1959 and 1965 confirm her account. With paint troweled on then carved and hacked away in what DeFeo came to consider "a marriage of painting and sculpture," the original fanned-out geometry tightened by 1960 to a more rigidly crystalline net. To this DeFeo began adding rough-textured redwood slats and small clusters of pine dowels to improve definition and bolster the paint against sagging. The files of Bay City Paint, where DeFeo bought gallon cans of black and titanium white and a dense, chalky texturing foundation called Prime-Rite, show that between 1960 and 1965 she paid a total of $5,375.51 for materials, most of which went into *The Rose* alone. DeFeo also introduced metallic powders into the mix for a micalike sparkle, and there are rumors of other additives – bits of copper wire, beads and pearls from her mid-'50s jewelry-making period. ("I think I saw a barrette go in there once," McClure said recently.) A 1961 photograph shows the artist posed lithely before a nearly all-white version in which the rays have been subsumed in an allover glacial slump. By around 1964 the straight ridges buckled to accommodate "an interweaving of organic shapes" – outcroppings of (again) gray pigment that, according to Conner, resembled giant acanthus leaves, and which soon after, in what DeFeo called her "super-baroque" or rococo phase, became a system of blowsily plumped-up loops. "I really wasn't aware of how flamboyant it had become," she told Karlstrom. "I had been so involved . . . and suddenly I walked into the studio one day and the whole thing seemed to have

gotten completely out of hand. I felt that it really needed to be pulled back to something more classic in character."

Conner has likened the atmosphere in DeFeo's studio during the making of *The Rose* to that of "a prehistoric cave." Thick with wads of discarded paint, the floor sloped away from a six-inch rise directly in front of where the painting stood cross-lit by daylight coming through the side windows. Traversing this encrusted space was, Conner says, "like walking on the back of a whale." A typical Christmas or birthday gift from DeFeo in those years would consist of a shoebox containing a slice of the painting laid out on black velvet. Entertaining often consisted of restretching parties at which friends helped DeFeo unfasten and then secure the canvas more tightly on its strainers. The building's air well served as a dumping chute for an ever-mounting collection of empty paint cans. Hedrick remembers: "It was driving her crazy. She would line up these radiating lines and get them where she wanted them and would come back the next day and go berserk. She fought this by working harder and drinking a quart of Christian Brothers brandy a day and smoking two to three packs of Gauloises. It was like a lubricant. Her hands would be covered with white lead. It killed her."

Whether or not "lubricant" abuse in combination with continual exposure to oil paints and other materials caused DeFeo's eventual death from lung cancer at the age of sixty in 1989, such excesses certainly had an immediate impact upon her condition. As early as March 1965, Walter Hopps was trying to get DeFeo to let the painting go and allow it to be exhibited (with its new title, "The White Rose") at the Pasadena Museum of Art, where he was then the director. According to James Demetrion, the Pasadena curator who eventually succeeded Hopps in 1967, "Walter was concerned that the picture be released and not botched up." True to form, DeFeo kept putting off the show and, with it, the removal of the painting from her studio – a daunting proposition that Hopps had offered to manage and use his Pasadena resources to pay for. The fateful process, Conner says, "needed an uncontrolled event to make it stop," and the sudden termination (due in part to DeFeo's excesses) of DeFeo's and Hedrick's lease at 2322 Fillmore toward the end of 1965 provided just that.

Shot over two days in early November 1965 and finally completed in 1967, Conner's seven-minute film *The White Rose* documents rapturously the last look of the picture as it existed in the Fillmore studio and the events over seven hours of its removal "by Angelic Hosts" (as the subtitle indicates, referring to the team of Bekins movers in their white coveralls) from the otherwise bare apartment to a van on the street below. By way of jagged cuts, blinks, and flickers, in six loosely defined movements, Conner communicates the stress of the immediate occasion and a great deal of the ardor surrounding it. For the soundtrack he chose the elegiac first half of Gil Evans's extended orchestration of the adagio from Joaquin Rodrigo's *Concierto de Aranjuez*, with Miles Davis in the lead on trumpet. "The Great Rose Transplant," as DeFeo called it, involved sawing away a two-foot section of windowsill to allow the painting to make its exit to the forklift outside. "All that day I wondered if Jay was going to go out the window herself," says Conner, and two images from the film support his apprehension. In one, Conner and the Bekins crew, returning from their lunch break, find DeFeo stretched out across the painting, thus lending the recumbent assemblage with its paper wrappings and packing crate the aspect of an open, makeshift coffin. In another, with the van having pulled away and footage running out, she sits forlorn on the carved-out sill, legs adangle in midair; when Conner comes around the corner of the adjacent window, she briefly indulges the filmmaker's camera-eye with a brave little smile.

Within a couple of days, DeFeo's picture arrived at the Pasadena Museum, and shortly afterward, she followed. Off and on for three months in Pasadena, with a chronic case of flu and no place else to go (once she and Hedrick left Fillmore Street, they lived together only sporadically and their marriage soon ended), she stayed with Hopps and, finding *The Rose* installed in a darkly painted storage gallery, struggled to make the refinements she envisioned for the work. Mostly, it seems, she set herself to sharpening the edges toward the center and adjusting the highlights along the rays, illusionistic touches that clinch *The Rose* as the marvel of complex visuality we see today. She told Karlstrom: "They gave me a little room directly to the right of the

entrance. It was my little cell of solid black. The only light was a little grate. If you peered up you could see the sidewalk or . . . light coming through. It reminded me of being interred in medieval days." After Hopps convinced her she had given the painting all she could, she abandoned it to his and Demetrion's keeping and retired alone to a country house in Ross, outside San Francisco. Three years later, in the spring of 1969, *The Rose* passed in rapid succession from Pasadena, where Demetrion finally exhibited it in March, to the San Francisco Museum (spreading its charms there before a black backdrop), and then across town to the conference room in the newly completed wing of the San Francisco Art Institute, where it remained, bolted to a concrete wall, and eventually hidden from view, until last year.

In 1972, DeFeo commented in a letter to Conner on the myth that had formed around the painting's creation – "the poor painting," she wrote, "is the physical symbol of that myth." Asked by DeFeo, also in 1972, to examine the painting and propose a way to secure it, the conservator Thornton (Tony) Rockwell quickly identified its structural essence as "an unnatural act . . . the attempt to suspend [a ton] of paint in midair supported only by a thin sheet of cotton canvas." Rockwell remembers: "Jay was worried that the painting was on the verge of collapse. Her fears were indeed justified. The canvas was not up to supporting the massive weight of the paint. Small tears had started to develop along the tacking edges at the left and right. Draws were developing. The painting had sagged over the bottom edge of the stretchers and along the top edge, as well, in an arc. Deep cracks were developing in the paint film due to shifts in the canvas. Chunks were detaching, and other chunks were in danger of doing so."

Over the next couple of years, DeFeo and Conner, in his role as DeFeo's "manager," redoubled their efforts to place *The Rose* in one or another permanent collection. At one point, the San Francisco Museum, where Rockwell was then chief conservator, proposed a public conservation exhibition, with *The Rose* as centerpiece, to raise funds for treatment, but there was no commitment to acquire the work, and the museum soon backed away from the project. DeFeo's own funds were running low – she had $1,500 from an NEA grant plus a friend's

$500 donation to put towards conserving the work – so that, in 1974, Rockwell could set about completing only the first phase of his prescribed two-phase campaign. He and his assistants managed to clean the surface of grime, including coffee and nicotine stains, and to fill the many undercuts and cracks with a temporary wax and rosin adhesive. They then applied a complex, multilayered facing that would act as a truss to both reinforce and protect the surface. Held in place by wire mesh stretched across a top layer of white casting plaster, this support system – similar to the kind used for archeological items – brought the object's overall weight to well over two tons. Not long thereafter, the already mummified *Rose* went into deep storage, virtually entombed in its schoolroom setting behind a partial wall of fiberboard.

The epic engineering feat that allowed *The Rose* to reemerge last October from its suspended life had its beginnings in 1992 when Leah Levy, a trustee of DeFeo's estate, commissioned the archeologist and conservator Niccolo Caldararo, who had worked closely with DeFeo on examining and treating her works in the 1980s, to make a preliminary diagnosis of the painting before creating a plan for its full-scale conservation. Working in the conference room over the next two summers and the winter break in the Art Institute's 1993–94 academic year, Caldararo gathered data from a range of testing devices – spectrographic analysis of paint samplings, microwave and ultrasound scanning, gas chromatography, and fiber-optic "lipstick" camera views – to determine the consistency and state of the pigment and how well the canvas was holding on its strainers. For close inspection of the surface and the taking of paint samples, Tony Rockwell worked with Caldararo to cut three square "windows" into the facing. The paint had early on sagged in two huge bulges to the rear of the lower half on either side of the central strainer, and there were many air pockets and fist-sized voids within the pigments DeFeo had spread in uneven gobs across her canvas. Given those prior conditions, the conservators' examinings, together with the ultrasound imagery and fiber-optic views, showed no further signs of collapse.

In October 1994, the Whitney Museum of American Art committed itself to acquiring the painting once the extraordinarily elaborate

and risky steps toward its conservation had been undertaken. (The decision was prompted by the curator Lisa Phillips's initial researches for the Whitney's current exhibition, "Beat Culture and the New America: 1950–1965," in which *The Rose* holds pride of place.) By early 1995, Caldararo and Rockwell had joined with mural conservator Anne Rosenthal to form the Rose Conservation Group, and the three of them finalized a treatment proposal as well as a plan, worked out with art-handler Scott Atthowe, for lifting and lowering the painting in a steel carriage from the conference-room wall and, when the time came, out the wall-sized window for transport to Atthowe's warehouse in Oakland and thence to New York.

In June, with *The Rose* in its protective facing and new carriage hoisted by a pair of gantries into a face-down position on a deeply padded platform, the group started excavating from behind. They stripped away most of the canvas wide of the center (where some slices between rays go clear to the support) and the top and side edges (where the paint layers often thin out to a mere smudge). The back surface that they exposed appeared shot with inconsistencies. Anne Rosenthal observed that the paint itself was "hard and brittle, but with 'osteoporosis' throughout." The cavities in thickly painted areas, where some of the paint remains uncured in malleable, cheeselike clumps, were seen to be arrayed like catacombs. Tapping on the exposed paint revealed still more cavities to be opened for filling. Occasionally, a small pine needle – presumably from one of the many defunct Christmas trees DeFeo tended to collect at Fillmore Street – would be found nestled in the pigment. By early September, Caldararo, Rockwell and Rosenthal had proceeded, after shielding with a polymer the more delicate areas of canvas and thinly applied paint, to consolidate the backside with a thick spread of epoxy putty, "fingers" of which were pressed into the air pockets and voids. With structural and aeronautical engineers and consultants from Industrial Light and Magic's fabrication studios, they devised and put in place a heavy-duty backing structure built up from multiple fiberglass and epoxy laminations. On top of this blanket they contoured (and further laminated) a plywood grid attached by ninety-two threaded stainless steel rods, hooked at one end

over the wood and set with epoxy into holes drilled in the thicker paint masses of the painting itself. The steel pins, Rockwell remarked, "make a good mechanical bond with the back of the thick paint masses and provide structural support to prevent the downward creep or cold flow of the paint in response to gravity." A hollow steel-bar frame was set into notches inside the perimeter of the grid to accommodate handling rods and hanging fixtures, and a similar but detachable lift frame was built to ease transporting the picture and setting it up for exhibition.

With its new backing – the entire structure now weighs over 2,600 pounds – the painting was hoisted again on the gantries and turned belly-up. (Seen this way, with its fabled "pregnant" profile raised skyward, it suggested the contour map of an ancient, partially collapsed ziggurat.) The conservators spent the next six weeks undoing Rockwell's protective facing: they chipped away at the plaster molds, plucked out excelsior stuffing, peeled back the pads of cotton muslin and tosa (mulberry) tissue and slowly warmed and extracted wax-and-rosin fillings from cracks and undercuts. They injected a synthetic resin emulsion into fragile areas of the paint and reaffixed many small chips that had come loose. They found the front mostly intact, firm, but with spots of mold and darkened areas of white paint (since any white will discolor when left in unbroken darkness over a long period). They cleaned the surface and performed inpainting with a removable acrylic resin on salient fractures, including one horizontal hairline crack that curved just above the picture's center point like a Madonna's smile. On October 12, *The Rose* was lifted by a crane off the balcony outside the conference room and lowered onto a flatbed truck. For another week, cleaning and inpainting continued at Atthowe's warehouse, and a few people were invited to view the picture there, at last upright in its lift frame. On November 9, flood-lit at the far end of a gallery corridor, it was brightly greeting visitors at the Whitney's "Beat Culture" opening.

DeFeo seems to have considered her paintings habitually in sets of twos and threes, or multiples thereof. She often worked in pairs but conceived of many of her paintings in triads. Of the numerous works leading up to *The Rose*, *The Eyes* and *Doctor Jazz* (also from 1958) occur as rare one-shot images; another, *Apparition* (1956) finds its companion

piece many years later, in *After Image* (1970). *The Rose* had its spiky, many-hued counterpart in *The Jewel* but also, DeFeo said, formed "a triptych" with two earlier, impasto-strewn paintings, *Origin* (1956) and *The Veronica* (1957), because they all deal with plant forms. A more telling factor about *The Rose*, however, is that the number of rays in the image (eighteen) correspond in kabbalistic numerology to the Hebrew word *Hai*, meaning "life."

No mistake about it, *The Rose* is a creation picture. In a talk on her work at Mills College in 1986, DeFeo likened its kaleidoscopic memory process to "a pinwheel where everything gets swept into it on one side [and] then, on the other, were things spilling out." In *The Rose*, "things" also spill out in a fair pictorial account of the unity of divine light caught in the cosmogonic act, the effulgent issue of which – the changeable universe – is that light's self-shattering. Of course, what distinguishes *The Rose* from other kindred, mandalalike images is its paradoxical, palpitating meatiness. Taken at face value, the thing is imposing. At a glance, the sheer mass flares into visibility of the kind to induce gulps in the unwary viewer, and its staying power – both as you look and as you call it to mind days afterward – is equally immense. It's that sort of head-on collision with ineffability locked into earthy stuff that had the intimates of DeFeo's process recalling the work, as George Herms did last year, as "the ultimate living being." If *The Eyes* is about sentience and *The Jewel* pinpoints in a flash the splendid irritability of matter, *The Rose* concisely summons up the subjective life of the infinite. It makes tumultuous creation look variously sociable and moody. The suspended image burns the near air, an incandescence that feels both related and alien to the muddy substances producing it.

Look closely, and you see the care DeFeo lavished on her project, and how well she knew what she was doing: how the reverse illusionism of highlightings on the bottom flattens the sculptural effect, bringing the outer flarings to sit optically in the same dimension as the central point, smooth and light-reflective and tender as a doily. And how regular one-point perspective is turned accordingly, switching the centric focus outward in the perceiver's direction. (DeFeo apparently conceived of plotting the center at her own eye level, but since she was

only about five feet tall, the five-and-a-half-foot-high midpoint jibed only when she stood on the mound of shavings that accumulated under her as she worked.) Every painting must make its pact with gravity. This one hinges, and rocks, from the median span, with wings (or flippers) scalloped at the extremities on both sides. The wide angle of the span, a sort of sprung horizon, makes a buoyancy while deep clefts in the rays below effect a shudder as if a gong had gone off at a depth behind the paint. The gross weight lifts from an inspissated, crotchlike fold about three-quarters of the way down the middle. Given the proper viewing distance, the elusive colors suffuse among themselves. There are obsidians across from charcoal blacks, and lambent whites next to grays that abruptly scintillate out of their leaden slurries. In the slurries are gouges and more delicate marks, like engravings on bone.

> *A small picture presented the interior of an immensely long and rectangular vault or tunnel, with low walls, smooth, white, and without interruption or device. Certain accessory points of the design served well to convey the idea that this excavation lay at an exceeding depth below the surface of the earth. No outlet was observed in any portion of its vast extent, and no torch, or other artificial source of light was discernible; yet a flood of intense rays rolled throughout, and bathed the whole in ghastly and inappropriate splendour.*
> – Edgar Allan Poe, "The Fall of the House of Usher"

A peculiar Gothic strain, typified by what Greil Marcus calls "a precious intensity," in the works of DeFeo, Conner, and others of their immediate circle links those California artists' mystic leanings – so often mordant or languid – with Poe. Thus, in a 1969 review, Alexander Fried said that seeing *The Rose* is analogous to "looking into a long, long tunnel . . . From the tunnel's glowing heart emerge bursts of . . . clouds or fallen volcanic stones and clods." The obvious parallel is with Poe's conjuring of one of the "pure abstractions" and "phantasmagoric conceptions" over which Roderick Usher's elaborate fancy brooded, and whose relative smallness is no underqualification. (Not all of DeFeo's works were big; indeed, many of the best ones of her later

years – the photo-collages she made with Conner in mind in the early 1970s and the exquisite oil paintings that mark her return to the "mountain" theme in the late '80s – are of modest dimensions.) Gothicness in its medieval guise historically held that the job of image-making was, as Roger Bacon put it, "to make legible the spiritual sense." DeFeo's own divinations have a hunt-and-peck candor: she pledged herself to a higher reality without much of a clue as to its contours or even at what elevation it might be found. She granted that Romantic touchstone, negative capability (in Keats's formula, "of being in uncertainties, mysteries, doubts, without any irritable reaching after fact and reason"), a permanent green light.

How much did DeFeo get in the way of her own picture? The work took her over for more than seven years and might well have destroyed her. (Consulting Cirlot's *Dictionary of Symbols*, as she did, she must have mused wanly over the passage beginning "the single rose is, in essence, a symbol of completion.") But the destruction had to have been, at least partly, reciprocal: compelled to heap everything onto the successive versions of the same surface, she very likely lost the definitive image in the process. The same could be said – indeed has been said – of de Kooning's *Woman I*, another abandoned work that achieves the improbable status of "failed" masterpiece. Like de Kooning, DeFeo was attempting a symbol that would be at once comprehensive (what else is artistic greatness but a terrific amplitude of vision posed outright for anyone to see?) and accurate. As it looks now, she very closely succeeded both ways.

1996

Hung Liu, Action Painter

You make a little culture for yourself – like yogurt.
— Willem de Kooning

It's very hard to draw a clear border.
— Hung Liu

The drenched look of Hung Liu's recent paintings follows from her will "to preserve and dissolve" in even, pointedly ambivalent measures. Fourteen years after arriving in America, Liu contends with a dual sense of herself as "Chinese from China" and "Chinese-becoming-American." Scanning the evidence of a China accessible in documentary photographs taken by European and American visitors from the mid 1800s onward, she will fasten upon and prod a detail so as to come face-to-face with a history she is part of but expects never to completely grasp.

The prodding is insistently pictorial. Liu typically speaks of "history's ultimate mystery" and then of the "madness" in painting, its overarching intentionality, which acts as a foil to photography's more random truth-effect. Given the bare compositional guide of charcoal tracings derived from projecting a slide onto the canvas, she proceeds to match her appetite for cultural knowledge with a renegade taste for the pleasures of unencumbered painterliness (the latter exacting a sweet revenge against the conceptually blinkered perfectionism of Socialist Realism, in which she received her early training). It's the quality of tension between these two kinds of salient fact – depicted document and painted paint – that decides a picture's singular strength. Nowadays, Liu's resourcefulness both ways seems boundless. Passages of liberated brushwork unhinge the pallid halftone from its album leaf. Curdling or corrosive, the remake of photographic imagery in the solvent light of painting can have an aggressive edge. In *Lanterns*, for example, rude streaks seep through seven densely rendered paper lanterns. (One of these gourdlike festive objects is inscribed with the

character for "happiness.") The runny paint leaves the ceremonial group looking hacked at and frazzled. Surface congestion is relieved by inserting into the picture's upper third a smart cameo couple from the bird-and-flower repertoire. The canvas is host to both "studio time," with its sequentially slow, procedural footfalls, and the teasing assertion of instant facts plucked from assorted irretrievable actualities, which is photography's special domain. In the overlay, what we see is simultaneity made recognizable as texture.

A year ago, Liu told the curator Kathleen McManus Zurko: "Between dissolving and preserving is the rich middle-ground where the meaning of an image is found. The process of painting has become the investigation of a document which stands between history and me." Liu's editorial method of playing out images rather than creating them from scratch may have earned her a place squarely in the field of present-day conceptualism, but by working over the putative fixities of historical record with a full array of painterly techniques, she has moved into, and handily remodeled, the premises of the one type of modernist painting that, in principle at least, closed the distance between history and whoever held the brush – the type Harold Rosenberg characterized in 1952 as Action Painting.

In Rosenberg's original definition, Action Painting promised a kind of backdoor version of Albertian *istoria* – the art's hope of big-time cultural respectability brought back home, as it were, through the service entrance. The hypostatizing means of delivery was the relentlessly purposeful artisanal mark – as Rosenberg neatly put it, "changing a surface with paint." In the "dialectical tension" between paint-as-paint and whatever image emerged, the once-sanctioned semblances of mythic figures gesticulating before eternity found their true mid-twentieth-century substitute. Piquantly glimpsable in such improvisational acting-out was a virtual History Painting. According to Rosenberg, the fictive surface formed of accumulated marks achieved probity as "an extension of the artist's total effort to make over [her] experience."

Over the past two decades or so, the operative terms of that makeover have been used in different ways for other purposes. The

rugged, action-y swathes, splatters, and runnels that by 1960 suffered preemptory absorption as the gorgeous but ultimately blank elements of a period style began a new existence in the 1970s as transposable and endlessly mutable signs, or, more simply, as images from or of which further images could be made. To cite the most obvious example: Pat Steir's transmutations of drips you might find in mid-'40s Gorky or early-'60s Norman Bluhm into "paintings of drips which form waterfall images," some of which in turn recall the cataracts and towering mountains of old-time Chinese paintings. In the case of Hung Liu's pictures – aside from her own feelings of solidarity with the gestural landscape style of the literati, as well as with such American predecessors as Willem de Kooning and Joan Mitchell – what may appear as an ornamental thinning of tube colors with a surfeit of linseed oil signifies in at least three directions at once. The drips are applied, Liu says, "to cut loose the surface"; in place of the Beijing Central Academy's cosmetically smooth resolution she puts forth "an ambiguous surface – unstable. I like to see how gravity does its work, to be surprised by how the flow moves, the colors it makes." Then, too, she adds, in Chinese to make photo prints is "to wash," so, by implication, the memories such images claim to embody have washed away, or faded.

Liu's spillways of color are also signs of conceptual overflow – of ironies so exorbitant that no margin or contour can contain them. To be a history painter now is to be aware of history's basis in particularities of moment as well as any moment's specifically fibrillating multivalence. Painting – a charged surface across which possible meanings skitter (some may stick) – is the perfect medium by which to register an historical consciousness uncertain of its own parameters. (An icon of such consciousness might be the pensive little girl in *Fisherman's Daughter*, her head tucked demurely inside a kerchief, her thought buoyed by the tiny boats that float in tiers about her.)

Significantly, Liu's boldest, brightest new work is the series of etchings juxtaposing traditional acrobats with examples of mathematical permutations according the ancient tangram of the Qi Qiao Ban. The clear, instructional look hardly masks the enigma that waits at the end of any systematic regimen. The prints might constitute a parable of

painting's orderly apparatus versus its tolerance for chaotic sensation. But, as Liu says (albeit in language Rosenberg would understand), "They could also be about a marriage. A rational system, but also the need for split-second decision: going through the hoop you stretch your body to the extreme – any second you might fall."

Addressing historical images with slashes and pourings of pigment, Liu concretizes anxiety about the terms by which a graphic image bids for recognition, how official memories confirm or contrast with her personal ones. Such ad hoc moves bewilder archival fact while intimating that new meanings may be held in suspension, as it were, between the drips. In turn, the painting as a whole throws into question the self-evidence of abstract forms.

One constant in all this is the unpredictability of what a photographic image will look like when Hung Liu represents it in paint. Although the color choices are hers, she says, "the photographs dictate some logic." A detail such as the one used for *Mother, Daughter and the River* may generate several versions, each with its own wildly different tonalities, except that the two women invariably appear in spectral grisaille. It's a hellish image, whether in a recent etching's sulfurous tints or in the present diptych's sunsplashed view. Bent to their task and clambering over sharp rocks that stick out from the shallow dabs and ripples of the fateful stream, the ghostly pair hauls an invisible load (the Raft of Sorrows perhaps, or Barge of Time?).

Prominent among Liu's recent sources have been the "Chinese-type" profile portraits done in 1868–72 by the American John Thomson for his book *Through China with a Camera*. As instances of a double exoticism the whole set is remarkable. (Thomson's way of seeing the "exotic" Chinese circa 1870 looks painfully exotic now.) But the most striking of these orientalist finds are the shots of women with enormous decorative buns of hair cantilevered from the backs of their heads. Liu's variations to date on this theme have occasioned some of her more raging painterly excesses. There are glamorous, late–de Kooningesque green-orange-yellow rainbow swirls, fully saturated chrome flares, a scrim of pale turquoise, and a few scoured pockets where the eye halts abruptly as at the rim of a void. Some of the leaner,

darker flows resemble liquefied ash. With the copious signs of gravita-
tional pull, there obtains an unallayable paradox: the picture, seemingly
overcome with its own liquefaction, keeps every figurative hair and
sinew in place.

1998

Music Pictures

The aura of photography is of a silence broken, if at all, by snaps – purposeful fingerings like those on a trumpet valve. Lee Friedlander's latest collection, *American Musicians*, is a superbly silent book, all the more so for its foregrounded typology of sounds made by the people depicted in it. Music is a good analog for what Friedlander in particular does with a camera. In a photographic mode that looks to be as much a documentation of personal physical response to the visual field as of whatever can be seen in the instant the camera clicked, his "stills" are full of implied counter rhythms from behind the lens. For the viewer, there's the continuous sensation of a mostly hidden, keyed-up, waywardly mobile character (Friedlander himself cast as a visitor from another world) improvising upon any given view with his handy perception-enhancing instrument, the viewfinder 35mm camera.

The retrospective of Friedlander's work that toured in 1989–91 took its title from the classic Charles E. Calhoun rhythm-and-blues lyric "Like a one-eyed cat peekin' in a seafood store . . ." The first seven images in the catalogue for that show, three of which appear in the new book, were of musicians – members of the so-called "atomic" Basie band asleep on a bus, Coleman Hawkins, Mahalia Jackson, and others, taken between 1956 and 1962 – but there, as far as that museological version of his career let on, the connection ended. In fact, however, Friedlander was the sessions photographer of choice for Atlantic Records from the mid 1950s, when he was in his early twenties, until well into the '70s. During those same years, he also did publicity work for RCA and Columbia. (For the latter, he made many photographs of country-music figures, as well as a series of stunning headshots of Miles Davis.) In Aberdeen, Washington, where he grew up, Friedlander had begun taking photographs professionally at age fourteen, in 1948; two years later, after hearing his first Charlie Parker record, he developed a parallel enthusiasm for improvisatory music. In 1956, having dropped out of art school in Los Angeles, he went to New York. One of the two dedicatees of *American Musicans* is the late Nesuhi Ertegun, co-director with his younger brother Ahmet of

Atlantic. The other is the photographer's son, Erik Friedlander, now in his late thirties, an accomplished cellist and composer.

Friedlander's previous music book was *The Jazz People of New Orleans*, a 1992 compendium of photographs he had taken of marching bands, small groups, and individual players in and around that city beginning in 1957, when he accompanied Nesuhi Ertegun on a scouting visit there. In *American Musicians*, some of the same players show up again. Their names themselves are photogenic: De De and Billie Pierce, George Lewis, Wellman Braud, Isidore Barbarin, Snooks Eaglin, Wooden Joe Nicholas . . . In *Jazz People* there's a tight closeup of a music stand and a microphone far behind which Joe James adopts a faraway look as he considers from his piano bench whatever the guitarist-singer William "Specks" Robinson is putting forth. It's the activity of intense, committed *listening* – of attending to sounds as part of making and combining them – that both books so beautifully convey. That, and an eye for character similar to Whitney Balliett's in his description of the Creole multi-instrumentalist Manuel "Fess" Manetta: "He has a hound dog face, with a pendulous lower lip that folds up like a drawbridge when he speaks."

American Musicians is set in a near-square format that recalls the look of mid-century ten-inch record sleeves. This format is repeated, ranging in dimensions from full-page to considerably smaller, for many of the 514 photographs, especially those in color that were made with a Mamiyaflex and intended for use as actual front-cover images. (Interspersed throughout the book are well-known portraits of the likes of Charles Mingus, Ornette Coleman, Chris Connor, Mabel Mercer, Sarah Vaughan, and Lefty Frizzell.) The most perplexing colors are those in the picture of Lennie Tristano that was used, with different cropping, on the front cover of Atlantic's 1962 LP *The New Tristano*. Across the top half, behind the pale figure of the blind pianist in tan T-shirt, spreads a nasty, nameless array of purple-, blue-, and brownish-dyed textures – curtains and wallpaper, I guess – that throw over the whole setting an undersea light.

Country musicians show up dressed in variants of red, blue, and yellow. It appears that Friedlander seized every opportunity he could

get to pose them outdoors, framed mostly by fences or trees. (They sit on the fences and lean against or stand before the trees.) One remarkable picture has Tammy Wynette standing in the middle distance in a kind of rose-tinted majorette's dress and shiny, bright red boots; she's backed up against a tree trunk with a lot of big, ambient foliage closing in. Another, more archetypally screwball Friedlander arrangement shows the vocalist Arlene Hardin stretched out along a slow diagonal in pink cotton and white pumps on freshly mown grass, her somewhat defiant expression (perhaps just her way of compensating for a severe overbite) veiled by a soft-focus baby pine tree plumb in the center.

Friedlander has said: "You have to be responsible to the subject. A flower can't look like concrete." Some of his facing-page layouts set up palpable contrasts. In mood – in comparable sense of moment, even – two pictures of gospel groups, one African American and the other white – *James Shorty and Family, 1960*, and *Estil and Orna Ball Group, Grassy Greek, North Carolina, 1961* – read across the gutter as inversions of each another. Even so, most of the photographs in *American Musicians* are markedly transparent. They're just shots – documents straight-up by a professional photographer – of people either at work or on a break between numbers or sets. Some of them could just as well be images on trading cards. The term "ultraclean realist," which Friedlander applied to E. J. Bellocq, whose images of New Orleans prostitutes he collected and reprinted in the 1970s, applies here, too. I'm told that, in sorting through the photographs here, Friedlander himself says he didn't dwell too much on their artistic merits, but his interest shows everywhere, and, more often than not, his unique sensibility comes skittering into the frame, as well.

What makes the people in these pictures, personalities from the music world, different from the ones that pop up unnamed in other Friedlanders? Essentially, nothing. Some names ring like the subway turnstile bell that, in the '30s (e.g., before fame came knocking), de Kooning said he imagined sounding a fraction louder as he passed through. Some of Friedlander's subjects are viewed up from under for statuesque effect. Others – many, in fact – are lesser lights, though not necessarily inconsequential musically. Among the unidentified street

musicians in Chicago and New Orleans you readily spot those you want to know, or more properly, to hear. "The complete absence of glamour" that Martha Rosler once noted in Friedlander's pictures serves his images of sometimes helplessly glamorous performers especially well. So forceful is his way of returning us to flat-out, zero-degree perception that any prior distinction – in this case, a person's celebrity status – is automatically put on hold. If Ray Charles or Mingus looms large among the many companion figures, it's because that person projects such a distinctive look, and not for what else we know about him. What is most striking about the image of Billie Holiday's funeral that closes *American Musicians* is the very ordinariness of its pomp. Friedlander told Malcolm Jones Jr., "These were very heroic people to me, and that's how I approached them." For how effectively heroic character can be communicated, see the series of studio and club-date images of Sarah Vaughan from 1956, culminating with the one of her sitting with Morris Levy and Billy Eckstine during a rehearsal session. But, to paraphrase something Steve Lacy says in a conversation with Friedlander transcribed at the back of the book, the point is not "the glitter" but a life, as it were, of regular work. In the second of two portraits of Mingus, the bassist's huge face, seen in shadowy closeup, is impressive, but even more so is that of the instrument, the neck and scroll of which appear to rise up independently like an idol at his side, grimacing fiercely.

By conventional logic, the closest equivalents to the pictures in this book should be the images Friedlander made in Wisconsin in 1985 at the invitation of Cray Research, Inc., of people at work in that company's computer manufacturing plant and, later that year, of others similarly occupied at MIT – both sequences fascinating for the patently transfixed expressions of those workers at their apparently simple tasks. However, the musicians as Friedlander envisions them rarely seem to be doing much of anything – frenetic as they may appear, they don't partake in what could be called action shots. To that extent, the Friedlander nonmusic picture that best matches up in tone with those in *American Musicians* is *Egypt, 1983*, in which eight or nine stray dogs face towards or away from the camera, at rest (albeit absolutely attuned

to the occasion) on a desert slope, beyond the rim of which can be glimpsed the upper portions of a couple of pyramids and the head of the Great Sphinx.

1998

The Photographist

The gallery walls devoted to the sumptuous Carleton Watkins exhibition at the San Francisco Museum of Modern Art during its inaugural run there last summer were painted a variety of solid, somewhat somber colors keyed to a thematic arrangement of Watkins's photographs. From a narrow, deep-grape entryway you passed into a fairly orderly maze of rooms successively decked with mustard yellow (for "San Francisco and Vicinity"), lichen green (for "Yosemite"), and so on, through blue and mauve, and (for the late works of "New Series") back to green. The pictures – original prints of different sizes, from small stereocards to the multiplate panoramas and so-called "mammoth" wide-angle views on which, beginning in the early 1860s, Watkins's fame first rested – were hung at intervals around the rooms in black-painted wood frames. A final gallery had twelve computer terminals equipped with especially designed goggles for viewing a programmed selection of two hundred out of the thousands of stereographs Watkins made during his long career. Using new technology to get a high-resolution version of the effects of the old, museumgoers could "flip through" the assortment electronically and, with a double-image card brought into instant binocular focus, take in this once-ubiquitous medium's impressive, realer-than-real (hence really weird) three-dimensional immersion experience at a click of a mouse.

In every room, running along the base of the walls, was dark brown wainscoting. The period look of the galleries matched up well with the surface hues of Watkins's photographs – sepia, lavender, light blues, purples, blacks, creams and grays, and the gold tonings, which were among his specialties. (The subtleties he coaxed from a liberal use of this expensive process of letting gold bond with the layer of silver particles on the albumen sheet to deepen the tones and register distance are among the greater glories of his work.) But the slight mismatch of elegant wall colorings with dadoes that smacked more of Victorian schoolrooms than parlors or exhibition halls was especially appropriate for Watkins's peculiar mixture of earnestness and stunning excess, as

well as for the cultural history within which the show's curator, Douglas R. Nickel, means to locate him. The overarching wonder of Watkins's great pictures – and there are enough of those to secure a place for him in the first rank of photographers ever – is based on their mundane, but no less insistently high-pressure, practicality.

To Lewis Mumford, the Civil War years, during which Watkins emerged as an artist, saw "the colors of American civilization abruptly changed. By the time the war was over, browns had spread everywhere: mediocre drabs, dingy chocolate browns, sooty browns that merged into black." Accordingly, Mumford identified the ensuing thirty-year phase of the arts in this country as "the Brown Decades," the title of his 1931 book on the subject. The painters who made their own equivalents for this color scheme were Winslow Homer, Thomas Eakins, and Albert Pinkham Ryder. As Mumford noted, the spirit of the times was "spattered and muddied":

> The means of life were changing rapidly from the [1850s] onward; here was a necessity for inventive adaptation which turned men from the inner life to the outer one, and to such manifestations of the inner life as had a plastic or structural equivalent. For lack of an harmonious system of concepts and feelings, this necessary change did not lead to an intelligent adaptation of the environment; in the planning of cities and the layout of railroads, highroads, farms, in the exploitation of mineral resources and the utilization of the land, a good part of our soils and cities were ruined; indeed, the new industrial towns were ruins from the beginning. But the necessity for invention was present, and if it was passed over by the vulgar profiteers . . . and industry, it was nevertheless a challenge and a stimulus to the best minds.

The point of Nickel's installation, and, more so, of his catalogue essay, was to put Watkins's work and its way of manifesting his "engagement with the phenomenology of perception" firmly and instructively in the proper milieu. Inspired by such recent scholarly texts as Jonathan Crary's *Techniques of the Observer*, Nickel argues that, rather than perpetually reaffirming Watkins's excellence as a proto-modern anomaly ahead of his time, we must see how "both the photographer and his

audience were products of, and responding to, new modes of visuality emerging in the nineteenth century, brought about in part through modern innovations in the realms of entertainment, communications and travel." Among the optical devices and entertainments then in play, Nickel brings to the fore Eadweard Muybridge's motion studies, "railroad vision" (or how travel by Pullman car "warped the . . . individual's perception of space"), painted panoramas and dioramas, the household stereoscope, and other optical entertainments. All of these existed in tandem with, or because of, the improved camera. Watkins's own, unique improvements in the medium, Nickel says, "defeat interpretations of the narrative or symbolic sort because they aspired to be something altogether different from traditional art: they aspired to be perceptual, to engage the sensibilities of their beholders in an exercise of ocular gratification and visual intelligence."

Watkins's perceptiveness amounted to what the French call *le compass dans l'oeil*, like perfect pitch in music. His artistic engagement with this faculty extended first to a fascination with view finding as such and a quick grasp of the terms of early photography, particularly its way of fastening on spreads of seemingly infinite, sharp detail. It's possible to see photography's success and the "ocular possession" that Crary says came with it (preeminently by way of the tantalizing stereopticon) as symbolic of the era's general acquisitiveness, but Nickel is careful not to lay complicity with the bad habits of capitalism too mightily at Watkins's door. When Watkins photographed Yosemite in 1861 it was already taken for a correlative to the economic upthrust of the American West – a primeval, catastrophic landscape hailed as lordly emblem for the commensurably catastrophic obligations of Manifest Destiny. Twelve years later, thanks largely to the circulation of Watkins's images, it had roads and a major visitors center. For most of his career, Watkins was charged with making accurate images of parts of the physical world as prospective elements for an improved material life. Historians readily write of him out on some ledge, "prospecting" for views. He photographed cities and their crowds, mountains, rivers, deserts, iron works, mines, lumber mills, oil fields, bridges, railroads, ferryboats, agriculture and horticulture, dams, hotels, dilapidated mis-

sions, shipwrecks, residences of the new rich, and workers in all these situations. In every instance, history adheres to his pictures. He was often invited to document burgeoning industrial sites. His places are full of felled trees.

We know Watkins was ambitious but not exactly how he wanted to be seen. Like Eugène Atget, whose photographic career began just as Watkins's was winding down, he left us, aside from the evidence of the work itself, next to no clues as to his intentions and none at all regarding his attitude toward his subject matter. There are huge gaps in our knowledge of him, most of them due to the loss of almost all of his papers, along with the prints and negatives that remained in his shop, in the San Francisco earthquake fire of 1906. This was the capper on a long list of misfortunes. In 1866, a New York firm pirated his early Yosemite images; in 1875, after a relatively prosperous decade (during which he nevertheless went heavily into debt), he was caught in a wave of bank failures and lost his gallery and its contents to a creditor who turned Watkins's negatives over to an unscrupulous rival; by 1890, in his sixties, Watkins began to suffer from incipient blindness, arthritis, and persistent vertigo; five years later, he was sheltered with his ever-discontented young wife Frankie and their two children in a boxcar; after the 1906 fire, he lived another ten years, the last six of them in a mental hospital, where he died, bleakly, aged eighty-seven. Compromised by a seemingly unyielding naïveté, felled by circumstance, Watkins joined the ranks of eminent California casualties: Johannes Sutter, Watkins's early patron John C. Frémont, and at least two more of Watkins's immediate circle, Albert Bierstadt and Frederick Law Olmsted – even the wildest success stories were often tinged, if not terminated outright, with severe financial setbacks, other forms of hard luck, and ultimate dementia. The general mood of the time, as Mumford writes, "was sometimes less than tragic; but at bottom it was not happy."

The artist now known by the trim, euphonious name of "Carleton Watkins" is the same as "Mr. C. E. Watkins, the eminent photographer of San Francisco" whose arrival in 1867 in the Dalles, Oregon, was noted in a local newspaper. For a while, in the catalogues and critical

literature of the 1980s, the first name was spelled out and the middle initial retained, but both Nickel and Weston Naef, who curated the other large Watkins show that opened in February at the Getty Museum in Los Angeles, have adopted the short form. Most of what we know about Watkins's life derives from the research of Peter E. Palmquist, whose chronology, originally printed in an elegant little handbook published by the Getty in 1997, has been updated and expanded somewhat in Nickel's catalogue. Palmquist tells us that Watkins was born to the proprietors of a hotel in Oneonta, New York, in 1829. At the age of twenty-one, he followed his older childhood friend Collis P. Huntington to San Francisco and thence to Sacramento, where, for the next three years, he worked variously as a carpenter and as a clerk in Huntington's hardware store and in another fellow Onteontan's bookshop before finding himself, apparently by chance, as a replacement operator in a daguerreotype studio. (By 1856, a newspaper advertisement cast him as an expert in Ambrotype portraiture, specializing in baby pictures.) Huntington, who began his California adventure modestly enough by selling supplies to the gold fields, soon became one of California's "Big Four" financiers, embarking with Mark Hopkins, Leland Stanford, and Charles Crocker on building the Central Pacific and Southern Pacific railroads. Over the years, Huntington's railroad, shipping, and agribusiness connections provided Watkins with a number of important documentary projects, as well as free passage for himself and his wagon and elaborate equipment to distant sites. In the 1880s Huntington assigned Watkins to shoot the real estate along the financially troubled Central Pacific's right-of-way to promote the farming ventures that Huntington was encouraging there to recoup his losses. It was Huntington, too, who rescued the Watkins family from their boxcar doldrums in 1896 by deeding them a small ranch.

Although Watkins never went on record as considering himself a fine artist, he was interested enough to know other people's opinions in that regard. There's a twinkle of irony mixed with pride in his report to a friend on the reception of his final views of Yosemite Valley: "Everybody says they are better, softer, more artistic, etc." He clearly

had nothing in common with documentary hacks, and, as Nickel points out, unlike his peers William Henry Jackson and Timothy O'Sullivan, with whom he has typically been grouped, was only rarely an expeditionary photographer, and even then, the teams he joined up with were of a low-budget, specialized, scientific character rather than the federally endowed, long-term surveys for which the others worked. Included in Watkins's enterprise, however, for him as much as for Jackson and O'Sullivan, was the task of verifying the indescribable for a majority of the population without firsthand knowledge of the awesome western vistas that these adventurous photographers were becoming accustomed to haunting.

His immediate audience was a select one, many members of which shared what Mumford calls "a new sense of the land [that] was scientific and realistic . . . chiefly the work of a handful of naturalists, geographers, and landscape planners." Literati like Emerson and Oliver Wendell Holmes admired and wrote about his work. In Jesse Benton Frémont's San Francisco salon, presided over by the Unitarian minister Thomas Starr King, he met accomplished landscape painters like Thomas Hill, Virgil Williams, and William Keith. Bierstadt saw Watkins's Yosemite views in the early 1860s and later bought a set of them for $600; in his second painting trip to the valley in 1872, however, Bierstadt was accompanied by Watkins's arch-competitor Muybridge. Watkins's scientist friends and supporters included the exploratory geologists William H. Brewer, Josiah Dwight Whitney, and Clarence King and the botanist Asa Gray. When Gray's Harvard colleague Louis Agassiz visited San Francisco in 1870, Watkins photographed the great naturalist standing chalk in hand before a board strewn with drawings of primordial animal shapes. A couple of years earlier, Whitney had given Agassiz's name to the strangely jointed and contoured rock that became one of Watkins's favorite subjects in his "New Series" Yosemite work.

Another, even more intriguing connection is the one between Watkins and the landscape architect Olmsted. Like Watkins, Olmsted, who early on styled himself a footloose gentleman farmer, wandered unprepared into his art. One of the heroes of Mumford's historical narrative, he was first lured to California in 1863 by the trustees of the

Mariposa Estate, the gold-mining operation that bordered on Yosemite Valley to the north. The Mariposa had belonged to the Frémonts, but John Frémont had sold his and Jesse's majority interest in it after losing much of his fortune in a series of unsuccessful political campaigns. Olmsted became superintendent-manager of the Mariposa in late '63. The next year, partly due to Watkins's documentation, the U.S. Congress declared as "inviolate" both Yosemite and the adjacent Mariposa Big Tree Grove, and California's Governor Low appointed Olmsted chairman of the first board of commissioners. Olmsted in turn assigned Clarence King to survey the boundaries of the preserve and asked Watkins and his painter friend Thomas Hill for suggestions as to how best to treat it. Olmsted, whose connections with his original Central Park plan were severed during the war, envisioned Yosemite unsentimentally as a kind of open-air natural science museum, which was pretty much how Watkins, tutored by the naturalists, pictured it. (When Fitz-Hugh Ludlow, Bierstadt's companion in his first Yosemite visit, wrote a bombastic description of the place, Olmsted promptly called Ludlow's account "an abomination.")

Unlike the painters, photographers had no recourse to dramatic lighting or atmosphere to tie the details of their sublime landscape conceptions together. Muybridge, who, like the painters, tricked out his Yosemite scenes with anecdotes and atmospheric flim-flam, was dashing and complex, and some of his pictures now look like overacting. Watkins, whose pictures continue to look fresh, was purposeful, no less agile, and a splendid simplifier. Like today's imp of the spectacular, Bill Viola, whose retrospective coincided with the Watkins show at SFMOMA, Muybridge was a master of legerdemain and garrulous middlebrow metaphysics. By contrast, Watkins's accounts have a tight-lipped, "look-here" positivism.

Whether working on commission or for the open market, Watkins was a thoroughgoing professional; his professionalism was a large part of his genius. His practice was unusual. He liked to display his pictures in custom-bound presentation albums and to stack them in black walnut frames salon-style on the walls of his Yosemite Art Gallery and at expositions. He also tended to hold out for prices higher than the pop-

ular market could bear. The record shows nothing of what he may have thought of the goings-on in land speculation or the social or environmental conditions in the cities and mining camps, which the pictures so often record. Any "investigative" aspect to his procedures would have to be an anachronism – it's unlikely that anything untoward captured by Watkins's lens got there other than inadvertently. In any event, taken cumulatively, his work comprises a kind of book of hours showing the conditions of life along the outer reaches of the continent (and on occasion, as far back east as Montana) in the last half of the nineteenth century. The photographs show his capacity for all that he could take in, hold, and in turn assert so as to make it presentable to viewers variously informed (or eager to be) or resolutely skeptical. Inadvertently or not, Watkins grasped his own, and the nation's, need for a conscionable rhetoric.

In 1858, appearing in one of the land-dispute cases for which he furnished testimony in the form of photographs he had made along with his spoken assurance as to their accuracy, Watkins described himself as "a photographist." The need for larger images to function in courtroom settings may have led to his eventually ordering from a cabinetmaker a camera that would hold negatives as large as eighteen-by-twenty-two inches, but it was immediately following delivery of the camera, duly fitted with a Grubb Aplanatic Landscape lens, that Watkins set out to take his first Yosemite pictures.

Nickel's selection is restricted to outdoor views; hence no portraits, set pieces, or still lifes and only one or two architectural studies. (Weston Naef's choices at the Getty are also mainly landscapes, with more pictures of buildings and two portraits, one of Jesse Frémont and the other of an unnamed Chinese actor.) Fair enough. Outdoor photography was what Watkins prided himself on. In 1878, geared up for the penultimate surge of his imagemaking career, he advertised himself as "the leading landscape photographer . . . from Alaska to Mexico." Few of the landscapes have any people in them, and when they appear, they serve mostly as scale markers for gigantic natural facts, like the guide posed at the foot of the "Grizzly Giant" sequoia in the Mariposa Grove. Whatever Watkins's motives, it's hard not to feel, when con-

fronted with examples from his Yosemite or Columbia River pictures, that the person who took them was unusually responsive to the sights that such places afforded. The amazement, glee, even exaltation he found in the face of what he set out to photograph can be imagined if not really demonstrated. Nevertheless, the strength of his literally "gritty" realism derives partly from how a sense of bodily self-assurance – of being "on the spot," as Whitney would put it – inflected the operations of his machines. Physically, Watkins was a strong, stocky type – about 5'7" but with broad shoulders and large hands. Well into his fifties he could muster the stamina for long, hard treks with mules and accoutrements on new campaigns up and around places like Glacier Point, Mount Shasta, and Round Top, and then for the arduous tasks of preparing, exposing and storing his huge glass-plate negatives under difficult conditions.

In those settings, part of the job was to discriminate graphically one spatial element or distance from another, a ledge in the foreground from the ridge facing it across a half-mile divide. In this regard, Watkins was a perfectionist. It's been remarked that the details in a stereograph flatten and poke out at you like flaps in a child's pop-up book, while the split between one shred of vision and the next is abrupt and freakish. Watkins enlarged upon this binocular disparity by tweaking the lenses further apart than was normal to arrive at even more drastic perspectival jumps. The result is a space littered with sudden, glassy voids or otherwise unintelligible transitions between jaggedly contiguous stuff. But in the big prints, it's the stuff itself, mass rather than spatial relations – the sheer spread of rocks, water, wood under blank egg-white skies – that Watkins best communicates. Still photographs of very still things, the mammoth views, taken one by one, show not an instant but an accretion.

Obviously, Watkins would use whatever came to hand to make his images both legitimate and legible. For his "stills," he used exposures through a lens uncapped for periods ranging from fifteen seconds to half an hour. For images of falling water, as in what became the graphic efflorescences of Yosemite and Multnomah Falls, there's the shock of salient photographic time: a cleanly delineated, brilliant blur. With

objects, the simplest, starkest symmetry would do: In any photograph, a solitary tree cast as a central character will tend to look ill at ease; Watkins's specimen trees – the buckeye draped absurdly over a shack, for example, or the explosive arbutus menziesii pursh stranded in a plowed field – are no exceptions. For prospects of town or field, one device was the smallish, highly reflective, often geometrical detail – a white house – placed in the center to snap the scene into focus, much like the tiny dabs of crimson Monet and Renoir placed in their otherwise de-centered Impressionist scenes. In his late work, Watkins ratcheted up his bare-bones plainness to an acme of almost unbearable clarity. Beyond the clean forms are any number of fabulous messes, visions of places so desolate or chaotic that there could be no angle from which to set them right. To contemporary eyes, the near-perfect waste of *Mt. Lola; Looking NW Showing Effect of Wind on Trees*, as well as many of his studies of hydraulic mining, is just as ennobling as the more classically plotted views.

As a describer of surfaces, Watkins found his touchstone in the thirty-foot-high, unplucked, weathered remnant called variously – in the midst of the naming frenzy to which Yosemite in the 1860s was subjected – "Ten-Pin Rock," "the Magic Tower," or Agassiz Column. (Ironically, when Josiah Whitney named the rock after Louis Agassiz, who in his youth had proposed a theory of "ice-age" formations over millennia, neither man could have known that in fact it had survived as part of the granite that rose above the line of maximal ice and thus wasn't worked on at all by glaciers.) For some sixty years, the Column was a notable feature at the Union Point overlook. Still visible from below, it is no longer on the park map because the trail that led past it from Glacier Point down into valley was rerouted in 1928. A recent color snapshot by the poet Clark Coolidge finds it, seen from above, to be a speckled reddish-brown lump of no sure size; holding, as Coolidge writes, "a chock in its mitten," it's obscured in parts by branches of Douglas fir and chaparral, framed by them and matted against the far cliff.

In Watkins's more head-on portrayals, the scale of the thing is graduated upwards. In one print from 1878–81, the rock, taken as if from a hovering point in midair, looms high above the compound of

buildings on the valley floor – to its right Yosemite Falls, to its left two masses of granite, one a few feet and the other, in a golden haze, an indeterminate longer distance away. Where the sky would be is a uniform grayish blank, which defines both the far horizon (the ridge line) and the uppermost cleft of the rock with one long, graceful curve. The image is tight but, due to foreground shadows, unclear. The clearest shot of the Agassiz Column is the Getty's small (nearly five inches square) 1878 vignette, in which many of the same details occur but with no shadows to mar the face. The ur-boulder in all its singularity strikes a pose that could stand to characterize the sublimity that is the largest aspect of Watkins's work, its steady candor, with a fillip of something extra, taut, a vibration inside the monolith.

2000

The Searcher

Elmer Bischoff is generally regarded as one of the leaders among the so-called Bay Area Figuratives – painters in and around San Francisco who, after contributing to the initial local emergence of abstract expressionism during the 1940s and early '50s, shifted the terms of their spectacularly sensual brushwork to explore recognizable imagery. If David Park was the classicist of the founding triad of the group, and Richard Diebenkorn the modernist, Bischoff was the romantic. (Such distinctions seem a bit fussy, however, when you consider that all three were typical American moderns in the pastoral mode.) Park continued painting figures until his untimely death at the age of forty-nine in 1960, whereas, over the next decade and a half, first Diebenkorn (in 1967), then Bischoff (in 1972) returned to abstraction, albeit markedly different from the kinds they had practiced in their youth.

Bischoff's pictures are full of tensions between an obvious delight in the material, protean facts of painting and his oft-stated ambition to create a work that would sweep all such facts aside, to arrive at what Bischoff himself called "totality" – a wholly encompassing vision with the power to strike chords deep in the viewer's consciousness. His pictures tend to be reveries, possessed of an ever-deepening nostalgia for an infinitude of sentiment: a lone boat pulled up on a cove; a bather against a crashing wave; a profligate dawn coming over a ridge; sunsets on land and sea. In the 1960s, in the midst of his figurative phase, Bischoff said: "My aim has been to have the paint on the canvas play a double role – one as an alive, sensual thing in itself, and the other conveying a response to the subject. Between the two is this tightrope." Using paint to cultivate feeling, he wanted a resonance beyond substance – or, to put it another way, he wanted *substance* in that other sense defined by *Webster's* as "an ultimate reality that underlies all outward manifestations and change."

Accordingly, Bischoff's somewhat schoolmasterish sense of esthetic probity was definable by such keywords and phrases as "unity," "freedom," and treating the canvas as "an area of search." Although, as he searched for a direct line from visual fiction to inner life, he was drawn to

the generalized and primeval, he had a good eye for detail. ("I get nourishment from this spot," one artist who attended his classes at University of California, Berkeley, during the 1980s recalls him saying.) The drama of his art in its entirety can be seen as a struggle over how to bust out, to maximize the breadth of vision – and with that, of emotion – while keeping all the constituent parts in place. Perhaps this is why every wall in his figure paintings seems to give, or to be stretched beyond its limits, toward a more spacious, yet ever-judiciously built-up, view. For all the flamboyant brushwork, Bischoff stayed styleless. Inconsistency was the point: one idea of freedom was to let a painting vocalize in several registers at once, thereby suggesting a correlative fullness. Guided only by this liberation theology of art, Bischoff's search pattern, like that of many artists, was circular: remnants of the "twirling, strutting and flying forms" that Alfred Frankenstein saw in Bischoff's mid-1940s abstractions can be spotted in those of the '80s. As it happened, he let his originality shake loose in the ebullience that is the glory of his late work, those hither-thither flurries of pictorial incident that, by dint of pushing the question of certifiable dramatic import to one side, resolved much of the stress.

Bischoff came of age as a painter at the start of modernism's post–World War II hypermaterializing phase, when the candor with which an artwork declared its physical characteristics, whether impacted or evanescent, was likely to be matched by a concomitant, and equally immoderate, bid for transcendence. In 1946, Clement Greenberg announced that it was advanced painting's mission "to identify itself with its material vehicle, with paint and canvas, surface, and shape." That same year, Bischoff returned from his stint as a noncombatant in the U.S. Air Force in England to the San Francisco area, where he was born, and began his re-education on the faculty of the California School of Fine Arts (CSFA, now the San Francisco Art Institute). At CSFA the exemplary markers along the thick/thin scale of insistent physicality at the time were Clyfford Still's "blistered slabs" at one end and Mark Rothko's sentient banks of color at the other. Bischoff, for his part, later recalled being especially "keen about" what Rothko was doing, and his feeling for the older artist's work remained with him. His paintings of figures in rooms are full of nondescriptive, scumbled areas, similar to Rothko's

"multiforms" of the '40s, where the terms of description – light source or indoor/outdoor – become reversed. (The feelings of urban confinement in those smack as well of Rothko's 1930s subway scenes.) You can see reminiscences in Bischoff's late abstractions of the earlier "mythomorphic" Rothko of *Slow Swirl at the Edge of the Sea*, 1944, a picture that entered the collection of the San Francisco Museum also in 1946.

Harold Rosenberg remarked that the archetypal Action Painter of the '50s would be "not a young painter but a reborn one. The man may be over forty, the painter around seven." Although Bischoff had his first one-person show in 1947, at the age of thirty-one, he was pushing forty before he hit his stride. He was an in-betweener in more ways than one: born in 1916, he was five years younger than Park, six years older than Diebenkorn and only a few years the junior of such first-wave abstract expressionists as Pollock, Motherwell, and Reinhardt who had appeared as full-fledged artists while Bischoff was still in his self-avowed "Picassoesque mouthings" phase. While, undoubtedly, one reason for Bischoff's slow start was the four and a half years taken up with his Air Force duties (he spoke of also having to consider, once the war was over, what it had meant), another may have been that he needed time to move beyond the "open-form" type of abstraction then being practiced among his peers. Compared to his later paintings, his early abstractions occasionally look cramped. The figurative approach he adopted in 1952, following Park's lead, released his enthusiasm for both color and the physical expanse of the surface.

Bischoff was first and foremost a colorist, and in this he was true to the latter-day symbolist impetus that ruled his art. Beside Rothko, his "models" (as he called them) included Titian, Rembrandt, Goya, Lautrec, Kandinsky, Bonnard, and Munch; you can see Gauguin (the first to identify color as the primary factor in an art of endless suggestibility) in his broad camouflage patches of mottled tones. He constructed immense seawall-like horizons against which dense, blocky driftwood chunks toss and the more acrobatic hues swim and dart like gulls feeding indiscriminately on and off shore. What his bravura color most wants to do is surge. His great sweeping displays of it go right to the canvas edges and often find their finest moments there.

Bischoff's virtuosity in the realm of color resembles that of Hans Hofmann – with whom some of the young Bischoff's 1930s Berkeley professors had studied, and the announcement of whose gift to the university of forty-five paintings plus $250,000 towards a new art center in which to house them coincided with Bischoff's own appointment to the faculty there in 1963. As with Hofmann, sheer handling assumes responsibility for most of the highs and lows of Bischoff's art, the grand breathing (sometimes heaving) vistas and the choked, over-lathered ones. Both artists regularly offset their painterly extravagances with the conceptually bare-bones armature of a cruciform grid. Like Hofmann at his most symphonically romantic, Bischoff shows innumerable transubstantiating things that color can do when handled in innumerable ways. (And only Hofmann could match Bischoff – once the latter got going, with his full-tilt, late-figurative "Wagnerian" manner – in the *schwarmerei* department.) Bischoff's mixed-up colors – cadmium and alizarin reds and oranges, lemony yellows, hot pinks, cobalt, violets, deep mahogany browns, turquoise, spinach and other, acid, euphotic greens – have a deliberately sought-after impurity. (Hofmann, by contrast, was never interested in tone.) Bischoff could make white soft and gritty like air landing on an inner-city windowsill or else piercing, with a quartzlike brilliance. He trusted his paint to achieve an impassioned glow when divided into bands and flecks of color. The resultant aura, evenly intense throughout, has the strength of prior experience committed to memory.

In succession, both Park and Bischoff began their new figuration in a get-acquainted mode of tight, clear-contoured renderings of people in ordinary settings, absorbed in their tasks. It was clear from the outset that what was being sought was a way to make recognizable images with surface energy equal to that of the most energetic abstract painting, but the expansive brushiness associated with Bay Area figuration came later, around 1955 (coincidentally the same year that Diebenkorn began painting still lifes and landscapes and initiated group drawing sessions in his Berkeley studio). The kind of exploded Intimism Bischoff invented at about that time stands as his major contribution to the representational mode. Against extremely static situations he would play a razzle-dazzle of brushy dynamics – unorthodox chromatic twists, shaggy stretches of

chiaroscuro, and the like. Not every detail in a scene is recognizable, though many are, and unrecognizable parts are readily understood as areas of color that contribute to the mood. Often, as John Ashbery said of Bonnard's pictures, "shapes dissolve and outlines swoon." Mood is feeling's formal residue. There is light without reflective surface: a contradiction. Everything, including color, bears the poignancy of something remembered, an afterimage doubling as a steady adumbration of effect.

The Bay Area Figuratives were notorious for their seemingly paradoxical refusal of realism. Except for brief moments in Park's and Bischoff's paintings of the early '50s and in some of Diebenkorn's graphic work, direct observation of the kind practiced during the same period in New York by perceptual realists like Fairfield Porter and Alex Katz or sensibility painters like Jane Freilicher was pretty unanimously disdained. (In New York, the general figurative approach, comparable to the Bay Area one, was also known as "gestural realism" – or, in James Schuyler's phrase, "Action Painting with nameable subject matter.") For Bischoff the outer world served mainly to jog his memory and trigger the emotions that were the point of making art. Appearances were negligible for him compared to the sublimation he believed should occur. This was opposed to the emphasis of sensibility of a painter like Freilicher who, when she painted a reclining figure in the early '50s, would sometimes lie down to see how it felt. Bischoff's figurative works are stunning for the absence in them of any but the broadest detail. By throwing his colors around and muting the particulars of any scene, he guarded his work every which way from genre. Hence, outdoors for him worked better than indoors, simply because fewer things impeded the flow of articulated color from edge to edge. (For all that, many of his pictures intimate how the observed contour edge of a limb, or light glancing off a tree trunk or shimmering over water captivated his imagination.) Bischoff's bathers avoid costuming that might hold them to a specific moment. By contrast, from the '50s on, Porter and Katz painted people with their clothes on, with the sense that the clothes themselves, their styling and other temporal associations, signaled part of the content. It is a rare Bischoff – for women's fashions and hairdos, *The Glass Chandelier* is one example – that allows for such specificity.

In creating their figures, Bischoff and Park had good memories for the looks of particular people, including studio models and their assorted poses, but Bischoff had an even better memory for art. Bischoff filled his work with samplings, sometimes combined within the same painting, of other art. Roberta Smith declared of this aspect recently: "Somehow, it is not bad that so many famous names come to mind in front of Bischoff's paintings . . . He seems to have been at his best when he edged closer to other artists, creating his own distinctive variations on their themes and styles." This is true. Bischoff's nods in the directions of the artists he admired go far beyond pastiche and may in fact show him at his most personal. Take Bischoff's *Figure on a Red Couch* (1957), for instance, which openly engages with Edvard Munch's riveting image of *Puberty* painted some sixty years earlier: Like many painters, Bischoff appreciated Munch's formal strengths – his frontality and ferocious facture – as well as his psychological candor. But unlike Munch's scared girl, Bischoff's woman has an Anubis-like alertness; rather than let her retreat into shadowy folds, the whisking strokes he has used to limn her legs give her an almost aggressive aspect, like that of sprinter about to vacate the starting blocks. Or again, but differently: A motif like that of a woman's ankle radically flexed above a brightly colored high-heel shoe might have come straight from Bonnard, but the Frenchman would never have inflected it with the same humorous, Rockette-inspired kick. (Indeed, it is that sort of humor, wry or bumptious by turns, that makes Bischoff so very unlike the more consistently pained artists – Munch for one, Max Beckmann and Francis Bacon for others – whom he admired.)

Bischoff avoided direct portraiture although some identifiable likenesses crept in. Most of his men and women appear to be muscular, sturdy types in their prime, but otherwise of no clear age or station in life. You feel him keeping his distance from them. Many are seen with their backs to us as repoussoir elements whose main job seems to be to show us the rest of the painting. His paintings of couples in rooms have a strong, convincing light, which then seems at odds with the dream state the rooms are in. In some pictures, anonymous women hold umbrellas as props: umbrellas seem to have fascinated Bischoff for time in the 1950s; he rendered them thickly as if they masked the weight of the world.

There is the well-known difficulty of knowing how to care about these figures. What one cares about finally is what the painter himself considered important, that the painting goes about its transcendent business, enlivened rather than impeded by descriptive chat. Bischoff himself sometimes spoke of the people in his pictures as apparitions and of the action of variable light in them as dominant; indeed, some of them seem possessed of a "sixth-sense" aspect, as if they were momentary issue of the psyche or memory, animate yet not quite present, a ghostly agitation in the field. Bischoff's vision of people in contemporary settings is that they don't fit. To begin with, they're studio inventions. In order to remind you of that, he gives them a displaced, drastically inactive look, so that you feel them to be insecurely propped, intimate to their own adventitiousness. What specificity they might have is lost in light.

Outdoors, the situation is otherwise. Boats and trees and other things next to which figures are not seen but implied have great heaves of air pushed forward and a fructifying light. The outdoor views Bischoff painted in the 1960s have an elegantly carpentered look. In *Boats*, which might be Bischoff's "Brise Marine," the air seems chiseled, light a matter of vectors crisscrossed along some unseen wiring. An even broader light commands the wide view in *Girl on Porch*, with its troweled-on burnt-caramel-and-mocha cumuli, a last gasp of daylight putting pink highlights on a bunch of oranges in a russet bowl.

Arguably, Bischoff's best paintings are, whether they show it directly or not, either landscapes or marines – e.g., variously horticultural or tidal in their painterliness. Fairfield Porter described *Houses and Hills* in terms of a powerful flow "which keeps rocking . . . like the successful carrying out of a wager that he will navigate the painting into port through the roughest seas." It was with his seascapes that Bischoff achieved some of his most powerful grand-opera effects. (Had he stayed with them a few more years, such effects would not have seemed out of place among the more tempestuous varieties of New Image painting, especially those by such European practitioners as Sandro Chia and Rainer Fetting.) In some pictures of the late '60s you can see the energy of his figures running out, almost demanding to be replaced by something else. The vision of the ocean as an ineluctable,

absorptive force just about predicts the dissolution of overt figurative references in the paintings that followed.

Christopher Knight observes that, in keeping with their pastoral bent, Bischoff's pictures, both figurative and abstract, are largely on one or another theme of origins – the Edenic, the cosmogonic, the Golden Age – or (as Bischoff himself put it to Suzanne Boettger) "an earlier day of accord before the Fall." Perhaps the reason his living-room types look so displaced is that they really have no business in such surroundings; they should be back on the river bank with Matisse's (and Puvis's and Park's) bathing nymphs and satyrs. Knight says: "These fictional constructions, whose remoteness from the social space of postwar American life is part of the subject of Bischoff's art, partake fully of the traditional Modernist dream of an ideal domain of freedom. And Bischoff's nonfigurative paintings represent the same absolute in abstract terms."

How abstract are the late works? One answer is: abstract enough to admit a vocabulary in free fall with little or no syntax, aside from vague geometric scaffoldings across a wide tissue of light and air, to support it. Among the salient incidentals are pockets of furtive figuration – discernible, even nameable items lodged in loosely gridded space. Common among these are Alpine sunrises (some of them replete with "hosanna" chorales), Katzenjammer legs, all manner of machine part, windows, heraldic stripes, arcs and tunnels, trail loops and switchbacks, maps. Hilarity is the key, together with – or maybe occasioned by – a new and even loftier conception of idyllic content. As Susan Landauer tells it, Bischoff's notebooks of the mid '70s record his fascination with gnostic cosmogonies – the conception of an original unity burst into particulate masses, the reassembling of which then requires human intervention. (Bischoff's discovery and treatment of the theme recalls Jay DeFeo's in the '50s and '60s, when she was painting that behemoth of a creation image, *The Rose*.)

Rather than being at odds with one another, playfulness and a great theme combined to spell a kind of spunk long overdue in Bischoff's manner. The great theme itself breaks down into paired subthemes of no little significance: order and chaos, matter and light, memory and oblivion, gravity and fate. Parading his aerialist configurations across

the square or near-square canvases that he favored throughout his career, Bischoff used white to edit and make the varied impulses cohere. The lordly white works as both smear and fixative. If the identities of Bischoff's previous figures were slowly lost in light, the incidentals of the late abstractions are pinpointed by the flash of corrugated, allover radiance. The layered whites are scored with reticulated lines in quadrants that replay in tick-tock motions the ninety-degree angles at the corners of the canvas. In turn, such jolting luminosity makes these pictures more truly narrative than his figurative ones. In the more complicated ones, it is as if we are witnessing the reverberations of some primal gong, the stroke of which is permanently lost in the welter of its offspring.

The fanciful inclusivity of *Untitled #15* (1975) is dazzling – at bottom, there is a purple hand pointing through what appears to be inclement weather towards a slippered foot at the end of a vaporous limb – held together here by grays. Bischoff varied his surfaces in these years by using, along with acrylics, array of other materials, including chalk, pastel, and charcoal. Cartoonist force lines that had appeared in his paintings early on zip, just as enlarged apostrophes of "sweat" hover, in spaces clear of any object. (In one instance, squiggles of "steam" emit from an enigmatic, wedge-shaped "boot.") Another marvel, *Untitled #44* (1979), puts a greenish tinge on its inventory of ribbons, slashes, and hatchings – how many different types of "mark" can a picture hold? – while slipping in a yellow crown, a wishbone, a musical note, and a miniature variant of 1940s cruel-cop-and-sleeping-Mexican cartoons.

It's tempting to say that Bischoff literally went out in a blaze. His late manner, with its unpretentious feeling for celestial mechanics at work, has the feeling of an extended ode, a broad elation. You can't help feeling he had found a way to put more of himself – as was his wont, without egocentricity or stunt flying – into the performance. Thus, elements in the figurative work that were poetically weighted and mysterious appear sprightlier, and if anything have gained in mystery. That rhapsodic sprightliness was salutary. Bischoff arrived at the state of enchantment that had been his subject all along.

2001

The Portraitist

For most of the 1950s, during which decade Elaine de Kooning came into her own as an artist, New York painting enjoyed a run of unprecedented good health. Roomfuls of "young prosperity pictures" – as Edwin Denby, apt as ever (and never without a flicker of irony), called them – combined to produce "the splendid state of confusion" that Frank O'Hara saw as every insider's pleasure to contemplate. The so-called Tenth Street touch – nervily loose, sketchy, grooved, juicy to overflowing – was the most salient aspect of an objective period style that looked then, as now, as admirable as any in the history books. Anything so good, of course, was bound to degenerate, with less high purpose, in time, and by the early '60s the appearance of big painterly swatches of decorous color tended to communicate little more than that "art" as it was commonly expected to look was recognizably present. (Hence the Pop masters' – Warhol's and Lichtenstein's – casting of it as such, as a dramatic image.) It fell to Elaine de Kooning and a few other, mostly younger painters, abstract and otherwise, to sustain, beyond its periodic trajectory, the vitality still plausible inside the style.

Born in 1918, Elaine de Kooning belonged to the in-between generation of the New York School. She was fourteen years younger than her two, main, unofficial teachers, Willem de Kooning and Arshile Gorky, and only half as many years senior to such younger painters as her friends Joan Mitchell and Alex Katz. One reason that at some point she decided to adopt a later birth date, 1920, may have been to align herself more closely with her second-generation peers. Beginning with the cooperative Ninth Street Show in 1951, she showed where they showed (Stable, Tibor de Nagy, Graham, Tanager); and as for shared attitude, her 1955 essay "Subject: What, How, or Who?," together with the send-up "Pure Paints a Picture" written two years later, nailed the then-prevailing partisanships "about style and subject as distinct elements of painting," which threatened to constrain the more adventurous direction-takers. In the former, as one who "always hung onto some kind of subject," she wrote:

Nature might be defined as anything which presents itself as fact – that includes all art other than one's own . . . Nature does not imitate art; it devours it. If one does not want to paint a still life or a landscape or a figure now, one can paint an Albers or a Rothko or a Kline. They are equally real visual phenomena of the world around us. That is, there is a point where any work stops being a human creation and becomes environment – or nature.

One might say of her, as she did of Gorky, that, given her taste for many different kinds of painting, her talent and temperament took care of her style. The fact that neither Gorky nor de Kooning when she met them in the 1930s felt any conflict between the abstract and realistic pictures they both made encouraged her own sense of latitude. The point for many artists in the early '50s was to make pictures at once containing recognizable images and possessed of the same surface energy as the abstract paintings they admired. For the rest, temperament would tell. In 1961 Fairfield Porter wrote that Elaine's "abstract paintings, for all their dashing contemporaneity, do not seem to liberate her talent, which is a very great one. They simulate a life not her own. It is as though she were making conversation." Portraiture, Porter went on to say, was "the kind of thing that liberates her talent, what she uniquely can do."

Lawrence Campbell, the most consistently perceptive of her critics, called her an "expert" portraitist. Indeed, her drawing skills, having developed steadily from age eight, got a fabulous boost from de Kooning himself who set her to tightly rendering windowsill still-life subjects, focusing hard on the intricate folds of cloth they rested upon. During the '30s and '40s she based her painted portraits on preliminary drawings, in some of which the signs of struggle over a tolerable likeness – erasures, smudges, and so on – actually produce a concomitant tenderness in the features. A 1948 Edwin Denby seen up-from-under tilts his head, straining away from his bow tie, with soulful mien. Gorky, his hair brush-cut in a military manner, appears to pounce on his drawing board. Aside from their documentary interest, the drawings she did of Willem de Kooning make palpable the many-sided personality of legend. The 1940 image shows him with Luciferian – or Shiva-esque? – eyes narrowed, intent on some scheme. In a later draw-

ing of Ornette Coleman the eyes are closed, the mind fixed on its instrument, the musician's diminutive white plastic sax.

Most of her portraits were of other artists, and most of those were men. Among the painters portrayed there was reciprocity: Fairfield Porter's oil painting of her hangs in the Met; one of Alex Katz's best images of the 1960s was of Elaine cast in close-up as a liberal-era Joan of Arc. At one point she did a series of men with children. When she resumed painting a year after John F. Kennedy's death, she did a series of women, beginning with her friend Denise Lassaw and including the amazing visage of Sari Dienes.

A man sitting with legs crossed is an off-kilter "X" with a dollop of skull up top; but the paint as its own image works conversely, flowing up and out, each color blazing. You can see the pleasure she took in depicting a shoulder's ridge, the ripples along a sleeve or not exactly depicting but adumbrating an intersection of chair parts or floor. You see the human frame the way Larry Rivers once described it, as a bashed-in milk carton. In their very different ways, the Rosenberg, Ashbery, and Kennedy images recall Jean Helion's remark that a seated man has something inherently godlike about him.

Having done a series of frontal seated male figures, she spoke of being "fascinated to see how men's clothing divided them in half: the shirt that buttoned down the center, the suit and necktie and so on." All such things are presented, as she would say, as "action on the surface." In 1959 she wrote: "When I painted my seated men, I saw them as gyroscopes. Portraiture always fascinated me because I love the particular gesture of a particular expression or stance . . . Working on the figure, I wanted paint to sweep through as feelings sweep through . . ."

It's fascinating to watch how the men seem bent on finding individual ways of bracketing themselves, to advertise thereby a personal bulk or diminish it. Such method gets displayed in Gandy Brodie's isometrically flexing fingers, the splayed left elbows of both Tom Hess and JFK, John Ashbery's rather primly folded arms. The period jazziness, along with what Campbell proposed as "a bundle of simultaneous, imaginative conceptions," still clicks, is vivid. Sentiments thus are bound up with a particular torque in appearance, and that's where the expression projects.

The portraits of Hess and Harold Rosenberg tell a lot about both sitters. Hess, a Yale graduate who lived up on Beekman Place, cut a tweedy figure amid the blue-collar posturings of the downtown art scene. Sardonic and committed, both he and Rosenberg had a way of teasing artists so as not to be bluffed by the grandeur they felt in their presence. Hess, for his part, had a self-effacing quality that manifested itself by his standing always a little shorter than he was, knees bent and slouching beneath a cigarette held high from a limp wrist (not fey, just saying "relax"). By contrast, Rosenberg pulled himself up to his full, imposing height, partly because he had a bad leg that wouldn't bend. "What's your point of view?" he would demand, taking the stance of an intellectual brawler.

The official commission to paint Kennedy's portrait for a niche in the Truman Library followed from a series of narrow, six-foot-tall pictures of Denby, Merce Cunningham, O'Hara, and others, and the rumor that these had been done in single sittings at uncommon speed (Elaine referred to some of them as her "martini portraits"). Invited to begin work at Kennedy's Palm Beach White House, she set out in December 1962 to (as Harold Rosenberg put it) "invade Florida" with her art materials. What she delighted in as the perfect "presidential pose" – forward, with an extra intentness about the shoulders – was actually a contrivance by Kennedy to lift pressure off his troublesome back.

Part of Elaine's "white goddess" aspect in the 1960s was her curiosity about young people who had just then come on the scene. I remember a party at her temporary loft in 1960 where I found more people my own age than I had known were interested in art. (The youth stars of the immediate neighborhood then were Red Grooms and Mimi Gross; another was the painter and playwright Rosalyn Drexler.) This newly activated mentor mode went hand in hand with her engagement in contemporary politics. In his 1963 article on the portraits, Campbell reports on Elaine's plans that spring

to undertake a politically engaged painting to be called The Burghers of Amsterdam Avenue. It would be a life-sized ("If it looks life-sized, it must be painted larger than life") group portrait, a juvenile Inferno

consisting of some twelve New York high school kids, all lined up in a non-aligned way, all at the same time, sitting and standing, each standing free.

That same picture, a twelve-footer looking just as Campbell described it, commands one long wall in the present show. Its manifold characterizations are prodigious, spatially true. She was very good at this. As in her other painted portraits of the time, the big, rollicking brushstroke had become, as often as not, something with which to build resemblance and shower it with life.

2001

What the Ground Looks Like

Industrial parks, vacant lots, yards, enclosures, fields, arenas, slopes, siding, tarmac, blacktop, service roads, parking lots, drive-in-deposits, libraries, roller rinks, drag racing, karting, plazas, reflecting pools, evergreen hedges, war memorials, turnarounds, supermarkets.
　　　　　　　　　　　　　　　　– John Ashbery, *The Vermont Notebook*

It was then in a way that I really began to know what the ground looked like. Quarter sections make a picture and going over America like that made any one know why the post-cubist painting was what it was.
　　　　　　　　　　　– Gertrude Stein, *Everybody's Autobiography*

In 1983, in a short review of a book on Precisionist painting and modern photography, Yvonne Jacquette wrote: "I love provocative conjunctions." She was quick to register how pictures by certain American landscape painters in the 1920s and '30s conjoined with her own complex interests: "These artists were pragmatists using the analytic methods of abstraction . . . Their single-mindedness has a grandeur because they brought the American image close up." There are (in some paintings by Charles Sheeler, for instance) "disjunctions of surface in favor of stronger planar harmony." There are also big questions tangential to those Jacquette herself confronts regularly in her work: "Which artists had a healthier ambivalence about urbanization making their work more emotionally satisfying than those caught in 'technological optimism'?"

Compared to the mechanistic vistas the Precisionists sought out for their paintings, the world Jacquette chronicles is technologically managed edge-to-edge, and the radical overview – observing her subjects from airplanes or the upper stories of tall buildings, which has been her preoccupation since 1973 – is symbolic of such changed topology. The odd, oblique angle of vision on commonplace terrain lays bare a peculiar interconnectedness. (The a priori part of this peculiarity of course is Jacquette's, and our, ability to go airborne.) By day or night, seen from

the air, a variegated stretch of town or countryside shows, as Jacquette says, "how things gradually accumulated in this geographic form."

In her contemporary precision images, Jacquette pays special attention to harbors, bridges, farms, rural factories, and other large, often riverine industrial sites; traffic flows, clusters of urban architecture and its sometime pendants, massive neon signs. At the time she wrote her book review, Jacquette was in the midst of painting a set of views from above the heavily contested Maine Yankee Nuclear Plant (she spends her summers nearby, in Searsmont, Maine), having the year before made a large charcoal drawing of its more notorious relation at Three Mile Island. The point in both instances was to acknowledge a discrepancy between appearances (a beauty indeed as insidious as it is banal) and the underlying facts of the situation, and thus, as is Jacquette's unrhetorical way, to avoid too facile commentary. Typically, Jacquette will go for the maximally spacious outlook built of many delicately perceived details. As she told a student audience in San Francisco, she worked the surfaces of her power-plant pictures "to keep the level of emotion coming through steadily and slowly."

In painting and drawing what she sees from far off, Jacquette reminds the eye of the complexity, not the ease, of seeing.
— Carter Ratcliff

One of the side effects of modernism and abstract art was to upset and clear away old painting methods, training systems, traditions, so you could start representing again as though from zero . . . [Sixties realists] were not involved with the practice of an old craft, but with making discoveries. They made you feel that the question of what the world looked like was a wide-open one.
— Rackstraw Downes, *In Relation to the Whole*

Jacquette is mainly a perceptual painter. She has made the luxurious aerial scheme her specialty without dramatizing its alien's-eye oddness. Her pictorial ecology relies upon scrutiny and its imagistic follow-

through, "the kind of structure that really looking carefully gives the picture." The structures she delivers can be readily apprehended as analytical, sensuous, playful, meditative, highly nuanced, by turns disconcerting and exhilarating. Born in Pittsburgh in the mid 1930s, she arrived in New York in 1955, the year before Jackson Pollock died. She therefore belonged to a contingent just old enough to have caught the waning of the first phase of New York School glory and young enough to feel aligned with the terse yet flashy skepticism that eventually would declare itself as the new spirit of the 1960s. Pollock had allowed the perceptual and sensational aspects of his poured and flung paint to outstrip conceptualization at every blink of the eye or shift in the viewer's plumb line. Jacquette made her own synthesis of what had since intervened, including the play of cultural recognitions that both Pop art and minimal painting and sculpture made central. (For a while in the '60s her paintings showed household objects cast in a style she remembers as "minimal realist.") Coming into artistic maturity in the 1970s, she put perception squarely at the center of her process in a way that would affect sensation and thought with equal force. Perhaps this is what gives her work the visionary tinge that has been sometimes been ascribed to it. (The paintings are otherwise very un-strange – plain, even calm, in their grasp of things.)

By the early '50s, proponents of various types of realist art, inspired, rather than hampered, by Pollock's and de Kooning's big, open, brushy surfaces, had begun asserting themselves. "Action Painting with nameable subject matter," in James Schuyler's phrase, was an acknowledged option, as was the painterly tendering of rooftops or a friend's face in terms of (according to another of Schuyler's formulations) "a translation in which the painting of the subject is part of seeing it." Temperamentally unsuited for out-and-out abstraction yet covetous of its surface excitements, the energetic realist wing of the New York School found ways to project their accounts of the observable world with equally vigorous applications of oil paint.

During her early years in New York, Jacquette was impressed by Fairfield Porter's "straight-on" realism, as well as by the sympathetic clarity she found in the photographs and films of Rudy Burckhardt,

whom she met in 1961 and married three years later. (From Burckhardt she first got the notion of working with "just a bit of something you can see out a window, instead of trying to do a big spread.") Via cultivations of "touch," such painters as Porter, John Button, Jane Freilicher, and Nell Blaine brought their sensibilities as close up to the picture plane as their subjects. The sensibility painter discovers what he or she feels about a particular motif by painting it. In a review for *Art News* in 1952 Porter reported that Freilicher "when she paints a reclining figure . . . may lie down to see how it feels." Jacquette talks of the luminosity in Freilicher's pictures as "an equivalent of the fact of seeing, the glow of objects in nature." The related yet reductive manner with which Alex Katz in the late 1960s subsumed intimist touch in an abruptly monumentalizing style struck her as a strong alternative – "a reticent way of doing something very rich." About the cognitive basis of his images at the time, Katz stated his terms succinctly: "The viewer has information in his head; the painting supplies other information. The subject has to exist in a believable space." And about procedure he has famously said: "The paint moves across the canvas making discriminations." For her part, Jacquette still likes to quote the puzzler that Edwin Denby discerned in Katz's startling likenesses: "How can everything in a picture appear faster than thought, and disappear slower than thought?"

It's great to have someone show you something you have passed thousands of times as something you never saw, and after seeing it you continue to pass it again and again and not see it.
– Alex Katz, "Rudolph Burckhardt: Multiple Fugitive"

But if you start looking at New York architecture, you will notice not only the sometimes extraordinary delicacy of the window framings, but also the standpipes, the grandiose plaques of granite and marble on ground floors of office buildings, the windowless side walls, the careful, though senseless, marble ornaments. And then the masses, the office and factory buildings pile up together in perspec-

tive. And under them the drive of traffic, those brilliantly colored trucks with their fanciful lettering, the violent paint on cars, signs, houses as well as lips . . . Do you see all this? Do you see what a forty- or sixty-story building looks like from straight below? And do you see how it comes up from the sidewalk as if it intended to go up no more than five stories?"

<div align="right">

– Edwin Denby, "Dancers,
Buildings and People in the Streets"

</div>

Rudy Burckhardt's photographs evoke precisely what can't be found in anyone else's: the "climate" of New York, the distinct variety of buildings, the air between them, the weight and extent of sky, the tempo and spatial intricacies of the lived-in city. Denby credited Burckhardt with opening his eyes to the "momentary look" of such things. Likewise, Jacquette recalls how first seeing Burckhardt's pictures returned her to follow her original ambition to be "a portraitist of American cities":

> I saw this whole range of photographs, often from rooftops . . . and having an incredible sense of the life of New York, and still dealing with these very real forms like water towers and the roofs. He got an evocative thing into something very physical.

A late-'60s polyptych of clouds in flux constituted the sort of "episodic image" she was inspired to make after watching Burckhardt's films. ("One thing Rudy and I discovered about each other, we both had a literal mind, and it's not to be disparaged.") But her aerial views tend to look specific about time, as well. As a native New Yorker I discover in her New York pictures not just aspects of, but feelings for, the city of my youth. They tell of city life in a city-dweller's terms – spectral, ever watchful, a bit hunched, unpredictably entranced. Jacquette portrays her hometown as a luminous admixture of the plausible and unreal, with busy nocturnal thoroughfares like lava flows scorching the ground plan and daytime euphorics of steel and mirror glass sometimes mistaking themselves – and any passerby – for air and water. Nor is she shy of evoking the city's tremendous glamour – viz., the cinemascope-proportioned

woodcut *Tip of Manhattan*, the skyline a string-and-strand array of blue-tinged zircon globules embedded across unruffled dark. (Note, too, how the lights of each building tautly imply its basic shape.)

I switched to painting in the early seventies, as painting, even then, was alleged to be dead. There was a big vacuum there in which to operate . . .

— Mary Heilmann

Unofficially speaking, the 1970s were a good time to paint. Jacquette speaks of those years as as a period when she located her own need to make "whole pictures that haven't been painted before." Meanwhile, as she says, there was "the energy and excitement of . . . original things coming out of women working in new mediums." Painting itself in this context insinuated itself as a new medium. Consigned in theory to the afterlife, it was almost surreptitiously reanimated by women – Heilmann and Jacquette among them – who did so largely by dismantling the art's constituent elements (canvas shape, types of paint application, and so on), with an eye to finding out methodically just what a painting might be and/or contain (headlong encyclopedic retellings of styles, those art-historical worry beads, were rampant). Then, too, in the pluralism of the 1970s – just when rigorous exertions of the art audience's sensory awareness supposedly were reserved for large, mostly outdoor sculpture – perceptual realism got a second wind. Artists of Jacquette's age group who arrived at their mature styles around the same time she did included Chuck Close, Rackstraw Downes, and Richard Estes. Jacquette's studio conversations with new-found peers like Downes, Sylvia Plimack Mangold, Pat Steir, Janet Fish, and Susan Shatter were crucial.

For women artists of the post-minimal era the pictorial unit put under the most constant surveillance was the mark. As Richard Wollheim reminds us, the mark is one of the ur-facts of painting – a term that covers, without necessarily connoting, others like "brush stroke," "line," "gesture," or, for that matter, "touch." (Other ur-facts

for Wollheim are surface and edge.) Thomas McEvilley writes of Pat Steir's "patient working through of the idea of the mark, from simplicity to complexity and back to a more fully integrated and understood simplicity again." The far-off space in a Jacquette is a frontal agglomerate of marks – "curved marks, short sharp, long thin, short fat," she calls them – on the support. The surface doesn't give, and the marks remain discrete even when looked at from across the room, but, near or far, there is also, as Jacquette says, "the wholeness so the eye can take it in at once more quickly."

Part of Jacquette's method has become the adoption in oil painting of types and qualities of marks appropriate to other mediums. When, after discovering the granular distinctness of the pastel colors she had begun using for landscape studies from small planes, she "started trying to paint like pastels," the details in her pictures gained in emphasis and light. Similarly detectable in her paintings are strokes that normally would occur in woodblock prints and etchings (both of which media she has frequented), as well as the "crisp drafting style" residual of her early years of ruling-pen commercial work. Her repeated "strokiness" can resemble the tight-knit, compulsive hatchings of naïfs without ever immobilizing into masonry. Following the deft abbreviations, directional signals, intertwining stitches, streaks and stippling in varying orders of appearance, we can drift, weave, and circle back, adverted by the steady intensity of separate marks to the complete image's overriding mass.

Jacquette's realism is, so to speak, "time-based." The glimpses it evokes are intermittent, prolonged or quick. In layered nanoseconds, the picture's light of moment appears elaborate and dense. Painted into the present, it keeps, as Jacquette says, "a contemplative kind of time." For all the patient methodology involved, a viewer will keep returning to the fiction that the scene was captured as-is, *alla prima*, on the spot. But there is also a feeling for time in the sense of what Rackstraw Downes calls "legible stories," an interest in "what's happening as well as how it looks and how it feels." Jane Freilicher, notating from her studio the progressive changes in nearby acreage – open space of scrub and wild grasses she had painted for many years previously – broken up for

development, said: "I realized I was painting history." Jacquette herself, from her vantage points, habitually reads the landscape, watchful for telltale signs – "certain contingencies you wouldn't notice from the ground." (One example she spoke of recently: "why particular buildings perch at river's edge.")

Fifteenth-century Flemish realists introduced the high-window overlook. Pissarro fretted about the dominant sooty grayness of his renderings of Rouen and Paris rooftops. Manhattan's after-dark "canyon" enfilades have their portrayers from Sloan and Glackens through O'Keeffe and de Kooning's black and white abstractions of the 1940s. Jacquette's new soft style, contiguous with velvety night effects, is original. She wonders "when you look out at the darkness why is it so hard to see certain things but you can feel them." At one time she made her trees from clay models; now she is likely to envision real ones as having been made of confettilike dabs (remnants of a hole punch). About choosing what to paint, it's fair to say that Jacquette has preferences – and, like Cézanne's, hers are dictated by ideas of order peculiar to herself. ("Configurations," she tends to call them.) She doesn't necessarily take you over the scenic route. If the image "can't be practically flat like a map," you will find yourself negotiating its necessary bumps, hollows, major arteries and side roads, the fields salted with sheds. Times of year are intuitable but not specified at large; there can be a wet look to the streets ("I like to use the effect of being rainy when it isn't"). Aren't clouds, air currents, rivers and other bodies of water (as well as the "flow" of traffic) themselves symbols of passing time? Diverging from the normal instances of water abruptly contained by a city's straight edges and the glossy/matte thatchwork of her rivers and lakes, the reptilian rills and eddies Jacquette depicts around *Dragon Cement Co., Rockport, Maine* create a quasi-subliminal pun. A cardinal rule for painting's efficacy: Suspense is prerequisite. "I think I have patient emotions in my work," Jacquette says. "To give intimacy to vastness" a painter must be "impertinent about spatial relations."

The supernova that comes into focus as a section of the Jersey side of the Hudson is seen to be so near because it is palpably of and on the surface of Jacquette's paint. Scooting away over dark water from the

Statue of Liberty a lit-up ferryboat has a firefly's lightness. Combined guidelines of accuracy and vitality encourage the eye to find its way across the diffusion of signs for different kinds of material life that, deposited appropriately, carry a more than material significance. All these things, as Frank O'Hara said of taxicabs, "stir up the air." As there is no one avenue, nothing is peripheral. A thinning out of incident at the corners may instead make room for something piquant: deep in the upper left corner of one recent scene, a floodlit two-way traffic tunnel flares; the shock recalls the expulsion-from-Eden vignette Fra Angelico tucked into his Cortona *Annunciation*. Any one of these mark-perfect surfaces might be the setting for a Fall of Icarus, but, as this is far from Jacquette's intentions, the all-too-logical collapse will not happen; instead, there is a keen, measured interval of sheer existence, buoyancy that consoles while facing gravity head-on.

2002

The Sensational Pollock

*But [Pollock's] work is not about sight. It is about seeing and what
can be seen.*
— Frank O'Hara, *Jackson Pollock* (1959)

For what is hidden . . . is of no interest to us.
— Ludwig Wittgenstein

Are we just muddy instants?
— Frank O'Hara, "Ode"

. . . to be alive and to see the light of the sun.
— Homer, *The Iliad*

First disclaimer, the prim one: My talk is called "The Sensational
Pollock" – this is not about this year's sensation, the Ed Harris movie
Pollock, which anyway is not sensational, but sympathetic and, as far as
the melodrama of the historical personage Jackson Pollock is concerned,
true. Nor is my "sensational" the "shock value"– registered early on,
and still not completely discounted – of Pollock's method, his suppos-
edly avant-garde art. But to turn it around, I'm looking at the real,
esthetic value of Pollock's shocks, as they are felt sensibly in his pictures.

Second, the inevitable hedge: The thing about pictures like *Lucifer*
– meaning all of Pollock's so-called drip paintings and most of the other
important pictures of the modern era – is that you really must be in
front of the painting, the actual physical object, to see it. Slides don't
work; memories are misleading. Barnett Newman once said that mod-
ern art was a struggle against the catalogue – the false generalities and
topological mutilations of textbook and monograph with their plates
and stylistic divisions; the lecture with its slides; our postage-stamp ren-
derings of work, of which the physical presence and real-time optical
workings are crucial, are where the payload resides, so to speak. By
definition, the immediacy of sensation, especially of sensation tied

almost exclusively to the physicality of a painting in whatever environmental conditions you are likely to see it, simply isn't reproducible. As it is, what Pollock called "the state of order" of such a painting is glimpsable in person only intermittently, and thereafter, or in-between, long deferred.

Every nuance of its material life is what makes this Pollock, *Lucifer*, work. Every suspended detail contributes to the image before you, hanging in its pictorial dimension, aloft and still. Buoyancy. It is from that succinctly tethered relation to gravity that everything else about the picture is delivered.

In *Lucifer* the greens are crucial. From slide to slide, in various reproductions, you'll see greens either too dark or too light, or too dull, and never in proper relation to the grays and silvers that are, as it were, their nearest of kin among the terms of this painting. Pollock's paintings are generally un- or antiphotogenic. They have no, or very faulty, afterimages. Away from *Lucifer*, I tend to think of it as "that green painting" – despite the fact that, even though green is what clinched it, the actual painting is at the very most one-sixteenth green.

The first time *Lucifer* was reproduced was in black and white – both whole and in a detail, on the first page of an *Artnews* spread of artists' statements regarding Pollock at the time of the 1967 Pollock exhibition at the Museum of Modern Art. The caption merits quoting in full:

> Lucifer, 1947, oil, enamel and aluminum paint on canvas. 42 inches high [below], reproduced here for the first time. Detail [above] about actual size [about 7 ½ by 9 inches, or nearly ⅝s of the page] reveals the complexity of Pollock's paint skeins. Originally given by Pollock to a psychiatrist as a fee, it was bought by its present owner, Joseph Hazen, for a reputed $100,000.

Note that neither black-and-white reproduction shows anything like the flashes of green that sit so prominently upon the painting's topmost layer, nor do the densities of either gray or aluminum paint register, nor even the pungent, blond airiness of the bare, sized canvas that seem finally to kick in as the most vibrant patches of the entire image, as if

that had been the point of Pollock's efforts all along, to make this nine-foot length of sailcloth come alive in the phenomenal world.

The artists who contributed at Tom Hess's invitation to the two-part symposium in the summer and fall 1967 issues of the magazine included such New York School regulars as Barnett Newman, Robert Motherwell, Lee Krasner, Helen Frankenthaler, and Elaine de Kooning, plus a few younger artists who had claimed Pollock's art as a source for their own (Allan Kaprow, Kenneth Noland). Hess's guest list was conservative: Missing among those who might have been relied upon to say important things about Pollock at the time were Donald Judd, James Rosenquist, Frank Stella, Richard Serra, Robert Smithson, Eva Hesse, Jasper Johns, and Sol LeWitt. But the symposium did include an interesting set of New Realist interlopers like Larry Rivers, George Segal, Claes Oldenburg, Jane Freilicher, and – arguably, a more significant inclusion than any of the rest – Alex Katz.

In his customarily direct, no-nonsense, three-paragraph entry, Katz discussed the effect of seeing his first Pollocks around the time he graduated from Cooper Union in 1949:

> I was in a state of intoxication. I had found myself. I had discovered direct nature painting. I was bothered by the way my paintings looked. I remember painting sunlight coming toward me through trees, and ending up with contained planes. When I saw Pollock, I realized he had sensation, energy and light, and it seemed much more like the motif I was painting than my paintings. He opened up the areas of sensation painting and gestural painting, which wiped out the rules I had been painting by, and opened areas that I'm still following . . . Pollock made it possible for me to participate. The establishment of sensation painting was something I could relate to my own experience, and questioning the standards of the great twentieth century European painting made it possible for me to accept myself. It became evident it was my sensation, my picture, and either I was there in the present tense or it was all wrong.

Katz ends with a large professional nod – a deep bow, even – to Pollock in what still seem the most pertinent terms:

The establishment of a grand impersonal style offered many possibilities for a large number of artists.

In the middle 1950s, Katz responded to a questionnaire "What is your ambition as a painter?" His answer: "To continue the great tradition of the New York School." Katz's work from that time well into the 1960s reflected admiration, from the perspective of an ambitious thirty-something-year-old perceptual realist, for the work of such senior abstract painters as Kline, de Kooning, Rothko, and Guston – but only surreptitiously, then, of Pollock.

Katz went on to enlarge drastically the deliverables of sensation and light, while keeping to the basic terms of his realist genre. When, by the late 1960s, competing with contemporary abstraction at its own scale, he exercised the option to smooth his paint surfaces, the sharply "artificial," nonchalant Katz style of the past thirty years was achieved.

Lucifer, like most but not all of Pollock's drip paintings, is a sensational picture. O'Hara's observation that Pollock is "about seeing and what *can* be seen" places the work precisely where it belongs, in the domain of perceptual painting with an edge of optical contingency. Where is anything? Where does surface begin and not-surface leave off? You can see at a glance that everything is where it should be, an order, but how it hangs together is a thing you feel but hardly ever quite perceive completely.

Sensation is any modern aesthete's prime mode of approaching or being attracted by an artwork. To register sensations as they happen is to be outside of "flat" or "volumetric"; sensation is essentially nondimensional, a rush, weightless and mobile, a drift of unruly impulse felt before you have a name to fix it with. To account for sensation, we use terms of weight and concreteness – an amount of green in *Lucifer* strikes you, you may feel forced to say, like a dazzle of sunlight on moving water. Or we get lost in a vocabulary of synapse and cortical or adrenal discharge. The squeezed, shot, and trailing blobs and strands of bright yellow, purple, red, and other colors cringe beneath such desperate nomenclature as "dendrites," "tadpoles," "comet trails," or "sperm."

Our eyes organize these things, the pieces of paint a Pollock is comprised of, much as Pollock himself must have, in a kind of bob and weave of pattern recognition – a faculty I believe Pollock found himself extraordinarily possessed of. Which prompts, too, an extraordinarily active mode of seeing: To travel a Pollock involves more than eyes; you *go after* it, noticing – zinging along arrays of dashing incident, filaments and shimmers. As you range with the work, the center of gravity (your plumb line) becomes subject to indeterminate tugs. Infinitude occurs not in the picture's reaching beyond its borders – Pollock almost always shows you where the painting "ends" in that respect – but rather in the endless back-and-forth, the long inventories of scanning, the accumulations and jump cuts of discrete stuff he made as one.

Rather than open-ended, we might say "open-faced."

Early modernism didn't invent but was full of analogies to such blasts of sensory happenstance and perceptual tangency. What T. J. Clark has called "Pollock's smallness" is the converse of Cézanne's "little sensation." In his *Lucifer* phase (1947, the year of the first run of sixteen drip paintings), Pollock tended to start big, laying down broad sweeps of ground tone or sizeable glyphs, and then would go into smaller, finer detail. Conversely, in the details you sense the largeness of the whole – because Pollock's details invariably *connect* as nodes of the same specific mass.

Lucifer measures almost nine feet across, not such a big picture as big abstract pictures go. The appropriate viewing distance is approximately six feet, to fill the field of vision but still see every nuance. All but one of the other paintings done in fall and early winter of 1947 are similarly proportioned but oriented vertically. They soar, or whirl, or rustle in place; *Lucifer* has a slight crouch to it.

Pollock was inventive in his uses of so many different ways of getting the paint down. He made a hole in a tube of paint, and then squeezed paint through that hole, and then flicked with his wrist or forearm, that paint onto the canvas, so that it would make a tidy gob or dab, in most cases extended by a tapering length, of orange, blue, red, purple, and a couple of yellows. Pollock used his tosses of paint the way Tiepolo used clouds – to frame, to lighten or weigh, to shape, to pronounce sub-

stance. This is a painting that's full of little skitterings of black enamel paint, sometimes like skipping rocks across shallow water, sometimes cannily to make a point about where the edge is; and all that distinct from the large boles and limblike shapes and otherwise thin vectorings by which black presides in every sector. There are also sudden scrapes or tiny puddles of aluminum, of the kind that prompted Clement Greenberg to complain that it made a painting "almost too dazzling to be looked at indoors." The aluminum here is subtler than that, subtler even than the beeps of red and orange, as subtle as the purple that, darting more sparsely here and there, is the painting's most insinuating color.

In the light of *Lucifer*: This is a painting that, like its later, more obviously landscape-evoking peers, *Autumn Rhythm* or *One* (both from 1950), has a characteristic light, an emanation. There's this strange sort of gray sfumato of underpaint that pulses forward somewhat, and the sized canvas, yellowed with age perhaps, that, along with so many reflective enamel paints, seems to be what creates the painting's ambient, surface glow.

Mel Bochner referred to Pollock as "a profoundly superficial artist." The interval between surface and image is tightened so that one may speak of a "presentational" image, made impersonal by dint of the interventions of gravity and air. Upon inspection, the neutrality of sensation is the painting's starting point. There is an architecture anyone can demonstrate, but once you have pointed it out, it feels trivial. The amplitude you experience when confronted with the picture – even that this combination of cloth, pigments, and other matter pretty mysteriously *is* a picture – feels linked to its plainness as a region of cumulative sense data. "The mud abounds in Pollock's larger works . . . space tautens but does not burst into a picture; nor is the mud quite transmuted" – that 1943 remark of Clement Greenberg's, seemingly neutral in itself, is to the point, if by "mud" we understand "paint" in its many Pollock-borne guises. Did Greenberg, as we may, end up admiring the stubbornness of colored mud's actuality? Ultimately, I think, that is what we are left caring for, in the way of an image of closely worked, tumbled actuality. "Is this a painting?" Pollock asked Lee Krasner, whose reply we can only guess about. But you can imagine Pollock's

qualms, both seeing and appalled by the proposal that, as it were atomistically, across unfounded distances, in an amplitude of dense dumb matter and its frictions, the "statement" he was after had been made.

Who or what is the Lucifer of the title, and why this title? The 1947 pictures have titles, as most of the later drip paintings don't. Titles like *Enchanted Forest*, *Alchemy*, *Sea Change*, *Full Fathom Five*, suggest the casting of spells; ones like *Comet*, *Big Dipper*, and *Shooting Star* are obviously celestial; others like *Cathedral* and *Phosphorescence* have a little of both. Krasner claimed that Pollock proudly titled *Lucifer* himself. Lucifer means "bearer of light" and originally served as another name for "star," or especially Venus, the morning or daystar. In Isaiah, the Babylonian king in disgrace is mocked as a fallen "Lucifer," hence the later confusion of Lucifer with Satan, the rebel angel, fallen from heaven. Fallen angels brought alchemical procedures with them from heaven. (The alchemist Prospero and his agent Ariel preside over the 1947 Pollock workshop.) The Greek equivalent is Prometheus. But another equivalent, just as suitable for the original light-bearing force, is Hermes-Mercury. Lucifer is an agent of change. A Lucifer was an early phosphor match.

The key to *Lucifer*, as I see it, is the set of green splatters that salvaged the work. The green was added, put on last, and blatantly on top, maybe when the painting was hung or tacked up provisionally with what is now the left side at the top, so that the green ran down. And you see it running now – not down, but from left to right – flaring or traipsing (on winged feet? Or have the wings been clipped, thus slackened?) across the spread. The same green commands most of the expanse of *Full Fathom Five*, the green that O'Hara called "a green that is like a reminiscence of blue," but there it is integrated into the whirl whereas in *Lucifer* it is not. *Lucifer*'s green is of a shade known only in the can of house enamel Pollock scooped it from; no grass, leaf, moss, parrot's feather, no lady's damask cheek is evoked. The closest association may be the green they used for jeeps in the 1940s, but that's more what you see in the poorer reproductions of the picture where the color dulls out toward khaki. (Better, maybe, is "boathouse green.") "Splatter" here is fair – splattered and lambent; here a streamer, there a lick of green. The

point seems to have been not any particular shape or even "skein" but just to get down green in such amounts in such places, roughly. Green mediates between the other candid paints – the primaries, the orange, the purple. It's a neutral shade like the flat dim gray the painting began with. It's the end of the labyrinth in that respect, where Pollock, as de Kooning's would say, has "painted himself out of the picture" with headlong dispatch. It pulls the picture out without in any way depicting, but reinforcing concisely the feeling of breeziness coursing laterally (like a long-breath line – of "bardic" extension, so to speak – in verse).

T. J. Clark imagines Pollock's *Autumn Rhythm* as a talking picture: "Trees in painting should be this size, it says. Landscapes should stop miniaturizing what they are of." Then hear Pollock himself on his painting: "Abstract art is abstract. It confronts you." In the *Artnews* artists-on-Pollock symposium Jane Freilicher quotes Fairfield Porter as saying that Pollock's "fierce and gorgeous doodling" looked to him "like tracings of thorn bushes in the snow." By those lights, *Lucifer* may be a sense memory of some frosty pond off The Springs, Long Island. (Careful with these wintry associations, though: Pollock's barn of a studio, unheated for most of the years he was in it, was mostly useless in very cold weather.) How much of Pollock's work in the years he lived on Long Island, which include all three or four years of the drip paintings, is based in landscape sensation? There have been shows of de Kooning's East Hampton pictures, pointing them up as responses to the "knife-like" light and Dutch flatness of the South Fork. No such shows have been mounted to account for Pollock's feelings for the same terrain, the Accabonac Creek area of The Springs, East Hampton, and the (as he said) "vast horizontality" of the nearby Atlantic, although he moved there a decade earlier than de Kooning, in 1945.

"Trees in painting should be this size." That could be what Katz found when he found himself, his motif, and Pollock, all in one sensory/cognitive surge. Simon Schama writes of how, when looking at Katz's recent landscapes, the viewer is "engulfed by physical sensation" – which is inaccurate: Neither Pollock nor Katz "engulfs"; sensation in both artists' terms is discreetly confrontational. More often than not, as Carter Ratcliff tells us, the type of sensation made available in percep-

tual realism "reminds the eye of the complexity, not the ease, of seeing." So does Pollock. As Fairfield Porter put it, "Paint is as real as nature and the means of a painting can contain its ends." "I am nature," said Pollock – and so by implication is his paint. Porter's account of Katz reveals a hair's-breadth discrimination: "He is not overwhelmed by nature but stands outside it; it is outside him and includes his subjectivity." Katz told Porter that "in nature he preferred a field. (A Field is not an object.)" One often feels the closest thing to a Pollock is a tangle of tree branches – a model of literal articulation, and yet try to see it articulately all at once. A tangle of tree branches can strike one, just as Pollocks regularly strike people, as chaotic.

Next to last, some truths about Pollock, and about Alex Katz: To use Michael Baxandall's term, both Pollock and Katz are "professional visualizers." In 1970 Katz told an interviewer: "The viewer has information in his head. The painting supplies other information. The subject has to exist in a believable space." Roger Bacon in the twelfth century identified the obligation of medieval church art "to make literal the spiritual sense." "Energy and motion made visible," Pollock wrote. Energy and motion are the sacraments of Pollock's, and our, era. Pollock was interested, he said, in "expressing [the] immediate aims" of his culture from "within." In this way, Pollock identified himself thoroughly, as Katz would not, as his own first, or even ideal, viewer – the one who matches up, however tenuously, the information proffered from either side of the viewing gap.

A quote from Pepe Karmel (1999): "Pollock's achievement, in his pictures of 1947–50, was to transform graphic flatness in to optical flatness – to show that by piling layer upon layer. Sign upon sign, you could generate a pictorial sensation equivalent to that of the primordial visual field." No doubt Karmel is onto something. In fact, abstract-expressionist painting in its many individual modes may be considered as a set of explodings (de Kooning's, it's said, is an "exploded Cubism") of prior types of sign and sensation, sometimes so as to effect a merger of the two, or a third term, more or less strictly referential to the work itself.

Katz for his part shared with his contemporaries Roy Lichtenstein, Andy Warhol, and James Rosenquist an interest in the type of sensation

projected by mid-century movies and commercial graphic design – the "flash associated with advertising," Edwin Denby called it. Lichtenstein spoke of commercial art as "not our technique . . . It is our subject matter and in that sense it is nature." Commercial art (of the sort that Clement Greenberg had long demonized as *kitsch*) was the enemy for most of Pollock's abstract-expressionist peers. Pollock never did commercial art and never reflected an awareness of it one way or another in his pictures. Nonetheless, Pollock worked from a *type* of Pop imagery – the primal schematics found in popular texts of the '30s and '40s on the collective unconscious and primitivism. For a New Yorker in the '50s and '60s, the billboard and movie theater marquee and wide screen emerged as elements of a second nature, as well as that era's equivalent to an art of uplifting public murals.

Denby discerned in Katz's startling likenesses a mysterious time element that could just as well be applied in discussing Pollock: "How can everything in a picture appear faster than thought, and disappear slower than thought?" Both Pollock and Katz are statement makers. Pollock took his mythopoeic sign language, borrowed and/or original, and squeezed it into a motley of physical incident. Once a loose system of referrals, his image making became an immediate fact – expressiveness condensed into the pressurized skin of paint. As Dave Hickey recently remarked, Katz's distinction among his New Realist peers from the 1960s is that where many of them take graphic representations and then represent them as "pictures," Katz takes his own observations and approximates them as large-scale signage. Hickey writes: "Katz . . . makes graphic images of the visible world." Where Katz in his early years would have to scramble to match Pollock in the breadth and candor of his sensationalism, in the past decade or so, often by turning to where he started – "sunlight coming through trees" – he has asserted another "state of intoxication," grander, with melancholic overtones.

"Abstract art is abstract. It confronts you," said Pollock. People in front of large pictures figure largely in their energy fields. Both Pollock and Katz appear aware of this. The energy and motion of a large enough Pollock can be made differently visible by the introduction of other people, viewers presumably, into one's visual field. The repoussoir

figures in Thomas Struth's photograph *Museum of Modern Art I*, 1994, show something of the shearing and wiping effects I have in mind. Such occlusion of the view can be a kind of relief: Let *them* frame it, contain and manage and mete out what after while your eyes alone cannot get hold of. People in front of a Pollock complete the situation if not the image. Strangely, they make the occasion of Pollock's paint more strictly optical; moving to and from, in and out of the fabled "web," they transmute. Pollock's dance is ours. Let there be communal enactment of looking at Pollock. Imagine "*Lucifer* Viewing" as a cultural pasttime like going to see cherry trees blooming in tenth-century Japan!

Pollock's "paint slinging," says Carter Ratcliff, "generated a power that overwhelms understanding." My own experience of the work is that it is precisely when most engaged with a Pollock painting's terrific specificity that one "understands" it; only in retrospect, in the confused afterimage, does such understanding become elusive ("that green painting," *oh yeah*), largely because the specifics of Pollock's paint – including those wide prospects where an infinitude of sensation merges impressively with material tautness – are no longer there to guide and refresh one's thought.

In his book on Pollock, O'Hara wrote of how, in the throes of experiencing one of Pollock's fields, "Insight into any one quality led onward to another until gradually the painting revealed itself in the history of one's responses." It's not farfetched to say that this also describes how Pollock himself experienced the "easy give and take," when such obtained, of the paintings in progress: "It all ties together," he was quoted as saying.

Conceptual schemes about Pollock's art tend to reduce it to a fairly intelligible graphic image, a cartoon of its creational method. Meanwhile, whenever scrutinized, a Pollock – *our* Pollock, meaning *Lucifer* – keeps fibrillating, effervescing, slipping away, and returning to focus – bewildering as dreams and yet as plain, exact, and tirelessly signifying as vision itself.

2001

Arneson's Doubles

The theory of the self does not entail egoism. The self's care about itself is special, not in its unique magnitude but in its distinctive reflexiveness; each of us can say, "I care about myself simply for being me." We care specially about our current and our future selves because they are us; we care about identity because we care about ourselves. Such caring is rather like the pride of craftsmanship, except that it is more like the act of craftsmanship, but with no external object . . .

 – Robert Nozick, *Philosophical Explanations*

And patience till the one true end to time and grief and self and second self his own.

 – Samuel Beckett, "Stirrings Still"

Robert Arneson sculpted his first self-portrait in 1965, at the age of twenty-five. He was then some three years into his series of glazed-ceramic caricatures of household objects (a toilet, a beer bottle, a typewriter, and so on), a series that proclaimed the simultaneous arrival of Funk as Northern California's great contribution to late-twentieth-century esthetic discourse and clay as its most consistently revelatory medium. On a roll with his work but queasy about its seemingly low-ball qualifications, Arneson tried for a straightforward likeness of himself in the blue-collar-Houdon manner, a cut above what he called "the silly stuff" with which he was quickly becoming identified. During the last of many returns to the kiln, the already much-altered portrait bust burst open down the middle, an imagistic rift the sculptor accepted, decorating it with a downward trickle of glued-in marbles.

Six years went by before Arneson took himself again as a subject for his work; by the mid 1970s his customarily bearded face and the great dome of his head became regulars in his studio repertory, and from then until his death in 1992, the elaborations of self-image – alternately jocular, tender, exasperated, blissful, bemused, and pained –

increased in expressive outreach. In the process, Arneson affirmed with fresh piquancy and wit his ancient medium's symbolic link to the figure of a primordial being formed from clay, with its measure of soul on board (en-vesseled, so to speak), accordingly.

Among the works of Arneson's final years, the double portraits are the most candid as well as the most insistently mysterious. "Who am I?" / "Who's asking?" goes the well-worn joke. Arneson deepened the joke by throwing innumerably refractive senses of self into play with each other, casting himself literally in the image of his own head and putting one such image smack up against another – each as the other's physical double and psychic counterpart – and making the two of them, thanks variously to the firing process or gobs of epoxy applied at the joints, inseparable. (Queries as to which, if any, of these surrogate selves might be the "original" will be met with a succinct "Don't ask" accompanied by much creaky laughter.)

As pages in a 1991–92 notebook show, Arneson played fast and loose with his road company of personal pronouns. Song and movie titles helped: on one sheet, "Earth Angel" sidles up to *The French Connection*, and on another is written the name of the Rock Hudson/Doris Day vehicle *Pillow Talk*. There are clippings of kissing couples from the print media, as well as this unattributed item pasted beneath the sketch for yet another of Arneson's rather bedraggled, grinning selves:

> True realism, Robert Louis Stevenson said, is to seek joy and give it a voice, for joy is a hidden kind of fun, a mad vitality. Certainly an oak is a joy, for a boy or girl to climb, to sit under with a picnic, or to rest beside after a hike up dry grass rolling hills under a summer sun. True realism might also be said to seek strength and give it a form. Just as surely as an oak is joy; it too is strength, its massive trunk sustaining limbs despite the pull of gravity.

Formed from mirror and/or snapshot views, the double portraits teem with last-ditch assertions about existence. Interim versions drawn in conte crayon have a savagery of intent matched only by their raging deftness. Just the right fleck of greased sepia sent darting between eyebrows

indicates a moment's fervid uncertainty. In colors ranging from the plainest earthenware tints to panoplies of the sulfurous and bloody, the wall-mounted reliefs show such moments, and more, in the broad scale Arneson habitually commanded. Clearly, to come to terms with any idea of oneself, a high degree of embodiment, so-called, no matter how implausible or gross, is required. In identity's teetering shadow play, the physical realization of even the giddiest pun is no trivial matter.

In *Crush*, the interchange is colossal: two heads collide like continents cheek-to-cheek, with eddied ruts worn in the bare clay, and blue underglaze puddlings amid white follicles like on a coral reef. Then, in *Tongue Catcher* and several others, the same two turn and kiss, often with one long tongue protruding, intrusive. What does it mean for oneself to stick one's tongue clear into his wincing double's ear and out the other side? (Insofar as Arneson was congenitally deaf and the exit point is visible only if you take the piece from the wall, it probably means something we couldn't begin to guess.) And what is all this kissiness anyway but one stratagem among many in what Robert Hobbs calls Arneson's "own tragic and hilarious efforts to live with himself"? Are there signs of respite amidst the strife? To find out, look deeply into the deep blue-green iridescence of *G-O-O-D-N-I-T-E-S-W-E-E-T-H-E-A-R-T* – and sigh.

Under the heading "A Brief Lecture to Me," a couple of lines in the notebook stand out as emblematic of these final colloquies: "Soul maintenance through art," wrote Arneson, "Reflect on the absurd marvel of your existence."

1999

"Existing Light"

Although Henry Wessel comes originally from New Jersey and emerged as a photographer while still on the East Coast, he is identified with California, both its legendary sunny climate and the often riotous incongruities of its vernacular architecture and outdoor leisure-time spaces. Whether taken in Los Angeles or in the San Francisco Bay Area, where Wessel has lived since the early 1970s, a Wessel photograph will tend to look a bit bland at first, then a comic illogicality about the details takes hold, followed by a deepening appreciation of the rightness with which the strange spread of human event has been set before your eyes. Each of these perceptual phases has something to do with how the specific light makes visible, transfixes, and enlivens the sorts of often-negligible things the picture contains. Beside California, Wessel has photographed around the Southwest – the by-now iconic image of a sign for "ice" in big block letters on a white board in the midst of desert waste is titled *Walapai, Arizona, 1971* – and he has also frequented Hawaii, where bright sunlight is just as pervasive and some degrees starker.

In 1987, when asked about the insistent luminosity of his pictures, Wessel told the Czechoslovak poet Stefan Janacek that, technically, as far he was concerned, the photographer's task "is to describe the existing light . . . Chances are, if you believe the light, you're going to believe that the things photographed existed in the world." It's clear that every color or tone in one of Wessel's prints – and in another way, every texture – is an aspect of light. It's light that drives the image across the sheet from edge to edge.

Wessel's love affair with California light began in midwinter 1970 with a visit to San Francisco from Rochester, New York. Wessel was twenty-eight years of age and had been attending Rochester's Visual Studies Workshop at the invitation of Nathan Lyons. Rochester was deep in a blizzard; by contrast, San Francisco had whole weeks of uninterrupted, bright January sun. Wessel made a telephone call and arranged to move west.

Wessel is a creature of habit who is unfailingly alert to the times when his work habits need recharging. For years, since arriving on this coast, he has shuttled back and forth between the Bay Area, where he lives, and Los Angeles, where, arguably, his richest subject matter – and, as he points out, a greater physicality of light – exists. By 1995 he was still exploring the beaches and residential sections of L.A. but he shifted to night shooting in a vintage-1940s San Monica neighborhood. In 1990, after decades of making black-and-white pictures often involving views of local architecture, he began a series of color portraits of single-family homes in Richmond, not far from his own house. Much of the latter series was shot over the next two or three years from the vantage point of the armrest of Wessel's truck; the views are frontal, each structure sitting full-face in its own peculiar mass and fanciful paint job. In both instances, the change was salubrious, ushering in a fresh, new set of perceptions. Wessel said recently: "It's the physical world that pushes me around, that makes me change places. If I want to clearly describe something in the world, its nature will dictate my process. The idea in the real-estate pictures was to make myself as transparent and neutral as possible. I wanted to see how many different kinds of photographs I could take within that narrow type. I like the edge produced in the contest of making it as clear as possible and still showing as much complexity as possible."

What's missing from both the "House Pictures" and the "Night Walk" series is people. Or rather, people are there, too, but only by implication – a wooden clothes hanger hanging from a nail under the front porch eaves; a newspaper in a clear plastic bag on a lawn at 3:30 A.M., with the overhead light still on above the entryway. About half of Wessel's other types of pictures center on people sitting, walking, or reclining in public settings. As expressive factors or matters of social commentary, photographers' images of people other than themselves tend to force the issue. Wessel's human figures can appear sculptural (the longhaired man on a beach in *California, 1973* exhibits the mass and torque of one of Bernini's river gods) or like dancers in an antique frieze. A social truth made plain in some of his beach and highway pictures is that the isolate men and women seen striding across the sand or

standing roadside are caught in the act of going nowhere. The appropriate distance Wessel maintains between himself and his subjects is similar to the distinction kept in his photographs between people and things. An empty phone booth is vastly different from an occupied one; the white paper cup at a surfer's elbow in *Southern California, 1985* has its own center of gravity, independent of function. Shots of people facing Wessel's camera are rare, and when they occur, an extra tension gathers in the middle of the frame. More common are somewhat abstracted figures like the balding man facing away from us in *Santa Barbara, 1977*, whose elongated shadow seems to join with tree shadows and those cast by a flock of skittery pigeons to point us toward something deep in the recesses of the view. (Follow that orthogonal logic to its end and you come up empty-handed, or almost so.)

The noirish tinge in many of the L.A. nocturnes suggests a kind of retroactive menace. Looking at one of them, Wessel said with a slightly uneasy chortle: "Something horrible happened in this house thirty years ago, and the couple haven't spoken since." You sense that his pictures generally were taken by someone who immersed himself in each particular setting. They project a feeling more of moments apprehended in the process of looking around than of flatfooted determination, and there's more patience in them than in most street shooting. What looks staged is in fact a disclosure. Wessel has turned his attention loose long enough to soak up the wealth of particularity in the place he shows you.

By extension, the pictures with their gentle candor let us wander apace in them, too. They look lived-in but are not so idiosyncratic that they crowd you out. They refuse to resolve themselves as satire or indeed any kind of commentary because any generalization of the experience they project is immediately superseded by the strength of every detail as itself. Take away the quality of light or throw one element into prominence at the expense of another and the whole thing would degenerate into a cruel joke or something otherwise sappy. But Wessel's approach is at once too tender and too exuberant for that. Ultimately, he's a formalist whose sympathies, although evident, remain carefully contained. His photographs declare their charm long

before you get around to seeing what's impressive about them. The charm – along with the quiet manner by which a picture's parts are built into an altogether vibrant, purposeful graphic unity – helps guide you to the significance, which anyway is unforced, an accumulation of everything that is there, percolating to be seen.

2000

Warhol's History Lessons

Let me recite what history teaches. History teaches.
– Gertrude Stein, "A Completed Portrait of Picasso"

*I was disappointed that nobody in Dallas wears cowboy hats any-
more. The cowboy look is dead, I guess.*
– Andy Warhol, November 20, 1985, *The Andy Warhol Diaries*

Andy Warhol's "Cowboys and Indians" paintings extended from a
portfolio, commissioned in early 1986, of fourteen silkscreen prints on
the same theme. Preparatory to the prints were a series of graphite line
drawings, some of them embellished with acrylic wash. The prints
were shown first in Fort Worth that March and then in June went to
the Museum of the American Indian in New York. Warhol, who died
in February, 1987, never finished making paintings of the whole run of
images, nor have the canvases he did finish, including those in the pres-
ent exhibition, ever been shown before.

The choice of imagery for "Cowboys and Indians" was Warhol's.
His assistant Vincent Fremont told me: "Andy chose the images that
were meaningful to him – and a large part of the meaning was their
popularity." Then, too, there was Warhol's own fascination with
Americana, generally; his personal collection included, along with
Edward S. Curtis photographs and Native American jewelry and moc-
casins, the Plains Indian shield, Northwest Coast mask, and Kachina
dolls depicted in the series.

"Cowboys and Indians," like "knights in armor," is a set of con-
ventions with practically no substance behind them. Or else the sub-
stance is vestigial, in much the same way that, in the mid 1980s,
painting's claims to substantiality were vestigial at best (the "elegiac"
mode then employed by younger painters made hay of that assump-
tion). As a children's game, the euphemistic proposal, now defunct,
once allowed acting out of garden-variety aggressions and often solitary
lyric wanderings, as well as, thanks to the likes of John Ford and

Howard Hawks, feelings plausibly up there within range of the American Sublime. De Kooning once said that his teenage ideas about America were formed by Hoot Gibson movies. By the time Warhol took hold of the theme, it's unlikely that kids anywhere in the world had a clue about such things. (Real cowhands and members of diverse American tribes participate only tangentially in the myth.) Warhol's series was for grownups like himself for whom Roy Rogers fantasies and the attendant dress code were second nature.

Retrospect tells us the theme was there from the get-go. Among Warhol's earliest movie-star portraits, for example, were the quick-draw Elvises of 1962. In 1963, Warhol painted his "Death in America" pictures: the suicides, car-crash victims, electric chairs, and – arguably most relevant of all to the present instance – race riots. In Arizona four years later, he filmed *Lonesome Cowboys*, a Wild West sex farce. In 1976, he painted *The American Indian (Russell Means)*. Lurking some-where in here, as well, must be the specter of Ronald Reagan, the poster boy for Warhol's in-crowd in the '80s, who then was tall in the presidential saddle and often photographed as such at his Rancho del Cielo home. Reagan had done his share of oaters – in fact, played an ultra-benign George Armstrong Custer in the 1940 Warners' epic *The Santa Fe Trail*.

These are powerful images, partly because of what Warhol typically recognized would be recognizable about them and partly for what he did to transform or even thwart that recognition. Late Warhol still rules as the laureate chronicler of Imperial America, its dreams, depredations, disasters, and eventual self-parody. In the near decade and a half since his death, not much has changed: you can go down any street and see the world in terms of his kind of detailing.

A Warhol portrait, no less than one by Hans Holbein or Hyacinthe Rigaud, is history painting by association. His Kachinas historically belong to the deadeye museological category "southwest Indian art." Both Sitting Bull and his victory over the grandstand warrior Custer came to form parts of the same entertainment industry within which Buffalo Bill Cody performed the double role of producer and star. While at work on his series, Warhol remarked to Pat Hackett about

John Wayne: "It's a still from a Warners' movie and I don't know why it's even called a John Wayne because otherwise you couldn't tell WHO it is." Was Teddy Roosevelt a real-life cowboy? He had a cattle ranch in Dakota territory for a couple of years in the 1880s and soon after wrote *The Winning of the West*. But the image Warhol used is TR in his faux-frontier Rough Rider garb. Publicity stills like this show a trajectory of a century or more for the "image world" that Warhol called home.

The dart of light on a shaded cheekbone is as informative as a cocked pistol. There is no right or wrong version. Annie Oakley reversed is no less the sharpshooter whom except for Rodgers and Hammerstein we would but dimly recall. Sitting Bull waits out the camera with such radiant simplicity we would fain know his thoughts; Warhol, it appears, intuited them well enough to eventually blank out the photographer's phony landscape backdrop, leaving an iconic presence equal to any in his repertory. Geronimo, too, tells us more than his sad end would allow, his hard-bitten determination seething at hallucinatory pitch.

All this Warhol conveys deadpan. He leaves nostalgia for America's past behind in the dust of old photo albums. In place of nostalgia, he puts whatever we may make of these shapes suspended before our eyes. He and his squeegee work collective memory to the nub. Then they move on. If bits of grim fact and horror ensue, those are our business. So is the grandeur residual of our erstwhile national genre, strange to tell.

2001

Spellbound

The constellations are rising
In perfect order: Taurus, Leo, Gemini.
> – John Ashbery, *The Skaters*

There are no perfect waves – . . .
> – William Carlos Williams, *The Descent of Winter*

In the mid 1960s, while still a graduate student in Los Angeles, Vija Celmins announced her determination to create what she called "dead-pan paintings," a mission she accomplished promptly with a set of laconic still lifes centering on isolated studio objects. In what has come to be typical Celmins fashion, the still lifes' sullen looks are insidious: a double-necked desk lamp, a fan, a television set, a space heater, a hot plate – each object emits, or else looks capable of emitting, a steady infernal glow. The still lifes were followed in 1966 by gray paintings based on news photographs of World War II bombers and fighter planes. In Celmins's hands the killer aircraft appear paradoxically help-less and chilling – weird and slightly faded, clunky imprints upon the twentieth-century soul.

During the intervening decades, Celmins has continued to build on rudiments taken from documentary halftones, many of them found reproduced in books. Choosing commonplace views of enormous, untenanted expanses – most persistently, stretches of ocean and starry skies – she transforms them into artworks muted of manner yet high-yield in effect. Her recent images, including a new group of splendid, albeit relatively microcosmic spider webs, render phenomenal sites of unalloyed wonder linked fatefully to feelings that range from euphoria and quietude at one end to utter desolation on the other. Anonymous photography's straight-edged, residual plainness reduces her subject matter's inherent mystique. (There is no such thing as a poorly com-posed night sky.) Hence, the basic, allover gist becomes light reflected across a large, particular span, whether veiled with haze or keenly artic-

ulated. That light Celmins keeps tethered close to the carefully worked surface, where it does double duty as the prime index of implied motion. Just how footloose Celmins has become in her starfield renderings is indicated by *Night Sky #18*, in which the heavens assume the khaki pallor of freshly mixed cement accented with ominous black flecks that appear to have bled through the smoothly painted fabric from behind.

In conversation, Celmins habitually describes her way of working as a kind of pictorial masonry. Up close, you can see how she has culled the spread of pigments into and across the weave, sometimes leaving texture as a quality of the image. The canvases, rough or smooth, have all been painted on a conventional easel but worked this way and that, "in the round." Much of this labor constitutes what Celmins calls "fill." She told me: "I sort of punish the canvas. I paint, I sand, I fill it again, maybe eighteen times, like Formica." The battered textile will often require a sturdy wood panel as extra backing. Rather than distress, subtlety follows – what Celmins has called "little, unnamable nuances" that form a painting's opaque yet buoyant and charismatic whole.

The spider webs, with their obvious purposefulness and cautionary intimations of seduction and sting, are perfect analogues of painting's efficacy. Like the sky pictures begun nearly thirty years earlier, the webs signal fresh turns in Celmins's aptitude for pattern recognition and her way of running up an image in an indeterminate scale. One is tempted to see them as rendered actual-size, but their history as printed matter leaves us clueless as to what perspective originally claimed them. As is her wont, Celmins pries her photographic evidence loose from its status as a graphic sign only to encase it in another, more perceptually malleable and telling artifice. She reclaims the image as a sensuous fact that rings deep and wide in the viewer's consciousness. The spider's gridlike secretions tend to hang on all four sides. Along one midsection of silky thread a bead of dew may swell, weighing in like distant thunder. At one point, I could have sworn I saw the painting *Web #2* venting steam at the edges of its tattered countenance. The web is many things, a multivalence. "A fragile but loaded image," Celmins says, and further, "An image of decay: something or some place has been left to gather these webs." Get near to one of them, it strikes like lightning.

Like the tangencies and tensile filaments Celmins so deftly portrays, the tautness her surfaces advance is at once forlorn and haunting. In memory, the actual honed image proves an elusive shimmer. The ghost image you carry away is likely to be epigrammatic, a juggernaut of compressed insinuation like that deep, gummy gray thrumming madly of *gravitas*, heavenly *gravitas* (the music of the spheres augmented by a gritty, subterranean drone). Returning, you recognize the work by its unique tenor, luminosity, or heft. Spellbound again by the mischievously real-enough likeness, the mind is readied for more of the same inexhaustible call and response between barely registered, intermittent bits that is the stuff of painting, its measure of grace.

2001

What Is There

In 1951, Fairfield Porter began to write short reviews and feature articles for *Art News*, having been hired by Thomas B. Hess, the magazine's editor, at the suggestion of their mutual friend Elaine de Kooning, who had been writing criticism only a few months herself. Although, at forty-four, Porter had been painting seriously on and off for more than twenty years, he was just then beginning to exhibit his pictures regularly. The pictures were portraits of friends and family, landscapes, and household interiors done in ways that reflected Porter's veneration of Vuillard (whose significance among modernist painters he considered counter to Cézanne's) and also aligned him with such contemporary abstract painters as Willem de Kooning and Franz Kline as well as with other, younger realists like Jane Freilicher and Alex Katz. When Porter left *Art News* in 1959 to become the art critic for *The Nation*, one of his first weekly columns there delivered what remains the best account of de Kooning's paintings. *Art in Its Own Terms*, a generous sampling of Porter's writings chosen by the English-born, American-trained landscape painter Rackstraw Downes, first appeared in 1979 and by the mid '80s was generally unavailable; the present paperback edition, identical but for a different cover design, came out in 1993.

Artists who also write about art have this dual advantage, that their writing helps define conceptually what they themselves are up to as artists, and that they bring to criticism, beside their passion as committed insiders, a technical knowledge that makes them reliably more informative. One can imagine Porter entering the lists of art criticism with a sense of mission, as a corrective to the prevalent types of magazine prose, which he disliked. Two of the very few art writers he admired were Adrian Stokes and Paul Rosenfeld. His sentences, their surefootedness as well as the sometimes odd indeterminacy of their sequencings, one to the next, recall Whitehead's in *Modes of Thought*. Downes quotes Porter as tracing the formation of his critical attitude to lessons learned in Whitehead's classes at Harvard in the '20s:

> What I remember of what I got from him was the importance of having very clear terms in your discussion and knowing what they mean . . . He also told us that the artist doesn't know what he knows in general or what can be known in general, he only knows what he knows specifically.

For Porter, the critic's job was not to develop a closely reasoned argument but to lay out in grammatical clusters a number of meaningful perceptions about the work on view. In the process, his abrupt non sequiturs were guaranteed to make his editors dyspeptic. (Lucky for us, Hess, with his hands-off policy toward the "real writers" on his staff, pretty much let them be.) Likewise, Porter's opinions – "blunt" is how Barbara Guest has described them – are not evaluations so much as judgment calls along the lines of professional ethics, with frequent appeals to the higher court of everyday manners. They can be completely mystifying (viz., "Two is a weak number, and most Rothko paintings seem to express this number") or simply and beautifully accurate, as in this about de Kooning:

> There is that elementary principle in any art that nothing gets in anything else's way, and everything is is at its own limit of possibilities. What does this do to the person who looks at the paintings? This: the picture presented of released possibilities, of ordinary qualities existing at their fullest limits and acting harmoniously together – this picture is exalting.

"The Short Review," written for the Artists' Club journal *It Is* in 1958, contains observations on what is good to read in criticism. As an assessment of the state of this dubiously founded literary genre in Porter's own time, it accomplishes what Baudelaire's "A Quoi Bon?" did for the 1840s, and, like Baudelaire's similarly brief, speculative piece, it has a strong, residual pertinence. "Criticism should tell you what is there," writes Porter, creating for the frontline critic as plausible a motto as we are ever likely to get. Further along, in his summation, he elaborates:

Painting and sculpture are made to be seen and touched; they are sensuous things; even if they are about ideas . . . rather than about the sensuous world, still these ideas are sensuously communicated. Realist painting, which has an obvious subject matter, can be most valuably discussed in terms of its forms – how and how well is its reality presented? Abstract painting in which the sensuous elements are undisguised and obvious can perhaps best be written about in terms of its subject matter, which is largely the artist himself, that is, his character.

Reviews should be short. Who likes to read art criticism? One likes to read it if it is worth reading, as Ben Shahn said. But this has nothing to do with the correctness of its evaluations; nor with the painting to which it refers; just as it is not what painting or sculpture refer to, but what they present, that makes them worth looking at.

In 1959, Porter told Robert Hatch, his editor at *The Nation*, that he hoped his art writing would help make him better known as a painter and expressed the conviction two years later, when he quit writing criticism entirely, that it had worked. Can the same spell be cast to work the other way around? Now, nearly twenty-five years after Porter's death, his painting can be said to be widely appreciated, and his criticism badly overlooked.

1999

A New York Beginner

Soon after New Year's 1959, I left Providence, Rhode Island, where I had been attending Brown University, and returned to live full-time in New York. My plans included transferring to Columbia, but secretly I wanted to experience firsthand the steam-heated life of poetry and some other, seemingly connected fantasies of accelerated living. This other New York culture, despite its happening practically in my old backyard, was far from my original, rather checkerboard bearings on the Upper East Side. It existed for me as occasional nights in MacDougal Street coffeehouses and jazz at the Five Spot (Thelonious Monk opened there a month before my eighteenth birthday), the Half Note and the Village Gate. For the music at least I had an ear, but the places were just drab rooms; no context enveloped them or their occupants, except of course the unifying factor of everybody keeping New York time.

In the three and a half years since going away, first to boarding school and then college, I had started writing poetry, and at Brown began discovering rather haphazardly contemporary writing that matched the levels of excitement in the few modern masters (Eliot, Pound, cummings, Gertrude Stein) who had already come my way. "First came Patchen, then Ferlinghetti," as Ron Padgett recalls the initial jolts absorbed in different parts of the country by beginners like us, and even those in quick succession swept aside by Ginsberg, Kerouac, Corso, Creeley, Ashbery – on down an ever-widening street. That an energetic poetry was possible alleviated what before had seemed an encirclement of dullness. The depressive *New Poets of England and America* anthology appeared in 1957, but then so did, as if on cue, *On the Road* and the first four issues of *Evergreen Review*. On the cover of *Evergreen's* third issue was a photograph of Jackson Pollock, who had died the previous August. Inside, along with pictures of Pollock at work, were stories by Patsy Southgate and Samuel Beckett, essays by Camus and Alain Robbe-Grillet, and poems by Frank O'Hara, William Carlos Williams, and Barbara Guest. In the 1950s, like many people, I had heard of Jackson Pollock – the name was memorable, and his work

method was notorious. Ed Neilson, a pipe-smoking literary type, sat in his respective dormitory room making little paintings by dipping lengths of string in poster paints and then ingeniously dropping them.

At Brown the people I knew talked about literature, social life, and current events (although events were stirring, we didn't have anything like a mentionable politics yet). Like jazz, contemporary poetry was a small-group topic. If art was mentioned it was something halfway downhill at the Rhode Island School of Design where the girl students wore exotic long hair piled up, and shawls, and gave surrealistic formal garden parties. John Willenbecher, then an art-history major at Brown, spoke admiringly of Harry Bertoia. What painting I saw coming out of RISD was likewise abstract. In retrospect it follows that anyone becoming conversant with painting and sculpture at that time might tacitly accept abstraction as natural, art history having been defined pretty much as a connoisseur's chronology of arranging and rearranging significant forms. In the one such introductory course I took, understanding a Picasso still life (*The Red Tablecloth*, as I recognize it now) meant reduplicating and gluing down its pancake shapes in different shades of cutout construction paper. Of the slides paraded during lecture sessions I remember looking especially hard at Raphael's *School of Athens* (the traffic control amazed me), Michelangelo's Medici tomb sculptures, a spotless 1920s Mondrian, and (with what eyes I can't recall) *Agony* by Arshile Gorky.

Spring semester, 1959: while waiting to get accepted at Columbia for the next term, I decided to take classes at the New School for Social Research. Searching the catalogue, I saw that John Cage, whose name then rang some distant bell, was teaching experimental composition in a classroom at the school's Twelfth Street headquarters and, in the woods near his house in Stony Point, a course in mushroom identification. Pointless now to wonder if I didn't play it safe by signing up for, instead of one of Cage's offerings, William Troy's relatively standardized modern poetry course (for which I eventually wrote a paper figuring out Williams's "variable foot") and a poetry workshop taught by Kenneth Koch. Kenneth's class was held in the afternoon. Sitting very upright at one end of the long table, he invented as he

went, uncertain in spots, but with surges of glee at the edges of his thought. (The slight stutter he had then was later cured by psycho-analysis.) Part of each lesson, the fun and suspense, was watching him wind toward describing graphically the pleasurable aspects of the poetry he liked – the poetry of Whitman, Rimbaud, Williams, Stevens, Auden, Lorca, Pasternak, Max Jacob, and Apollinaire, as well as of his peers Frank O'Hara, and John Ashbery. Then, too, he would make an analogy between some moment in a poem and the sensibilities of New York painting – the amplitude of a de Kooning, Larry Rivers's zippy, prodigiously distracted wit, or Jane Freilicher's way of imagining with her paint how the vase of jonquils felt to be on the window sill in that day's light. All of these things would dovetail into the writing assign-ments Kenneth gave us, which were designed to (and really did) help precipitate and sustain energy and surprise in our poems.

One spring afternoon in the Cedar Bar I introduced myself to Larry Rivers because not only had Kenneth mentioned him but I had seen a photograph of him and Frank O'Hara collaborating on litho-graphs. (The portfolio, *Stones*, was shown at the Tibor de Nagy Gallery that fall along with *Oranges*, the poem paintings Grace Hartigan had done on Frank's texts.) The man I spoke to wasn't Larry but another painter, a near-look-alike, named Friedel Dzubas. That was the begin-ning of a beautiful friendship. The reason I had wanted to meet Larry was that, based on the little I knew then, I had decided that he repre-sented the most dynamic conception of what it meant to be an artist: much handiness, restless curiosity, sophistication (hip), a life and an art both going full tilt, and the nerve to sustain a daily overload of what was then called the Absurd (the spillover, mostly, I would later realize, of a frenetic self-regard). I was going on twenty; in a few months Larry would write an autobiographical essay for *Art News* with the sentence "When you're twenty you want to be somebody, when you're thirty you want to do something." Just about on target. I thought from seeing his paintings that Larry Rivers must be the sharpest person alive, but when I got to know him he seemed as confused as anyone else, not sophisti-cated at all. How could that be? Frank O'Hara said: "Maybe he's just come out the other side."

Eventually, Larry and I were featured players, running mates actually, in Kenneth Koch's play *The Election*, which ran as an after-hours show at the Living Theater during election week 1960. Larry was LBJ and I was John F. Kennedy. Since Kenneth's script took off on Jack Gelber's play about addicts waiting for dope – the candidates were likewise strung out, needy for the vote – my part consisted mainly of laying around front stage in a withdrawal stupor while Larry/Lyndon speechified on the shortfalls of democracy. Before he became president, Kennedy's distinctive intonation wasn't so familiar to us; Kenneth knew he had gone to Harvard so he wanted my jivey entrance line delivered with a WASP-ish Ivy Leaguer's lockjaw drawl: "Oh mahn, ah'm wiggin'!" The improbability of following Kenneth's direction without appearing entirely off the mark got a laugh every time.

Fast and furious – the general quality of forward motion in early-'60s hometown art set the pace for my extended initiation into the facts and mysteries involved. The endlessness of getting to know New York painting was similar to that of finding out about poetry; in both there was always, so to speak, more at the door. The difference for a follower of painting has to do with the apparent contradictions of style and attitude that follow from the art world's prodigal, souped-up sense of fashion and generational shifts. In May 1959 at the Janis Gallery I met painting in the form of de Kooning's landscape abstractions. The best poem I could imagine for some time afterwards would have something like those paintings' expansiveness and speed. In Paris that August I heard a sinister-sounding tape recording of William Burroughs reading the first chapters of *Naked Lunch*. (The people who crowded into a small room on the second floor of George Whitman's bookshop to see *el hombre invisible* were met by a reel-to-reel playback on a plain wood table.) Back in Manhattan I acquired three pictures from the Tibor de Nagy Gallery: a small Rivers still life of a V8 can and paintbrushes contoured against a black field; a Freilicher of a central mass of white flowers in a wilderness of red, orange, and light blue marks; and a Maine landscape by Fairfield Porter with a white lawn chair that seemed to double as a miniature de Kooning. John Cage's *Indeterminacy* was issued on LPs, and John Ashbery's long knockout poem "Europe" was just around the

corner (it would appear in *Big Table* the following spring), as was Donald Allen's *New American Poetry*. Toward Christmas I wandered alone into the Stable Gallery on Seventh Avenue and screwed up my face before Rauschenberg's *Monogram*; the whole arrangement – wooly goat, car tire, canvas-covered platform with lettering on it, sad daubings on the goat's face – signaled one vector of the shift occurring under my feet. It struck a chord compounded of one part Ornette Coleman (Rauschenberg's fellow Texan who meanwhile had arrived from L.A. and checked into the Five Spot), one part Jack Kerouac braying (on another record recently acquired) "Laugh to hear the crazy music!"

Pretty soon life in this expanding universe became identified with Frank O'Hara and his poems. I was crazy about Frank's poetry – the poems I was writing were largely amalgams of what I saw in his and Ashbery's work – and it was plain how he figured in the ambience known to its inhabitants as "downtown." Of the New York poets, he was the one who was most, in Franz Kline's phrase, "around it." Aside from his own poetry, Frank was the enthusiast insider whose normal workday at the Museum of Modern Art was lifted by his approaching it as an imaginative composite of salons at the court of Louis XIV and the 1930s Warners' lot. I met him because one day after class Kenneth suggested that I accompany him and his wife Janice to a party given by Jane (Freilicher) and Joe Hazan. (Others at the party would have included Vincent Warren, Harry Mathews, Fairfield and Anne Porter, Kenward Elmslie, Jimmy Schuyler, Alex and Ada Katz, Larry Rivers and Maxine Groffsky, Nell Blaine, John Bernard Myers, Morris Golde, Arnold Weinstein, Barbara Guest, and Trumbull Higgins.) By the end of the next year Frank and I became fast friends, I quit Columbia and went straight to graduate school as a sort of glorified copy boy at *Art News*. Central to the curriculum was overhearing, through the thin partition that separated my cubicle from Tom Hess's office, his running banter with the likes of Harold Rosenberg, Bill and/or Elaine de Kooning, and Philip Pavia. A frame of reference was rapidly getting knocked together. Like professional sports, the art world, intense as it was then, bred insiders overnight. Going with Frank to Philip Guston's studio one flight up in an old firehouse on the westside, I experienced

for the first time that peculiar, discrete phenomenon, a painter's studio packed with elements of a substitute world. A weight in the air differed from the buzz or frantic mess of other painters' lofts. The atmosphere was more fraught than businesslike. Philip said later that I was strangely silent. I'm sure that was true; I had no answer for being thunderstruck. The next day, annotating my memory of the scene in a journal, I scratched the word "INTEGRITY" in tall spindly letters.

I immersed myself in rounds of lofty chatter, dipsomaniacal weeps and rages, raw camp, and cooler, subtler forms of intelligent behavior, all of these oddly bundled, often indistinguishable. Everyone was interested in sex and seemed to assume it could take any form, depending on the circumstances, which were limitless, even if one's particular desires weren't. I took to the wonders of George Balanchine, modern dancers like James Waring, Merce Cunningham, Paul Taylor, and later the Judson Theater group, especially Yvonne Rainer, on whom I developed my first esthetic crush. Frank's feelings for concert music, especially French and Russian (Faure, Poulenc, Prokofiev, Scriabin), and for suave or sentimental '30s movies, were infectious. My appointment calendar for a typical week (winter 1961) lists going to see a new French movie (*Zazie dans le Metro* by Louis Malle), the New York City Ballet at City Center, an evening at my place with Frank, Joe LeSueur, and Norman and Carey Bluhm to watch a Busby Berkeley musical on TV, a raft of lunches, two big midtown art parties (Earl and Camilla McGrath and Fay and Kermit Lansner), a Saturday date at the Tropical Gardens, and Mingus at the Jazz Gallery after. Madeleine Renaud was appearing in Beckett's *Happy Days* at the Cherry Lane. Nureyev and Fonteyn rocked the Met. At a benefit for LeRoi Jones at the Living Theater (money for legal fees to clear *The Floating Bear* of obscenity charges), Frank and Morton Feldman played four-hand piano. Frank complained afterward of the difficulty of matching the lightness of touch that Feldman's pieces required and that Feldman's own large fingers could muster.

September 1961: At a lawn party given in Watermill by Jane Wilson and John Gruen to celebrate their daughter Julia's third birthday, John Myers presented me with a handful of advance copies of my first book, *Saturday Night: Poems 1960–61*, just arrived from a friars' printing shop in

Venice. Also at that party I met de Kooning for the first time, and a few hours later at Larry Rivers's house I gave him a copy of the book. "Hey," de Kooning said, seeing the dropout lettering on the red, white, and blue cover, "I did a painting called *Saturday Night*, too." "Don't I know it!"

Our best contemporary art critics are preoccupied with assessing, surveying, tallying and rating – with history and the history of painters, less with the achievements of the paintings themselves and our response to them.

– Frank O'Hara, "Nature and the New Painting," 1954

No one I knew believed that Clement Greenberg's idea of modernism when it appeared around 1960 was especially pertinent. In *Art News* Jack Kroll dismissed the chief critical premise of Greenberg's just-published *Art and Culture* as an "intellectual malted-milk-with-egg." To other critics and artists who had given their hearts to abstract expressionism, any but the most modest divergence was suspect. In that regard, Johns's articulated sense that de Kooning did not need his help to make more de Koonings was salutary and true. Pursuit of the Great American Artwork – a novel, painting, or opera – informed midcentury art in this country (has it ever let up?), whereas by the early '50s Europe had said (and *then* they really meant it) goodbye to "art as art." If pre-war Europe invented formalism, postwar Europe threw it over. Only in England did Greenberg's fixed idea carry any serious weight. Postwar European art – Lettrism, the Situationists, COBRA, the Independent Group, and eventually Fluxus and the New Realists – anticipated the "anti-esthetic," or anyway antiformalist, art recognized twenty years ago as "postmodern." But you can search the pages of *Art News* in the '50s and '60s in vain for any mention of Guy Debord or even of Asger Jorn or Piero Manzoni. New Realists like Yves Klein and Jean Tinguely were acceptable to New York's sense of itself; indeed they courted such acceptance. Meanwhile, for those old enough to care, criticism on the street carried on types of Depression-years name calling: a spot of vermilion might be analyzed as "fascist," and all good gestalts were "Trotskyite."

The art world I entered in its waning years was made up of artists, writers, dancers, musicians, theater folk, and otherwise a few adventurous dealers and very few collectors and patrons. Likewise, the magazine critics were artists, poets, journalists, men of letters, or amateurs. In the mid '6os a group of underemployed young art historians made a full-time profession out of what had previously, and best, been a pastime. Despite their efforts the most telling essay form of the '6os was the interview. Homeric '4os/'5os artspeak took its grammar from Damon Runyon and bebop. Reviews could be parsed into variants of ultra-hip sports writing and obscurantist sci-fi or True Romance. Were the artists really that embroiled and dashing, their patter that entrancing? Often. Was the critical language accurate and sincere? A near miss. Art criticism since then, the criticism of career professionals, has been more methodical and more rarely inspired. Abstract expressionism was an art for urban professionals – the intellectuals, sociologists, lawyers, psychoanalysts, and literati who constituted the high end of bohemia. The first-generation New York School and their followers failed to charm café society in the way that the surrealists did. Pop brought about a merger of high fashion and the serious art scene.

In the early '6os Marcel Duchamp could be perceived as a highly refined, neighborly, purse-lipped seventy-something who looked closely everywhere he appeared, whether at a small gallery show or a Happening. The American edition of the first big book on his work, with a text by Robert Lebel, appeared in 1959. Works that favored Duchampian playfulness and inclusion were labeled neo-Dada, which meant they were anti-art, not really serious. The 1961 Art of Assemblage show at MoMA institutionalized this phenomenon. During the opening I wandered alone into a large gallery at the far end of which hung Rauschenberg's astonishing combine painting *Canyon*. I had been in the clutches of this complex image for a minute or so when a twangy voice in my ear, Rauschenberg's, said: "Pretty good, huh?" Without taking my eyes off the wingspan of the eagle on a tin box cantilevered near the bottom edge, I replied, "I was just thinking so, myself." Rauschenberg lurched closer, snarled menacingly: "And it's no joke, either." Later that evening, in the King Cole Bar at the St. Regis,

I confessed to Jasper Johns the notion just then dawning on me that Duchamp really was a great artist, whereupon Johns stated flatly, "Oh, I think Duchamp is as important as Picasso." (As Picasso was the god of modern art this was equal to John Lennon's quip a few years later that the Beatles had become "bigger than Jesus.")

Edwin Denby, Rudy Burckhardt, and Alex and Ada Katz all lived in the Chelsea area of the West Twenties. Alex was, and remains, for me a kind of painting mentor. Early on, to clue me in and educate my taste, he took me to other artists' studios – most memorably, Tom Wesselman's and Al Held's. The approach that Held and Katz shared with respect to their images' appearance put in abeyance the supposed rupture between figurative and abstract.

The first Rudy Burckhardt films I saw were *Eastside Summer* and *Millions in Business as Usual*, both made of New York footage that brought the city home in the poignancy of its details and irregular scale. Another night, a few years later (1963), a couple of gawky brothers from the Bronx, George and Mike Kuchar, showed up at Rudy's with brightly colored, genre-type movies they made with friends, *Anita Needs Me* and *Lust for Ecstasy*. The Chelsea ethos, as I think of it, exemplified by Rudy's films and Edwin's poetry, was Manhattan mandarin, a nonaggressive, steady access to high style. Early on, in the '30s and '40s, de Kooning, who lived around the corner, had set the attitudinal standard, and Edwin's later writings about him, as well as his dance writings with Balanchine as protagonist, communicated the importance of each in terms of an alert, unsettled classicism. The professional push was all in the work; after work, fronted by sociability, there was critical attitude, but promotion and the wider audience either followed or didn't as a matter of course. If the work is interesting, they'll come for it, was the idea – perfectly correct if "they" is a neighborhood of engaged parties, numbering altogether around three hundred, like the one that existed until the '60s boom demolished it.

If in the '40s and '50s the basic design elements of fine art were dictated by the cubism that Picasso and others enlarged upon in the 1920s, the ambitious artists coming of age within the past thirty years have taken theirs from minimalism and its subcategory, Pop. Early Pop

maintained the sportive look of Action Painting, the perversely messy-looking, wide, overflowing artisanal mark that by then certified whatever it was applied to as art. Once the technological facet perceived as style could be taken for a readymade thing, portable, disposable, or up for grabs, the historic '6os had begun.

The Brillo boxes are also close to nothing. They aren't the real thing; Warhol had the basic wooden boxes made by an anonymous cabinetmaker, he ordered silk screens for reproducing the labels and he used assistants even for the painting and silk-screening of the boxes. They are not very interesting as art, and might look best in an artificial museum-like plastic case with a little brass plate that reads, "Brillo Box, Souvenir of an Exhibition by Andy Warhol, 1964."
 – Gene Swenson, "The Other Tradition," 1965

In a late-'80s museum exhibition recapitulating the history of design-oriented '6os art, the Brillo – and Kellogg's and Campbell's – boxes were shown encased in snug-fitting plexiglas cubes, which suggested that they are both far from nothing and fragile. The Boxes are now big-time souvenirs, collector's items shielded from the wear and tear they originally seemed to cry out for. Swenson was right about the Boxes' afterlives in a museum context but wrong about their nonreliquary existence in everyday life. A single Brillo Box never looked better than in the cramped living room of a Lower East Side apartment – Ted Berrigan's, as it happened – where it accommodated scuffs and Pepsi stains and, like the rest of the furniture (there was more art than furniture), multiple stacks of reading matter.

April 1966: outside the Castelli Gallery after the opening, the breeze took three of Andy Warhol's silver pillows into the air above Seventy-seventh Street. Up they went, past Madison Avenue, between the apartment buildings, the water towers and roof terraces, heading east but coated with the late afternoon light from across the Hudson.

1998

Acknowledgements

"Thiebaud's Vanities," *Art in America*, December 1985.

"Kline's True Colors," *Art in America*, October 1986.

"First Painter of Character" (as "Alex Katz, First Painter of Character"), *Art in America*, November 1986.

"Sweet Logos," *Artforum*, January 1987.

"The Sweet Singer of Modernism," *Art in America*, June 1987.

"Facing Eden" (as "David Park: Facing Eden"), *Art in America*, October 1987.

"The Idylls of Albert York," *Art in America*, September 1988; revised 2003.

"In Living Chaos," *Artforum*, September 1988.

"David Ireland's Accommodations," *Art in America*, September 1989.

"Ambassador of Light," in Robert M. Doty, *John Button*, Currier Gallery of Art, 1989, and *Art in America*, November 1989.

"Ethiopia," *Art News*, December 1989.

"Sensation Rising" (as "Martha Diamond: Sensation Rising"), *Artforum*, January 1990.

"Invocations of the Surge Protector," *Artforum*, May 1990.

"The Dark Pictures," *Philip Guston 1961–65*, McKee Gallery, 1990.

"Critical Reflections," *Artforum*, November 1990.

"Bladen's Mounds" (as "Bladen: Against Gravity"), *Art in America*, December 1991.

"A Moment of the Psyche," *Artspace*, November 1992.

"What Piero Knew," *Art in America*, December 1993.

"De Kooning, with Attitude," slide lecture, San Francisco Museum of Modern Art, October 1995; *Modern Painters*, summer 2000.

"In the Heat of the Rose," *Art in America*, March 1996.

"Shaw Business," *American Craft*, October–November 1996.

"As Ever, de Kooning," *Art in America*, February 1997.

"Nagle Wares," *American Craft*, August–September 1997.

"Herriman and Friends," *Homage to George Herriman*, Campbell-Thiebaud Gallery, 1997.

"A New York Beginner," *Modern Painters*, fall 1998.

"Hung Liu, Action Painter," *Hung Liu*, Rena Bransten Gallery, San Francisco, 1998.

"Music Pictures," *Art on Paper*, spring 1999.

"The Portraitist," *Elaine de Kooning / Portraits*, Salander O'Reilly Gallery, New York, 1999, and *Modern Painters*, spring 1999.

"Arneson's Doubles," *Robert Arneson: Double Portraits*, Brian Gross Fine Art, 1999.

"What Is There," *Modern Painters*, winter 1999–2000.

"The Photographist," *Art in America*, April 2000.

"Existing Light," *Henry Wessel*, Rena Bransten Gallery, 2000.

"The Sensational Pollock," slide lecture, Stanford University, December 2000.

"What the Ground Looks Like," Hilarie Faberman, *Aerial Muse: The Art of Yvonne Jacquette*, Hudson Hills/Stanford Art Museum, 2001.

"The Searcher," Susan Landauer, *Elmer Bischoff: The Ethics of Paint*, University of California Press, 2001.

"Warhol's History Lesson," *Andy Warhol Cowboys and Indians*, John Berggruen, 2001.

"Spellbound," *Vija Celmins*, McKee Gallery, 2002.

THIS BOOK WAS DESIGNED AND COMPOSED
BY DEIRDRE KOVAC IN GRANJON FONTS
(MACINTOSH VERSIONS)

This edition of *The Sweet Singer of Modernism*
is limited to 1000 paperbound copies.